Seurat

and the Making of *La Grande Jatte*

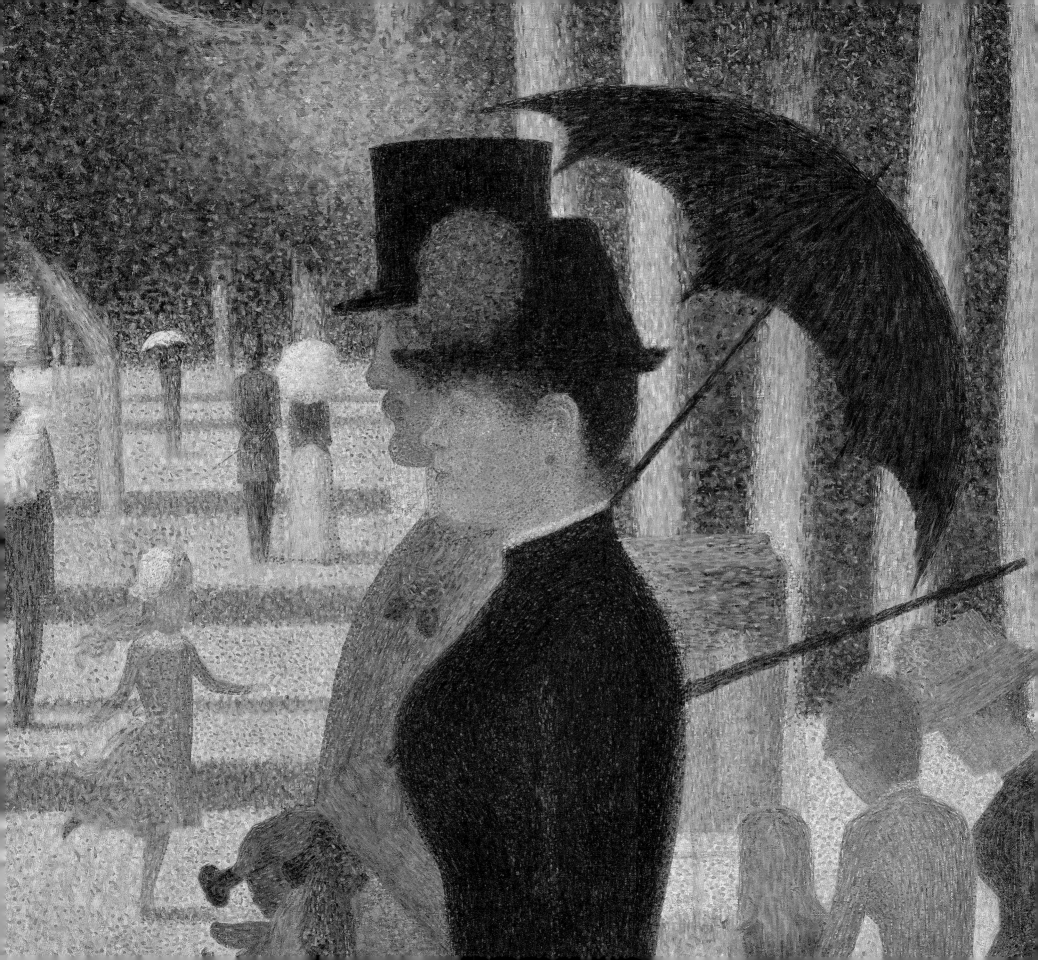

Seurat

and the Making of *La Grande Jatte*

Robert L. Herbert

With an essay by Neil Harris

Contributions by Douglas W. Druick and Gloria Groom, Frank Zuccari and Allison Langley, Inge Fiedler, and Roy S. Berns

The Art Institute of Chicago
In association with University of California Press

This book was published in conjunction with the exhibition *Seurat and the Making of "La Grande Jatte,"* presented at the Art Institute of Chicago from June 16 to September 19, 2004.

The exhibition was organized by The Art Institute of Chicago and is supported by the David and Mary Winton Green Research Fund and The Elizabeth F. Cheney Foundation. The exhibition is generously supported by a gift from Irma Parker.

First edition

Printed in Italy

09 08 07 06 05 04 9 8 7 6 5 4 3 2 1

Published by

The Art Institute of Chicago
111 South Michigan Avenue
Chicago, Illinois 60603
www.artic.edu

in association with

University of California Press
Berkeley and Los Angeles, California

University of California Press, Ltd.
London, England

Produced by the Department of Publications of the Art Institute of Chicago, Susan F. Rossen, Executive Director

Edited by Katherine E. Reilly, Assistant Editor, Scholarly Publications, and Susan F. Rossen, Executive Director

Production by Amanda W. Freymann, Associate Director of Publications, Production, assisted by Annie Feldmeier, Photo Editor

Unless otherwise noted, all photographs of objects in the collection of the Art Institute are by the Department of Imaging, Alan B. Newman, Executive Director

Designed and typeset by The Grillo Group, Inc., Chicago

Color separations by Professional Graphics, Inc., Rockford, Illinois

Printed and bound by Mondadori Printing, S.p.A., Verona, Italy

ISBN 0-520-24210-6 (cloth)
ISBN 0-520-24211-4 (paper)

Cover, pp. 6, 176: Detail of *A Sunday on La Grande Jatte—1884* (CAT. 80)
p. 3: Detail of *The Couple* (CAT. 61)
pp. 4–5: Detail of compositional study (large sketch) for *La Grande Jatte* (CAT. 64)
p. 20: Detail of *Tree Trunks* (CAT. 46)
p. 228: Detail of topiary of *La Grande Jatte* (Harris, FIG. 18)
p. 262: Detail of *Sailboat* (CAT. 41)

For photography credits, see p. 288.

Library of Congress Cataloging-in-Publication Data

Herbert, Robert L., 1929–
 Seurat and the making of La Grande Jatte / Robert L. Herbert ; with an essay by Neil Harris ; contributions by Douglas W. Druick ... [et al.]. — 1st ed.
 p. cm.
 Published in conjunction with an exhibition organized by the Art Institute of Chicago and presented June 16–Sept. 19, 2004
 Includes bibliographical references and index.
 ISBN 0-520-24210-6 (cloth : alk. paper) — ISBN 0-520-24211-4 (pbk. : alk. paper)
 1. Seurat, Georges, 1859–1891. Sunday afternoon on the island of la Grande Jatte—Exhibitions. 2. Seurat, Georges, 1859–1891—Criticism and interpretation. I. Harris, Neil, 1938– II. Seurat, Georges, 1859–1891. III. Art Institute of Chicago. IV. Title.

ND553.S5A68 2004b
759.4—dc22
 2004041138

Contents

Preface and Acknowledgments

La Grande Jatte holds a unique place, not only for the world as part of the larger history of modern art, but for the city of Chicago and for the museum that serves as the painting's home. This exhibition and book, which gives Seurat's masterpiece the in-depth exploration it deserves, would not have been possible without the collaborative effort on the part of many individuals.

Particular acknowledgment is due to the authors of this publication. A special debt of appreciation goes to guest curator, main author, and preeminent Seurat scholar Robert L. Herbert, Andrew W. Mellon Foundation Professor Emeritus of Humanities at Mount Holyoke College. In his thorough and insightful examination of *La Grande Jatte* Professor Herbert accomplishes the seemingly impossible: making a venerable icon fresh, challenging, and exciting. His vast knowledge of Seurat's work, which he generously shared, proved invaluable to the project. In addition to individuals at the Art Institute who gave welcome assistance, Professor Herbert would like to thank Joseph Berton, Joan Halperin, Adèle Lespinasse, Richard Schiff, Paul Smith, and Paul Tucker for providing advice and sharing current research. He also acknowledges Eugenia Herbert and Christopher Benfrey, who made helpful comments on early drafts of his text. The curators would like to thank Richard Thomson for his thoughtful counsel at the outset of the project.

Our appreciation also goes to Neil Harris, Preston and Sterling Morton Professor of History at the University of Chicago, for his engaging essay on how *La Grande Jatte* achieved its iconic status both locally and nationally.

One of the most valuable contributions to this project is the groundbreaking technical research conducted by the Art Institute's Department of Conservation. An essay by Executive Director Frank Zuccari and Allison Langley, Assistant Painting Conservator, provides an in-depth exploration of Seurat's use of studies in developing the painting's composition. Inge Fiedler, Conservation Microscopist, gives the most detailed examination to date of Seurat's materials and technique. Working with the museum's Conservation and Imaging staffs, Roy S. Berns of the Rochester Institute of Technology's Munsell Color Laboratory explains the complex process of digitally rejuvenating *La Grande Jatte*.

Douglas W. Druick, Searle Curator of European Painting and Prince Trust Curator of Prints and Drawings, and Gloria Groom, David and Mary Winton Green Curator, contribute an introduction on the history of *La Grande Jatte* in the Art Institute. Working closely with Professor Herbert, they conceptualized and organized this ambitious exhibition.

This unique opportunity to see Seurat's masterpiece hung alongside nearly forty preparatory studies and almost eighty other related works would not be possible without the public and private collectors who kindly agreed to lend from their distinguished collections; we offer our deepest gratitude for their generosity (see Lenders to the Exhibition, p. 281). The directors of these lending institutions deserve particular thanks, as do the following: Sylvain Bellenger, Laurence des Cars, Michael Clarke, Philip Conisbee, Marianne Delafond, John Elderfield, Katherine Galitz, Ivan Gaskell, Ted Gott, A. V. Griffiths, Torsten Gunnarsson, Colta Ives, Brian Kennedy, Marit Lange, John Leighton, Caroline Mathieu, Kynaston McShine, Corinne Miller, Jane Munro, Patrick Noon, Rebecca Rabinow, Richard Rand, Elisa Rathbone, Christopher Riopelle, Joseph J. Rishel, Marie-Pierre Salé, Scott Schaefer, David Scrase, George Shackelford, Susan Alyson Stein, Gary Tinterow, Gerard Vaughan, John Zarobell, and Jörg Zutter. Other colleagues provided research and photographic materials, and helped to secure loans: Joseph Baillio, Julian Barran, Marc Blondeau, Ivor Braka, Étienne Breton, Françoise Cachin, Patrick Cooney, Desmond Corcoran, Susan Davidson, Elizabeth Easton, Christopher Eykyn, Walter Feilchenfeldt, Marina Ferretti-Bocquillon, Frank Giraud, Vivien Hamilton, Marla Hand, Jean-François Heim, Jan Howard, Ay-Whang Hsia, Jan Krugier, Yutaka Mino, Ryuichiri Mizushima, Achim Moeller, Jean-Paul Monery, David Nash, David Norman, Pascale Pavageau, Thierry Picard, Lionel Pissarro, Jussi Pylkkanen, Stephanie Rachum, Bertha Saunders, James Snyder, David Spatz, Jacques Tajan, Anne Thorold, Michael Wakeford, and Guy Wildenstein.

At the Art Institute of Chicago, special thanks are due to Julie Getzels, Edward Horner, Lisa Key, Dawn Koster, Dorothy Schroeder, and Maria Simon.

In the Department of European Painting, we are particularly grateful to Jennifer Paoletti, who held

together the disparate parts of this enterprise with unusual efficiency and grace. Geri Banik, Darren Burge, Adrienne Jeske, and Barbara Mirecki were instrumental throughout the development of the exhibition. A number of dedicated interns and volunteers gave valued assistance: Dorota Chudzicka, Doris Morgan, Sheetal Prajapati, and Jill Shaw. In Prints and Drawings, we acknowledge the support of our colleagues Jay Clarke, Suzanne Folds McCullagh, Elvee O'Kelly, Chris Conniff-O'Shea, and Harriet Stratis.

From the inception of this project, conservation research has been a crucial element. In addition to the authors whose work is published here, we would like to thank Francesca Casadio, David Corbett, Timothy Lennon, Steve Starling, Kirk Vuillemot, Jeanine Wine, and Faye Wrubel.

This richly illustrated catalogue would not have been possible without the Art Institute's Department of Imaging, ably led by Alan B. Newman. His team—Siobhan Byrns, Chris Gallagher, Bob Hashimoto, and Greg Williams—assumed a leadership role throughout the project. In addition to securing high-resolution digital captures of *La Grande Jatte*, they created a digital model of the "rejuvenated" painting in collaboration with Roy S. Berns and the Conservation Department. Thanks are also due to Jon Meyer of GrafixGear, who secured the equipment and assisted with the technical details of the image capture.

The book has greatly gained by the efforts of the staff in the Publications Department. Susan F. Rossen has championed the project and supported its authors at every step of the editorial process. Katherine Reilly played an invaluable role in the final realization of the manuscript, bringing together the various voices of the team of authors. Amanda W. Freymann supervised the book's production, aided by Annie Feldmeier and Shaun Manning. Also deserving thanks are Faith Brabenec Hart, Cris Ligenza, Brandon Ruud, and Britt Salvesen. We are grateful for the support of our copublishers at the University of California Press. For the elegant design of the book, we are indebted to the staff at the Grillo Group, Inc. ProGraphics provided excellent color separations, and Mondadori Printing, the quality printing and binding.

Jack Brown, Peter Blank, and Susan Perry of the Ryerson and Burnham Libraries have been a tremendous help in our research. In Archives, Bart Ryckbosch and Deborah Webb helped us on several fronts that went far beyond their normal duties.

For the design of the installation, the wall texts and labels, and the multitude of exhibition-related material, we thank the Department of Graphic Design and Communication Services—in particular Lyn DelliQuadri and Joe Cochand. The Department of Museum Education, especially Robert Eskridge, Levi Smith, and David Stark, developed myriad programs to complement and enhance the visitors' experience of the exhibition. In Museum Registration, Mary Solt, Debra Purden, and Tamra Yost all provided exceptional coordination of the loans and indemnification application. A number of other staff provided indispensable support at significant points in the project: Cheryl Bell-Carrier, Tiffany Calvert, Alice Dubose, Bernard Geenen, Raymond George, Betsey Grais, and Greg Nosan.

The exhibition benefited from an indemnity from the Federal Council on the Arts and Humanities. We particularly recognize the support of Alice Whelihan of the National Endowment for the Arts. We are also grateful to William Acquavella for his assistance with the indemnity application. We extend a special note of thanks to our generous sponsors, who made this book and exhibition possible: the David and Mary Winton Green Research Fund, The Elizabeth F. Cheney Foundation, and Irma Parker. In addition, we want to thank Tru Vue, a division of Apogee Enterprises, Inc., for providing the Art Institute with new glazing for *La Grande Jatte*; their contribution, like the exhibition itself, allows this watershed painting to be seen afresh.

James N. Wood
Director and President,
The Art Institute of Chicago

"Almost by a Miracle": *La Grande Jatte* at the Art Institute of Chicago

DOUGLAS W. DRUICK AND GLORIA GROOM

Seurat and the Making of "La Grande Jatte" is the first exhibition that takes as its exclusive focus a work that for eighty years has resided in the galleries of the Art Institute of Chicago. The accompanying publication is not, however, without institutional precedent. In 1989 the museum published an issue of its semiannual journal, *Museum Studies,* devoted to *La Grande Jatte,* including papers delivered at a scholarly symposium marking the one hundredth anniversary of the painting's completion and first exhibition. In 1935, more than fifty years earlier, Art Institute curator (and later director) Daniel Catton Rich wrote a small book, *Seurat and the Evolution of "La Grande Jatte,"* a study that our current enterprise brings full circle.[1]

The dust-jacket copy of Rich's publication began with a remarkable statement, in fact an overstatement of the kind routinely devised in more recent times to market so-called museum blockbusters:

> Georges Seurat played a major role in rescuing art from the technique and aesthetic of Impressionism, helping to re-establish classical order at a moment when painting was threatened with formlessness and dissolution. His greatest painting, "Sunday on the Island of La Grande Jatte," is one of the most prized possessions of the Chicago Art Institute.... [In fact] the French government has offered one-half a million dollars for its return.

The basis for and significance of such claims are explored and contextualized in the texts by Robert Herbert and Neil Harris published in this volume. Suffice it to say that the breathless tone of the copy, along with the period certainties that Rich's text intertwines with enduring insights into the picture's qualities, suggests the climate in which *La Grande Jatte* was pursued, secured, and celebrated.

Art Institute Director Robert Harshe learned in June 1924 that *La Grande Jatte* was destined for Chicago. The news arrived in the form of a letter (see FIG. 2) written by Trustee Frederic Clay Bartlett (see FIG. 1) from the SS *Homeric* en route to the United States from Europe:

> We have had wonderfully good luck in adding to our collection as we were able to get almost by a miracle what is considered to be almost the finest modern picture in France "La grande Jatte" by Seurat. Adolph Lewisohn of N.Y. has if you remember the small canvas a study of the same subject [CAT. 64]. Ours is 11 x 7 feet and every inch of it is *superb*. There are 44 personages in it.
>
> It is quite a little larger than the one the Tate gallery in London has just purchased (The Bathers).[2]

In two sentences, Bartlett signaled those qualities that secured *La Grande Jatte* its definitive place in the Art Institute's collections and Chicago's cultural identity: historical significance to modern art, inherent beauty, compositional ambition and magisterial scale, the masterpiece of an innovative artist's short career, and hence a miraculous prize— the envy of institutions worldwide.

Although Bartlett's letter went on to announce other purchases made during his six-week buying spree—including pictures by Derain, Gauguin, Van Gogh, Hödler, Modigliani, and Utrillo (and major acquisitions would follow)—*La Grande Jatte* was and would remain the centerpiece of the remarkable collection he had begun to form for the Art Institute. The canvas arrived at the museum on July 7, 1924; two months later, it made its institutional debut in Gallery 256 (today Gallery 245) of Gunsaulus Hall (see FIG. 4). Bartlett had initially suggested displaying the "recent acquisitions to the Birch-Bartlett Collection" in a separate room, as had been done in September 1923, when works he had just purchased—including significant examples by Van Gogh and Matisse—were exhibited briefly in nearby Gallery 260 (today Gallery 247). Instead, *La Grande Jatte* and other new arrivals were displayed together with some, if not all, of the canvases previously on view. As both galleries were the same size, it is likely that museum staff, Bartlett himself, or both made a selection from the collection's holdings at the time. In any case, this was certainly done when determining the final gift, which excluded a number of works in Bartlett's possession.[3]

Little is known of Bartlett's collecting interests prior to his second marriage, in January 1919. The son of a millionaire who had made his fortune in the hardware business, Bartlett left Chicago in 1891, at age nineteen, to study art, first in Munich and then in Paris. In October 1898, he returned to Chicago, where he married Dora Tripp and established a largely local reputation as a muralist

FIG. 1
Frederic Clay and Helen Birch
Bartlett, c. 1923.

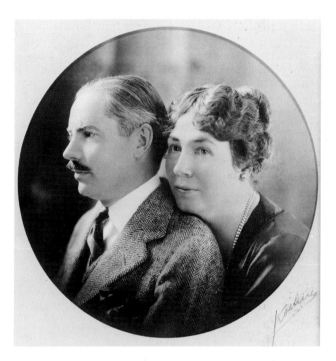

and painter. For his various Chicago-area patrons, he produced murals and other decorations in close collaboration with local architects.[4] His interests then seemed more regional than international; unlike other Chicago collectors, he did not, for example, purchase anything from the famed Armory show, exhibited at the Art Institute in 1913.

In 1919 Bartlett, widowed for two years, married Helen Birch, a thirty-six-year-old poet and musician from his own privileged and well-traveled circle. During their short marriage—it ended with Helen's death in October 1925—Bartlett began paying serious attention to the work of the avant-garde, mainly French artists. While there is no written evidence explaining this change of focus, it is possible to speculate as to why this shift took place.

Bartlett's collecting activity could well have been stimulated by his assuming the mantle of his father and others of his acquaintance in the cultural and philanthropic life of Chicago. While he had been a member of the Art Institute's Art Committee since 1905 and active in juried exhibitions of work by local artists, in 1923 he became a museum trustee, like his father, who had served on the board from 1887 to 1922. By September 1923, as we have noted above, his growing collection went on view. Less than one year later, he had acquired additional important works, foremost among them *La Grande Jatte*.

Recent developments at the Art Institute may have prompted Bartlett's new collecting interests. In 1921 Joseph A. Winterbotham gave $50,000 to be used toward the purchase of modern European

art. That same year, the Joseph A. Winterbotham Committee—composed of Harshe, Art Institute President Charles H. Hutchinson, collector and Trustee Martin A. Ryerson, and Bartlett—bought a 1918 canvas by Matisse as the first of thirty-five significant works to enter the collection under the Winterbotham credit line. Two years later, Bartlett was instrumental in securing for the museum a Tahitian landscape by Gauguin with Winterbotham funds.[5]

The following year saw the donation of paintings from Bertha and Potter Palmer; in addition to featuring French Romantic and Barbizon artists, the gift brought the first major group of French Impressionist work to the museum's collection. Thus, in one dramatic move, the vanguard artists of the generation preceding Seurat's became a permanent fixture in the Art Institute, installed in Galleries 25 and 26 (now Galleries 206 and 207).[6] Works by Cézanne, Monet, and Renoir in the collection of Mr. and Mrs. Martin A. Ryerson went on view at the Art Institute in 1921; they would return in 1933 as part of the couple's donation, the most important in the museum's history. Significantly, a recently discovered address book that Bartlett kept in the 1920s contains the names of these and other individuals who would leave their collections to public institutions, including Louisine Havemeyer in New York and Carroll S. Tyson and A. C. Barnes in Philadelphia.[7]

In December 1925, Bartlett crystallized his intentions when he offered his collection to the Art Institute as a memorial to his recently deceased

wife. In the letter to Harshe in which he proposed the gift, Bartlett recognized the importance of recent developments and the role the collection would play in strengthening the museum's current status: "With the Potter Palmer and Martin Ryerson collection of Impressionists, and Mr. Winterbotham's and Mr. Ryerson's examples of the moderns, and the Birch-Bartlett Collection, . . . I think we can justly feel that we have a stronger collection of modern art along these lines than any other museum."[8]

In making his donation, Bartlett looked to the Art Institute's existing installation, in which works were displayed not according to school and chronology but rather by collection, highlighting the tastes

FIG. 2

Detail of letter from Frederic Clay Bartlett to Art Institute Director Robert Harshe, June 13, 1924, aboard the SS *Homeric* en route from Europe to the United States. The letter announces the collector's purchase of *La Grande Jatte*. The July 13 date the letter bears seems to have been in error. Another hand corrected it to June.

and acumen of particular donors. While requesting that his collection be hung together, Bartlett allowed for exceptions at the discretion of the trustees, foreseeing that future acquisitions might impact the "character" of the museum's holdings and the logic of their installation.[9]

Bartlett's clear distinction between the "moderns" and the Impressionists who preceded them suggests the various forces that informed his collecting and that made his purchase of *La Grande Jatte* so particularly "miraculous." On the one hand, it points to Bartlett personally, for he saw himself as a modern artist. In 1891, five years after the first exhibition in Paris of *La Grande Jatte*, he had embarked on the training that led him, like Seurat, to the École des Beaux-Arts. During his time there, he studied with Symbolist painter and muralist François Aman-Jean, who had been a close friend to Seurat during their student days. Aman-Jean and Seurat were said to have assisted Puvis de Chavannes in 1884 when the latter was painting the mural *The Sacred Grove* (see CH. 3, FIG. 13), a reduced version of which would enter the Art Institute as part of the 1922 Potter Palmer gift.[10] Thus, Bartlett's student experience in Paris would have made him particularly responsive to *La Grande Jatte*. The canvas was regarded as the fruit of Beaux-Arts "thoroughness," as Rich termed it, involving more preparatory studies than any other of the artist's works. Rich observed that it bore comparison to the practice of Ingres, the last great champion of the French classical tradition of history painting. Rich credited Puvis for having transmitted its lessons

"direct to Seurat," but the Neoimpressionist's deep understanding of the tradition's "basic principles" realized in a contemporary idiom allowed him to "re-establish classical order at a moment when painting was threatened with [the] formlessness and dissolution [of the Impressionists]."[11]

While Rich made this observation in 1935, it expresses ideas that had surfaced in the early 1920s, by which time Seurat was being hailed by French painter and critic André Lhote as the "beacon" for modern artists. Bartlett's own distinction between "the Impressionists" and "the moderns" speaks to his awareness of the current intellectual debate regarding the nature of painting of the past half century.[12] At issue was the view that artists of modern persuasion had moved in the direction of structure and order, and thus away from the freely brushed, seemingly spontaneous vision of the Impressionists. Bartlett's address book includes the New York residence of critic Walter Pach, one of the several voices—including Gustave Coquiot, Lhote, and André Salmon—responsible for constructing this history and for identifying Seurat as one of the four canonical Postimpressionists, along with Cézanne, Gauguin, and Van Gogh (see CH. 6). Moreover, Bartlett collected examples by each of these artists and embraced the work of a number of younger ones considered as beneficiaries of what critics termed "the call to order," including Derain, Matisse, Picasso, Henri Rousseau, Vlaminck, and—most notably vis-à-vis *La Grande Jatte*—Lhote. Quite possibly Bartlett considered the collection he was forming to be a beachhead of modernism in

the sea of Impressionism that the Palmers and Ryersons, among others, were creating at the Art Institute.[13] And while the Winterbotham Fund had been established, it was still young.

It is telling that, when Bartlett installed his collection in the Art Institute's Gallery 42 (now Gallery 220) in the late 1920s (see FIG. 4), he gave his work by Lhote a prominent position to the left of *La Grande Jatte*, on the north wall (see FIG. 3). In so honoring Lhote the painter, whose *Ladies of Avignon* he had purchased in 1923, the year it was painted, Bartlett may have been guided by the words of Lhote the critic.[14] In the previous year, the Frenchman had written an appreciation of Seurat that not only identified him as the inspiration of the modern movement, but also contended that *La Grande Jatte* alone was sufficient to demonstrate his achievement. Further, Lhote chastised French officialdom for its lack of vision in not acquiring the painting. Alluding to past oversights, he predicted that the nation would not realize *La Grande Jatte*'s importance until it went abroad, and then an "enormous price" would be required to repatriate and install the picture where it belonged: in the Musée du Louvre, beside Ingres's monumental 1827 canvas, *The Apotheosis of Homer*.[15] Bartlett's acquisition of the Seurat two years later fulfilled Lhote's prophesy. It was the failure of the writer's scenario to be completed—for the French were not able retrieve the errant masterpiece, despite an apparent offer of a vast sum (see Harris, p. 238)—that fed the picture's celebrity in Chicago and the copy of Rich's dust jacket.

The installation of the Helen Birch Bartlett Memorial Collection in Gallery 42, 1931. The second painting to the left of *La Grande Jatte* is *Ladies of Avignon* (1923) by André Lhote, a painter and critic who wrote of Seurat as the "beacon" of the modern movement. All the works in the gallery bear white frames designed by Frederic Bartlett himself.

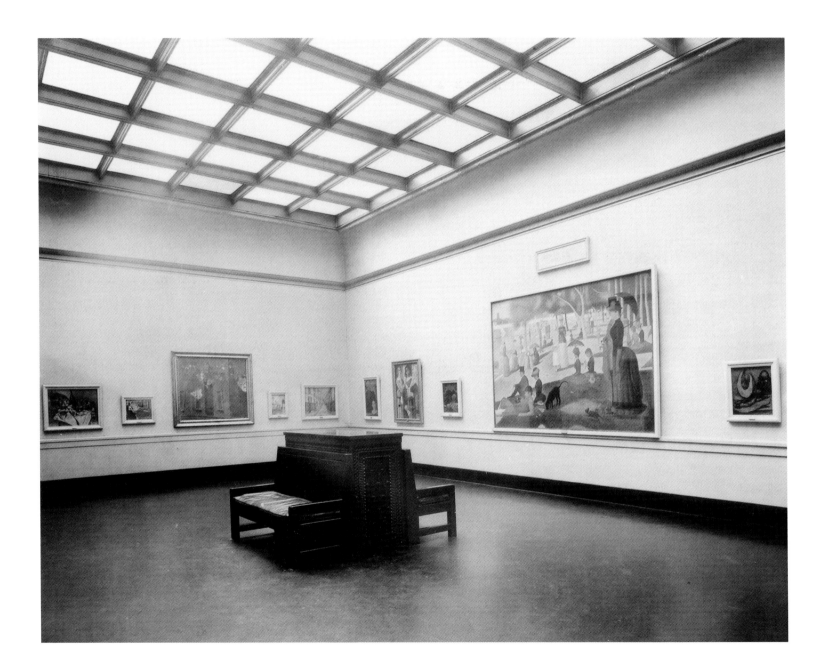

FIG. 4

The Art Institute of Chicago's Allerton Building and Gunsaulus Hall, map of the second-floor galleries, 1923. The various hangings of *La Grande Jatte* are indicated in green. The painting was exhibited at the museum for the first time in Gallery 256 of Gunsaulus Hall, where special exhibitions were staged. After the trustees accepted the Birch Bartlett Collection, it was installed in Gallery 42 of Allerton (this map, which predates the Bartlett gift, signifies that this gallery held the Nickerson Collection). After being hung in Gallery 46 (labeled here as displaying the Buckingham Collection) during the 1933 exhibition, it returned to its more or less permanent home in Gallery 42. The Birch Bartlett Collection was the only exception to the new chronological, rather than donor-based, hanging adopted after the fair.

Rich's book drew upon these currents in placing *La Grande Jatte* within a lineage that included, in addition to *The Apotheosis of Homer*, Delacroix's *Massacre of Chios* (1824) and Courbet's *Burial at Ornans* (1849). He argued its preeminence at the Art Institute by noting that, while it hung in the Birch Bartlett gallery "confronted by masterpieces, like Cézanne's *Basket of Apples*, Van Gogh's *Bedroom at Arles*, and Toulouse-Lautrec's *At the Moulin Rouge*," it nonetheless dominated the display "not only through size but through intrinsic greatness."[16]

In 1933 Rich had the opportunity to position *La Grande Jatte* within a different context. In conjunction with the Century of Progress Exposition of 1933, the Art Institute mounted a monumental display occupying the entire museum. Comprising loans as well as works from the permanent collection, it aimed to present the history of western art from the early Renaissance to the present. Rich installed the Seurat on the east wall of Gallery 46 (today Gallery 223; see FIG. 5), where he believed the greater viewing distance would allow visitors to appreciate the composition's "sensation of depth," as well as its "flat pattern design."[17] With this installation, the curator literally expressed the now-current perspective on the *La Grande Jatte*'s place in the history of modernism: he flanked the painting with works by Henri Rousseau and filled the rest of the gallery with Gauguins; thus, he intimated the ways, in the wake of *La Grande Jatte*, the concepts of primitivism and modernism had become interdependent, in what Herbert calls the shift toward Postimpressionism (p. 109).

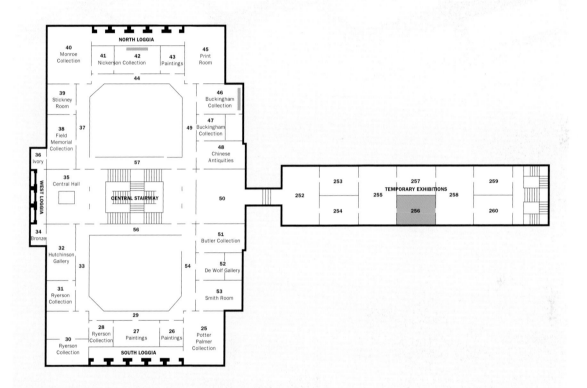

When the Century of Progress show closed, Rich and Harshe decided to continue the model they had established for the exhibition, presenting the Art Institute's holdings not as a series of collections but rather in a way that provided a sweep of the history of western art over time and according to national school. Nonetheless, in the end they deferred to the wishes of Bartlett; even though the terms of his gift allowed for flexible hanging, he believed that it still looked best as an isolated unit. Thus, while the Potter Palmer and other collections were now absorbed into a larger, historical presentation, the Birch Bartlett Collection remained apart, with *La Grande Jatte* as its centerpiece.

However, acquisitions over the past seventy years have underscored the collector's foresight in

FIG. 5

Installation in Gallery 46 of *La Grande Jatte* during the *Exhibition of Paintings and Sculpture Lent from American Collections* during the 1933 World's Fair. Separated from the Birch Bartlett Collection for the first time, the work is flanked by two paintings by Henri Rousseau. The canvas to the left, *The Waterfall* (1910), is part of the Birch Bartlett Collection as well.

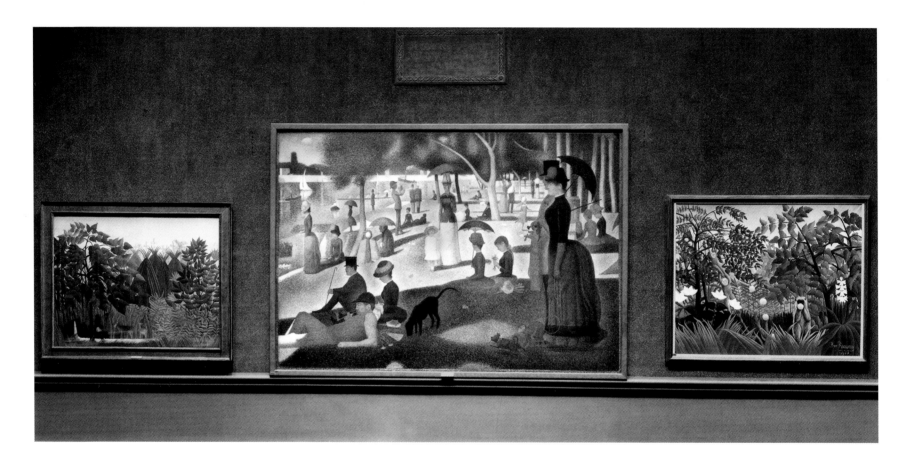

entrusting the display of works in his collection to succeeding generations of the Art Institute's management. The short story of modern art that Bartlett's holdings provide has become, with time and many additional acquisitions, a grander narrative, necessitating not a single space but a sequence of many. Today, *La Grande Jatte* hangs with other works of its historical moment, many of which belong to the Helen Birch Bartlett Memorial Collection.

In the evolution of the Art Institute's holdings, *La Grande Jatte* has figured importantly. Successive generations of directors and curators have, whether consciously or not, responded to the shaping presence of the picture in developing the collection. Indeed, the benchmark set by Seurat's masterwork can be detected in such major, large-scale acquisitions as Matisse's *Bathers by a River* (acquired in 1953), Caillebotte's *Paris Street; Rainy Day*

(acquired in 1964), and Delvaux's *Awakening of the Forest* (acquired in 1991).[18] Given *La Grande Jatte*'s impact on the Art Institute and the city of Chicago, an exhibition celebrating its gestation and legacy is, if anything, overdue.

Notes

1 "The *Grande Jatte* at 100" 1989. Rich 1935.

2 Frederic Clay Bartlett to Robert Harshe, June 13, 1924 (see Harris, note 18). The study then in the hands of Lewisohn (CAT. 64) is now in the Metropolitan Museum of Art, New York. *Bathing Place, Asnières* was purchased for the Tate Gallery by a fund set up by Samuel Courtauld (see Harris, p. 236).

3 Works Bartlett owned that did not enter the Helen Birch Bartlett Memorial Collection included examples by Dufresne, Dufy, Foujita, Herbin, La Fresnaye, Marcoussis, Pascin, Severini, and Vlaminck. See Courtney Graham Donnell, "Frederick Clay and Helen Birch Bartlett: The Collectors," *Art Institute of Chicago Museum Studies* 12, 2 (1988), p. 99 n. 25.

4 Ibid., p. 87.

5 See Lyn DelliQuadri, "A Living Tradition: The Winterbothams and Their Legacy," *Art Institute of Chicago Museum Studies* 20, 2 (1994), p. 106. Bartlett made five of the six purchases for the Winterbotham Collection in 1929. Winterbotham had stipulated that his collection could be improved over time by deaccessioning pictures in order to acquire ones of higher quality. See ibid., p. 104. Matisse's *Woman Standing at the Window* was sold in 1958. Gauguin's 1892 *Hibiscus Tree (Te burao)* (1923.308) remains in the collection.

6 Works by Monet, Renoir, and Sisley had been displayed intermittently at the Art Institute on loan from W. W. Kimball, as well as from the Palmers and Ryersons. When the Potter Palmer collection was exhibited in the galleries in the fall of 1921, the museum's *Bulletin* boasted: "The Potter Palmer collection, shown after a lapse of eleven years, entices us to ransact [*sic*] the whole Museum in search of French painting. So comprehensive has now become the display of French painting of the nineteenth century at the Institute"; *Bulletin of The Art Institute of Chicago* 15, 5 (Sept.–Oct. 1921), p. 158.

7 The original address book is at Bonnet House, the Fort Lauderdale home of Bartlett and his third wife, Evelyn. Now managed by the Florida Trust for Historic Preservation, it is open to the public. See Donnell (note 3), p. 99 n. 20.

8 Bartlett to the trustees, meeting of the Board of Trustees, Jan. 27, 1926, Trustee Minute Books, vol. 9, AIC Archives.

9 Ibid.

10 See Donnell (note 3), p. 86; and Patrick-Gilles Persin, *Aman-Jean: Pientre de la femme* (Paris, 1993), p. 20.

11 Rich 1935, pp. 47, 49, 4–5, respectively.

12 Lhote 1922, pp. 11, 8, respectively.

13 While the Ryersons' collection of Impressionist works was considerable, its representation of "modern" art at the time of Bartlett's gift was limited to a single painting, Cézanne's *Bay of Marseilles, Seen from L'Estaque* (c. 1885; 1933.1116). The Ryersons would acquire more "modern" work before their 1933 bequest to the Art Institute.

14 Bartlett purchased Lhote's *Ladies of Avignon* from the Salon des Tuileries that spring (it was exhibited as no. 691). Interestingly, it is directly related to a mural-like canvas (almost 5 x 6 feet), exhibited a few months later at the Salon des Artistes Indépendants (*The Fourteenth of July in Avignon*; Musée National d'Art Moderne).

15 Lhote 1922, p. 8.

16 Rich 1935, p. 14. Like Ingres's painting, both the Delacroix and the Courbet are in the Louvre.

17 Rich 1935, p. 39. The English critic Roger Fry had described another Seurat work's "flat pattern design"; Rich applied the phrase to *La Grande Jatte*.

18 *Bathers by a River* (1953.158); *Paris Street; Rainy Day* (1964.336); *The Awakening of the Forest* (1991.290).

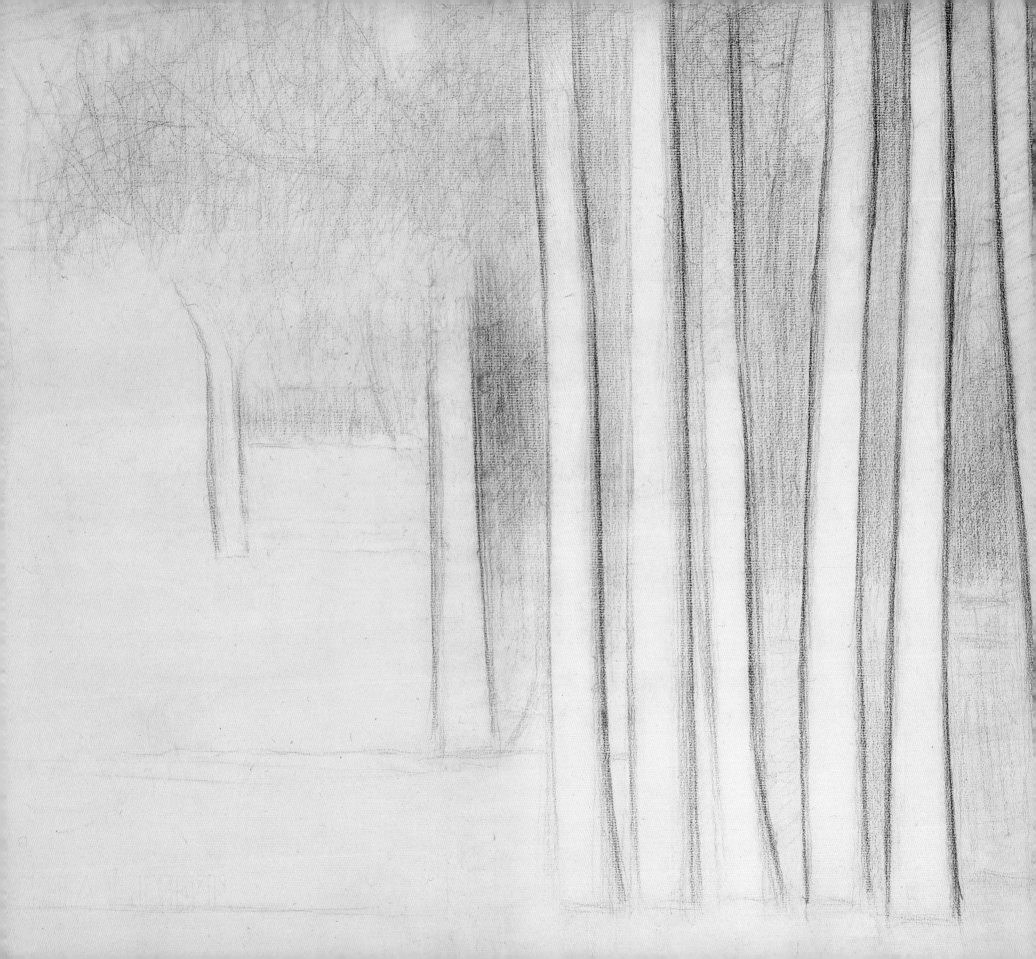

Seurat and the Making of *La Grande Jatte*

Introduction

In 1987 *La Grande Jatte*, without its frame and glass, was wheeled on a dolly through the galleries of the Art Institute after it had been examined in a closed room by a group of scholars. Museum visitors followed the procession in ever larger numbers, stopping at the entrance to the gallery where the painting normally hung. Alone in the room, staff members wheeled the dolly near the huge frame supported a short distance from the wall, and then carefully lifted the canvas by hand to put it in its frame. At the very moment when it reappeared behind its glass, the public viewers burst into spontaneous applause. It was a wonderful homage, a modern parallel to the procession of Cimabue's altarpiece through the streets of Siena in the fourteenth century.

What has given this painting its singular fame? Why do many people make a veritable pilgrimage to Chicago to see it? Of course fame breeds fame; yet we know from the current media that a star can quickly fade. *La Grande Jatte* has never lost its luster since it was first exhibited 118 years ago. While *Seurat and the Making of "La Grande Jatte"* is the first exhibition that attempts to gather together all of the picture's related studies and drawings, the painting has been reproduced and discussed in nearly every history of early modern art. Such a huge literature has been appended to it that few other nineteenth-century works can match it, perhaps only Géricault's *Raft of the Medusa*, Delacroix's *Women of Algiers*, Courbet's *Burial at Ornans*, Millet's *Gleaners*, and Manet's *Olympia*.

All of these works remain in Paris; *La Grande Jatte* is the only such painting to have left France.[1]

In May 1886, *La Grande Jatte* was shown in Paris in the eighth (and last) exhibition organized by the Impressionists. The picture gained instant notoriety; even the art press in London mentioned it. Because Paris was one of the leading centers of Western culture, an event there had far more resonance than one in a provincial city. For that reason, the picture's fame cannot be separated from the capital's preeminence. In addition Impressionism was itself the most notorious art of the day and had only just become acceptable to a small number of art lovers. *La Grande Jatte* in fact appeared as a scandalous eruption within Impressionism, a deliberate challenge to its first practitioners. Seurat was only twenty-six, about twenty years younger than the Impressionists, so he had the sometimes dubious credit of being a young upstart.

Although Monet and Renoir had abstained from the Eighth Impressionist Exhibition, they, along with Morisot, Pissarro, and Sisley (Manet had died in 1883), were the artists whom critics thought of when they expressed their astonishment at Seurat's large picture. For the Impressionists thrived on improvisation and a suitably spontaneous handling that gave objects, not just air and water, a fluttery and tremulous insubstantiality. In *La Grande Jatte*, no improvisation, no spontaneity, and no insubstantiality! The figures are solidly modeled and still. Although grouped in twos and threes, they do not seem to communicate with one another; they lack

the Impressionists' sense of life plausibly caught in a moment of time. The brushwork was so regularly applied that both detractors and admirers deemed it the result of "scientific" color theory.

Seurat was not the only practitioner of the startling new manner represented in the May exhibition. The older Impressionist Pissarro, his son Lucien, and Signac all exhibited work with similar handling and clearly defined forms. They, along with the press, immediately acknowledged Seurat as the leader of a new and rebellious form of Impressionism. *La Grande Jatte* appeared again in late summer with the Société des Artistes Indépendants, a jury-free exhibition organization that Seurat and Signac had helped form in 1884. That autumn the critic Félix Fénéon gave the movement its definitive name, "Néo-Impressionnisme."[2] By 1887 the group gained new adherents in France and Belgium—in that year, *La Grande Jatte* had its third showing, in Brussels—and for a time Neoimpressionism was seen widely as the current vanguard in painting. *La Grande Jatte* benefited from this expanding activity, for it was constantly referred to as the style's showcase piece. Its appearance coincided with the rise of Symbolism in France and Belgium, and many of its young adherents were drawn to Seurat and the "Néos." Seurat became the darling of the new literary movement until his early death in 1891, when Gauguin displaced him.

Because of its representation of contemporary outdoor leisure, the preferred subject of the Impressionists, and its compositional clarity, recalling

"primitive" arts of the past, *La Grande Jatte* solidly attached modernity to tradition. Slightly more than six and one-half by ten feet, the painting is much larger than Impressionist pictures, another reason to associate it with the huge compositions that had characterized the annual or biennial Salon, the government-sponsored exhibition that had dominated Parisian art for well over a century. No one who observed the work's apparently rational technique and its display of current fashions could doubt its modernity, and yet it had the size and solidity of museum pictures. This was in stark contrast to the Impressionists, not least because the canvas was clearly the result of many drawings and paintings, evidence of the procedure attached to the academic tradition that the Impressionists spurned.

For friendly critics, *La Grande Jatte* was not a stuffy return to the past, because its spirited modernism embraced a unique kind of "primitivism." Seurat ordered the figures along such regular lines that he appears to have ignored all the clever overlappings and spatial immersions of art since the Baroque era, and to have reverted to the visual vocabulary of a much earlier age. Moreover, his figures seemed to convey a similar innocence, like so many cutouts. They were aptly likened to Egyptian art, early Renaissance painting, and Kate Greenaway's children's-book illustrations, as well as to dolls and wooden toys. The painting's group of characters is solemn, yes, but also full of humor. A seated nurse on the left, seen from the rear, resembles a seated Egyptian scribe; not far away,

a round-hatted boor plays a horn, which he points at two soldiers; the diminutive, top-hatted dandy sitting on the left, if erect, would only reach the waist of the tall male stroller on the right.

Sad to report, *La Grande Jatte* suffered a serious loss of its original colors not long after the artist's death. In 1892 critics pointed to the fact that, owing to impure pigments, many of the picture's yellows and oranges had turned brown, and its emerald greens, dull olive. Astonishingly, these alterations of the original colors have not adversely affected the painting's high standing. While credit for this must be given to the strength of its forms and structure, which can withstand the loss of color, for decades the painting was known chiefly from black-and-white reproductions. Except for its regular display at the Art Institute of Chicago after 1926, it appeared in public just five times following a flurry of exhibitions at the turn of the century. Only from the mid-twentieth century on has it been customarily reproduced in color.

The surprising durability of Seurat's composition is demonstrated in other ways. It is one of the most often used images in advertising, and also has been parodied in innumerable cartoons. A substantial exhibition could be made of popular variations on the picture, including prints and cartoons, tapestries, pillow covers, ties, T-shirts, and picture puzzles, not to speak of murals and at least one topiary garden. Far from spoiling the painting's appeal, these only prove that it commands a nearly folkloric status and has maintained a continuing

dialogue with popular culture, from mass media and highbrow publications to parks in which modern people spend their leisure time. Some of these associations are discussed here by Neil Harris.

The present catalogue is the first to take account of new studies of the colors and brushwork of *La Grande Jatte*, both in my early chapters and

in essays by my colleagues (see the contributions by Zuccari and Langley, Fiedler, and Berns). It is also the first to include a historiography of the painting from 1886 to the present. The second half of my text traces the various interpretations the work has received over the nearly twelve decades since its creation and examines the views of leading writers. I devote special attention to the thinking of the most recent generation, including T. J. Clark, John House, Linda Nochlin, Paul Smith, Richard Thomson, and Michael Zimmermann. Although my own views enter into these commentaries, I postpone until the final chapter a full statement of them.

One caution: by concentrating on *La Grande Jatte*, this book presents only a partial view of Seurat. It is tempting to believe that his masterpiece embraces the whole artist, but this is not so. The painting's well-measured forms and technique make it easy to think of him as a master planner who applied rules in a mechanical way, leaving emotion behind. However, he is the same artist who drew *Men in front of a Factory* (CH. 1, FIG. 6) and the same one who exhibited alongside *La Grande Jatte* drawings like *Acrobat by the Ticket Booth* (CAT. 31, p. 119), with its aura of somber mystery. Seurat followed *La Grande Jatte* with a succession of other paintings, including dazzling seascapes and, at the end of his short life, *Chahut* and *Circus* (CH. 5, FIGS. 12–13), major works full of dynamic energy that reveal a very different artist.

Until now in writings on Seurat, the issues raised by his work after 1886 have been superimposed over *La Grande Jatte*, bringing to bear ideas that are not directly related to it. It is only after the Eighth Impressionist Exhibition that Seurat's possible associations with *wagnérisme* and music, with Charles Henry's theories of the psychology of art, and with anarchism can be appropriately discussed. In Chapter 5, I will mention these three issues in a brief recapitulation of the second half of the artist's career, but even though they have taken central place in recent Seurat literature, they must be set aside if we are to look freshly at the work that culminated in his masterpiece in 1886. Among most writers of the last decades, these post-1886 issues have so deeply colored the analyses of *La Grande Jatte* that the painting has seldom been free from anachronistic reasoning.

In my essay, I have also avoided the testimony of friends and supposed witnesses to Seurat's art who wrote about him several decades after his death, proposing ideas that have also entered into interpretations of his masterpiece. For example, Signac claimed in 1935 that Seurat had said about *La Grande Jatte*, "I might just as well have painted, in a different harmony, the Horatii and the Curiatii." This evocation of David's *Oath of the Horatii*, made five decades after 1886, fits well with Signac's consistent effort to downplay the significance of Seurat's subjects in favor of his color, but he never voiced it earlier.[3] Most modern writers have taken the statement as Seurat's own, and they have similarly accepted the assertions of Gustave Coquiot (1924) that he knew Seurat—there is no proof of this—and that La Grande Jatte was a place of bawdy encounters. There are many signs that elsewhere in this book Coquiot greatly embellished his "memories," so it seems safest to discount them, along with other secondhand accounts whose veracity cannot be established.

During long hours in front of Seurat's paintings and drawings at the time of the artist's 1991 retrospective (Herbert et al. 1991), I tried to clear my head of prior conceptions. I then realized that I had paid insufficient attention to the actual colors and brushwork of his early paintings and the studies for *La Grande Jatte*. Although a distinct individual with unique procedures, he was like other artists who built up experience through the act of painting, and I realized that I had greatly exaggerated the role of scientific color theory in his development. If he can be called "scientific" at all, it would be from his use of trial and error, constantly shifting his practice according to the results of what he was making. For these reasons, the first three chapters of my text concentrate on his actual practice, revealing new aspects of his work in oils that help explain the preparation and completion of *La Grande Jatte*. The other new feature is my account, in later chapters, of how *La Grande Jatte* and Seurat were received in the twentieth century. It goes without saying that successive generations reevaluate works of art according to their own predilections. In the 1920s and 1930s, Seurat was seen as an engineer of form and color, and *La Grande Jatte* as a kind of painted geometry. Meyer Schapiro's objections to this (1935) were not often heeded until the 1960s, when interpreters of Seurat's paintings and drawings moved away from formalism

and "science" toward closer examination of his subjects and their implications. I trace these chronological shifts by keeping the focus on *La Grande Jatte*, trying to be fair to colleagues' points of view while inevitably using my own judgments of their merits. In other words, the essay ends by looking at this great painting from the vantage point of the present day. Nevertheless, enough will be said of the development, exhibition, and reception of the painting to let the reader attempt to recapture the excitement *La Grande Jatte* provoked when it first appeared in 1886.

Whether we think of Seurat at the time of *La Grande Jatte* or later, his personality is hard to grasp; we have no diaries and few letters to help us. If the reader wishes at all cost to have a description of the artist, then I believe the one which comes closest is that by the Belgian writer Émile Verhaeren, who interviewed him several times:

To hear Seurat explain and confess himself in front of his annual work was to follow someone who was sincere and to be won over by someone who was persuasive. Calmly, with definite gestures, his eye never leaving you and his slow and steady voice searching for slightly didactic words, he would indicate the results achieved, the clear certitudes, what he called "the basis" [*la base*]. Then he would consult you as a witness, waiting for the word that would indicate you had understood him, very modestly, almost fearfully, although one sensed silent pride in himself. He never undercut others, even admitting

to certain admirations that in his heart he did not feel, but one sensed condescension, not jealousy.... If I understand him well, Seurat seemed to me to have taken on the mission of freeing art from groping among the vague, the floating, and the imprecise. Maybe he thought that the scientific and positive spirit of his era required in the domain of the imagination a more clear and solid tactic for the conquest of beauty.[4]

Notes

1 *Raft of the Medusa* (1819) and *Women of Algiers* (1834) are in the Musée du Louvre. *A Burial at Ornans* (1849), *The Gleaners* (1857), and *Olympia* (1863) are in the Musée d'Orsay.

2 Fénéon 1886b.

3 Paul Signac, "Les Besoins individuels et la peinture," *Encyclopédie française*, vol. 16 (Paris, 1935), cited in House 1980, p. 347. David's 1784 painting is in the Louvre.

4 Verhaeren 1891 (ed. 1927, pp. 200 and 202).

Author's Note to the Reader

By repeatedly comparing Seurat's paintings and drawings on exhibition in 1991 (Herbert et al. 1991), I felt able to refine their dates. In the present book, "c. 1882" or "c. 1883" is often used instead of "1882/83" (meaning sometime between the beginning of 1882 and the end of 1883). I retain the latter wherever there is less reason to choose one over the other. Finally, I use hyphenated years (1882–83) to signal that the artist worked on the object over more than one year.

Because many panels and drawings have borne vague titles—often simply "Study for *La Grande Jatte*," I have given some of them new descriptive titles here.

All works, unless otherwise noted, are by Seurat.

Three works by Seurat are discussed so frequently that callouts are not provided in the text each time they are mentioned. The locations of their respective reproductions are provided here:

Bathing Place, Asniéres, 1883–84, The National Gallery, London (p. 46)

Compositional study (large sketch) for *La Grande Jatte*, 1884, painted border 1888/89, The Metropolitan Museum of Art, New York (p. 81)

A Sunday on La Grande Jatte—1884, 1884–86, painted border 1888/89, The Art Institute of Chicago (pp. 82–83 and rear gatefold)

Dimensions are given in centimeters, height before width, followed by dimensions in inches in parentheses.

For shortened references, consult the Selected Bibliography.

In the text, references to publications for which both author and year are given are not footnoted unless the text includes quotations from them.

For well-known artists, only surnames are used; full names are found in the Index.

I | Before *La Grande Jatte*

Seurat was born in Paris on December 2, 1859, into a bourgeois family with enough income to support him throughout his short life. Not much is known of his father, who retired as a court bailiff and lived on investments, but there are many indications that his mother encouraged his art. Schoolboy drawing led to his enrolling, at age sixteen, in a municipal art school, and then at the prestigious École des Beaux-Arts, Paris, in 1878. There, he studied for a year and a half with Henri Lehmann, a notable follower of Ingres. His few, extant drawings after Ingres, Lehmann, and others show that Seurat followed the conventions of academic training. He regularly placed toward the bottom of his class, perhaps because of an independently minded spirit; in effect, his drawings strike us today as highly proficient. Hindsight has let us find forward-pointing qualities in his surviving drawings after casts of antique sculptures and live models. Typically, these are single standing male figures (see FIG. 1), smoothly modeled in charcoal and black chalk and stressing strong silhouettes with unbroken edges.

After one year of military service, which ended in November 1880, Seurat gave up all schooling and began to make independent paintings and drawings. The latter are the first works that bear the marks of a mature artist. This is no surprise, for two reasons. A drawing can be executed with far fewer preparations and complexities than a painting, and drawing was the basis of academic training, preceding lessons in oils. Moreover, students were expected, outside the classroom, to draw from life as a way of sharpening the eye and establishing a repertory of forms. These were to be subordinated to the composition of paintings in which the artist suppressed the vagaries of ordinary life in favor of generalized forms that transcend the here and now. As we shall see, that ambition, in modified form, underlies *La Grande Jatte*.

Many pencil studies show that Seurat took little notebooks into the streets and parks of Paris, drawing men and women seated on benches, standing still or walking, mostly alone but occasionally in pairs. In the first year after his military service, he continued these quick sketches. *Woman Seated on a Bench* (FIG. 2) probably dates from 1881. Diagonal hatchings in black crayon establish zones of light and dark, laid over a shorthand of mostly straight lines that superimpose an analytical geometry on observed form. He also made larger drawings in conté crayon as finished works in their own right, not as studies for paintings. *Harvester* (CAT. 1, p. 27) of 1881 is one of the few extant drawings that Seurat signed and dated. Here, the hatching is denser but still quite conspicuous. Freer slashes around the figure's waist and arm define the shirt and upper body with an assertive freshness. The man's dark trousers and arm are set off from the background by lighter tones, and his light shirt by dark hatching. Such calculated oppositions were practiced by a number of French artists, notably Prud'hon at the beginning of the nineteenth century.[1] Such contrasts could be observed in nature and were well described by M.-E. Chevreul, whose famous book on color Seurat had read and annotated (see p. 32). The scientist pointed out that

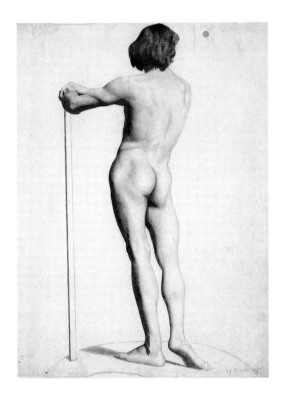

when one juxtaposes two areas of different tone, the light will seem even lighter and the dark, darker, each heightening the other's tone. Seurat carried out this kind of contrast in nearly all his future work, including *La Grande Jatte*.

The systematic hatching and synthesized form of *Harvester* mark the continuity from Seurat's school training, as does his preference for single figures centered on the page. While he used a life study to create generalized form, he made it as an independent work, not an academic composition, a striking structure that declares the artist's remarkable abilities at the age of twenty-one.

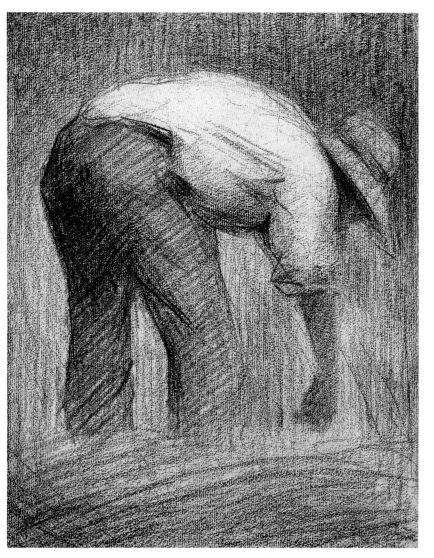

Other drawings of this era, such as *Woman Leaning on a Parapet by the Seine* (CAT. 2, p. 28), display the same technique. But here, as in most of his early mature drawings, Seurat stroked the crayon repeatedly to build the female figure until it became a dark tone free of visible lines. Beyond her he moved the point of the crayon in swirls, crosses, and hatchings to create oppositions of light and dark (a halo surrounds the woman). By leaving visible the means by which he constructed the image, he moved away from the academic tradition of smooth modeling. Already here we find the formal elements that look forward to *La Grande Jatte*: the stark geometry of the tree trunk, its dialogue with the woman's rounded shape, the framing of her upper body by two saplings, and the overall pattern of spatial compartments that present a believable if shallow depth.

Harvester is one of many early drawings Seurat did of peasants at work, and these reveal his knowledge of the drawings of Millet (see FIG. 3). The Barbizon School master worked in conté crayon to achieve similar velvety darks and lights, and his forms have a monumental blockiness that apparently appealed to the younger artist. Seurat's early landscapes also bring Millet's example to mind. While *Railway Tracks* (CAT. 3, p. 30) depicts an industrial subject that the Barbizon artist never would have undertaken, Seurat achieved his darks in the way Millet did, with constantly moving crayon marks that merge to form shadowy masses. Seurat's refined vision is astonishing for someone so young. The twinned poles, with their pale, mothlike insulators,

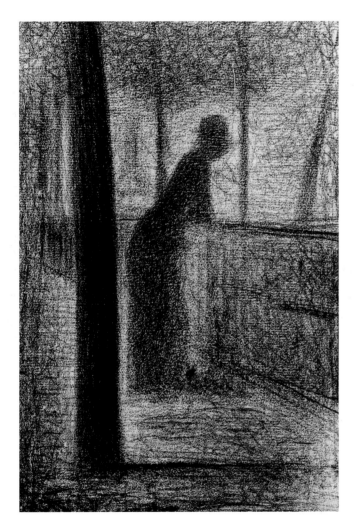

march between the skinny, undulating saplings on the left and the faint poles in the distance.

Although Seurat drew many rural and suburban workers, including stone breakers and diggers, more of his early drawings focus on urban dwellers and cityscapes. The latter offer clues to his preferences among older artists, a selection far removed from Ingres and the Italianate tradition of French classicism in which he trained. His seated, standing, and strolling Parisians recall the prints of Rembrandt, Goya, and Daumier, in both subject and technique. The woman's face in *The Lamp* (FIG. 4) looms mysteriously out of tangled skeins of lines that recall the whorls and hatchings of the Dutch master's etchings (see FIG. 5). Seurat's crayon rubbed the projecting fibers across the heavily textured paper he habitually used, leaving the tiny valleys untouched. The white sparkles through the web of crayon marks to achieve a dotted effect that has been likened erroneously to his later brushwork. (Seurat's painting technique required the application of successive layers of different pigments, instead of the continuous process of stroking tufted paper with one substance.)

In drawings such as *Nurse with Child* (CAT. 9, p. 31), the strong oppositions of light and dark remind us of Goya's etchings and aquatints (see FIG. 8). There is something of the Spanish artist also in the way that the mysterious looms out of the ordinary, both in *The Lamp* and here. Redon, Seurat's older contemporary, openly admired the Spanish artist (he entitled an album of 1885

Homage to Goya). Redon's dark manner in both lithographs and charcoal drawings (see FIG. 9) offers fascinating parallels with Seurat's approach; yet the former depicted strange and fanciful creatures, in contrast to the latter's human subjects, based on natural observation transformed by his penchant for tectonic structure. The young man seen in the 1881 *Orange Vendor* (FIG. 7), another rare signed and dated sheet, possesses a matter-of-factness foreign to Redon. Like other urban denizens Seurat drew, this one follows in the tradition of "Cris de Paris," prints and caricatures of street types at the heart of the broad shift to urban modernity in the middle third of the nineteenth century. These images, usually featuring single figures in a vertical format, were devoted to street performers and sweepers, fruit vendors, and the like.

We think of Daumier, a leading proponent of this mid-century tradition, when looking at *Orange Vendor* and other drawings Seurat made in 1881 and 1882. Although the young artist drew only generalized and anonymous faces, both the erect figure and scumbled background here resemble the caricaturist's many lithographs of Parisian men and women (see FIG. 10). Among similar devices found in both artists' work are the strong lateral shadows that anchor feet to page. Later sheets by Seurat, such as the 1883/84 *Nurse with Carriage* (CAT. 34, p. 32), carry on the artist's affinity with ordinary city life, but by then, on the eve of *La Grande Jatte*, his forms had flattened out and acquired a stronger surface geometry. This geometry

Railway Tracks, 1881/82.
Conté crayon on paper; 24.2 x
31.6 cm (9 ½ x 12 ½ in.).
Collection André Bromberg.
H 471.

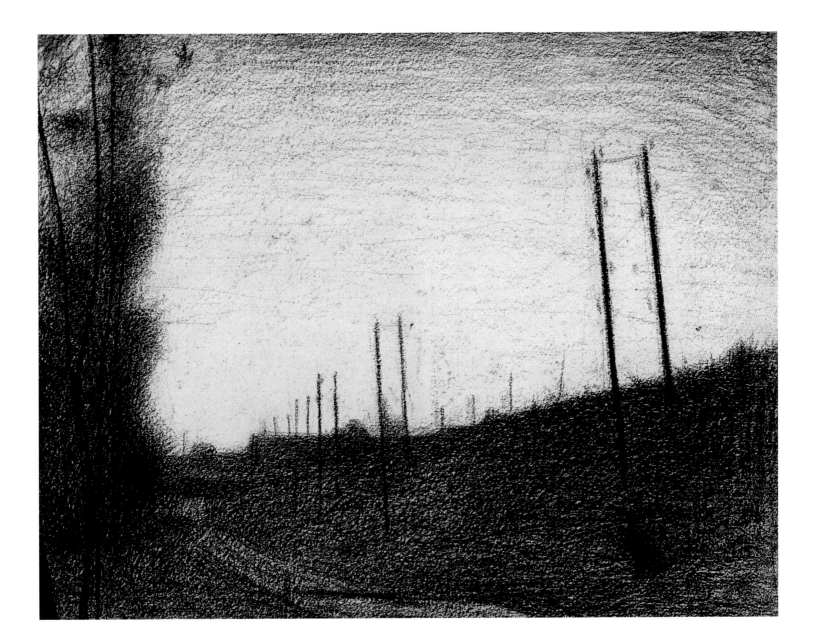

is not cold pattern, and the crayon marks are not mechanical. The drawing's mysterious quality derives not only from the insubstantiality of the pram—set off by the stark white of the nurse's apron—but also from the anonymity of the figure, her face hidden behind her circular cap. The seated nurse in *La Grande Jatte* wears the same uniform; the studies for this figure overlap with independent images such as this.

Although Seurat's early drawings offer little or no narrative content, as a group they signal his social awareness. The artist's rural and suburban subjects are always working: breaking stones, harvesting, digging, plowing. His city folk are middle-class women who sew or read by a window, street vendors, nurses and laundresses, market porters, and others he observed while strolling about. *Girl in a Slouch Hat* (CAT. 30, p. 34) invests a stubby child's form with humor and affection, whereas *Woman with Bouquet, Seen from Behind* (CAT. 11, p. 34) has the iconic presence of the antique statues Seurat studied in school. His cityscapes—drawbridges, locomotives, wagons, carriages, unpeopled streets—are rendered with poignant sobriety. Only occasionally did he provide his figures with a substantial environment. One such instance is *Men in front of a Factory* (FIG. 6) of 1882/83. It evokes a mood of social tension; the slashed and scumbled touches of crayon create an emotional setting for the questions we invariably ask: who are these men, and what is their relationship to the factory behind them?

The impersonality of all the figures in Seurat's early drawings leaves us unable to discern a specific social attitude for the artist, but these works show that he participated in a broad current of post-Barbizon naturalism. Naturalism was not a "school," and the meaning of the word shifted constantly, but it signifies an affinity for subjects drawn from contemporary life rather than from history, religion, and mythology, which dominated the academic tradition. The evocations of Rembrandt, Goya, Millet, and Daumier make clear the young artist's heritage from mid-century naturalism. Seurat was not unique in choosing to work in a smoky, dark manner: in addition to Redon, one thinks of Léon Bonvin, Henri Fantin-Latour, and Albert Lebourg,[2] but his conté drawings are far more condensed and schematic than theirs. Seurat revealed a greater sympathy than they with contemporaneous naturalist literature, in particular the writings of the Goncourt brothers and Huysmans rather than the novels of Zola, whose penchant for bursts of melodrama Seurat probably would not have appreciated. However, his drawings are not "literary." He avoided the details in which writers indulged, and instead followed the tradition of visual artists who pursued broad effects of naturalism, in which anecdote and detail give way to large patterns that we take in all at once, undistracted by particular incidents.

Early Paintings

The urban figures of Seurat's early drawings do not resemble his contemporaneous oils representing

peasants and rural or suburban landscapes. This is because painting involved a wholly different set of conditions for both subject and technique. When he turned to painting after 1880, the artist apprenticed himself to the dominant current of his day, the naturalism that grew out of the Barbizon artists, with their preference for rural settings. Earlier, the Impressionists had built on this tradition, and Seurat's contemporary Van Gogh was to follow this path in the same years. To understand why Seurat's early paintings are so different from his drawings, we must look again, briefly, at his student years.

While still in school, Seurat read Charles Blanc's *Grammar of Painting and Engraving* (1867), a liberal-minded compendium of academic theory, and the same author's essay on the art of Delacroix.[3] From Blanc he learned about Chevreul's *Principles of Harmony and Contrast of Colors* (1839) and copied sections from that famous book.[4] Chevreul, a scientist, insisted upon the relativism of color, which is influenced by neighboring hues and tones. In other words, each color projects a pale tint of its opposite (its complement) upon adjacent areas, so that blue adds orange—its opposite—to the orange already there, intensifying it, just as the orange heightens the blue in the same manner. Similarly, Chevreul taught that light and dark oppositions exalt one another, a practice Seurat followed in his early drawings. The key phrases that the author contributed to the vocabulary of color are "simultaneous contrast," which occurs instantly in our eye, and "successive contrast," which happens when we

look at one color for a time and then look elsewhere. In so doing, we unconsciously tint this other area with the pale opposite of the first color. Thus, for example, looking for a few seconds at a bright red and then switching to a white or gray surface will induce its opposite, a pale, bluish green.

Chevreul wrote that one need not paint these effects because they will arise automatically from duplicating the colors of the models, but Seurat in fact explored these contrasts by painting them. From Blanc he learned about Delacroix's practice of dividing color into several related or opposing tints that, Blanc insisted, would combine in the eye ("optical mixtures") to form more vibrant hues, thanks to the workings of contrast. While he was not interested in Delacroix's Romantic imagery, we can get a good idea of what Seurat found in Delacroix's art from notes he took, beginning in February 1881, on paintings by the Romantic master that he saw in dealers' shops and exhibitions. All these comments emphasize Delacroix's pairing of color opposites (orange-blue, green-red, purple-yellow), and his practice of breaking color into separate tints ("divided" or "broken" color) to produce an effect more exciting than that of a unified hue. In one of Delacroix's painted studies, Seurat saw that "shadows and everything else are hatched and vibrate: cheekbones, the turban's shadows," and proceeded to declare, "It's the strictest application of scientific princ. seen through a personality." The same notes include several sentences copied from Delacroix's journal, published in 1865. A few years

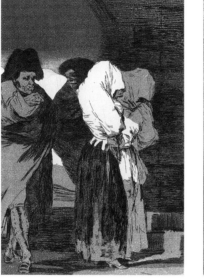

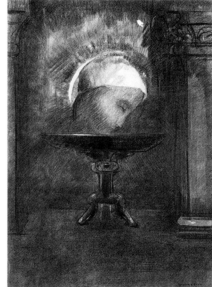

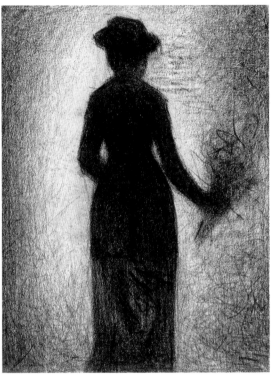

later, in interviews with the Belgian writer Émile
Verhaeren, Seurat spoke about this time:

> Little by little [Seurat] told me about his begin-
> nings, his apprenticeship with Lehmann, his
> school years, the whole chapter of efforts spoiled
> by routine and dead practices. Then how he
> found himself while studying others, by means
> of lessons and rules, as one discovers jewels
> ignored under stratifications and soil.[5]

Beginning in November 1878, during his military
service, Seurat had annotated a series of articles by

a classicizing theorist, David Sutter. Like Blanc and
Chevreul, Sutter stressed the need for a young
artist to establish ideals and rules to guide his vision.
Seurat placed asterisks next to such aphorisms as,
"One should therefore find the clear and precise for-
mulation of the principles of the harmony of line,
light, and color, and give the scientific explanation
of these rules." He found up-to-date precepts for
color in the French translation of Ogden Rood's
Modern Chromatics: Students' Text-Book of Color,
which he acquired in early 1881. Rood was an ama-
teur painter as well as a scientist, and his book was

liberally dosed with observations about painting as
he laid out the very latest color theories in non-
technical terms. He incorporated the findings made
in mid-century by James Clerk Maxwell and Her-
mann von Helmholtz that distinguished actual color-
light from the pigments used by artists, a distinction
that Chevreul and Delacroix had not made. Seurat
copied Rood's color wheel, which was derived from
prismatic light and which demonstrated, for exam-
ple, that purplish red and green are true color-light
opposites, not the red and green of pigments. Rood
demonstrated to Seurat why pigment mixtures
were inferior to natural light, and gave scientific
support for trying to approximate more luminous
effects in painting by crediting the effects of "optical
mixing" the young artist had already read about in
Blanc's text. Rood wrote that a mixture of small
dots of color would blend into one when seen from
a distance and would be tantamount to mixing
colored light. Although this was later disproved,
Seurat surely believed in it, testing the theory by
studying Delacroix's divided color. Rood's treatise
later became the veritable bible of the Neoimpres-
sionist movement.

There was evidently a huge gap between scien-
tific reading and actual practice, and it took Seurat
several years to incorporate into his own work the
higher luminosities he was reading about. Paintings
of 1881 and 1882, such as the small panels *Stone
Breaker and Wheelbarrow, Le Raincy* (CAT. 6, p.
35) and *Grassy Riverbank* (CAT. 5, p. 36), display
a relatively subdued, mid-century palette, but
they are enlivened by crisscross brushwork and a

moderate use of color opposites. In *Stone Breaker and Wheelbarrow*, the purples of wheelbarrow and shadow are set against attenuated yellow-tans of stones and pathway, and the blues of the worker's headgear and sash are enhanced by the adjacent orange-brown tones. By treating the orange-brown of the varnished wood support, which shows through here and there, as an essential color, Seurat followed the traditional practice of painting over a warm, dark ground.

Small panels, measuring about six and one quarter by ten inches, became Seurat's most common format. He referred to these works as *croquetons*, a term he apparently invented that blends the idea of a sketch with a biscuit or cracker into an apt description of these thin and crisp little pieces of wood.[6] They could be carried in a slotted box, and lent themselves to quick observations. He also used canvases, although less frequently. Like the panels, they are sketches in which he experimented with color without aiming to produce finished, exhibitable works. *Stone Breaker* (CAT. 4, p. 37) may have been painted in 1881, and surely no later than 1882. It echoes mid-century art in the same way as the small panels, but its large strokes and horizontal banding give it a curiously modern aspect. The man breaking stones has the blocky monumentality of early images such as *Harvester*. By contrast, the figure of a stone breaker in a slightly later painting (CAT. 10, p. 38) is less sculptural. Here, in a more elaborated but still sketchy canvas, Seurat took the step, unusual for him, of breaking the edges of the two workers' forms to integrate them with their environment.

White Houses, Ville d'Avray (CAT. 7, p. 39) is typical of several small canvases Seurat produced several months or a year later than those mentioned above. Its brushwork is tightly knit like so much finely chopped straw. In the foreground, touches of several oranges, tans, and reds, offset by occasional greens, create the impression of ripe grass or hay, while the shrubbery on the right has tints of green, orange, lavender, and red, along with several shades of blue. As Seurat had observed about Delacroix's broken colors, his own now were "hatched" and "vibrate." These early canvases and panels strongly resemble works of the Barbizon School. Corot's depictions of Ville d'Avray

collected,[7] an aspect of his style that would reappear in *La Grande Jatte*.

Farm Women at Work (CAT. 8, p. 40), probably painted several months after *White Houses*, shows Seurat's slow shift toward a brighter palette. The former evokes Millet's famous *Gleaners* (1857; Musée d'Orsay, Paris), but unlike his or Van Gogh's empathetic depictions of peasants, Seurat's images reflect a thoroughly detached naturalism. While until 1883 he depicted most of his rural figures at work, expressing his appreciation for the dignity of labor, in *Farm Women*—a sketch as opposed to a finished painting—outdoor color and light are as much the subject as the figures. Seurat's crisscross hatching conveys natural effects, for, like the Impressionists, he was applying Delacroix's lessons to nature. The light yellow and orange band in the foreground differs from the darker orange, yellow, and green stripes further back: it represents a path or roadway, not growing vegetation. Seurat, an eager reader of Blanc, Chevreul, and now Rood, found in foliage and field growth oranges, yellows, and tans, indicating reflected and partly absorbed sunlight, as well as various greens to establish local color and blue to signal indirect light in shaded portions. For Seurat's purposes, it was enough to set out his sketch in simple horizontal zones; modern viewers, schooled in abstraction, admire this quality as though it were a finished picture.

By 1883 Seurat's panels and small canvases openly disclose his awareness of Impressionism, although there are hints of this in earlier works. He surely had seen Impressionist paintings in dealers'

had made this location southwest of Paris quite famous, and Seurat's images of stone breakers recall Millet's field and garden workers. Seurat encountered Barbizon naturalism through the filter of many followers of Corot, as well as through Courbet, Diaz, Millet, and Théodore Rousseau, and especially Pissarro, whom he would meet in

1885. Pissarro's paintings of rural settings exhibit a blocky regularity (see FIG. 11) that looks forward to the architecture of *White Houses* and the summary form of Seurat's stone breakers. It should be said, however, that these pictures by Seurat possess a nearly primitive simplicity of form reminiscent of the folkloric prints that he

shops and exhibitions, but only now do changes in palette and subject show that he was learning from them. He tested rules derived from Delacroix and mid-century naturalist painting, supported by a growing knowledge of the art of Monet, Morisot, Pissarro, Renoir, and Sisley. They all used strokes of divided color, and they too (especially Renoir) admired Delacroix. In *Sunset on the English Channel* of 1883 (CAT. 110, p. 41), which evokes aspects of Delacroix's palette, Renoir divided his color in several ways. He occasionally put two pigments on his brush so that when he dragged it across the canvas, it left streaks of both colors as well as their combinations. At other times, he applied his oils with a stiff brush, its bristles sometimes scraping through to the layer underneath, revealing its color while depositing parallel trails of new paint. Two or three of these strokes frequently overlap and intersect to compound the hues. Seurat must have seen

examples of this technique, but he did not choose to emulate its sensuous and liquid quality.

At times we sense the latent presence of a particular Impressionist in Seurat's early paintings. Pissarro has already been mentioned, and again he comes to mind with *Seated Woman* (CAT. 13, p. 40). The elder painter frequently pictured female

peasants sitting or reclining against a backdrop of meadows or wooded clearings. He depicted the grass and foliage in *Peasant Girl with a Straw Hat* (CAT. 101, p. 42) using myriad small strokes that tilt and weave in different directions. The resulting tapestry of broken colors resembles aspects of Seurat's technique. In his much smaller picture, which is

White Houses, Ville d'Avray,
1882/83. Oil on canvas; 33 x 46
cm (13 x 18 ⅛ in.). National
Museums Liverpool. H 20.

CAT. 8

Farm Women at Work, 1882/83. Oil on canvas; 38.5 x 46.2 cm (15 ⅛ x 18 ¼ in.). Solomon R. Guggenheim Museum, New York, gift, Solomon R. Guggenheim, 1941. H 60.

CAT. 13

Seated Woman, 1883. Oil on canvas; 38.1 x 46.2 cm (15 x 18 in.). Solomon R. Guggenheim Museum, New York, gift, Solomon R. Guggenheim, 1937. H 59.

CAT. 110 (OPPOSITE)

Pierre-Auguste Renoir (French, 1841–1919). *Sunset on the English Channel*, 1883. Oil on canvas; 54 x 65 cm (21 ¼ x 26 ½ in.). Sterling and Francine Clark Art Institute, Williamstown, Massachusetts.

only a study, the meadow looms up more flatly and abstractly than in Pissarro's canvas, and his figure is more sculptural than the Impressionist's, which is motionless and pensive. Also distinctive about Seurat's work is his use of contrasts, stronger than those of Pissarro, especially the streaks of bright orange in the dark green shadow and in the deep blues of the woman's dress, as well as in the meadow.

Seurat's knowledge of Impressionism surfaces also in a number of panels he painted along the Seine in 1883. *Bridge; View of the Seine* (CAT. 12, p. 43) reminds us that, in the previous decade, Monet, Pissarro, and Sisley had painted the river beyond Paris, sometimes including prominent industrial barges in their scenes. *Bridge*, however, takes us to the industrial suburb of Clichy, the kind of naturalist subject that writers such as Joris-Karl Huysmans and the Goncourt brothers favored over the pastoral images preferred by the prior generation. The building in the background is the same as that in *Men in front of a Factory* (FIG. 6). Because of the fishermen in the foreground and the bright palette, the painting has little of the drawing's unsettling mood, although it too posits the relationship of humans to industry. The factory and bridge relate the panel to the buildings in the background of Seurat's *Bathing Place, Asnières*.

Bathing Place, Asnières

Seurat's first large canvas intended for exhibition, *Bathing Place, Asnières*, represents men and boys on the bank of the Seine at Asnières, on the northwest edge of Paris, at one of the work sites earmarked "Baignade" (bathing area) on contemporary maps. The exposed sandy gully seen here resulted from horses and dogs being led to the water, where

CAT. 101

Camille Pissarro. *Peasant Girl with a Straw Hat*, 1881. Oil on canvas; 73.4 x 59.6 cm (28 ⅞ x 23 ½ in.). National Gallery of Art, Washington, D.C., Ailsa Mellon Bruce Collection. PV 548.

boys and young men were paid to wash the animals. In the distance are the bridges and smoking factories of Clichy; in the upper right can be seen the island known as La Grande Jatte. Because the canvas was submitted to the official Salon in early spring 1884 (it was rejected), we can feel sure that the thirteen painted studies related to it date from 1883. Seurat executed one of these (*The Seine with Clothing on the Bank*; Mrs. Paul Mellon, Upperville, Virginia, H 90) over a white ground, emulating Impressionist practice;[8] its color range, like that of *Man Painting a Boat* (CAT. 14, p. 43), owes a debt to Manet. Seurat executed other panels, such as *Rainbow* (CAT. 16, p. 43) and *Horses in the Water* (CAT. 15, p. 43), on orange-brown varnished wood, but their palette is otherwise rather close to that of Renoir's *Oarsmen at Chatou* (CAT. 108, p. 45), for example. In the two panels' foregrounds, Seurat used what has been called his chopped-straw brushwork, but the horizontal strokes in the water and the more softly brushed skies are characteristic Impressionist textures. The summary definition of the boys and horses implies that Seurat made these panels on site. But he surrounded the forms with contrasting light or dark tones in the water, adapting the advice of Blanc, Chevreul, Rood, and the painter Couture, all of whom pointed out that colors in nature are much affected by such contrasts.[9]

In several other panels, Seurat studied boys, horses, and clothing on the bank, varying the landscape slightly. *Black Horse* (CAT. 17, p. 44) depicts typical activities at the site. By editing out the horses in the final painting, the artist eliminated

CAT. 12

Bridge; View of the Seine, 1883. Oil on panel; 16.5 x 25.4 cm (6 ½ x 10 in.). The Metropolitan Museum of Art, New York, bequest of Mabel Choate in memory of her father, Joseph Hodges Choate, 1958. H 77.

CAT. 16 (BOTTOM LEFT)

Rainbow (study for *Bathing Place, Asnières*), 1883. Oil on panel; 16 x 25 cm (6 ¼ x 9 ⅞ in.). The National Gallery, London. H 89.

CAT. 14

Man Painting a Boat, 1883. Oil on panel; 15.9 x 25 cm (6 ¼ x 9 ⅞ in.). Courtauld Institute Gallery, London. H 66.

CAT. 15 (BOTTOM RIGHT)

Horses in the Water (study for *Bathing Place, Asnières*), 1883. Oil on panel; 15.2 x 24.8 cm (6 x 9 ¾ in.). Private collection, on long-term loan to the Courtauld Institute Gallery, London. H 86.

CAT. 17

Black Horse (study for *Bathing Place, Asnières*), 1883. Oil on panel; 15.9 x 24.8 cm (6 ¼ x 9 ¾ in.). National Gallery of Scotland, Edinburgh. H 88.

CAT. 18 (BOTTOM LEFT)

Seated Man (study for *Bathing Place, Asnières*), 1883. Oil on panel; 15.7 x 24.9 cm (6 ⅛ x 9 ¾ in.). The Cleveland Museum of Art, bequest of Leonard C. Hanna, Jr. H 80.

CAT. 19

Two Seated Figures (study for *Bathing Place, Asnières*), 1883. Oil on panel; 17.5 x 26.3 cm (6 ⅞ x 10 ⅜ in.). The Nelson-Atkins Museum of Art, Kansas City, Missouri, purchase, Nelson Trust. H 91.

CAT. 20 (BOTTOM RIGHT)

Compositional study for *Bathing Place, Asnières*, 1883. Oil on panel; 15.8 x 25.1 cm (6 ¼ x 9 ⅞ in.). The Art Institute of Chicago, gift of the Adele R. Levy Fund, Inc. H 93.

the theme of working in favor of a scene of pure leisure. The study with a seated man wearing a round hat (CAT. 18, p. 44) is an early idea for the half-nude youth in the final composition. By the time he painted *Two Seated Figures* (CAT. 19, p. 44), Seurat was thinking more concretely about the large canvas and accordingly gave more care to rendering landscape and figures. Against the water, the half-nude boy is surrounded by strong tonal contrasts, dark along the exposed shoulder and arm, light elsewhere. The form of the second seated youth displays no such contrasts, because his ground possesses "natural" values (light sand, dark grass) that do not require them. After rejecting, adding to, and refining his studies, the artist made a sketch of the final composition (CAT. 20, p. 44). He had probably already roughed out the landscape on canvas, but he used this study to establish its main elements and to spread out the riverbank so as better to accommodate his figures and the still lifes of clothing.

In planning the composition, Seurat reverted to his academic training. He initially conceived several of the figures as nudes; sketched from life, they differ considerably from his independent drawings. *Seated Boy, Nude* (CAT. 21, p. 47) represents a studio model whose abundant hair and sagging shoulders put us in the presence of a real, if anonymous, youth. This carefully contrived image reveals Seurat's penchant for immaculately structuring every work on paper. Unlike the visible interlacing of lines that create the forms of unrelated figural studies, the modeling here is very smooth, as though natural

light were washing over a sculptural solid. However, the background, as in other drawings, acquires a halo around dark portions of the torso and head, and dark tones set off the light arms. These contrasts are greatly attenuated for buttocks and leg, in order to integrate the body with its support.

While executing *Bathing Place*, Seurat returned to several of the earlier studies, borrowing elements from them as he elaborated his conception. Of the ten drawings we know he executed for the picture (of which *Seated Boy, Nude* is one), several must date from the fall and winter, for they present the

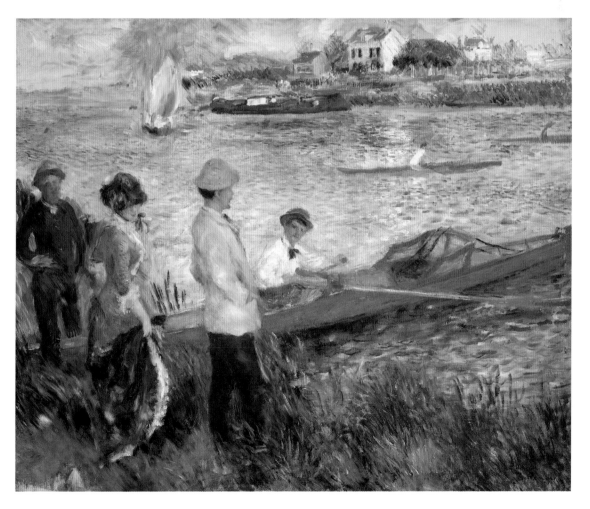

FIG. 12

Bathing Place, Asnières,
1883–84. Oil on canvas; 201 x
300 cm (79 x 118 in.). The
National Gallery, London. H 92.

CAT. 21

Seated Boy, Nude (study for *Bathing Place, Asnières*), 1883. Conté crayon on paper; 31.7 x 24.7 cm (12 ½ x 9 ¾ in.). National Gallery of Scotland, Edinburgh. H 598.

CAT. 22

Hat, Shoes, and Clothing (study for *Bathing Place, Asnières*), 1883. Conté crayon on paper; 23.6 x 30.9 cm (9 ¼ x 12 ⅛ in.). Fogg Art Museum, Harvard University Art Museums, Cambridge, Massachusetts, gift of Lois Orswell. H 593.

definitive forms after the artist established the colors and composition. *Hat, Shoes, and Clothing* (CAT. 22) is a studio piece; the hat leans against a wall, which explains its emphatic geometry in the final painting. *Reclining Man* (CAT. 23, p. 48) served as the model for the painted figure, aided by two other drawings of his head and shoulders; the form on canvas retains the sawtooth pattern of the drawing's dark trousers. The artist drew the half-nude study *Seated Boy with Straw Hat* (CAT. 24, p. 49) in strong studio illumination that exaggerated

the contrasts of light and dark; they are more subdued in the painting, where the boy is fully clothed. Seurat included the emphatic contrasts of *Echo* (CAT. 25, p. 49), a miracle of close observation and pictorial structure, in the water surrounding the boy on the canvas. In other words, the drawings formed the substructure of the painted figures: their lighter or darker tones conformed to this basic modeling. Seurat would follow this practice of painted studies and drawings when he undertook *La Grande Jatte* in 1884. The distinctive quality of these remarkable

drawings is their completeness as finished compositions. In this way, they are unlike the preparatory drawings for oils and pastels of the late nineteenth century's other great draftsman, Degas, which always disclose the artist's working processes.

Bathing Place, Asnières was refused by the official Salon, but was included in a show organized by a new jury-free exhibition society in May 1884. The group evolved into the Société des Artistes Indépendants (Society of Independent Artists), which Seurat, along with Redon and Signac, helped

CAT. 23
Reclining Man (study for
Bathing Place, Asnières),
1883. Conté crayon on paper;
24.5 x 31.5 cm (9 ⅝ x 12 ⅜
in.). Fondation Beyeler,
Riehen/Basel. H 589.

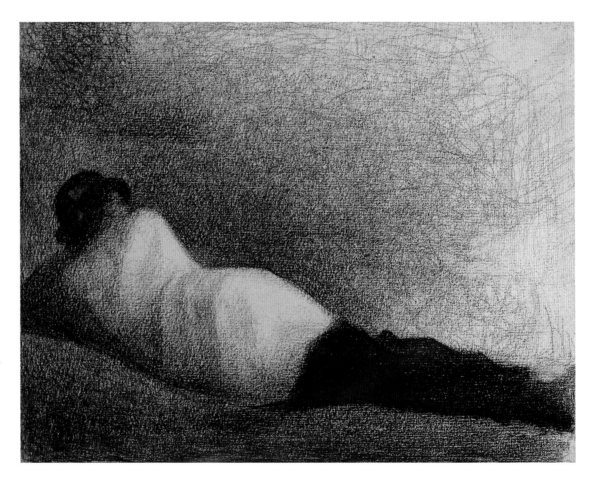

found; the future Neoimpressionist Albert Dubois-Pillet served as its de facto manager. Artists had long chafed under the conservative rule of the government's Salon, but the Indépendants became the first successful group (it is still in existence) operating with democratic procedures and a simple rule that anyone could exhibit by paying a modest membership fee. Seurat initially may have showed with them because he lacked an alternative but, like his new friends Dubois-Pillet and Signac, he remained a faithful member and exhibitor until his death.

The combination of tradition and Impressionism in Seurat's *Bathing Place* was noticed by the few critics who reviewed the show, mostly leftist writers who sympathized with the democratic and upstart status of the new exhibition society. They compared the picture with Renaissance frescoes and the work of Puvis de Chavannes, a leading mural painter whose style stemmed from the classical tradition but was deemed original because of his "primitive" way of conceiving figures and spaces.[10] For example, in *Pleasant Land* (FIG. 13), exhibited in 1882, both figures and landscape possess an archaic simplicity that viewers might have recalled when studying the younger painter's picture. Seurat certainly knew the work of Puvis, one of France's most famous living artists; several of his school chums numbered among the muralist's disciples. Comparison with Puvis was logical because *Bathing Place* was so shockingly different from Impressionism. Seurat's figures, like Puvis's, absorbed in rather solitary reverie, hark back to the solemnity and compressed solidity of classical

sculpture. Furthermore, they are painted with waxy smoothness, unlike the lively figures in Renoir's *Oarsmen at Chatou*, whose irregular surfaces and edges register the effects of graceful motion, mottled sunlight, and multiple reflections.[11]

Seurat's picture also displays the ambitious size and considered structure of Puvis's murals. It suggests more tangible depth than is Puvis's norm, but depends upon similar broad planes of simple geometry. The older artist's images transport the viewer to a vaguely Hellenistic past, long associated with public buildings and elevated national culture. In Blanc's *Grammar*, Seurat had read why public murals should be preferred to easel paintings. Blanc, a lifelong republican, regarded the former as repositories of public enlightenment, in contrast to small

CAT. 25

Echo (study for *Bathing Place, Asnières*), 1883. Conté crayon on paper; 31.2 x 24 cm (12 ¼ x 9 ½ in.). Yale University Art Gallery, New Haven, bequest of Edith Malvina K. Wetmore. H 597.

CAT. 24

Seated Boy with Straw Hat (study for *Bathing Place, Asnières*), 1883. Conté crayon on paper; 24.2 x 31.5 cm (9 ½ x 12 ⅜ in.). Yale University Art Gallery, New Haven, Everett V. Meeks, B.A. 1901, Fund. H 595.

FIG. 13 (BOTTOM)

Pierre Puvis de Chavannes (French, 1824–1898). *Pleasant Land*, 1882. Oil on canvas; 25.7 x 47.6 cm (10 ⅛ x 18 ¾ in.). Yale University Art Gallery, New Haven, The Mary Gertrude Abbey Fund. Reduced version of the original (Musée Bonnat, Bayonne), exhibited in 1882.

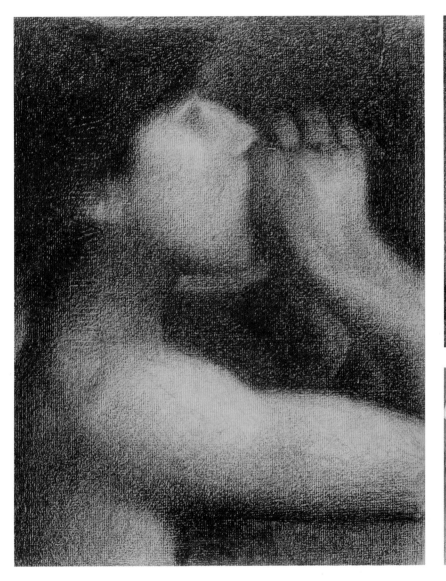

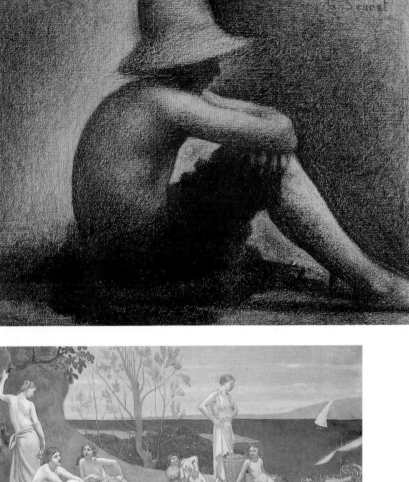

canvases, private commodities that he believed signified mere individualism. Blanc repeatedly ascribed moral purpose to the process of creating ideal forms that incarnate the very essence of life: "Indeed, the right way of idealizing is to efface the purely individual accents furnished by nature, in order to choose those that belong to a species, those that characterize generic life."[12]

From the vantage point of both Blanc and Puvis, however, *Bathing Place* would have been too thoroughly compromised by a concern for naturalism and Impressionism. The arresting individualism of the central boy's head, with its great mop of hair, places us in Seurat's present moment, as do the factories in the distance. The setting is an ordinary embankment of the Seine, with working-class or lower-middle-class boys and men who are not

necessarily connected with the huge industrial structures in the background.[13] Nonetheless, the presence of the factories allows the viewer to understand the figures' leisure as earned, in contrast to the indulgent pastimes pictured by Monet and Renoir. Naturalist authors such as the Goncourt brothers and Huysmans drew attention to the industrialized suburbs spurned by the previous generation; thus, like his drawings, *Bathing Place* reveals Seurat's sympathy with their writings. As we have noted, *Men in front of a Factory*, which depicts the same district, reveals Seurat's awareness of disturbing social realities.

To be sure, Seurat idealized a factory precinct in *Bathing Place*—he eliminated signs of work and sanitized the actual riverbank, bordered by boatyards and cafés—but he did not sacrifice social meaning

in favor of "form." Instead, he elevated it to the standing of high art. He honored Blanc by making an enduring monument from the ordinary clay of this suburban shore. *Bathing Place* is an allegory of summertime, but a highly unusual one because it juxtaposes masculine leisure with the workplace. The painting evokes an implicit social harmony in the dialogue of men and boys with work, so different from the connection between male and female that Renoir celebrated. It does not hark back to the eighteenth-century *fête champêtre* evoked in a modern guise in the Impressionist's *Oarsmen at Chatou*, for example. While this scene has a large industrial barge in the background, much like the factories of Monet's suburban pictures, its potential as an intrusive presence is subdued by the celebration of leisure. By contrast, Seurat's canvas puts us

fully within an industrial suburb, even if he idealized the setting. Like his small panels of peasants at work (mostly male), *Bathing Place* returns to the sober realism of Millet, as well as to that of Pissarro, with whom Seurat shared a similar moral seriousness.

Five of the figures in *Bathing Place* gaze across the river toward La Grande Jatte. The racing shell and the sailboats, which replace red and black industrial barges in two of the painting's studies, are not for them. One boy hoots a call over the water, as though he could bridge the distance to the care-free island. He is the only figure who moves his arms away from his body, thus partly escaping the sculptural gravity of the others. He does not, how-ever, substantially alter the somber mood that is Seurat's distinctive trait. The grand solemnity of *Bathing Place* has encouraged historians to

exaggerate the degree to which the painted studies led inexorably to the final picture. The artist's proj-ect certainly involved calculation, but we now know that it grew out of a process of trial and error in which he altered or rejected forms and images.

Seurat was painting other panels along the Seine that may have prepared him for *La Grande Jatte*. None of these can be dated precisely. They proba-bly overlap with studies for this, his second major composition, and provide further evidence of how open-air studies invigorated both undertakings. Many display wonderful bouquets of color and luminosities that reflect the excitement of fresh outdoor discoveries he was making in the wake of Impressionism. *Banks of the Seine near Courbevoie* (CAT. 33, p. 50) and *Courbevoie, Landscape with Turret* (CAT. 29, p. 50) are clear

instances of painting quickly on the spot. Treating the warm brown of the panels as a constituent color, Seurat made a few horizontal strokes over the water, enough to show reflections and strong light bouncing off its surface. The moored boathouse and other structures in *Banks of the Seine* encour-aged the artist to employ greater contrasts than he could in *Landscape with Turret*. In the latter, the brushwork that defines the shore is smaller and more varied in color, size, and direction than in the former. The strokes (with the exception of those defining the turret) respond to perception of hue without regard for identifiable images, a procedure familiar from Impressionism.

Seurat may have deliberately executed *The Bineau Bridge* (CAT. 36) as a response, in tiny scale, to Monet's and Renoir's paintings of bridges

over the Seine, which include similar generous displays of foliage. Riverside images such as Renoir's *Seine at Chatou* (CAT. 109) gave Seurat more than one lesson in how to break up color into separate tints that excite the eye. In this painting, for example, Renoir laid tiny touches of red, orange, and yellow-orange on top of the larger white spatters that represent blossoms; in the tall grass, he intermixed tints of yellow, tan, red, blue, purple, and white with several greens that together form the variegated tones he desired. Seurat carried *The Bineau Bridge* a step beyond *Landscape with*

Turret, developing the different colored zones with greater profusion of brushwork. He painted the bridge from La Grande Jatte; a third panel, *Boat near the Riverbank, Asnières* (CAT. 65, p. 51), depicts the same area. The latter probably dates from 1884, because its brushwork exhibits the regularity seen in panels for *La Grande Jatte*. By now Seurat had largely abandoned the earth colors he favored in 1882. Recent scientific examinations by Jo Kirby, Kate Stonor, and their collaborators in London show that by 1883, although Seurat's palette still retained such tones, it mostly comprised prismatic pigments, those with the strongest saturation of a given hue.[14] For example, he used cobalt blue and French ultramarine rather than Prussian blue or cerulean, both of which have a greenish tinge. Prismatic colors concorded better with Rood's lessons, and better emulated the high chroma of Impressionism.

It is likely that his new friend Signac featured in Seurat's increased attention to Impressionist methods and themes. As we have seen, Impressionism figured in the genesis of *Bathing Place* before Seurat met Signac, at the Indépendants exhibition in May 1884. Signac, Seurat's junior by four years, had begun painting in 1881 as an enthusiastic and untrained admirer of the Impressionists. Until 1886 his technique involved rather large, shaggy brushstrokes that would not have appealed to Seurat, but he admired the younger artist's daring palette, which eschewed earth colors, and his emphasis on strong contrasts. The warm orange-reds of Signac's

Paul Signac (French, 1863–1935).
Mariners' Cross at High Tide,
Saint-Briac, 1885. Oil on
canvas; 33 x 46 cm (13 x 18 ⅛
in.). The Dixon Gallery and
Gardens, Memphis, Tennessee,
bequest of Mr. and Mrs. Hugo N.
Dixon. FC 104.

Mariners' Cross at High Tide, Saint-Briac (CAT. 113, p. 53) stand out from the blues and greens of the water, and its brushwork is larger and far more varied than Seurat's at the same moment. Signac lived in Asnières and probably reinforced his new friend's interest in the adjacent banks of the Seine. Equally important, or perhaps more so, Signac had been involved in the world of letters since 1881, frequenting the literary café Le Chat Noir (in 1882 he published a parody of Zola in Le Chat Noir's new journal). He wasted no time introducing Seurat to contemporary café and literary society, pulling him

away from the conservative associations that marked his earlier years.

Through Signac, Seurat met the author Robert Caze in 1885. Caze, then thirty-two years old, hosted a regular gathering at which the future Neoimpressionists cemented relationships with the young literary vanguard. In his work, he was pushing naturalism in new directions and acting as a bridge to the rising generation of Symbolists. At Caze's home, Seurat met the writers Jean Ajalbert, Paul Alexis, Rodolphe Darzens, and Huysmans, and probably also Paul Adam and Gustave Kahn, all of

whom reviewed his exhibitions beginning in 1886. On the left politically, the group welcomed Seurat and Signac in part because they were rebelling against traditional art and its institutions. Ajalbert, Alexis, and Caze were urban naturalists who must have appreciated the social content of Seurat's drawings. In Caze's *Paris vivant*, published in 1885, we encounter vignettes on artists, models, writers, prostitutes, street vendors, female strollers, secretaries, and trial lawyers. Unlike Zola, whom Seurat's new acquaintances regarded as old-fashioned,[15] Caze wrote an unvarnished naturalist prose that concentrates on his characters and is devoid of descriptions of weather, time of day, and setting; Seurat would have been drawn to this focus. Both Signac and Seurat gave drawings to Caze: in May 1886, his widow—the writer had died in a duel at the end of March—lent Seurat's *Acrobat by the Ticket Booth* (CAT. 31, p. 119) to the Eighth Impressionist Exhibition.[16]

A painter's experience is a compound of many encounters with people and places that cannot be recapitulated easily. We know the part that Signac played in Seurat's life was significant, but not what it meant in detail; we can be sure that the interchange at Caze's constituted a powerful reinforcement for Seurat, but we can only guess at the connections. We are on more secure ground by studying how the artist built his craft. Like other painters, he constantly matched what he saw in nature with the way pigments appeared on wood and canvas after he placed them there. Looking is not a neutral, fixed perception but an act that

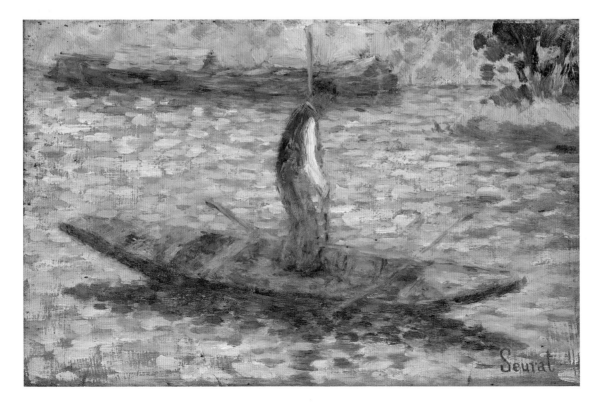

changes during the dialogue with painting. Seurat's later reputation as a veritable scientist has obscured his working method, which was not at all mechanical. It was instead the result of extreme sensitivity to the materials he used. In his drawings, for example, he pushed his conté crayon beyond the edges of his paper so that even the irregular sawtooth edges were covered. In his panels, he learned to vary the direction, width, and impasto of his brushwork, as well as his colors. At times he used the grain of the wood, which nearly always ran horizontally. Unless they were very wet, vertical and diagonal strokes sometimes skipped over the tiny grooves of the grain, leaving a shimmer of very thin horizontals. This effect not only broke up the paint, but also added a refinement that suits the panel's small size, as though the artist wished to emulate the precision of medieval miniaturists.

More surprising, but very difficult to see in reproduction, is Seurat's occasional choice of panels that were scored with a woodworker's block plane with projecting metal teeth (toothing plane).[17] Customarily, furniture makers used this tool to prepare wood to receive glue for attaching veneer. Whether Seurat employed the plane himself or turned this over to someone at the paint shop, his choice was deliberate. Had he wished, he could have specified smooth surfaces like that of *Landscape with Turret*. The fine teeth of the handheld plane made batches of parallel grooves at right angles to the grain. Each passage of the tool was made at a slightly different angle, so the resulting texture is not rigorously regular, although it forms a loose grid in combination with the grain. For example, toothed grooves are visible in the water on the right side of *Boat near the Riverbank*, and Seurat echoed them in the slender, upright strokes that define the fence along the embankment. Scoring is especially prominent on the left and right sides of *Riverman* (CAT. 37, p. 54). From 1884 onward, Seurat turned to a toothing plane more often. Because he produced over thirty painted studies for *La Grande Jatte*, our examination of the creation of that large canvas offers many occasions for looking into the craft of this singular artist.

Independent Canvases, 1884–85

Seurat began working on *La Grande Jatte* in May
1884; one might assume, from the many surviving
studies (nearly sixty), that he had little time for
other activity. However, during the two years he
devoted to the monumental composition, he contin-
ued to draw in and around Paris, painted a number

of independent *croquetons*, and completed several
canvases, five of them at Grandcamp, on the Eng-
lish Channel coast, in the summer of 1885. In these
he refined his technique of broken color, which
contributed to his work on the island site.

Field of Alfalfa, Saint-Denis (CAT. 76, p. 55)
probably dates to 1884, but Seurat may also have

worked on it in 1885. Meadows with poppies had
been a staple scene of mid-century and Impression-
ist painting. Works by Daubigny, Monet, and Renoir
come readily to mind; Monet's *Poppy Field in
a Hollow near Giverny* (CAT. 99, p. 56) offers par-
allels with *Field of Alfalfa*'s symmetry and large
planes. This is not to suggest "influence" (the two
paintings are contemporary) but instead to show
how many reverberations exist between the younger
artist's work and that of the Impressionists. There
are precedents for the broad foreground and
horizontal order of *Field of Alfalfa* in a number of
compositions by Monet, including *The Meadow*
(CAT. 95) of 1879. The Impressionist's brushwork
seems spontaneous and less systematic than Seu-
rat's, but in fact was carefully managed to give that
appearance. In this and other like paintings that
Seurat could easily have seen, Monet's technique is
readily revealed as very complex, requiring patient
work over many sittings. For example, in the fore-
ground of *Cliff Walk at Pourville* (CAT. 96, p. 59),
the artist articulated the cliff-top growth by divid-
ing color into many tints that he brushed in sepa-
rately, often over broader applications of pigment
that he had allowed to dry. Atop these he painted
thinly so as not to disturb the "spontaneous" tex-
ture of the thick, initial strokes he was covering,
sometimes with fine touches only one thirty-second
of an inch wide. Seurat would have understood that
Monet's procedure was as time-consuming as his
own, although the results are so different.

The horizons in *Field of Alfalfa* and *Poppy
Field* are equally high, another mark of Impressionist

abstract and for "all-over" textures. Despite the
choppy regularity of his strokes and the absence
of trees, bushes, or other details, Seurat succeeded
in tipping the space back into the distance. Color
contributes to this illusion, because our eye moves
from the curved shadow in the foreground (signal-
ing the tree under which he stationed himself,
something he would also do in *La Grande Jatte*),
dominated by blues and resonant dark greens,
through ever-brighter hues until we reach the
blond background. Equally important, the dabs
of paint become progressively smaller until they
are nearly smoothed out in the distance. This is not
a realistic device, but larger strokes somehow seem
nearer, which communicates the sense of a field
receding into space.

The five seascapes Seurat did at Grandcamp
in 1885, for which there are eleven panel studies,
display similar, tightened strokes, varied to suit
their more complex subjects. In the walls of
Grandcamp, Evening (CAT. 81, p. 60), the brush-
work is vertical, horizontal, and diagonal, following
the lines of each section. The foliage in the fore-
ground is defined by crisscrossed marks of similar
size, but in the water and sky one finds smoother
horizontals.[18] The architecture in this picture seems
a bit clumsy, as though Seurat were uncomfortable
with the need to foreshorten its planes. There is no
such problem in *Roadstead at Grandcamp* (CAT.
82, p. 61), because he limited himself to one diago-
nal wall in a composition otherwise characterized
by large horizontal areas. Here, too, the texture of
the strokes changes to suit the subject. The handling

practice that resulted in flattening the picture
plane. Pissarro sometimes placed figures in similarly
composed meadows or clearings. His *Repose, Young
Female Peasant Lying in the Grass* (CAT. 102)
features a broad, level area behind the figure and a
strong horizontal zone above, but of course she has

no counterpart in Seurat's *Field of Alfalfa*, although
she does in his *Seated Woman* (CAT. 13, p. 40).
Furthermore, Pissarro's broken brushwork, like
Monet's, incessantly changes direction and thick-
ness, whereas Seurat's has a regularity that later
appealed to modern artists' penchant for the

is jagged for the foliage, a mixture of vertical and
chopped-straw marks for the fencing, broadly hori-
zontal for the water, and smooth for the sky. In the
water, we see an important parallel with the effect
of the toothing plane on Seurat's wood panels. He
blotted out some of the oil in his pigments, so that,
as his brush moved sideways, it picked up the ver-
tical weave of the canvas without filling in the web.
Signac used the technique that summer at Saint-
Briac on the Brittany coast; it is readily observed in
Mariners' Cross at High Tide. Both young artists
would have seen that Monet represented water in
this way; for example, in *Cliff Walk at Pourville*,
he articulated the distant sea with dark greens
dragged horizontally to form parallel verticals. In
Seurat's canvas, shimmering verticals enliven the
water's surface; this was deliberate, since he largely
painted over them in the foreground and sky. If ear-
lier canvases by Monet taught Seurat about broken
color, the works the Impressionist was doing in
1885 show the great distance between the two on

the eve of *La Grande Jatte. Departure of the
Boats, Étretat* (CAT. 98, p. 64), like *Roadstead at
Grandcamp*, looks from the shore out to sea, with
both forming horizontal strata. But in contrast to
Seurat's very measured cadences and summery
mood, Monet's wintry composition harks back to
the Romantic theme of careened boats, and his
fluid, energetic facture deliberately conveys strong
forces of nature at play.

Le Bec du Hoc (CAT. 84, p. 63), Seurat's best-
known painting from Grandcamp, originally had a
surface like that of *Roadstead*, but he reworked it
in 1888 or 1889, when he added myriad tiny strokes
over much of the water and portions of the cliff
(the bluish green dots on the water are especially
conspicuous), avoiding any vertical shimmer. Like
the other paintings he did that summer, it demon-
strates that he knew Monet's work along the same

CAT. 84

Le Bec du Hoc, 1885,
reworked 1888/89. Oil on
canvas; 64.8 x 81.6 cm
(25 ½ x 32 ⅛ in.).
Tate, London, purchased 1952.
H 159.

coasts, and was consciously reworking similar motifs. In the study for this canvas (CAT. 83, p. 62), Seurat included some of the beach, but when he painted the final composition, he excluded the shore by moving back from the brow of the cliff. This made the beak of land hover more forcefully over the water. In paintings such as *Custom House* (CAT. 97, p. 62), Monet also chose a viewpoint above the bluffs; however, by centering the cliff and regularizing his brushwork, Seurat stabilized his view and provided a much more measured taste of the dramatic than Monet. All

the surfaces in his Grandcamp pictures, including sea and sky, comprise rather similar small strokes that contrast with Renoir's brushwork even more than with Monet's. For example, in *View at Guernsey* (CAT. 111), Renoir created lilting cadences with sweeping curves, elongated streaks, and occasional short dabs that construct a far more lyrical seacoast.

The flickering verticals of *Roadstead at Grand-camp* can be seen in the water in *The Seine at Courbevoie* (FIG. 14), but here too the canvas is largely covered over in the areas depicting solid

land. This 1885 painting is closely allied with *La Grande Jatte* and must have been executed just before or after the summer at Grandcamp. Seurat depicted the scene from the island (see CH. 3, FIG. 4), looking toward the buildings of Courbevoie, resplendent in their opposed oranges and blues. He studied these colors in a small panel (CAT. 85, p. 65), in which red and yellow were mixed wet to form a bright coral-orange. Similarly, he combined blue and off-white in vertical strokes that conform to the planes of the structures, whereas he rendered the water in horizontal dabs.

In *The Seine at Courbevoie*, Seurat left Barbizon and mid-century art far behind. It features a typical Impressionist subject and reveals obvious debts to his predecessors' broken color. The viewpoint is much the same as Monet's when he worked on La Grande Jatte in 1878. *Springtime through the Branches, Island of La Grande Jatte* (CAT. 94) is one of five paintings—two more appeared in the Fourth Impressionist Exhibition in 1879—in which Monet looked through a screen of blue-green foliage toward the orange roofs of Courbevoie. He gave the viewer an unstable perch high on the bank, so that the tree trunks do not reach the ground, adding a sense of the momentary to the fluttering foliage. On the other hand, Seurat's deliberate refashioning of such pictures involved composing a sequence of flat planes, in which toylike figures, such as the woman in *The Seine at Courbevoie*, move laterally within a plane rather than back into space. The picture's illusion of depth derives from the dark tree trunks and foliage, which act as a *repoussoir* beyond which we perceive the opposite bank. Here again Seurat's brushstrokes work closely with the shapes, including touches that bend with the tree's profile and rise vertically on the woman's dress. In this painting, we find the technique and forms that would dominate *La Grande Jatte*.

Notes

1 For example, see Prud'hon's *Female Nude* in the Pierpont Morgan Library, New York (1974.7).

2 See Thomson 1985, pp. 30–31.

3 From Seurat's letter to Fénéon (Appendix B), referring to Blanc's "Eugène Delacroix," *Gazette des beaux-arts* 16 (1864), pp. 23ff. Seurat's readings, most of them mentioned in the letter to Fénéon, are thoroughly documented in the appendices (particularly F–P) in Herbert et al. 1991. These include other artists and writers who will shortly be mentioned: Chevreul, Corot, Couture, Delacroix, Rood, and Sutter; in what follows here, all quotations from these can be found in the same appendices. For penetrating analyses of Blanc in relation to Seurat, see Zimmermann 1989 and 1991, and Smith 1997.

4 See Herbert et al. 1991, Appendix J; and Roque 1997, esp. pp. 304–20.

5 Verhaeren 1891 (1927 ed., p. 198).

6 In a letter to Daniel Catton Rich (Nov. 29, 1934; Art Institute of Chicago Department of European Paintings files), then a curator at the Art Institute of Chicago, Signac wrote that Seurat found the term in the Goncourt's writings, but this has not yet been verified. *Croquer* means to crunch or munch, but also to sketch; *croquis* is the common word for sketch. In the catalogue of the 1884 exhibition of the Société des Artistes Indépendants, Seurat listed "9 croquetons" under no. 242, and reviewers repeated the term. For a study of the kinds of panels Seurat would have found in art shops, and those he actually used (mostly mahogany), see Kirby et al. 2003, pp. 17–18.

7 Also documented in Herbert et al. 1991, Appendix C and pp. 174–75.

8 For a thorough account of *Bathing Place* and its studies, see Leighton and Thomson 1997.

9 Seurat's knowledge of Couture, like that of the theoreticians, is documented in Herbert et al. 1991, Appendix O.

10 The comparison with Puvis was made by Paul Alexis, who called the picture a "false Puvis de Chavannes" as a back-handed compliment (*Cri du Peuple*, May 17, 1884, in Seurat's Argus). By 1886 Alexis had become a friend and staunch defender of Seurat and Signac.

11 Seurat was probably unaware that exactly at the time he was creating *Bathing Place*, Renoir was entering his "Sour Period" (1883–87), when he shifted to solid, sculptural modeling inspired by a trip to Italy. Seurat met the older artist sometime before May 1886, because he inscribed his own address, "16 rue de Chabrol, Seurat," in an undated notebook of Renoir's (Alain Renoir Collection). Seurat had left that address by the time of the Eighth Impressionist Exhibition.

12 Blanc 1880, p. 339.

13 Paul Smith, in Smith 1997, p. 50, using contemporaneous sources, identified the costume of the seated boy—with straw hat, pink sash, and maroon trousers—as that of a carpenter or boat-builder; the felt hat (resembling a bowler), smock, and dark trousers of the reclining man were worn by "modish artisans" emulating the bourgeoisie. See Rewald 1956, p. 60, for a contemporaneous photograph of the riverbank at Asnières, showing that it was far from idyllic.

14 See Kirby et al. 2003. This team of conservators studied fifteen *croquetons*, including eight in the present exhibition: CATS. 14–16, 27, 35, 43, 65, 85, listing their pigments and the substances with which they were mixed.

15 Pissarro to his son Lucien, Jan. 23, 1886 (CP 2, no. 309). According to this letter, Signac first took Pissarro to Caze's *soirées* on Jan. 22, 1886.

16 Adam, Ajalbert, Alexis, Daudet, Degas, Geffroy, the Goncourts, Mirbeau, Seurat, and Signac were among those who attended Caze's funeral in April: see Anon., *Lutèce* 5 (Apr. 3–10, 1886), (Seurat's Argus). For Caze, see Smith 1997, pp. 75–83, and for other writers' relationships with Seurat, see Smith 1997, pts. 2–3.

17 Richard Shiff and I began corresponding in 2000 about these parallel grooves, and eventually identified them as the work of toothing planes. Shiff studied several panels more closely than I had ever done, analyzing how Seurat took advantage of the grooves in his technique; his work contributed fundamentally to my paragraphs here. For some of his findings, see Shiff 2002. By the early nineteenth century, and probably sooner, toothing planes were widely employed for painting on wood, but their use has been hidden underneath the pictures' surfaces. See Christine Carrie, "Nineteenth-Century Portraits on Scored Panels in the Cleveland Museum of Art," *Journal of the American Institute for Conservation* 34, 1 (1995), pp. 69–75.

18 This canvas was reworked in 1888 or 1889, when Seurat introduced the painted frame. He then added a number of very small strokes around the edges, to react to the painted surround, and others on the water and in the sky.

2 Genesis of *La Grande Jatte*

In a draft of an autobiographical letter to Fénéon (see Appendix B), Seurat insisted that he began to work on studies for *La Grande Jatte* and the canvas itself on Ascension Day, May 22, 1884. He retained the year in the full title of the composition when he exhibited it with the Impressionists in May 1886: *A Sunday on La Grande Jatte (1884)*. He probably completed the painted studies before the following December, for in that month he exhibited a canvas depicting the landscape as it would appear in the final work, but devoid of figures (CAT. 60, p. 80). In March 1885, according to his letter, he considered the big picture ready for exhibition with the Indépendants, an additional reason for dating the preparatory paintings to the warm months of 1884, since fall and winter would not have provided appropriate sun and shadow on the island (Seurat most probably needed to return to the site to verify his studio work). The 1885 show was canceled, however, and the artist turned to other projects, taking up the canvas again in October. He reworked it, incorporating lessons from a summer working on the English Channel coast at Grandcamp, and exhibited the picture in May 1886.

We can learn something about the genesis of *La Grande Jatte* from its many extant studies, even though we cannot arrange them in a linear sequence. Twenty-eight drawings, twenty-eight panels, and three canvases are known that are directly related to the final painting (see Related Works). Seurat may have painted some of the panels before May 1884. In any event, they were probably completed by the following autumn, although

we must allow for the possibility that one or more date from the spring of 1885. At a relatively early stage, he worked out the definitive disposition of the landscape; with only modest variations, it is the setting for many of the little oils. He almost certainly blocked it out on the large canvas by late spring or early summer, and he took time to perfect it in the small landscape he exhibited in December 1884. The scene served as a stage for his actors from the beginning, and changed only in minor ways as the picture progressed.

Given the large number of studies, and cognizant of Seurat's "scientific" theories, commentators have wanted to believe in a logical, step-by-step procedure from drawings and panels to canvases. Some of the drawings did in fact establish the exact outlines of many of the foreground figures, but these intervened late in the painting's evolution, after its main features had been established in the large sketch of the entire composition, now in the Metropolitan Museum of Art, New York. As for the small panels, although most show the setting as it appears on the final canvas, not all exhibit the same placement of shadows, and only a few of their figures are found in the finished work, often in different locations. Yes, Seurat was a methodical worker— the preparation of this canvas is a striking contrast with Impressionist practice—but his process was an empirical one in which he rejected as much as he retained.

By comparing compositions, brushwork, and palette, we can date some of the little studies early and some later, with the largest number falling in

between. As we have seen in Chapter 1, the idea for *La Grande Jatte* grew out of Seurat's work along the Seine at Asnières and Courbevoie, in studies for *Bathing Place, Asnières* and in other works, such as *Fisherman* (CAT. 27) and *Figures on the Shore* (FIG. 1). The fisherman is not included in *La Grande Jatte*, but the main elements of *Figures on the Shore* reappear in the far distance of the final composition. Its brushwork and colors

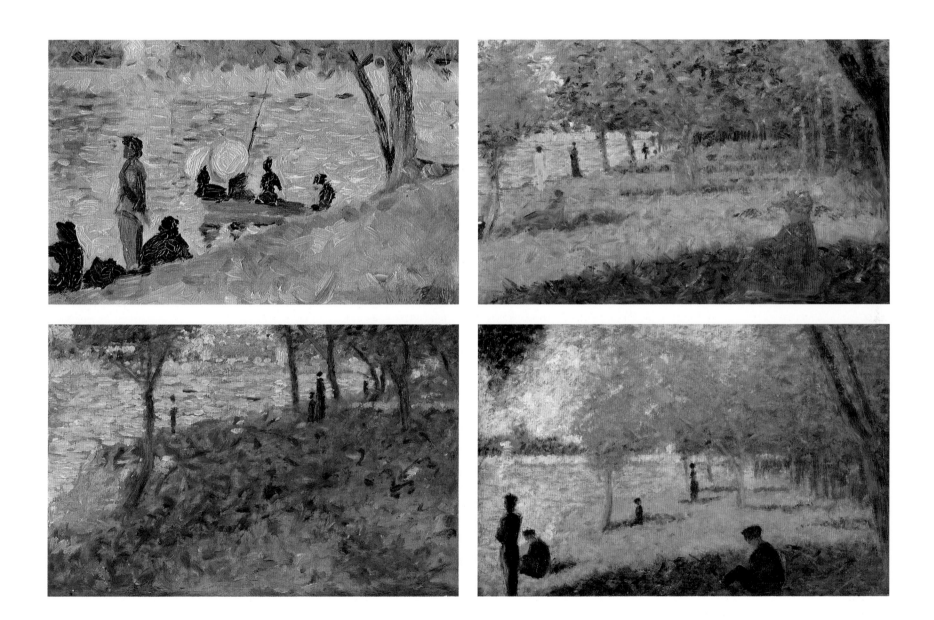

Genesis of *La Grande Jatte* **69**

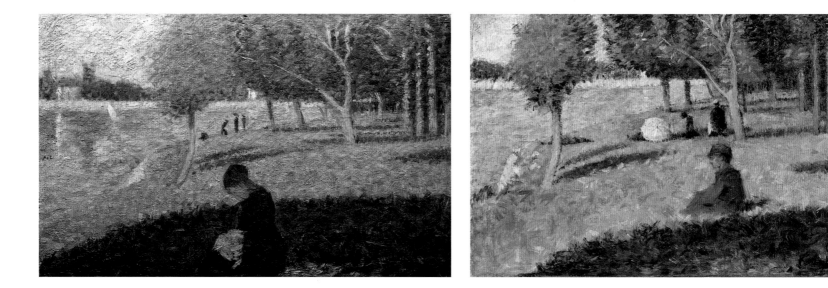

nevertheless suggest that he may have painted it before he conceived of the large canvas. This also may be true of *Landscape with Figures* (CAT. 35, p. 69), in which the position of the sun and shadows is the reverse of what we see in the final picture, because Seurat painted the panel in the morning.

With *Seated Woman* (CAT. 38, p. 69) and another panel, *Seated and Standing Figures* (CAT. 39, p. 69), we can be sure that Seurat had embarked on his big composition. Both include the main landscape features, including the individual and grouped trees, but in their upper right corners we see branches from the tree beneath which Seurat worked; it casts the huge shadow in the final canvas's foreground. These branches later disappeared, leaving only the small triangle at the upper right

edge of the finished picture as their curious remnant. At the left of *Seated Woman* are two tree trunks, one mostly hidden behind the other. Only a single shadow exists at the same spot in *Seated and Standing Figures*. But in the final painting, two are seemingly cast by one trunk, with the more distant of them serving as a kind of pedestal for the two figures who recline there. Other shadows function similarly; some the artist added or altered in the last stages of work on the painting to serve this purpose. The child in white lacks a shadow in the large sketch, but in the final painting acquires one that cuts across the mother's form, linking the two and making the latter appear to hover above the ground.[1]

These illogical double shadows feature in *Woman Sewing* (FIG. 2) and *Seated Figures*

(CAT. 40), both of which display tighter brushwork and more saturated oranges, indicating that they came later than the two panels discussed above. The distinctive presence of the boy in the foreground of *Seated Figures* suggests that Seurat executed this panel from life. The figures in these preparatory paintings seem to be ways of testing possible relations of people to landscape, rather than serious proposals for the composition. As Seurat returned repeatedly to the island, he attempted to study his colors and organize his veritable cast of characters by scattering them in various locations and positions throughout the panels. Some, in sunshine, cast shadows, while others sit or stand within the elongated reflections of trees—those insistent horizontals that give rhythm and depth to the space, as well as vital organizing forms to the surface.

During this early stage, Seurat took a drawing board to the island and executed at least two detailed studies of the site; perhaps he made more that have not survived. The drawing of the prominent tree that appears in the center of the final composition (CAT. 45) resembles the way he drew antique statues and nude models six or seven years earlier; it is more volumetric than its counterpart in the painting. Curiously, in the drawing Seurat deliberately suppressed the long branch that slants from this tree to the left (he also omitted it in some of the oil studies). He marked its growth from the trunk but stopped further work on it in order to map out the position of other trees to the left. His study of the group of trees on the right (CAT. 46, p. 72) also recalls his student work, as well as schematic renderings of Greek columns. In that regard, they combine "primitive" and classical qualities, as do the paintings of his elder contemporary Puvis de Chavannes. Instead of atmospheric shadows, thin horizontal lines—like so many stage flats—mark the trees' positions. Both drawings expose Seurat's willingness to incorporate the qualities and accidents of his paper. In the group of trees, the watermark MICHALLET sits exactly atop a thin, horizontal shadow. In the other drawing, wavy lines in the center foreground, which one might mistake for careless marks of his crayon, are in fact the consequence of stroking it over existing crinkles in the paper and leaving the result, something he often did. The shaded area in the upper right of this drawing clearly reveals the grid of the laid paper, another example of the artist's delight in exposing the nature of his materials.[2]

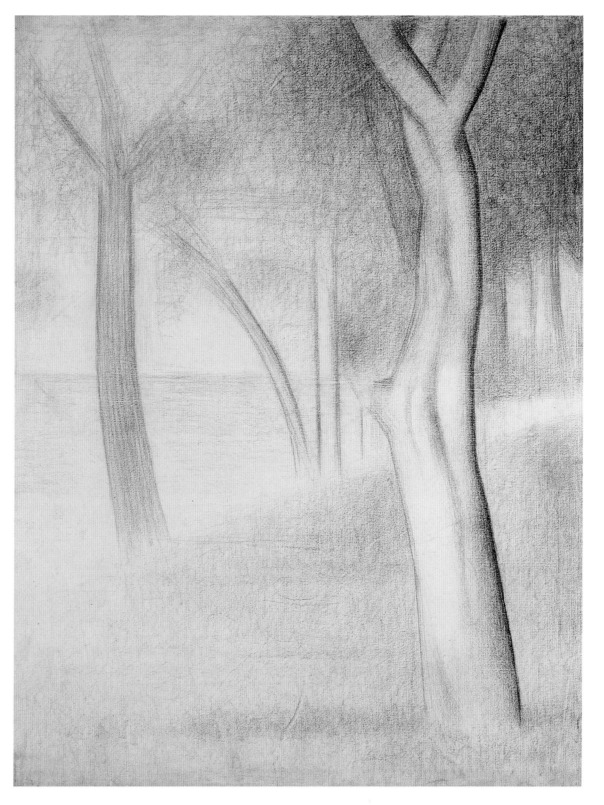

Tree Trunks (study for *La Grande Jatte*), 1884. Conté crayon on paper; 47.4 x 61.5 cm (18 ⅝ x 24 ½ in.). The Art Institute of Chicago, Helen Regenstein Collection. H 620.

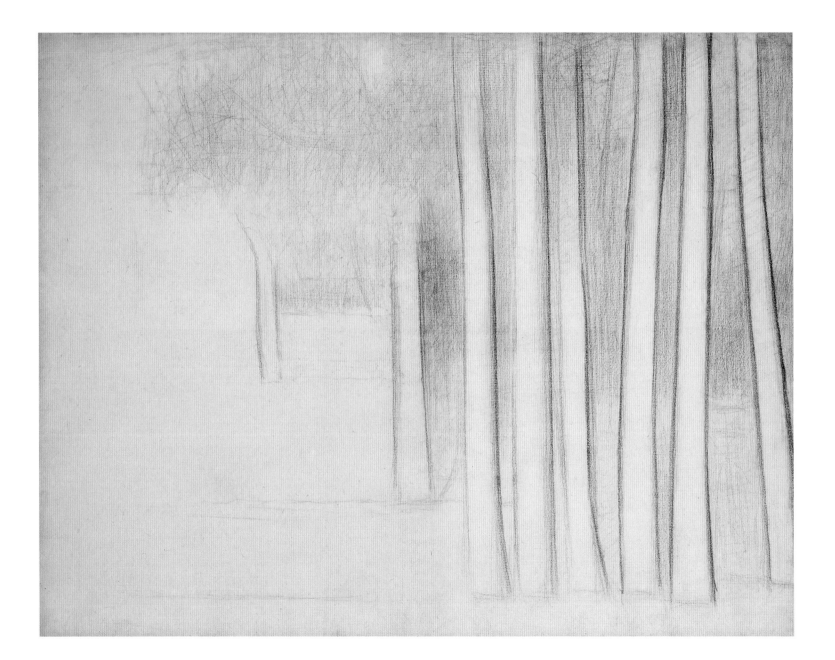

CAT. 42

Landscape, Seated Man
(study for *La Grande Jatte*),
1884. Oil on panel; 15.8 x
24.5 cm (6 ¼ x 9 ⅝ in.).
Collection André Bromberg.
H 111.

CAT. 41

Sailboat (study for *La Grande
Jatte*), 1884. Oil on panel;
15.9 x 25 cm (6 ¼ x 9 ⅞ in.).
National Gallery of Art,
Washington, D.C., Ailsa Mellon
Bruce Collection. H 110.

In two panels, *Landscape, Seated Man* and *Sailboat* (CATS. 42, 41), Seurat seems to have limited himself to rather large dabs, leaving much of the orange-brown wood panel exposed. Even in such summarily executed works, he was studying his arrangement. In *Sailboat*, for example, the gap between the two larger trees is wider than in *Landscape*. In other small paintings, one finds more refined brushwork. The orange-brown of the wood underlies *Standing Man* (CAT. 43, p. 74), but less of it is visible. It is thoroughly integrated by the use of a toothing plane, which formed a subtle grid with the lateral wood grain. Figures to the left and right assume roughly the positions they will have in the final version, and the erect stance of the man anticipates the cigar-holding dandy on the large canvas's right side. These panels indicate that Seurat was still making observations on the island, because in the distance of *Standing Man*, to the right of a pair of trees, grazes a brown cow or horse that has wandered in from one of the neighboring plots of land. Here, Seurat omitted the slanting branch of the forked tree in order to record this unexpected visitor.[3]

Seated and Standing Women (CAT. 44, p. 74) introduces the central female of the final canvas. She stands under the forked tree's slanting branch, which the artist now included; her brilliant red skirt assures her prominence. The woman in the left foreground will also appear in the final composition, farther back and accompanied by a reclining companion. To the rear can be seen the red and black tugboat of the large canvas. This panel displays smaller and more tightly woven strokes than *Standing Man*, which does not necessarily date it to a later moment in the evolution of the definitive composition. In *Standing Man*, for example, the location and rhythm of the distant shadows are closer to their disposition in the large canvas than the more schematically rendered ones in the background of *Seated and Standing Women*. And while *Three Men Seated* (CAT. 47, p. 74) is less tightly brushed than the previous panels, it is probably slightly later. Here, for the first time, we find the idea of situating three figures in the composition's lower left, as well as the two sun spots that will occupy an important place within the final work's huge foreground shadow.

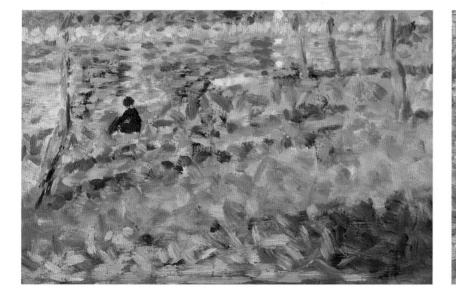

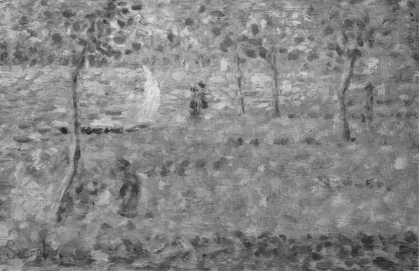

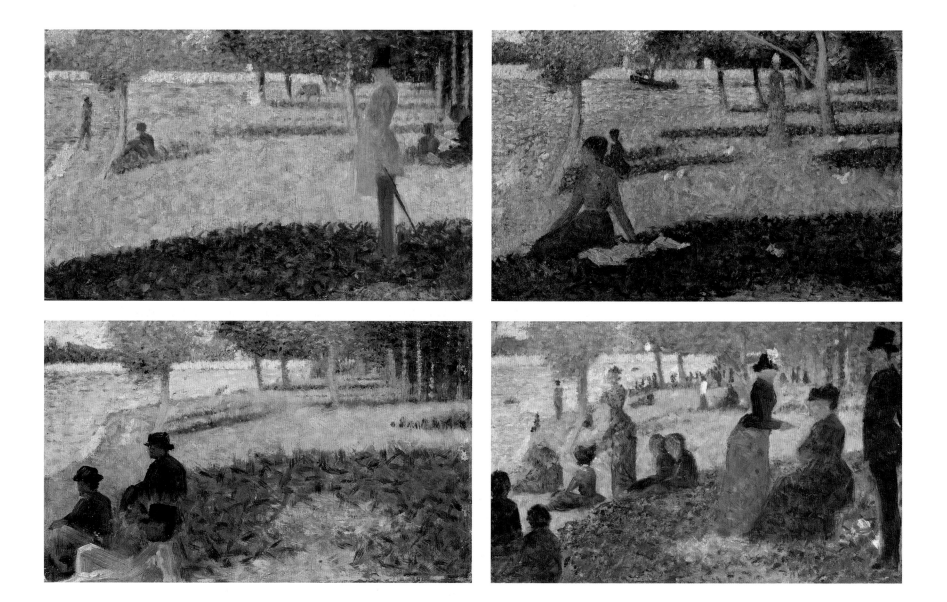

At some mid-point in the process, Seurat tried multifigured arrangements that signal his ambition to create a large composition. In its complexity, *Sketch with Many Figures* (CAT. 48, p. 74) resembles the final painting, but the figures are clumsily positioned, especially the three on the right, and few would be retained. Unlike most other *croquetons*, the protagonists in the panel seem to derive from studio work. The orange-colored woman standing on the left will be included holding a fishing pole along the shore in the large canvas. More important, perhaps, is that from this panel Seurat developed the idea of spreading figures across the foreground, some seated and some standing, and placing smaller persons along the bank and under the trees.

The panel *Woman Fishing and Seated Figures* (CAT. 49, p. 77) is devoted to the left two-thirds of the finished composition. It is calmer and more resolved than *Sketch with Many Figures* because it is less crowded and the holidaymakers more plausibly arranged. Seated nearly in the center is a woman in a straw hat who will accompany two men in the large canvas. Rising from the edge of the large foreground shadow are three females, two of whom will figure in the final composition, although one with her umbrella lowered. Included here is the slanted tree trunk, absent in *Sketch with Many Figures*; its episodic appearance shows how often Seurat debated each configuration of trees, shadows, and people for the final work. The fisherwoman is in her definitive location, modeled as she would be

in the big painting. Her sunlit side is a cream color, and the adjacent water is darkened in contrast. Seurat gave her mostly blue, shaded side a golden halo for the same purpose, so that, reading from left to right, we see the alternation of dark-light/dark-light familiar from his earlier drawings in conté crayon and his studies for *Bathing Place, Asnières*.

Rose-Colored Skirt (CAT. 51, p. 76) moves one step closer to the ultimate composition. Here, the panel is nearly completely covered and the colors more thoroughly interlaced than in most of the studies discussed above. Moreover, the modeling and color of the two largest figures has become more complex. On the left, their bodies and the woman's parasol glow orange in response to the sun, while the shaded areas accumulate blues. The assertive male—his pose lets us imagine that he is ogling the female—will not appear again, but the central woman already has the presence of her counterpart in the big canvas. To the right, a straw-hatted man holds a swaddled baby and turns toward his wife. This couple will find a place in the final picture, but farther back, beyond the forked tree (which in this panel lacks most of its slanted branch). Comparison of the motif of the central female with other panels reveals how Seurat developed his composition hesitantly, as though he were a theater director moving figures about on a stage. We have already seen a similar woman, without a parasol, in *Seated and Standing Women*. In another panel (FIG. 4), she appears well to the left of a child in white who will be joined to her in *La Grande Jatte*. In the final

version, Seurat would reverse the arms of the woman in the rose-colored skirt to accommodate the child.

The extent to which Seurat used models is an unresolved issue. Friends or family members may have served this purpose from time to time. His academic study and his many drawings of standing and seated figures gave him a knowledge of human form and a repertory of familiar poses, allowing him to paint his schematic figures without models. Most likely, he employed someone to pose for the woman in *Rose-Colored Skirt*. She is a miracle of brilliant color and observation. Her skirt, rose-colored from a distance, consists of pinks, streaks of wine red, orange, some yellow, and pale blue; the portion away from the sun displays darker blues, wine reds, and a deep lavender-pink. The artist defined her upper body in orange and wine red, with dark blue and wine red for the shaded side. Touches of green at her waist form a brownish hue to contrast with the reds and purples. An intense orange-red marks the sunlit side of her parasol; it is the brightest color present. The entire figure, with parasol, measures four and one-half inches in height.

The lone figure in *Soldier* [*"Cadet from Saint-Cyr"*] (CAT. 53, p. 78) suggests that Seurat may have based some of his personages on weekenders he encountered on La Grande Jatte. For this panel, he may have asked a soldier to stand still for him— the subject is an infantryman, not a cadet from Saint-Cyr, as the panel has been called.[4] Equally likely, the artist may have relied on his memory for such a simple figure. He may never have seen

CAT. 51
Rose-Colored Skirt (study for *La Grande Jatte*), 1884. Oil on panel; 15.2 x 24.1 cm (6 x 9 ½ in.). Private collection. H 121.

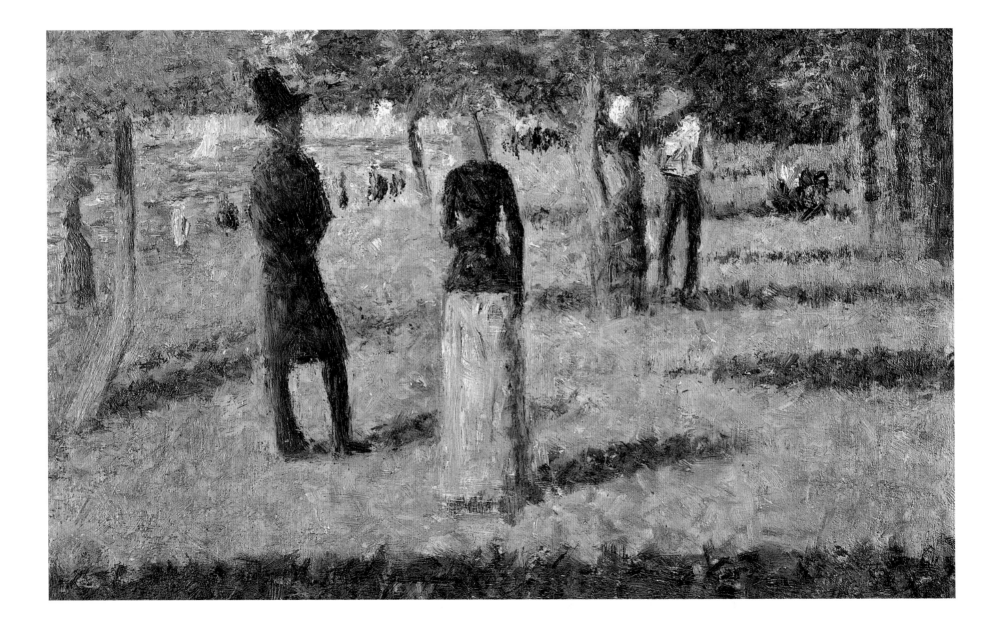

the island as empty as here, so placing the soldier is one of many arbitrary trials of scale, pose, location, and color in a painting primarily dedicated to studying the colors he would use. This panel is certainly an essential model for the corresponding portion of the large canvas. In the foreground, orange intensifies in the sunlit grass as it approaches the bluish green shadow. In response, the latter accumulates purple and darker blue. This is an example of merging light-and-dark contrasts with those of color, about which the artist had read in Chevreul and Rood. Elsewhere, color registers the angle of sunlight in the smallest areas, and proves his careful study of the site even if it involved studio work. The pinkish tan trunk of the tree on the left shifts to orangish tan as it reaches the foliage. The brownish orange of the forked tree's trunk turns to pink above; its slanting branch combines blue and dull orange with hairlike streaks of pink along its upper edge. Seurat painted two trees to the right of the soldier blue and wine red, but made the one to the right, farther from the light, decidedly darker.

Two studies for the *promeneuse*—the standing woman on the right of *La Grande Jatte*—may have involved studio models, but both figures can be imagined easily as invented forms. *Woman with a Parasol* (FIG. 3) shows a female dressed differently than her large-scale successor. Much closer to the final figure, *Woman with a Monkey* (CAT. 59, p. 79) is certainly a later effort, for the landscape is brushed more deliberately. In the finished composition, Seurat moved the woman closer to the

forked tree, and the phalanx of tree trunks will stand almost entirely to her right. In the large canvas, the monkey underwent several adjustments, including placing it closer to the *promeneuse*'s dress and giving it a much longer leash, so that the animal no longer seems to strain against it. These changes reinforce the composition's sense of stillness.

composition. For the sunlit grass, he first brushed in light brownish green in relatively large strokes; he then went over it with smaller touches of several greens, yellow-greens, light creams, and oranges. In other words, his "optical mixture" is really based on green; the other hues are present to enliven it. Thus, he did not rely upon the fabled spots of yellow and blue that early writers mistakenly believed become green in the eye. For the water—not reworked in 1885—the artist emulated the technique Monet often used, which involved squeezing out much of the oil from his pigment and then dragging his brush sideways so that the canvas's vertical threads caught the thickened paint, creating a corduroy-like texture In Seurat's case, the results, paralleling the effects of using a toothing plane on wood, create a glimmering quality that works with the horizontal strokes to simulate the depth and surface of gently lapping water. Subsequently (but perhaps while still working on the painted landscape), Seurat made a drawing (CAT. 63, p. 79) that stretches the view sideways to approximate the proportions of the large sketch and the final picture. It cuts off portions of the top and bottom of the painted landscape and increases the distance between the tree on the left and the forked tree near the center. Its main purpose, however, was to identify the tonal values of the setting, one of many proofs that the artist's conception of dark and light preceded and underlay his thinking about color.

At some point in the summer and early fall of 1884, Seurat executed the landscape of La Grande Jatte mentioned at the beginning of this chapter (CAT. 60, p. 80). He exhibited it with the Indépendants in December. Although he reworked the canvas in 1885, its main features remain unaltered (in 1884 it would have lacked the very small dabs that now speckle the shaded and sunlit grass and the shaded portions of the distant trees).[5] It is more square than the larger painting, giving greater prominence to the expanse of lawn in the foreground. With the final composition in mind, we might find this unpopulated scene desolate. Monet and other landscapists, however, painted empty parks and meadows, so Seurat's image was not unusual. This is a well-manicured setting designed for strollers and picnickers who are absent for the moment. Three boats animate the water and tell us that we are viewing a place of leisure; a white dog in the distance gives perspective.

In his 1884 landscape, Seurat was able to work on a larger scale than the panels afforded, and on canvas rather than wood, so he could try brushwork and pigments more suitable to the large

After the landscape painting, Seurat executed another canvas, *The Couple* (CAT. 62, p. 84), which is devoted to the right half of the composition (if

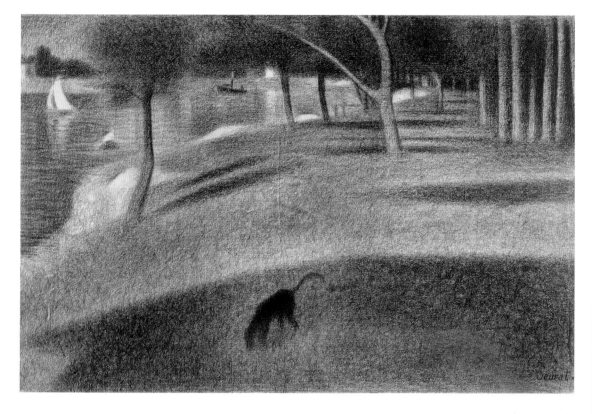

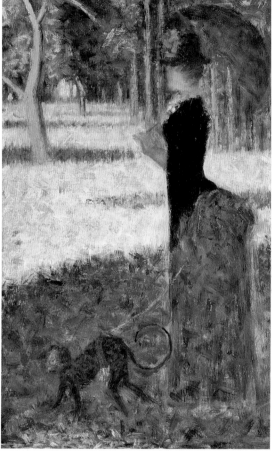

there was a similar study for the left half, it has not survived). Because it is squared up for transfer—faint grid lines can be seen—the painter may have used it to block in these figures in his large compositional sketch, although Frank Zuccari and Allison Langley believe the sequence is the reverse (see p. 186). The artist may also have referred to it in order to rough in the forms on the final canvas. It is very loosely brushed and shows us the way the surfaces of both the large sketch and the final work probably looked before he began the complicated layering of smaller marks (see Fiedler, FIG. 7). While testing the basic colors that would form the basis of the completed picture, Seurat obviously consulted some of his panels. To the right are a few strokes that signify the seated women and the pram included in one panel (CAT. 52, p. 86), and farther back, to the right of the forked tree, are even more minimal indications of the couple with a baby from *Rose-Colored Skirt*.

Intimately related to *The Couple* is a drawing of the same subject (CAT. 61, p. 85), which Seurat perhaps executed before the large sketch, although Zuccari and Langley argue that it came afterward. They also analyze the marks around the edges of the image, which conform to the spacing of the grids Seurat used in developing both the sketch and *La Grande Jatte* itself, but the drawing's principle function was to help set out or verify the forms on

CAT. 60

Landscape, Island of La Grande Jatte (study for *La Grande Jatte*), 1884, 1885, painted border 1889/90. Oil on canvas; 65.3 x 81.2 cm (25 ¾ x 32 in.). Private collection. H 131.

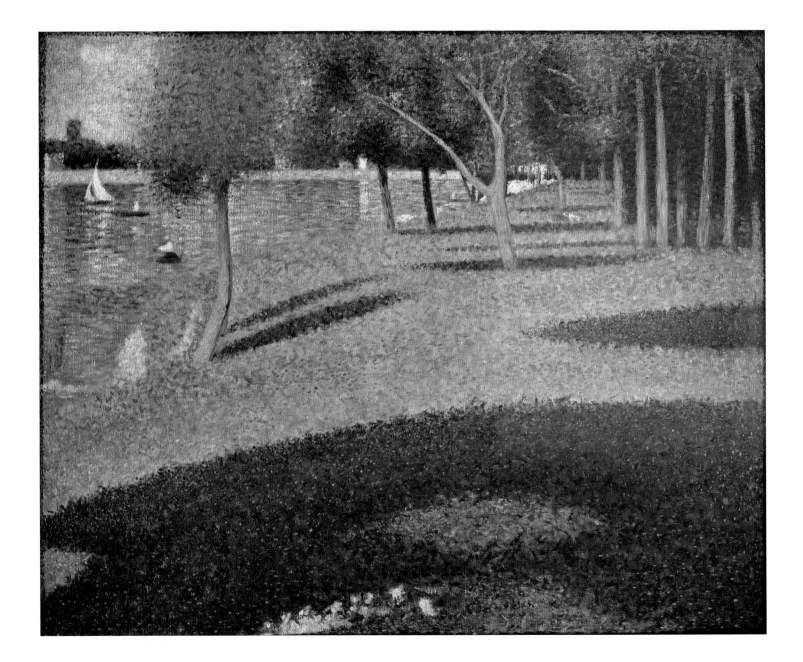

Compositional study (large
sketch) for *La Grande Jatte*,
1884, painted border 1888/89.
Oil on canvas; 70.5 x 104.1 cm
(27 ¾ x 41 in.). The Metropol-
itan Museum of Art, New York,
bequest of Sam A. Lewisohn,
1951. H 142.

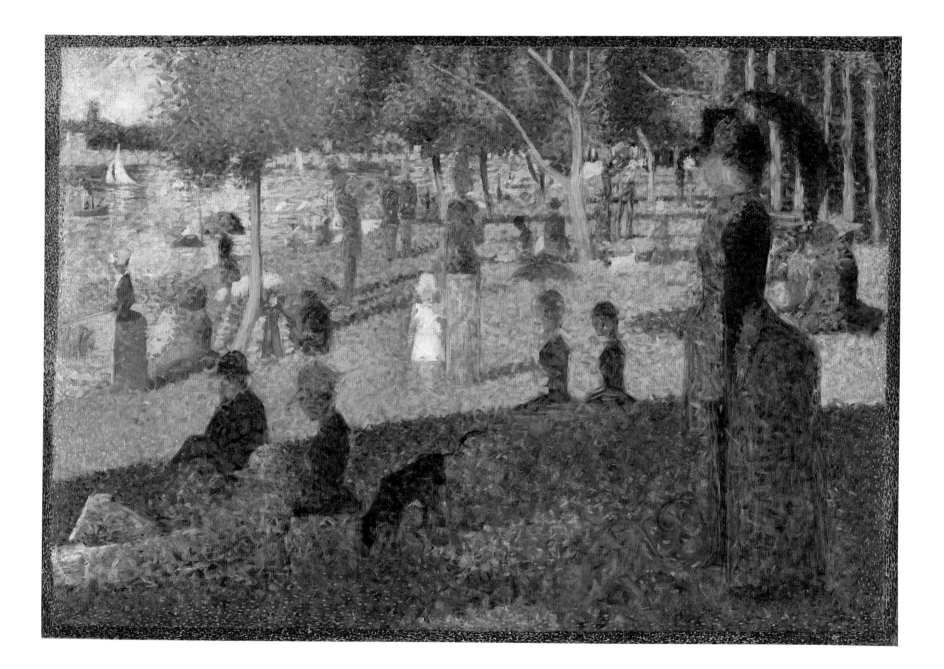

both canvases and to determine their tonal values. The foreground shadow does not dip down on the left, as it does in the related paintings, perhaps because Seurat gave priority to the way the horizontal suits his sheet of paper. Whether working from nature or, more likely, in the studio, the artist was modeling in light. On the left, the bodies of two seated girls seem devoid of heads, but their faint ovals can be discerned, separated slightly from the horizontal shadow behind them. Perhaps this unclear junction of grays inspired Seurat to eliminate the continuous shadow behind those two figures, throwing them into stronger relief. When, at some point in the summer of 1884, he began working on the large compositional sketch, he shifted the central horizontal shadow of *The Couple* to the right. Because it no longer serves as background for the heads of the two seated girls, they are more effectively isolated against the brightly lit grass.

By now Seurat had given all of the figures that will appear in the final picture their definitive locations, except for a few in the distance. However, Zuccari and Langley (see pp. 181–84) have discovered that Seurat modified several of them after the initial laying-in, so he was making alterations on the sketch well after he began the final canvas, a back-and-forth process in which he used the smaller work to test ideas for the larger one.[6] This seems to be another proof of the painter's empirical procedures, which we can also observe when we look over the many panels to trace earlier versions of the figures. What we must imagine is that Seurat had

already blocked in many of them on both the small and the large canvases, and was working on them while also looking at the relevant *croquetons*. In his large study, the principle color contrasts of orange-reds with greens and blues are spread across the canvas and are far more energetic than in any of the preparatory panels.

La Grande Jatte in 1885

What did *La Grande Jatte* look like in March 1885, when Seurat was ready to show it? It is hard to resist speculating on what would have happened if the Indépendants had not aborted their exhibition. Seurat reworked the canvas beginning the following October, and this process was extensive. Simply looking closely at the painting under strong light demonstrates that he widened the skirts of the *promeneuse* on the right and of the fisherwoman on the left (see Zuccari and Langley, FIGS. 9–11). He added curved and scalloped outlines whose sinuous rhythms contrast with the more rigid contours of the figures we see in several panels, in the canvas *The Couple* and its related drawing, and in the Metropolitan sketch. Curiously, the conservators' recent examinations show that Seurat painted the consort's hand holding a cigar, and the forearms of the horn player over the nearly completed landscape and water; this is true also of the expanded skirts of the foreground women. From this we can deduce that, when he began the final picture, the painter assumed he would eventually alter its simplified figures, but that, in the meantime, the landscape would serve as the solid armature of his

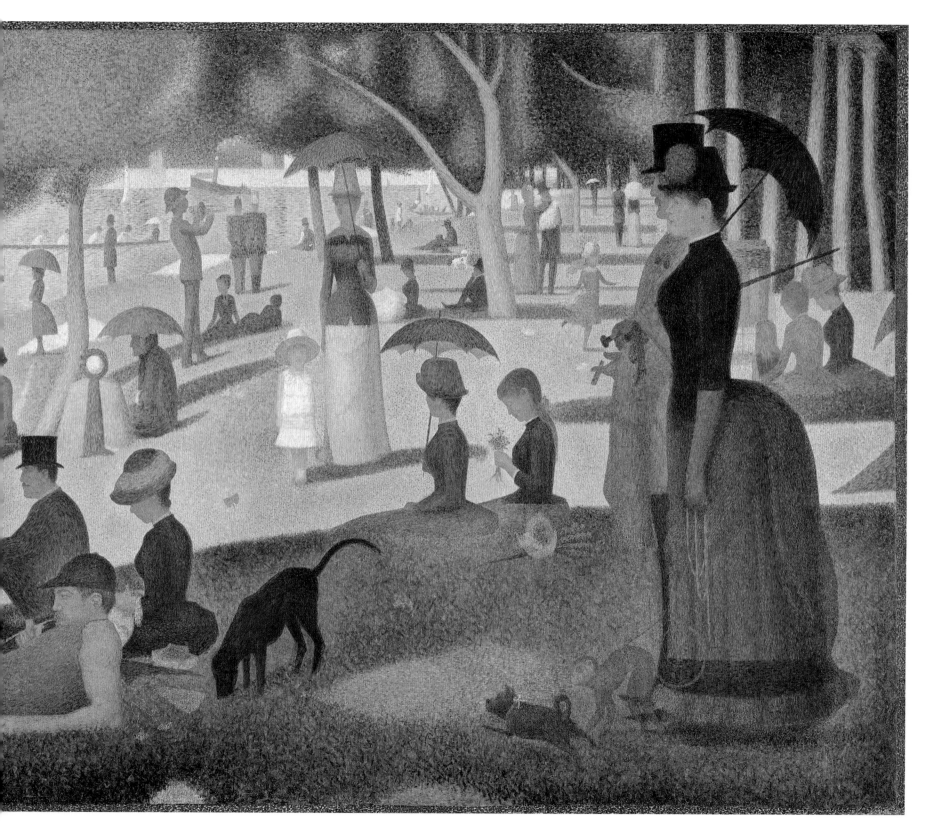

CAT. 62

The Couple (study for *La Grande Jatte*), 1884. Oil on canvas; 81 x 65 cm (31 ⅞ x 25 ⅝ in.). Fitzwilliam Museum, Cambridge, England. H 138.

composition. If we could subtract the additions and changes he made after October 1885, we would discover an image whose figures present an almost Egyptian aspect that rendered them far more startling than their more graceful successors.

If Seurat considered his picture finished in March 1885, he would have had to face the consternation that its radical primitivism would provoke. Although this is possible, it seems far more likely that he did not intend this composition to be understood as final. Listing his canvas as a work in progress would disarm critics while also putting his foot forward as a major innovator. His palette alone would have loomed large in public reactions, for, to our imagined picture of early 1885, we must apply something of the brilliant hues of the large sketch, even if the colors would have been partly subdued by the interweaving of small brushstrokes.

After we have done our best to imagine the canvas in the spring of 1885, we must jump forward to the painting of 1886 and try to understand all that intervened. Compared with the Metropolitan study, nearly completed in the autumn or early winter of 1884,[7] the final canvas shows numerous adjustments. In addition to changes in the animals near the large couple—Seurat moved the monkey nearer to the large woman and added the little leaping dog—he inserted a pair of figures between the soldiers and the horn-blowing man, one seated and the other reclining. These motifs had appeared earlier in *Seated and Standing Women* (CAT. 44, p. 74) and *Seated Man, Reclining Woman* (CAT. 50, p. 86). The artist shifted the tiny white dog with a

reddish head next to the running girl, well back to the left of the forked tree. The seated man in the lower left exchanged his bowler for a top hat. With light under his knee and a cane, he becomes far more elegant. In addition to modifying or changing his protagonists' specific characters, Seurat made alterations to the figures themselves, changing their silhouettes. In this process, he relied on drawings.

The Role of Drawings

Between the large sketch and the final canvas, Seurat produced a number of drawings that determined the shapes of several figures.[8] He executed some of these after March 1885, to soften the contours of his "Egyptian" forms.

Before we look at these, we should remember that a few drawings related to *La Grande Jatte* may have been made about 1883 as independent works, without regard to a large project. These include *Woman Fishing* (CAT. 28, p. 88) and *Fisherman* (FIG. 5), in many ways suburban equivalents of the city people he drew. The former served as the model for her painted sister, but the latter does not appear in the large canvas. Seurat did not use other drawings definitely intended for the painting either. Five sheets showing caged monkeys (CATS. 54–58, p. 87) demonstrate the care with which he researched *La Grande Jatte*'s elements, but none of these reflects the final form of the animal in the painting, for which no preparatory image survives.

Seurat made more than half of the extant drawings for *La Grande Jatte* at about the time of the

preliminary sketch and afterward, with the goal of fixing the exact forms and the tonal values of the foreground figures. As we have seen, he devoted one (CAT. 63, p. 79) to changing the sketch's proportions to those of the final canvas by stretching the island setting sideways. It is twice the size of his figure drawings but possesses the same subtle tonality, created with myriad delicate touches of conté crayon. We cannot know whether he made this drawing on the island or in the studio, but it likely combines work in both places, as do others. We can identify only two done solely in the studio, probably after March 1885: a study of the bustle of the *promeneuse* (CAT. 67, p. 89) and one of the whole figure, *Woman Walking with a Parasol* (CAT. 68, p. 89). For the first, Seurat may have placed the bustle over a dummy, a common academic

practice, because its sharp horizontal fold and flat expanse of skirt lack the three-dimensional quality a live model would have provided. The woman's clothing in the second drawing is both more fully rounded and closer to its appearance in the painting. The wall and baseboard behind the figure suggest a studio origin. Perhaps because a model posed for him, Seurat could not resist expressing her three-dimensionality, in contrast to drawings discussed below, whose forms are much less volumetric. Even with an actual model, however, the artist abstained from including her feet, giving her the floating quality that marks a number of early drawings and, of course, the figures in *La Grande Jatte*.[9]

Woman Walking with a Parasol has the aplomb of several promenading females Seurat depicted in independent drawings of the same

time, such as *Elegant Woman* (CAT. 77, p. 89). By now he had accrued several years' experience in giving form to men and women for his painting. A number of these individual drawings demonstrate the wit, bordering on caricature, that surfaces here and there in *La Grande Jatte*. In two images of a bustled woman holding a muff (CATS. 78–79, p. 90), one senses a gentle mockery, unlike the dignified figures he drew for the painting. In one the woman lacks visible feet, making her seem like an animated toy gliding smoothly along. She bends slightly forward, differentiating herself from her near-twin in the other drawing, who is more proudly erect, one of many instances that indicate how Seurat used slight differences to alter his characters' images. As an afterthought, the artist included in one drawing (CAT. 79) a dog trotting along in the upper right on

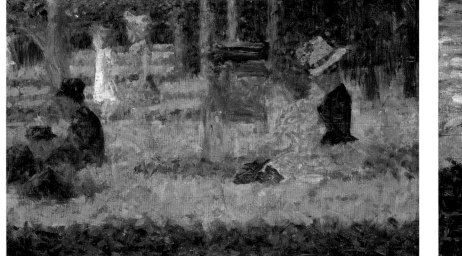

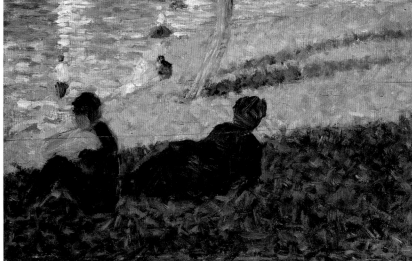

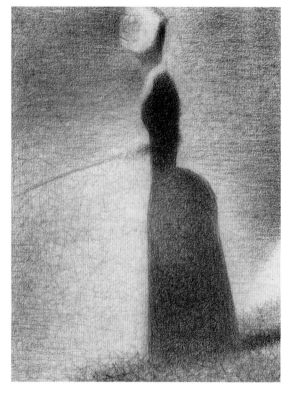

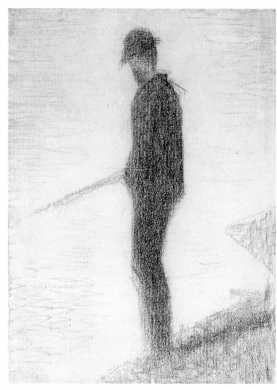

the sidewalk opposite, a very pale form made by erasing a zone of gray and adding a few strokes to articulate the animal. Although faint, the dog introduces an echo of Daumier's caricatures of street people. A similar sly humor activates *Man in a Top Hat* (CAT. 66, p. 90) of about 1884. Seurat drew the man's profile—one of the very few outlined faces in his oeuvre—with a cartoonist's economy. His wispy features lack substance, as though his reality is to be found only in his expansive body. Like the top hats

in *La Grande Jatte*, the overly large one he wears helps create a type.

Seurat could consult his rogue's gallery of human characters while developing his large composition, but he needed drawings of specific portions of it. On the right of *The Couple* can be found the gray shapes that will evolve into the final painting's group of seated women and a child beside a baby carriage. These figures derive from one of the oil panels (CAT. 52, p. 86), but needed another drawing

to fix their shapes and tones. In *Three Young Women* (CAT. 75, p. 91), the artist isolated them against their background, at the same time flattening them into a lateral plane. Different outfits could explain the fact that one woman's torso is darker than the other, but atmospheric distance accounts for the fainter gray of the shapes immediately to the right of the large *promeneuse*. Without the aid of the little painting where they originated, we might not have deduced that these pale forms represent a seated child with her mother's arm extended around her back, and above and beyond her, a three-wheeled baby carriage. The vehicle is so foreshortened that even in the large painting it has provoked puzzlement (some have called it a waffle stand). The identification of another mysterious object in the large canvas is resolved in this drawing. The downward-pointing orange arc that cuts into the right edge of the picture is what remains of the parasol in *Three Young Women*.

Three Young Women is one of several drawings that we know intervened very late in the process because they are in fact excerpts from what must have been a well-advanced composition. The miracle is that each of these, although subordinated to its function as a working drawing, is a satisfying composition in its own right. In *Nurse* (CAT. 74, p. 92) the dark square in the lower left is the top hat of *La Grande Jatte*'s seated dandy, here a mere fragment that anchors a masterful composition by offering a piece of pure geometry to compare with the hat and ribbon of the seated nurse.

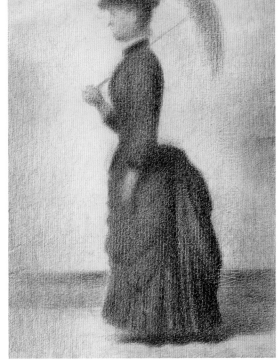
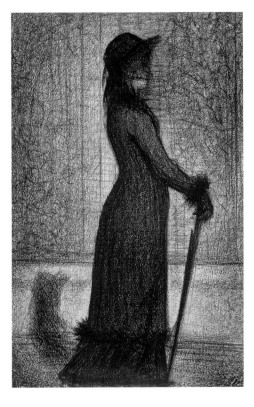

When we look back to drawings for *Bathing Place, Asnières*, we see how far Seurat evolved in just two years. For example, *Seated Boy with Straw Hat* (CAT. 24, p. 49) is a studio drawing with strong value contrasts that define the boy's well-rounded mass. By contrast, the figures in *Three Young Women* offer the barest hint of substance. In *Nurse* the old woman is more shadow than form, modeled only by a tonal shift from light to dark; her care-taker's body is flat, except for her shoulders' rounded edges. Despite the apparently imposed geometry of these works, Seurat's sense of actual illumination guided his hand, most clearly in *Child in White* (CAT. 73, p. 93). The grays and the untouched paper seem to emerge from a tremulous light, but one so intense that it has overwhelmed all detail. It is easy to imagine Seurat repeatedly squinting as he drew, whether or not he used models; the encounter that matters here is with his paper and not with "reality." William Homer had it right when he wrote of these drawings: "One feels that the human figures almost swim in a sea of luminous shadow and that light, rather than being thought of as an external illumination, actually emanates from the paper."[10]

Knowing that in the final painting the child's dress would be white and the skirt of the mother light pink, Seurat minimized contrasts of light and dark in the drawing. For the sheets showing the pair of seated girls, however, he emphasized shape

CAT. 78
Woman with a Muff, 1884/86.
Conté crayon on paper; 30 x
23 cm (11 ⅞ x 9 in.). The
John C. Whitehead Collection,
courtesy of Achim Moeller
Fine Art, New York. H 611.

CAT. 79
Woman with a Muff, 1884/86.
Conté crayon on paper, laid
down on board; 31.3 x 23.8 cm
(12 ⅜ x 9 ⅜ in.). The Art
Institute of Chicago, gift of
Robert Allerton. H 612.

CAT. 66
Man in a Top Hat, c. 1884.
Conté crayon on paper; 31 x
23 cm (12 ⅛ x 9 in.). The
John C. Whitehead Collection,
courtesy of Achim Moeller
Fine Art, New York. H 571.

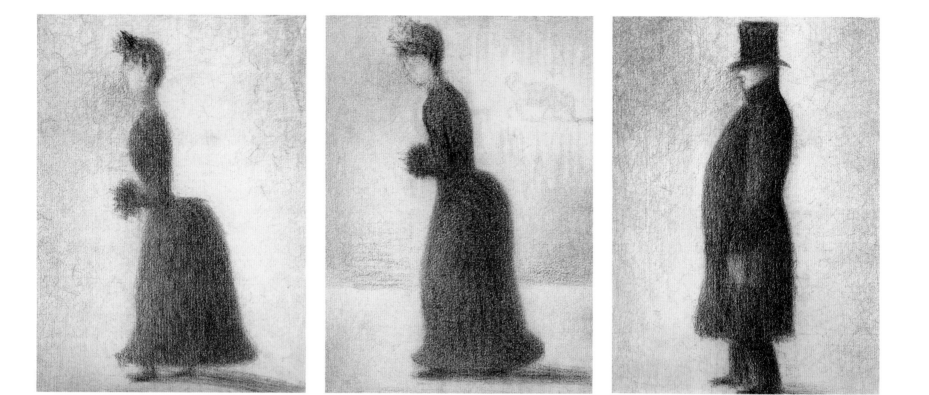

more than light; despite the subtle gradations of value found in each figure, they reflect the artist's awareness of the painting's darker clothing set against a light ground. *Seated Woman with a Parasol* (CAT. 71, p. 94) displays the striking silhouette of the figure's painted version, although a delicate gray locates her far arm and the hand that holds the parasol; her face, neck, and other hand have a similar spectral presence. Her partner, the subject of *Young Woman* (CAT. 72, p. 94), is the more wraithlike of the two. The variation in light

of the painted figure has no equivalent here, and her dark silhouette, modulated only by the light that nibbles at the left side of her form, rises from the paper like a premonition of the sculpture of Brancusi.

Perhaps the closest of these drawings to the final work are two of the woman seated next to the top-hatted dandy. *Seated Woman* (CAT. 69, p. 94) records the exact outlines and modeling of the painted figure, now much revised over her equivalent in the large study. Even so, Seurat made another drawing (CAT. 70, p. 93) to specify the

tonal values of the woman's head and hat. This sheet also denotes with great delicacy the shadow that the hat casts upon the face. If ever we needed proof of Seurat's distance from Impressionism, we can find it in drawings such as these. They continue the time-honored practice of considering modeling in light and dark (chiaroscuro) to be the substructure of painting, instead of the pure color responses that the Impressionists embraced. Seurat made his hues conform to the tonalities of drawings that capture the effects of light, both "real" and the

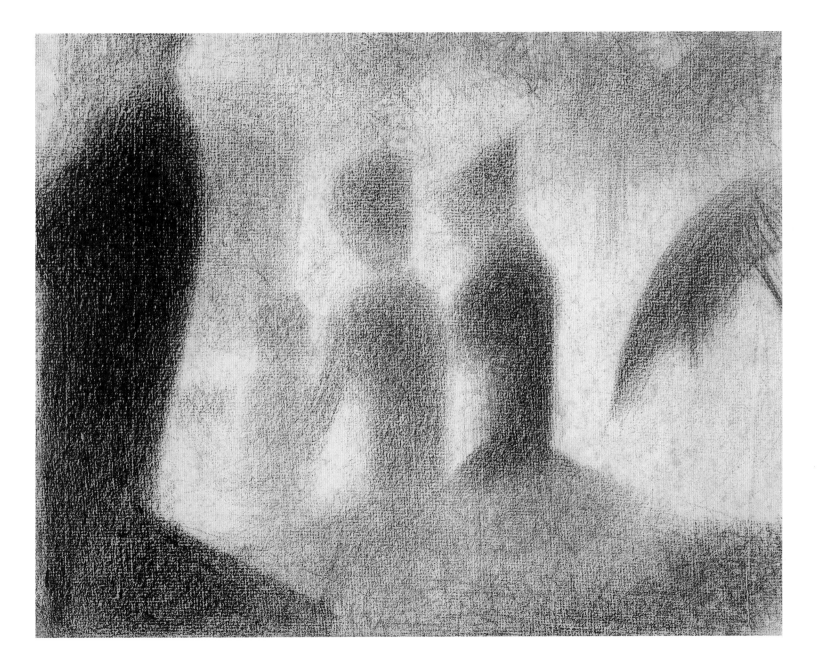

effects he created in his studio while manipulating crayon on paper.

We do not know whether Seurat used tracings to transfer his final drawings to canvas. Perhaps he simply held them close to the canvas and made the transfers by eyesight, but to do this, he had to have already determined his forms' final positions, if not in their final outlines. How then did he move the composition's elements from the large sketch to the final canvas? That he transferred them cannot be doubted, because recent work by the Art Institute's conservators reveals a near-exact duplication, with only minor differences. They also uncovered new evidence that Seurat used grids to transfer forms to the final canvas (see Zuccari and Langley, pp. 179–80). Seurat's was an elementary system that divided height by four and width by six, not a more complicated one like the golden section, which he seems never to have used.[11] Most trees, shadows, and figures are independent of the grid, although vertical grid lines pass through several figures (but not exactly at their centers or on their edges), and the base of the horizontal shadow behind the *promeneuse* falls on the central bisection of the canvas.[12] The grid was a transfer tool, but it did not freeze the forms into a predetermined geometric pattern.

The sheer size of *La Grande Jatte* necessitated a grid if Seurat was to preserve the proportions and outlines of his studies. Its use is yet another indication of how unlike the Impressionists he was. They did not work on such large scale, and because they were devoted to spontaneity, they eliminated any signs of prior measurement or planning.[13] Although

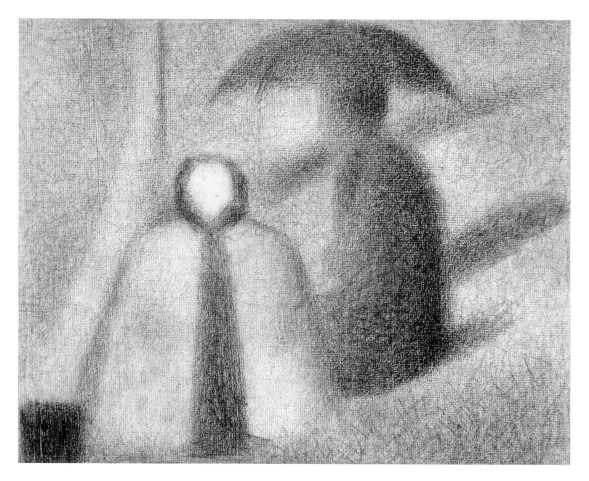

we are now aware of Seurat's constant changes of mind as the huge painting evolved, the grid tells us just how deliberately he proceeded. The same search for rational control is found in his use of drawings in black and white to underlie his painted forms. Considered together, his studied technique, grid, and drawings separate him starkly from Impressionism and show us why *La Grande Jatte* caused an uproar when it appeared in the last Impressionist exhibition, in May 1886. Nonetheless, as we shall see in Chapter 3, the completed painting contains a number of connections with the art of Monet, Morisot, Pissarro, and Renoir.

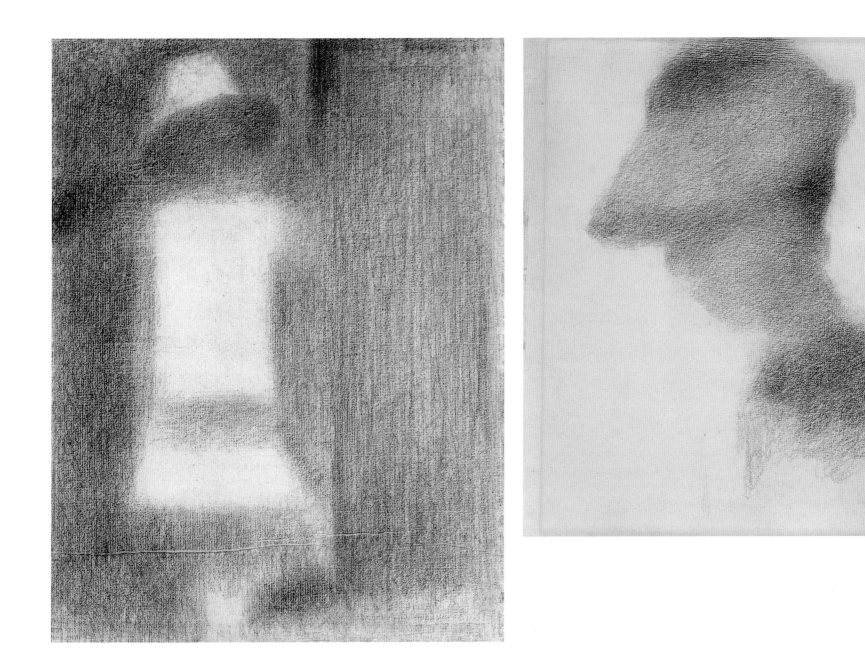

Seated Woman (study for *La Grande Jatte*), 1884/85. Conté crayon on paper; 30.2 x 16.5 cm (11 ⅞ x 6 ½ in.). The Philadelphia Museum of Art, The Louis E. Stern Collection, 1963. H 632.

Young Woman (study for *La Grande Jatte*), 1884/85. Conté crayon on paper; 31.3 x 16.2 cm (12 ⅜ x 6 ⅜ in.). Kröller-Müller Museum, Otterlo, the Netherlands. H 627.

Seated Woman with a Parasol (study for *La Grande Jatte*), 1884/85. Conté crayon on paper; 47.7 x 31.5 cm (18 ⅞ x 12 ⅜ in.). The Art Institute of Chicago, bequest of Abby Aldrich Rockefeller. H 629.

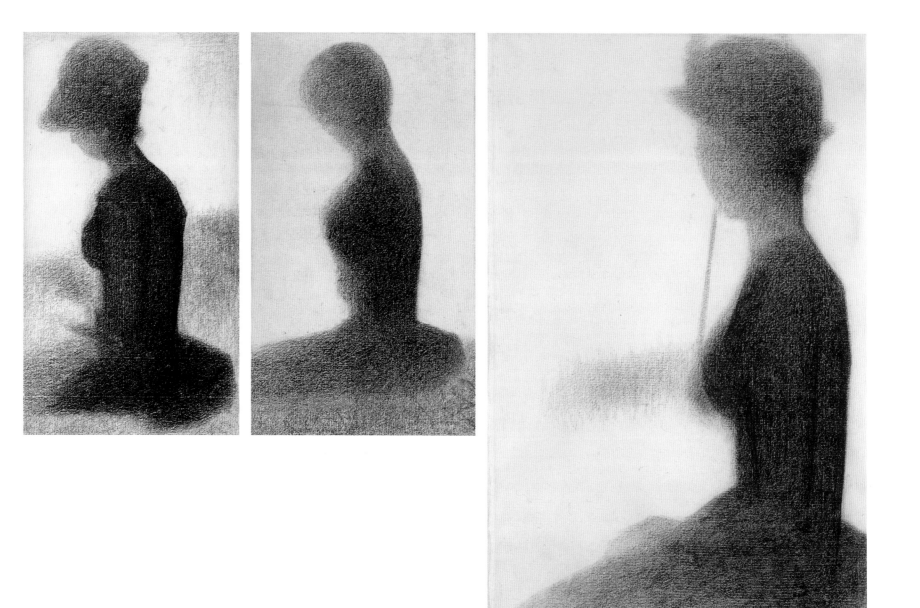

Notes

1 An effect pointed out by Frank Zuccari and Allison Langley (see p. 190). My colleagues' careful examination shows that Seurat's empirical practice continued right up to the final stage of work on the large canvas.

2 Laid paper reveals the grid of the screen on which the paper pulp was spread; wove paper involves no grid and hence lacks any such marks. That Seurat preferred laid paper is one of many indications of his wish to work with patterns of horizontals and verticals, whether "natural" as in laid paper and canvas, or constructed, as in his use of panels marked by a grooving plane (see p. 56).

3 Recent investigations by Zuccari and Langley (see p. 183) show that that animal appeared in a canvas study (CAT. 62, p. 84), as well as in the first stage of both the final sketch and the large canvas, all of which the artist subsequently painted over.

4 The large canvas contains two soldiers in different uniforms. According to the researches of Joseph Berton (in communication with author), neither is a cadet from Saint-Cyr. The man on the left (and here in this panel) wears the uniform of the French Infantry of the Line, "with a double-breasted dark blue frock with red epaulettes, a black belt, and red trousers. He wears the infantry shako with a red pompom." The other soldier, a cuirassier from a mounted unit, "wears a single-breasted, dark blue tunic with red epaulettes and a black belt. His helmet is silver and gilt metal with a red pompom and red side-plume. He wears red trousers and black boots. He would not be wearing his cuirass for a walk in the park." I am very grateful to Mr. Berton for these identifications. Seurat had a month's military duty at Laon in late summer 1885, with the Forty-Fifth Regiment. Renewed contact with the military may have inspired him to add a second soldier to his composition. Once he conceived the idea of two figures, he differentiated them, as was his wont.

5 Inge Fiedler (1984, 1989) examined the painted landscape when she was studying the pigments of *La Grande Jatte* (see Fiedler, p. 212.). Here, Seurat did not use the unstable zinc yellow, which badly altered the look of *La Grande Jatte*. Because he began employing this pigment in October 1885, he must have reworked the landscape canvas before mid-autumn of that year.

6 Zuccari and Langley (see pp. 187–88) show that the pug dog, absent in the large sketch, was present in the initial stages of the final canvas; at that point, however, there was no monkey. The monkey, included in the sketch, reappears in a slightly different location in a later stage of the large painting.

7 As we shall see in Chapter 4, sometime after 1887 Seurat added the painted border, together with a sprinkling of small strokes on the composition to react to it.

8 For an exacting study of how drawings relate to the large sketch and the completed painting, see Zuccari and Langley in this book.

9 The zigzag in the baseboard shadow to the right of the figure's skirt is the sideways M of the watermark MICHALLET, which, as a close look at the original discloses, rises to form a curious vertical prop.

10 Homer 1964, p. 128.

11 For years many writers, myself among them, assumed that Seurat used the golden section. Credit for debunking this notion goes to Herz-Fischler 1983 and Neveux 1990; see Herbert et al. 1991, pp. 391–93. If one projects images of Seurat's paintings to full scale and then superimposes the measurements of the golden section over them, it becomes clear that his compositions do not conform to this scheme.

12 Here, I disagree with Paul Smith (1997, pp. 19–21), who believed that the grid lines actually determined the positions of many figures.

13 The exception was Renoir, during his "Sour Period." See Ch. 1, note 11.

3 *La Grande Jatte* Completed

Aside from the dulling of its colors, about which more will be said, and the painted border and brushstrokes added later around the edges, *La Grande Jatte* appears today as it did when Seurat first exhibited it in May 1886. However, we are not able to look at it with the eyes of 1886. Even the most objective description (forty-eight people, three dogs, eight boats, and so forth) will inevitably turn into a contemporary account because our comparisons, emphases, and references are no longer those of 1886. Like all historic paintings, *La Grande Jatte* has been reinterpreted by succeeding generations. Keeping this in mind, I want to begin with a relatively neutral description, and postpone to the last chapters an account of the diverse meanings the painting has accrued.

Seurat's setting was an elongated island in the Seine (FIG. 1) just beyond Paris's city limits. The large, central portion of the island, crossed by a major suburban road (it extended Neuilly's boulevard Bineau into the suburb of Courbevoie), boasted restaurants, a dance pavilion, other buildings, and several docks. The two ends of this thin strip of land were given over to parks. Seurat chose the northwestern shore facing Courbevoie; it was less active than its southeastern counterpart, which fronts Neuilly. Sisley painted the Neuilly side in 1873 (FIG. 2), showing a residence along the road that ran around the periphery of the island. (Monet favored the Courbevoie aspect, as we shall see.) Two decades later, Luigi Loir pictured the same side of the island (FIG. 3), but this prolific painter

of Parisian streets chose the portion that most closely reflected city life. Featuring an open-air restaurant and busy riverside, Loir's composition has a gossipy activity and an attention to detail that the Impressionists and Seurat avoided. Nonetheless, *La Grande Jatte* presents Parisians crowding the island and parading about in "nature."

By the early 1880s, La Grande Jatte no longer had the cachet of the Bois de Boulogne, on Paris's western edge, or the right bank's Parc Monceau, because of the nearby factories (visible in the backgrounds of *Bathing Place, Asnières* and *Bridge; View of the Seine* [CAT. 12, p. 43]), and the rapidly growing communities of Clichy, Asnières, and Courbevoie. Contemporaneous guidebooks describe activities characteristic of this and other riparian shores near Paris: boating, fishing, picnicking, dining, and dancing. Well before the artist's day, promenading in public gardens was a staple subject of novels, paintings, the illustrated press, and of poems and prose vignettes in literary journals. While developing his picture, as we have seen, Seurat treated the park as a stage across which he could position a variety of persons strolling or at rest. From these self-administered auditions, he eventually selected the performers of his Sunday ritual, combining the functions of both playwright and director. *La Grande Jatte* should be seen as an artifice devoted to a social institution in a contrived setting: parks are not "nature," but rather artificial stages for human action based on earlier gardens and paintings of them.

In a letter of 1934 to Daniel Catton Rich, then a curator at the Art Institute of Chicago, Signac penned a diagram of Seurat's vantage points in the park (FIG. 4): A and its arrow place Seurat's view northeast into the park; B is the position Seurat took looking across the river for *The Seine at Courbevoie* (CH. 1, FIG. 14), which Signac owned; and C is the point from which the artist looked downstream to draw and paint *The Bridge at Courbevoie* in 1886 (CAT. 89, p. 134; CH. 5, FIG. 3). When in 1886/87 he executed another canvas, *Gray Weather on La Grande Jatte* (CH. 5, FIG. 1), Seurat was standing about where Signac marked B, also looking back in the direction of the Courbevoie bridge.

The Seine, prominent in French painting for several centuries, was closely identified with Paris, not just because it flows through the city but also because its suburban shores were an extension of urban culture. From Seurat's park, Monet painted *Springtime on La Grande Jatte* (CAT. 93, p. 99), as well as several other canvases in 1878. Like Monet, Seurat did not depict any of the cafés, wine shops, or shipbuilder's yards located elsewhere on the island. For both artists, the verdant banks of the river, with water sparkling in the sunlight, formed a setting in which nature, no matter how civilized by an expanding population, was available for art. But of course there are vast differences in their paintings. It is as though Seurat took Monet's scenes as starting points, and then utterly reconstructed them.[1] Gone are the foreground trees

FIG. 1

Map of La Grande Jatte, the
Seine, and suburbs of Paris.

FIG. 2

Alfred Sisley (British,
1839–1899). *Island of La
Grande Jatte*, 1873. Oil
on canvas; 50.5 x 65 cm
(19 ⅞ x 25 ⅝ in.). Musée
d'Orsay, Paris.

FIG. 3 (BOTTOM)

Luigi Loir (French, 1845–
1916). *A Boating Party on
La Grande Jatte*, c. 1890.
Gouache on paper; 30.5 x 47
cm (12 1/16 x 18 ½ in.).
Location unknown.

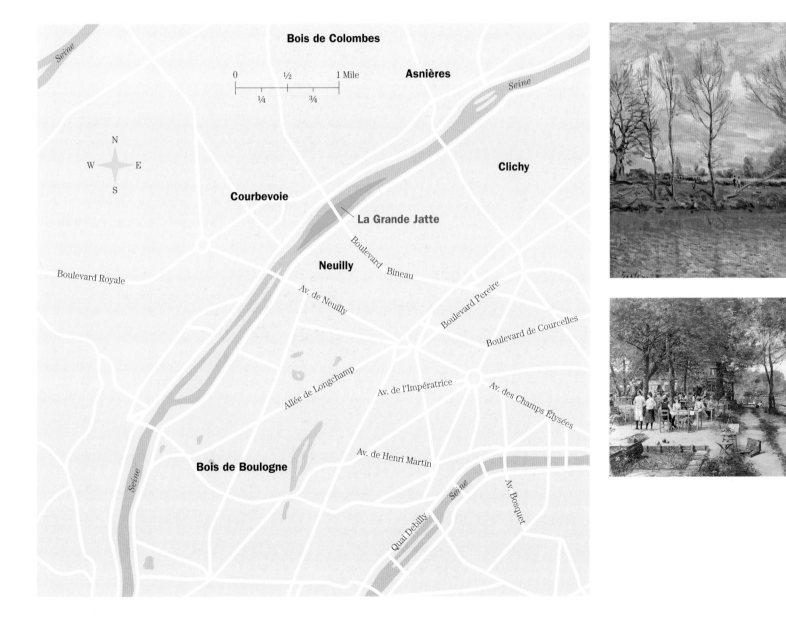

and foliage with which Monet created flickering and restless screens whose tiny apertures foil any attempt to find solid forms and planes (see CAT. 94, p. 66). Seurat converted the Impressionist's site to an open stage, an architectural nature whose construction defers to the mannequin-like Parisians he placed there. He framed the light-struck center of his space with a dark shadow along the bottom and a frieze of foliage at the top. These elements flatten the composition through the repetition of dark greens and their broad expanses (we cannot easily attach the poufs of foliage above to individual trees). Other devices that emphasize surface pattern include the pair of tree trunks that flank the central mother's head, the implied cross created by the fisherwoman and sailboat above her with the little steamboat and the rowing shell, the frequent contact of one form with another supposedly distant from it (the lower leg of the horn player touches the old woman's parasol, just as the central mother's skirt nudges the parasol of the seated woman), and the many right angles formed by figures and shadows. Despite these devices, we have a clear sense of space retreating into the distance at the right.

Contemporary reviewers emphasized the luminosity of the painting, sometimes grudgingly, more rarely with enthusiasm: "One understands the painter's intention: a desired and deliberate bedazzlement, a blinding, and little by little it becomes familiar; one guesses, then one sees and loves the large yellow patch eaten into by the sun, the golden powdering on the tufts of the trees."[2]

Verhaeren recalled his amazement upon seeing the work in 1886:

> Monet, although astonishingly full of clarity, hardly gave me this impression of immateriality and purity of solar life. He made me think of the nacreous tones, the beautiful and delicate pigments that formed the transparencies and mobility of waters and skies, in effect, of his palette. *La Grande Jatte*, by contrast, begged me to forget all color and only spoke to me of light. My eyes were conquered.[3]

The striking luminosity of the composition's broad, central expanse, still drenched with light despite the deterioration of the pigments, contains diagonal ground lines that lead our eye into depth. From the threesome in the lower left, we slant back to the right to the pair of seated women and then to the group to the right of the large couple. From the same trio, we are directed again to the mother and child, the forked tree, and other figures and trees beyond. Or, from the promenading couple, we angle off to the left past the seated pair to the mother and child, the horn player, and beyond him to the man gazing at the Seine. It is a wonderful game, inspired by the toylike figures, to trace other diagonals that move from foreground and middle-ground figures into the furthest distance.

Dominating the canvas are the couple on the right. The female, alone in most of the painted studies but now with a consort, has a certain stately elegance, although her fashionable bustle and pet monkey border on parody. The little pug dog seems to be hers also, because she holds both animals' leashes. In the left corner, three figures form a curious group. A husky man reclines, his cap and bare shoulders suggesting that he might be one of the many boatmen who frequented the island, some of whom are shown out on the river.[4] He offers a contrast—the picture is full of various

CAT. 93

Claude Monet. *Springtime on
La Grande Jatte*, 1878. Oil on
canvas; 50 x 61 cm (19 ⅝ x
24 ⅛ in.). Nasjonalgalleriet,
Oslo. W 459.

social types—with the dandy seated nearby, as well as with the elegant male standing on the far right. The feminine curves of the third party in this group—the seated woman—contrast with the blocky outlines of the dandy. A fan on the ground further underscores her femininity, and two paperback books next to her show her to be a reader. To the right of this group, a dog sniffs the ground. Unlike the beribboned little pug yapping at him, this is a large street animal who could have accompanied one of the people we see or could have strayed into the park.[5] In this citified assemblage, there is no room for the brown animal in the panel study *Standing Man* (CAT. 43, p. 74).

Further to the left stands a woman fishing, casting her shadow over a seated companion. To their right, by the bent tree, sits a most curious pair, a nurse (not a wet nurse, as has been suggested) and her elderly patient. Unlike the young women in the picture's center who hold their parasols easily aloft, the old woman rests hers on her lap so that it partly covers her head; her slumping shoulders alone indicate her age. We know the figure next to her is a nurse, for she wears the traditional uniform of hat and attached red ribbon, together with a cape. This is all we see of her, for she is the least individuated of the picture's main cast of characters, and the only one whom we can surely identify with the working class.

Striding forward in the center are a little girl and, we must assume, her mother, who have been brought together here from separate studies. The child is the only figure in the painting who looks directly at the viewer, even if her gaze is no more lively than that of a doll. Her mother seems equally toylike, although her sideways glance somewhat animates her. Between this woman and the promenading couple are two young females seated in poses that are a crisscross of oppositions. One has raised her parasol and sports a hat; the other's parasol and hat are on the ground. One looks up, the other down. One is dressed in a red garment over a blue skirt; the other wears the reverse. Because otherwise they are virtually twins, the pair is a good illustration of Seurat's later summary of

and a female coxwain (!), an official ferry flying the French flag, a fishing dinghy, and two steamboats; the last pair, which carry cargo, introduce work into this compendium of middle-class leisure. Like the island population, the boats comprise a spectrum of activity characteristic of the Seine at that juncture. The small, one-person steamboat and the racing shell look like playthings, as do some of the people on land. Just beyond the seated old woman stands the tall, comic figure of a man—obviously, an oaf—who rudely or unthinkingly blasts his French horn in the ears of two soldiers.[6] Elsewhere are standing and seated figures, a tiny brown and white dog, a couple with a swaddled baby, an orange butterfly, and a child running to the right, her blond hair flying. Accompanying them are small, light patches in the grass (two to the left of the girl in white, two others between the promenading couple and the forked tree), which have never been explained. They cannot be bursts of sunlight, since the area is already sun-drenched, and picnic debris seems unlikely; yet they function as welcome grace notes.[7]

Despite the generalized nature of Seurat's images, details reveal how carefully he inventoried their poses and positions. The tall man on the right is largely hidden by his companion, but we know his type from the nearly pictographic forms that the artist included. His fingers, cigar, and the ferrule of his cane project beyond his silhouette to give amusing and decidedly contemporary touches. Above, a boutonniere, hat, and monocle complete his characterization.[8] Far back, leaning against the tree

his aesthetic (Appendix A), which begins: "Art is Harmony. Harmony is the analogy of opposites."

Far to the right, a woman sits with her arm around the back of a seated child. They are accompanied by a female bending solicitously forward, while beyond them is a three-wheeled baby carriage, radically foreshortened and partly cut off by the female promenader's back (it appears fully in CAT. 52, p. 86). To the right of this group, we find the orange curve slanting in from the edge of the

canvas, which, as we have seen from the related drawing (CAT. 75, p. 91), is part of a parasol. Below, another orangish shape cuts into the composition, but there is no extant study to help us identify it.

Beyond these foreground groups, a sampler of diverse sorts spreads across the canvas. Several figures are echeloned along the bank, including a second, tiny fisherwoman in the far distance. All but one look out at the river, where there are eight craft: three sailboats, a racing shell with four oarsmen

FIG. 7
Alfred Grévin (French,
1827–1892). *"I bet that
doesn't cost him more than
twenty-five cents a meter."*
Cover, *Journal amusant*,
October 23, 1886.

FIG. 8
Bustle (study for *La Grande
Jatte*), 1884/86. Pen and ink;
16.5 x 10 cm (6 ½ x 3 ¹⁵⁄₁₆ in.).
Location unknown. H 615.

trunk that touches the central mother's shoulder, sits a man viewed mostly from behind, with a portion of his shirttail hanging out. Well to his left, overlapping the rowing shell, is a fisherman: his rod intersects with the rower's oars, so we must look patiently to discover it. Even more intriguing, a standing woman and reclining man can be discerned only upon very close examination in the deep shadows behind the colonnade of trees at the far right (FIG. 5). The woman, shown in profile, appears between the last tree to the right and the painted border. Immediately to her left, rising and falling strokes compose the inverted V of a male's bent legs; the tree trunk hides his body.

When we retreat from such close viewing and consider the more easily decipherable women and men, shown almost always in strict profile or facing full front, we register them as familiar archetypes. Some recall the vogue in the middle third of the century for prints and caricatures of street characters found most famously in Daumier's lithographs. Seurat's drawings of urban types from 1881 onward reveal his familiarity with this stream of images, but he had held this repertory back from *Bathing Place*. There, as we have seen, his figures represent a compromise with fine-art traditions. In contrast to that sober composition, *La Grande Jatte* is replete with humorous touches. The tiny man off in the distance, just to the right of the central mother's head (FIG. 6), bears the silhouette of *Man in a Top Hat* (CAT. 66, p. 90). He is the only shoreline figure who turns his back to the Seine. The strolling couple also derives from illustrations

of street promenaders, ranging from matter-of-fact images to broad send-ups such as Alfred Grévin's cartoon of October 1886 (FIG. 7). Seurat's awareness of such imagery can be seen in his parody of a bustle-clad woman, which he could have drawn anytime between 1884 and 1886 (FIG. 8).

With *La Grande Jatte*, Seurat challenged the Impressionists' modernity on their own turf, because his park setting stems from paintings of urban and suburban leisure by Monet, Morisot, and Renoir, and, to a lesser extent, those of Caillebotte and Manet. Furthermore, Manet and Degas had already

subverted academic conventions by incorporating into their work lessons from Daumier, Gavarni, and other graphic artists who embraced the new images and rapid notations suitable to contemporary life. Seurat's masterwork is far from the rural figures and landscapes that dominate his earliest paintings. In just three or four years, he had moved from mid-century painting in both palette and subject through Impressionism to his own new synthesis. He was determined to make himself a painter of modern life, but also to set himself apart from the older painters, even (or perhaps especially) in the

bosom of their own exhibition. Seurat had the same ambition for *Bathing Place*, exhibited in 1884, two years before *La Grande Jatte*, but its group of lower-class boys and men against a backdrop of factories give it a social content absent in the works of the Impressionists (except for Pissarro, whose images of rural life were equally distant from his colleagues' depictions of bourgeois leisure).

La Grande Tradition, the Primitive, and the Modern

Contemporary in subject and technique, *La Grande Jatte* nonetheless is saturated in what Renoir and others called *la grande tradition*. Like so many Impressionist images, Seurat's subject takes us back to the theme of the Garden of Love and the *fête champêtre*. With their light-struck tones and sylvan settings, these eighteenth-century paintings by Watteau (see FIG. 9), Pater, and others appealed to the Impressionists, particularly to Renoir. The Goncourt brothers supported this taste for the Rococo, despite the devotion to contemporary life they displayed in their writing. The *fête champêtre* was prolonged in many early nineteenth-century paintings and prints that depict middle-class city dwellers strolling through urban pleasure gardens. And it was not just artists but the bourgeoisie who emulated the aristocratic pleasures of outdoor picnicking, often on property that had once belonged to royalty, church, or nobility but that subsequently was taken over by governments eager to cater to this growing segment of the population. As Leslie Katz so aptly observed about *La Grande Jatte*,

"Fulfillment of the senses in social forms is at the core of French civilization. In Seurat's masterpiece the courtiers have become the bourgeoisie; unlike Watteau's people the Parisian middle class doesn't have to embark for Cytheria—they have arrived, and are installed."[9]

The factories and working-class boys in *Bathing Place* were part of Seurat's apprenticeship to naturalism. Too radical a separation of naturalism and Impressionism, however, is unwise, because the popular content of *La Grande Jatte* relates to both. Edmond Duranty, Degas's friend and a leading naturalist writer, virtually predicted Seurat's painting in his 1872 novel *Le Peintre Louis Martin*. Martin is a young Impressionist who executes "a rather large painting where people milled about among trees and lawns full of air, light, and verdure, where the characters, ranging from choice elegance to poverty, were closely studied. It was definitely a kind of mirror of Paris."[10] The Goncourts and Zola wrote numerous scenes of picnics and promenades along Parisian and suburban riverbanks, and Manet's *Luncheon on the Grass* (FIG. 10), shown in the 1863 Salon des Refusés (Duranty's Martin sees and admires it there), was one of the key pictures of its era. The threesome in the lower left corner of *La Grande Jatte* may even be Seurat's half-conscious nod to Manet's famous painting, which was exhibited again in his 1884 posthumous retrospective in Paris.

La Grande Jatte's modernity is obvious, but its composition relates as well to the French classical tradition. Its size approaches that of a history painting; like an academician preparing for the

FIG. 12
Detail of *La Grande Jatte*;
little girl at upper right.

champêtre. This kind of ordering was common among artists who used traditional devices. For example, in *Seaside, Honfleur* (FIG. 11) Louis-Alexandre Dubourg stationed vacationers in similar patterns, but gave them three-dimensionality. In *La Grande Jatte*, only three or four minor figures face the far background; the strictly frontal or profile positions of all the others serve to flatten and immobilize them. Comparison with the figures in *Bathing Place* underscores just how two-dimensional they are, as well as the degree to which Seurat had evolved beyond his academic origins.

Everywhere in *La Grande Jatte*, we find small geometries that echo the measurable controls Seurat placed over the entire composition, assuring the harmonies that Blanc situated at the center of the classical tradition (even if the theoretician would never have countenanced the artist's style). For example, there is the striking juxtaposition at the left of the dandy's top hat with the slanted, tubelike tree trunk and the rocklike form of the nurse. The twinning of the girls seated to the right of center is repeated in other pairs, including the soldiers and the male and female strolling away in the distance. The latter couple echoes the columnar structure of the trees; indeed, Seurat continued the woman's form directly into the tree behind her parasol, a deliberate merging of subject and pictorial structure that characterizes as well the way other figures are fixed to their shadows.

The abstract and cerebral aspects of *La Grande Jatte*, considered in and of themselves, anticipate twentieth-century formalism. But Seurat's patterns

official Salon, Seurat focused his energies on a large work that would be a *summa* of his art. The spontaneity of Impressionism is absent, both in the artist's painstaking process of making preparatory studies and in the canvas's forms and technique. We look out from the shadow of a tree overhead to a sunny expanse, a device found in sixteenth- and seventeenth-century landscapes, as well as in the

Barbizon views of Rousseau. Seurat conceived his scene in large and simple shapes; its shadows provide clear compositional subdivisions, in contrast to the suffused atmospheric meadows and riverbanks of the Impressionists. He clustered his figures in twos and threes, groups that repeat one another as they recede into space along slanting groundlines, much like those in the eighteenth-century *fête*

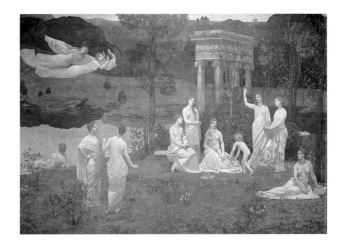

FIG. 13
Pierre Puvis de Chavannes.
Detail of *The Sacred Grove*,
1884. Oil on canvas, 460 x
1040 cm (181 x 409 ½ in.).
Musée des Beaux-Arts, Lyon.
A reduced version of this
mural was shown at the Salon
of 1884.

evolved in reaction to what he saw as he worked, rather than as a result of following a totally preconceived scheme. By going back and forth to the island, he was able to match studio work with what he wished to transmit from nature. Clearly, the artist took such pleasure in the painting's forms and colors that he could not have arrived at them through a recipe. Two examples will suffice. Each of the three sunspots within the shaded foreground presents a different blend of color. The palette of the one along the bottom left repeats that of the large, sunny areas to indicate a hole in the leafage overhead. The patch to its right along the painting's edge contains a mixture of pinks and blues, implying a less open break in the treetops. The largest of the three spots also results from light coming through foliage; in fact its gray-greens hint at sunlight filtered through a different mix of leaves.

The second example is the little girl sitting just beyond the *promeneuse*, facing the baby carriage (FIG. 12). Seurat painted her hair using dominant vertical streaks of orange, with additional touches of light brown, pink, wine red, pale blue, and medium green. Because the brushwork here is irregular and does not cover all the blues of the girl's blouse, her hair has a shaggy appearance. It vibrates strongly against its color opposite, the saturated blue of the shirt, consisting of thin stripes of several tints of blue and some pink; Seurat probably applied the few dots of blue to the surface during his reworking of the painting in 1885–86. The girl's flesh pink left arm is made up of separate touches of pink, darker rose, light blue, and pale

orange. The mother's blue arm becomes green exactly as it overlaps the girl's back (its several green tones prevail over a mixture of blue, ruddy brown, yellow, and pink). This shift to green distinguishes the woman's arm from the child's blue blouse. Color theory does not explain this choice; more likely Seurat simply wanted to put green next to the orange and blue above. Seen together these colors are a visual joy.

Seurat learned about broken color from pre-1885 paintings by Renoir, such as *Oarsmen at Chatou* (CAT. 108, p. 45) and *Sunset on the English Channel* (CAT. 110, p. 41). Renoir's figures appear to move fully in space; moreover, he integrated them with adjacent areas by breaking up their edges. His people are engaged with one another by pose and gesture, whereas Seurat's sit or stand in statuesque solitude, their crisp outlines sharply separating them from their surroundings. In *La Grande Jatte*, he virtually eliminated feet so that his figures appear to float above the grass over their pedestal-shadows. He enhanced this effect, as comparison with the large sketch demonstrates (see Zuccari and Langley, FIG. 1), by significantly raising the bottom edges of the skirts of the central mother and the *promeneuse* after he first blocked them in. The only visible feet belong to the strolling couple, but these greatly elongated triangles are so dark that the eye usually passes over them. The absence of feet in *La Grande Jatte* would have seemed unusual and unnatural to the viewing public in 1886, including those sympathetic to Impressionism. They would have had in mind such

paintings as Pissarro's *Woman and Child at the Well* (CAT. 103, p. 103). There, despite profile poses, the figures' bodies are solid masses and their feet establish not just spatial position but also character and situation: the woman's twisted ankles suggest the toll her rugged rural life has taken.

Some critics recognized Seurat's ambition in *La Grande Jatte* to impose classical order upon modernity, to make an art worthy of museums. They compared the work to the large, geometric harmonies and parklike landscapes of Puvis de Chavannes, as Paul Alexis had done two years earlier when commenting on *Bathing Place*.[11] Modern critics have juxtaposed Puvis's *Sacred Grove*, shown in the Salon of 1884 (see FIG. 13), to *La Grande Jatte* because they share such features as a body of water on the left, a slanting foreground with figures in statuesque poses, and a backdrop of columns and columnar trees. But Seurat, influenced as he was by mid-century naturalism, would

FIG. 14
Piero della Francesca (Italian, c. 1415–1492). Detail from *Adoration of the Holy Wood and the Meeting of Solomon and the Queen of Sheba*, c. 1452. Fresco; 336 x 747 cm (132 ⁵/₁₆ x 294 in.). Church of San Francesco, Arezzo.

FIG. 15
Lady Tuya. Egypt, Middle Kingdom. Stone; h.: 33 cm (13 in.). Musée du Louvre, Paris.

have found Puvis's reclining figures rather anemic and his palette pale and cerebral. *La Grande Jatte* may be an allegory of summertime, but it has a decidedly contemporary flavor. Proud and ambitious, Seurat considered himself a modern-day Phidias. Surely thinking of *La Grande Jatte*, he later told Gustave Kahn that "the Panathenaeans of Phidias formed a procession. I want to make modern people, in their essential traits, move about as they do on those friezes, and place them on canvases organized by harmonies of color, by directions of the tones in harmony with the lines, and by the

directions of the lines."[12] Seurat determined to update Blanc and Puvis through a new classicism that would remake Impressionism by eliminating the accidental and the momentary, while preserving the vitality of life in well-calculated forms that embody enduring ideals.

Seurat's modernity so modified his classicism that we can readily distinguish him from Puvis. Still, there is another reason to invoke the older painter, namely, his primitivism. Puvis was no mere imitator of classical art but rather an independent spirit who kept his distance from academicians. The archaicizing simplicity of his work appealed not only to Seurat, but later to Gauguin and Picasso. "Primitive" by comparison with conventional academic art, Puvis's figures, drained of specific classical attributes except for drapery, resemble half-remembered antique statues. While they have volume, they are disposed in lateral configurations that conform to the flatness of the walls they were intended to adorn. The younger painter's primitivism relates less to the art of Greece and Rome than to that of the early Italian Renaissance, as contemporary critics frequently noted. They articulated this comparison in general terms, naming no painter in particular; for them *La Grande Jatte*'s relative flatness and toylike elements signaled a return to what they called Gothic, by which they meant quattrocento painting. Modern historians have made a good case, if not an entirely persuasive one, for Seurat's familiarity with the work of Piero della Francesca.[13] Indeed, Piero's reputed love of science and the solemnity of his figures

FIG. 16
Artist unknown. *Little Hunters* (*Petits chasseurs*), early nineteenth century. Colored broadside; 26.8 x 34 cm (10 9/16 x 13 3/8 in.). Musée National des Arts et Traditions Populaires, Paris.

FIG. 17
Kate Greenaway (British, 1846–1901). *Happy Days*, from *Marigold Garden: Pictures and Rhymes* (London, 1888).

(see FIG. 14) make him seem anachronistically like a Seurat *avant la lettre*, but his figures overlap, unlike the isolated forms of the late nineteenth-century artist. And it is hard to justify the influence of Piero on Seurat over that of other quattrocento artists.

Closer analogies with *La Grande Jatte* might lead us to artists of the trecento, but none of these stand out as potential sources. Instead, Seurat's Italianate primitivism evolved from a mid-nineteenth-century tradition associated with followers of Ingres, such as Hippolyte Flandrin, Victor Mottez, and Dominique Papety. As disciples of Ingres, Seurat's own teachers would have made him aware of the archaic aspect of Neoclassicism. Blanc was alert to this current and, in the early 1870s, while serving as the government's Director of Fine Arts, he had copies of early Renaissance paintings by Piero and others installed in the "Musée des Copies" at the École des Beaux-Arts. While at the École, Seurat had made two figural drawings after the museum's casts of Ghiberti's famous *Gates of Paradise* on the baptistery in Florence. One of the two is from the Joshua panel, where the standing figure appears in profile. Seurat drew it from an extremely oblique angle, so that it is seen from the back, a remarkable instance of the primitivizing impulse that he was learning and that would later resurface in *La Grande Jatte*.[14]

Lacking another all-embracing term, we use "primitivism" to label Seurat's departures from the conventions of post-quattrocento art. He eschewed the depiction of humans in turning and bending

LES PETITS CHASSEURS.

poses, and in overlappings and intertwinings, thereby rejecting some of the chief purveyors of narrative structure in traditional painting. It is as though he were returning to an earlier era, "primitive" in the sense of first or primordial, "his return to primitive forms" as one critic put it.[15] In truth the term's only meaning for Seurat and all early modern art was a departure from academic practices. Early Renaissance art, popular broadsides, toys, and Egyptian art, all bearing some similarities with Seurat's painting, do not really share one style or set of conventions. The only trait in common is the absence of the three-dimensional renderings of the post-Renaissance period.

Did Seurat draw upon his knowledge of non-academic arts, or is it instead we modern observers who find parallels in them? The primitivism of his large painting stems from no one source, but we struggle to define it through appropriate comparisons. Several reviewers likened Seurat's Sunday

strollers to figures in Egyptian art, leaving us to wonder if these comments derived from conversations within Seurat's circle or, equally likely, from the writers' need to cite famous examples of "hieratic" art. This favored term of the Symbolists implied well-ordered structure, as in Egyptian and ancient prototypes. Indeed, the nurse sitting on the left possesses the chunkiness of Egyptian sculptures of seated scribes, and the woman in the center has the exact pose of the ubiquitous standing Middle and New Kingdom priestesses (see FIG. 15). The profile poses of all the foreground figures are so

FIG. 18 (TOP)
Fashion illustration,
detail, from *Paris illustré*,
supplement 25bis (March
1885), p. 2.

FIG. 19 (MIDDLE)
Fashion illustration,
detail, from *Paris illustré*,
supplement 35bis (October
1885), p. 4.

FIG. 20 (BOTTOM)
Fashion illustration,
detail, from *Paris illustré*,
supplement 35bis (October
1885), p. 2.

stately and distinct from Impressionism that they seemed "pharaonic" to some critics. We have only these broad comparisons and no evidence that Seurat thought concretely about Egyptian art. Still, Blanc greatly admired it, even if he reserved his highest praise for the legacy of ancient Greece. While reading Blanc's *Grammar*, Seurat would have become familiar with the repeated assertion that Egyptian art was like all truly great art because it disdains

> the practices of servile imitation and creates its own images, also living ones but of another life from real life. It does not invent these images to fool the eyes, but to touch souls. It only imitates reality to rediscover the ideal, and instead of showing itself inferior to nature by rivaling her in quality of materials, it shows itself superior in qualities of the mind.[16]

Other contemporary critics likened Seurat's figures to wooden toys, puppets, old tapestries, colored engravings, lead soldiers, and illustrations by Kate Greenaway (see FIG. 17),[17] because he both rendered his images with the emblematic clarity of a primer and gave them an amusing mannequin-like innocence. Some of these writers were probably responding to the artist's curious departures from conventional proportion, although they were not remarked upon in print until Meyer Schapiro discussed them in 1935.[18] The fisherwoman is on the same plane as the mother in the picture's center, yet would come up only to her shoulders; the seated man in top hat, if erect, would reach only

the waist of the tall promenader on the right. Equally curious are the small steamboat and racing shell that are on the same plane but patently not of the same scale. (These anomalies should have given pause to those of us who have overly insisted upon Seurat's "scientific" procedures.) Could these eccentricities of proportion be accidental, the result of patching together a picture from various studies? Or could they result from Seurat's studio being so tiny that he was too close to his canvas to harmonize the whole? Neither seems the case, because the large sketch reflects the same proportions, so that he had plenty of time, and the room, to ponder his choices.

Seurat in fact collected popular broadsides in which such "primitive" features are found; a large number were discovered in his studio after his death.[19] They were predominantly colored lithographs and etchings of figures and landscapes from the first half of the nineteenth century. Most feature flat and simplified humans and buildings and landscapes of charming naiveté, very much like those in *Little Hunters* (FIG. 16). Five of them were crudely colored images of mounted soldiers, their flat forms echoed in the two soldiers in *La Grande Jatte*. Seurat's collection of broadsides were not direct "sources," but they do reflect his interest in popular arts, an anti-academic current among artists and writers that dated from mid-century. Courbet had been attracted to broadsides, and Champfleury wrote about them. From their generation onward, popular prints were considered primitive in the sense of being first or original

FIG. 21
Detail of *La Grande Jatte*;
leaves of tree at upper left.

expressions of *le peuple*, untainted by official art and therefore more democratic and honest. In Seurat's time, Camille and Lucien Pissarro gave them a leftist political meaning; Van Gogh found a Christian humility in them.[20] Also appealing about the popular arts, in addition to their moral content, was their elemental forms. Writing in *Paris vivant*, Caze confessed a passion for wax figures he encountered in street fairs: "I am full of respect for their solemn gestures, stiff and frozen in the immobility of statues."[21]

La Grande Jatte also offers parallels with images from the popular press: cartoons, caricatures, and advertising. Embedded in social interchange outside the boundaries of the fine arts, they were the creations of sophisticated artists who drew upon folkloric arts, which exploited simple poses and patterns that make them appear untutored by comparison with the fine arts. In *La Grande Jatte*, several details resemble journalistic illustrations: the rugged profile of the reclining *canotier*, the silhouette of the top-hatted dandy, the cigar of the promenading gentleman, the boorish horn player. The wit of these inventions and the amusement we derive from them is far removed from the classicism of Blanc and Puvis.

Images from fashion display and advertising also play their part in the formation of Seurat's vocabulary. While I take up the issue of fashion in *La Grande Jatte* in Chapter 8, a look at department-store advertisements points us to yet another group of significant images, those for ready-to-wear clothing, which commonly feature several women,

some in profile, modeling bustles. Au Bon Marché and other establishments offered a range of bustles, from relatively sober and cheaper styles to the more fanciful and expensive (see FIGS. 18, 19). Seurat's promenading woman wears the plainer style, but this may be a result of his penchant for regularizing forms. Much the same can be said for his women's hats (see FIG. 20), which are not among the period's most embellished. For market reasons, advertisements frequently situated females in garden or park settings, linking them with "nature" and with the places where social display was paramount. Seurat's large picture adheres to this convention. The advertisements' simplicity, partly the result of engraving and lithography techniques, recalls the style of broadsides; the ads' authors consciously aimed for the clarity of an archetype to which they could affix the lineaments of their commodities. Writers at times have considered Seurat's *promeneuse* as derived from, or at least influenced by, such advertisements. The artist surely knew them, but his own drawings of women from 1881 onward chart the literal expansion of the bustle—it reached its most extreme proportions in 1885–86—and there is no need to think of derivation.

With the convenience of hindsight, we now see that *La Grande Jatte* was an early statement of a shift toward what was later dubbed Postimpressionism, in which the terms "modernism" and "primitivism" became interdependent. Seurat was not alone in this, as we shall see when considering Pissarro's and Signac's entries in the Eighth Impressionist Exhibition, in 1886. Seurat's

primitivism was quite conservative in some ways, remaining as it did within the confines of western art. (Egypt was recognized as being at the origins of occidental art, and it had been assimilated into European histories.) In 1886 Seurat borrowed from Gauguin an excerpt from a supposed Turkish painter's manual that emphasized static poses over movement, but there seem to be no visual parallels with Near Eastern art in his work.[22] Japanese prints had been a vogue in Paris since the 1860s, but by 1886 *japonisme* was so integrated into advanced painting that its initial impact was no longer evident. Seurat's flatter and more geometric post–*Grande Jatte* compositions can profitably be related to Japanese prints, but no convincing connections can be made in his pre-1886 work. Even at the end of the decade, Seurat showed no interest in the medieval, Asian, and Oceanic arts that attracted Gauguin, who put a new stamp on the idea of "primitivism."

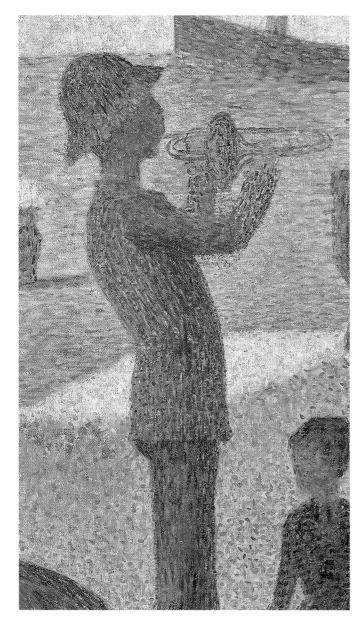

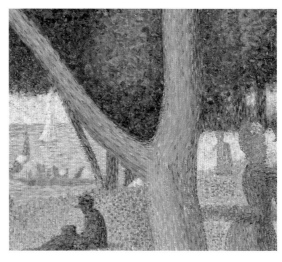

Color and Technique in *La Grande Jatte*

Shifts in the colors of *La Grande Jatte* make it
impossible to see the canvas as it was in 1886.
In addition to the patina that age normally confers,
Seurat used an unstable zinc yellow that changed
the pigments with which it was mixed. As early as
1892, several critics noticed the tragic dulling
of some colors, but it was not until Inge Fiedler's
work in 1984 that this unfortunate choice of pigment
was identified. Her essay in the present catalogue
brings her research up to date. As a result of her
scrupulous investigation, she has documented three
stages of work on the painting: the original of
1884–85, a reworking in 1885–86 (when Seurat used
the zinc yellow), and the addition of the painted
border in 1888 or later (plus a few touches on con-
tiguous areas of the canvas to react to the border).
Zinc yellow itself turned brownish yellow, while its

mixture with vermilion formed dull ochers instead
of the bright oranges Seurat sought, and its blend-
ing with emerald green deteriorated to a dull olive.
These form dark spots in the sunlit grass that are
particularly disfiguring. The effects of the impure
yellow can be seen in the novels on the grass near
the woman in the lower left, which once would
have been the bright yellow-orange of contempora-
neous paperbacks.[23] Recent specialized examinations
by Roy Berns and conservators at the Art Institute
have helped us understand better how the painting
must have appeared originally (see Berns, FIG. 1),
and indicate why contemporaries all referred to the
canvas's notable luminosity.

Even with these regrettable changes, the princi-
ple of Seurat's color harmonies is apparent, a trib-
ute to the residual strength of the conception. In
the most general terms, the composition depends
upon oppositions of light and dark, and of warm and
cool colors. Daniel Catton Rich pointed to these
contrasts in 1935:

> At the left the woman fishing wears a red-orange
> dress and is placed against the blue river; mid-
> way behind her is a patch of green weeds, and
> against them the red in her bodice brightens. In
> the foreground the seated figures appear mostly
> in violet; where they are silhouetted against
> the sunlit grass, the grass is yellower; where
> these figures cross the darker bands of greener
> shadow, the violet becomes redder. Perhaps
> the strongest contrast of hues is rightly reserved
> for the mother in the center. The red of her

FIG. 24

Detail of *La Grande Jatte*; skirt of *promeneuse* at lower right.

FIG. 25

Detail of *La Grande Jatte*; head of seated dandy at lower left.

parasol beats against the green of the trees; in shadow her hat turns violet against the yellowish tint of the opposite shore.[24]

When the viewer gets as close to *La Grande Jatte* as Seurat was when he painted it, the color and brushwork appear quite varied and animated. The surface is often wrongly described as a screen of uniform dots; in fact the strokes vary from small dabs to long streaks. Most of the dots were added in the repainting of 1885–86, and a few more around the edges two to three years later, when the border was painted; all lie above a complicated layering of pigment. For the river, Seurat used mostly horizontal strokes and saw no reason to change these when he reworked the canvas. Even at their most regular, these elongated marks vary in width and length, and tilt at slightly different angles (see Fiedler, FIG. 8). To indicate the myriad small leaves or blades of grass that comprise green growth, Seurat applied regular strokes that are not representational and instead have a directionless and nearly uniform texture (see FIG. 21). In this they act as a painter's ground, against which the figures and tree trunks stand out: the traditional "figure-ground" relationship. To give life and three dimensions to his people and trees, the artist applied paint in a curious kind of modeling. Trees are defined by elongated dabs that flow along the axes of their trunks and then change direction to bend or move outward on the branches, as if to trace the flow of sap through them (see FIG. 23). The strokes similarly follow the imagined reality of

the figures and their costumes. Seurat made paint move along the axes and surfaces of each portion of arm, leg, or skirt as it changes direction. So consistent is this directional modeling that even the mouth of the French horn consists of brushstrokes applied in concentric ovals (see FIG. 22). The upraised parasols display streaks that appear to pour outward and down from the tip, as rain itself would fall.

We discover even more features of Seurat's technique when we bring our eyes close to the picture's surface. Although at normal viewing distance some refined details cannot be observed—and certainly not in reproductions—I describe them here to demonstrate the complexities of the artist's craft. I also pay attention to the additions and changes Seurat made during his reworking in 1885–86; these are documented in greater detail by Zuccari and Langley. We have already noted that Seurat enlarged the skirts of the *promeneuse* and the fisherwoman, adding graceful arabesques to the more rigid profiles that characterized the picture in March 1885. For the fisherwoman (see Zuccari and Langley, FIG. 28), the artist applied dots of bright medium blue and brick red over the water, which shows through between them. Perhaps originally this expanded zone was not conspicuous, but it is evident now, even in reproduction. Additions to the bustle and skirt of the *promeneuse* (see FIG. 24) are nearly as visible, but their blues and purples, despite a sprinkling of oranges, blend more successfully with the blue costume and the dark grass. Other expanded

portions include the belly and back of the large dog, the bottom left side of the central mother's skirt, the forward edge of the skirt of the woman seated nearest the mother, and the right side of the flaring skirt of the girl whose parasol nearly touches the rowers' shell.

In further revising the picture, Seurat introduced a few entirely new figures to the background. Among them is the tiny top-hatted male to the right of the central mother's head. Also added is the half-figure between him and the young man in white facing him. Still further back, to the right of

the forked tree, we find a second instance of the fisherwoman's profile. This figure reduces the glare of what would have been a prominent off-white patch that is now behind her. Finally, even more removed are two grayish verticals that are resolved in close looking as a male and female couple. All these small figures are modeled in tiny strokes consistent with both the color harmonies and the directional textures of the larger people in the foreground.

Examination of *La Grande Jatte* without its glass and frame in February 2003 revealed a feature of Seurat's technique never before observed (at least in print). Portions of the silhouettes of most of the figures are outlined in extremely fine and continuous lines, invisible except when seen within four feet or closer; Fiedler discusses this in depth (p. 200). Seurat outlined much of the seated dandy's head (FIG. 25) in a bright, pinkish red, which continues around the back of his head and his chin, with only broken traces of red elsewhere. The bustle and skirt of the *promeneuse* feature the same thin, red outline. The artist placed this red atop already existing paint, but then a few tiny strokes overlap it. This may suggest that he added such outlines only in the reworking and that they were not present in March 1885, but this is not certain. Obviously, Seurat developed them to reinforce the edges of his figures, which otherwise avoid continuous brushstrokes. No color theory explains them; they are, once again, a component of his craft, a response to what he saw as he painted.

We observe this again in the way Seurat painted the foreshortened arms of several foreground figures: the fisherwoman, the central mother, and the woman seated nearest to her. The latter's forearm is a dark greenish blue, composed of touches of greens, blues, and pinks. Similar multiple strokes make the mother's upraised forearm a greener blue, while the fisherwoman's bent forearm is blue with a faint greenish tinge. In all three cases, the blues and greens are cool opposites of the adjacent warm reds of clothing, but they are much darker than we would expect. Admittedly, the arms are shaded from sun, but the reason for the dark tones is to keep them from projecting outward toward us. If we imagine them drawn and colored in a

traditional fashion, the fisherwoman's elbow and the mother's hand would appear to protrude sharply forward, the seated female's somewhat less so. Painted as they are, the women's arms remain within their outer contours.

Despite the great variations in the size and character of his marks, Seurat's brushwork seemed mechanical alongside Impressionist pictures. When we compare his painting with Renoir's *Lunch at the Restaurant Fournaise (The Rowers' Lunch)* (CAT. 107, p. 112) of about 1875, we see that, while both depend on contrasts of warm and cool colors (Seurat learned much from his elder), Renoir's brush caressed his forms with a Titianesque voluptuousness that befits the picture's social harmonies.

Even in 1885, when he was subjecting his Impressionism to new discipline, as in *La Roche-Guyon* (CAT. 112, p. 113), the greater regularity of his Cézannesque brushstrokes encouraged a more sensual and tactile response than Seurat's facture. It was Seurat's "scientific" color and technique that attracted attention in 1886 and that dominated discussions of the painting for many subsequent decades. To describe color relationships, Fénéon employed the scientific language that Seurat himself used, convincing terms because they suited other aspects of *La Grande Jatte* that spoke for methodical procedure and impersonality. In his Neoimpressionist period, Pissarro called his former comrades "impressionnistes romantiques," whereas Seurat and his new associates were "impressionnistes scientifiques."[25] For viewers who had only recently become accustomed to the swirling irregularities of Monet's, Morisot's, and Renoir's techniques, Seurat's impersonal brushwork embodied *La Grande Jatte*'s contrast with Impressionism. In the first—and still the most famous—analysis, Fénéon explained Seurat's divided color, which, he wrote, resulted in mixtures in the eye:

> If, in the *Grande-Jatte* of M. Seurat, one considers, for example, a square decimeter covered with a uniform tone, one finds all its constituent elements on each centimeter of this area, in a swirling crowd of slender maculae. For this greensward in shadow: most of the touches give the local color of grass; other touches, oranges, are scattered about to express the feeble solar action; still others, purples, introduce the complement of green; a cyan blue, provoked by the proximity of a patch of grass in sunlight, increases its siftings toward the line of demarcation and then thins them out progressively beyond.[26]

Although the colors do indeed vibrate, optical mixture does not really work.[27] If the strokes are small enough, there is some blending in the eye, but this is reflected light from pigments, not from the sun, for natural light and pigments are not at all the same. Color opposites in prismatic light rays, such as greenish yellow and violet, will produce white when the rays intersect, but two pigments so colored will form a dull, brownish gray. Pigments are themselves mixtures, and what we see is the light reflected from them, not prismatic light. The mid-century scientists Helmholtz and Maxwell clearly separated color-light from pigments, as Seurat learned when he studied Rood. Blanc, who admired Delacroix, had discussed the advantage of breaking color into separate touches and invoked Chevreul's writings as scientific proof, so Rood seemed to give added scientific validation to Seurat's earlier readings. Relying on Rood, the painter hoped that breaking color into small units would allow their mixing in the eye as though they were particles of color-light, but this does not happen. In *La Grande Jatte*, the colors we see are determined by several variations of the dominant hue, underneath Seurat's multicolored strokes. In the shade, the grass looks dark green because the artist first broadly brushed in several different tints of green and blue-green; he then enlivened the greens with scattered smaller touches of orange, yellow, blue, purple, and red.

Separate colors combine in our eye only if the colored units are so tiny as not to be separately visible! In *La Grande Jatte*, Seurat's mixtures usually produce a shimmering effect, a vibration in which one color becomes dominant. The costumes of several of the figures standing or seated in sunlight are brownish orange when viewed from a distance, because of their closely associated oranges and reds. Touches of contrasting blues and greens enliven the effect, but they are partly fused by the fuzziness of distance and are overwhelmed by related tints of oranges, brick reds, and wine reds. Yes, the separate strokes lead to new mixtures, but these are not the optical results of real light upon which scientific theories were based.

Seurat's lively mixed hues are due to his use of divided color, about which he had learned first from Blanc and Delacroix, and then from Impressionist practice. His innovation was to make the strokes nearly regular and systematically smaller. Critics in 1886 regularly likened them to tapestry stitches and hence called the technique "pointillism" (from *point*, French for "stitch"). Within Impressionism, it was Pissarro's technique of the early 1880s that was especially instructive. In works such as *Woodcutter* (CAT. 100, p. 115), which had special relevance for Seurat's early paintings of peasants, and *Peasant Girl with a Straw Hat* (CAT. 101, p. 42), the elder artist interlaced fine touches to form nearly abstract tapestries of paint. However,

he varied his facture in direction and size to create a "natural" look, and he avoided the strong contrasts between areas that give *La Grande Jatte* its striking patterns. Both artists' broken colors should be distinguished from the small strokes of Barbizon painter Rousseau, which occasionally have been compared with Seurat's application. Rousseau's *Springtime* (FIG. 26) exhibits regular, dotted brushwork. Perhaps Seurat was attracted by this texture and might even have thought of it as a precedent for his own art, but Rousseau's dots are quasi-images of blossoms and leaves, not elements of broken color.

In Seurat's painting, wherever sun meets shade, the contrasts identified by Chevreul take place:

light colors become even lighter and more intense, dark ones darker and also more intense. In reproductions these contrasts mostly disappear, but even here they are visible in the haloes that surround the figures over the water (see Zuccari and Langley, FIG. 14). From Chevreul and Rood, Seurat knew how to anticipate such reactions, so in the large sketch of the whole composition, he roughly recorded sunlit and shaded portions in large strokes. Of course he observed such contrasts in nature, but when he brushed in his colors in schematic form in the studio, he was conscious of the principles of contrast that Chevreul had effectively described. For example, in the large sketch, he painted the right-hand side of both nurse and seated patient in crisscrossed strokes of wine red and blue, but rendered the sun-facing sides in lighter colors. The old woman's umbrella likewise features purple-blue dabs on the right, but otherwise is orange and yellow (with a few touches of red). In the large canvas, these contrasts are rendered far more subtly, based both on what Seurat observed on similar surfaces outdoors and also on his knowing how to intermix many colors on canvas to produce the results he desired.

Seurat was aware of the differences between light and pigment, so his painter's craft won out. Because he could not use light, he enlivened his pigments with the vibration of separate colored strokes. All these reactions among areas of color

evolved over several years of work, as we saw when we looked at his earlier panels and canvases. The artist nonetheless hoped that his technique could produce the effects of color-light. It was a rational technique, yes, but it was "scientific" only in the sense of empirical practice. The artist nonetheless believed that he was approximating scientific color-light, so he referred to his art as "chromo-luminarisme" (color-lightism), a homely term that fortunately was displaced by Fénéon's "Néo-Impressionnisme," put forth in the autumn of 1886. So attractive was the scientific explanation of optical mixing, to both Seurat and his allies, that it entered firmly into the interpretation of their paintings. Not only Fénéon, but also other critics, spread the erroneous gospel,[28] further muddled by the common failure to distinguish light from pigments. Thus, generations of writers thought that Seurat used blue and yellow to form green, for example, and that he worked only with mixtures of the three pigment primaries: yellow, red, and blue. In fact, even when his palette reached its most extreme reduction in the late 1880s, it still consisted of eleven pigments fresh from the tube, before application to canvas. Each of the eleven could be mixed with its neighbor, and each, as well as the mixtures, could be blended with white.[29] The different pigment mixtures in *La Grande Jatte* have never been counted, but they are far in excess of those used in his last canvases.

Notes

1 Seurat's little panel of a canoeist (private collection, H 174), probably painted in 1884 or 1885, shows the Seine through trees and foliage. They form less of a screen than Monet used, but call his work to mind.

2 Fèvre 1886 (Seurat's Argus); repr. in Berson 1996, pp. 445–47.

3 Verhaeren 1891 (ed. 1927, p. 197).

4 Just who this man might be is disputed. Variations in interpreting the painting's figures and meanings are discussed in the final chapters.

5 For the dogs, see Thomson 1985, pp. 123–24.

6 For the identification of the soldiers, see Ch. 2, note 4.

7 Several of these small light patches appear in Seated and Standing Women (CAT. 44, p. 74), where they might more plausibly represent discarded paper or cloth.

8 Richard Thomson (1985, p. 123) reproduced a caricature of such a man, limited to these salient attributes.

9 Katz 1958, p. 47.

10 Edmond Duranty, Le Peintre Louis Martin (Paris, 1872), p. 347.

11 For Alexis's review, see Ch. 1, note 10. The belief that Seurat visited Puvis's studio or even worked with him, repeated as recently as Smith 1997, pp. 13–14, should be discounted, because all references to such a possibility were published long after Seurat's death and were based on hearsay.

12 Gustave Kahn, "Exposition Puvis de Chavannes," La Revue indépendante 6 (Feb. 1888), pp. 142–43. In this article, Kahn drew a parallel between Puvis and Seurat (as "un des jeunes novateurs impressionnistes"), stating that both were innovators, Puvis in line, Seurat in color, and that they shared "hiératisme" and "synthèse."

13 For example Roberto Longhi, "Un disegno per la Grande-Jatte la cultura formale di Seurat," Paragone 1 (Jan. 1950), pp. 40–43; and Albert Boime, "Seurat and Piero della Francesca," Art Bulletin 47, 2 (June 1965), pp. 265–71.

14 Both drawings after Ghiberti are reproduced and discussed in Herbert 1962, pp. 29–31, 178.

15 Adam 1886 (Seurat's Argus); repr. in Berson 1996, pp. 429–30.

16 Blanc 1880, p. 438.

17 Despite their sophistication, Kate Greenaway's illustrations were categorized as popular art. But long before her work was compared to that of Seurat, she was praised by Huysmans and Jules Laforgue. See Huysmans, "Le Salon officiel de 1881," in his Art moderne (Paris, 1883), pp. 211–12, and Laforgue to Charles Henry, Dec. 1881, in Oeuvres complètes de Jules Laforgue (Paris, 1925), vol. 4, Lettres, p. 65. For example, Greenaway was invoked by Firmin Javel, "Les Impressionnistes," L'Evénement (May 16, 1886); colored engravings by Marcel Fourquier, "Les Impressionnistes," Le XIXᵉ siècle 17 (May 16, 1886), n. pag.; wooden toys and tapestries by Octave Maus, "Les Vingtistes parisiens," L'Art moderne 6, 9 (June 27, 1886), p. 204.

18 Schapiro 1935, p. 12.

19 I inventoried the broadsides in 1956 (Herbert et al. 1991, Appendix C), but Seurat's heirs subsequently discarded them.

20 Contemporary Symbolist writers amalgamated these various "primitivisms" as well:

> Primitive art and popular art, which is the continuation of primitive art in the contemporary world, are symbolic in this fashion. Popular broadsides only draw outlines. In the perfection of their craft, ancient painters used this technique. And so too, Japanese art.

Edouard Dujardin, "Aux XX et aux Indépendants—le cloisonnisme," La Revue indépendante (May 19, 1888). Significantly, this was reprinted in Alfred Jarry's revue Perhinderion 2 (June 1896), along with an essay entitled "Imagerie populaire."

21 Robert Caze, Paris vivant (Paris, 1885), p. 283.

22 Herbert et al. 1991, Appendix P.

23 London conservators (Kirby et al. 2003) showed that Seurat used the faulty zinc yellow in The Bridge at Courbevoie (CH. 5, FIG. 3), leading to similar darkening of the oranges in the foreground.

24 Rich 1935, pp. 32–33.

25 Pissarro also gave Fénéon advice on color theory and wrote the dealer Paul Durand-Ruel in phraseology that reads like a scientific handbook. For Pissarro's views of "romantic" and "scientific" Impressionism, see his letters from May 1886 through February 1887 (CP 2).

26 Fénéon, 1886a, p. 271 (Seurat's Argus); repr. in Berson 1996, pp. 441–45.

27 It was J. Carson Webster (1944) who first debunked the idea, so central to Fénéon's initial texts, that Seurat used only a few pigments to produce real optical mixing. John Gage (1987) followed Webster by stating that Rood and contemporaneous science were not, after all, very significant for Seurat, who instead followed Chevreul's conceptions of color harmony. Martin Kemp (1990, pp. 312–19) agreed with Gage in his more extensive analysis of Blanc, Chevreul, Delacroix, Helmholtz, and Rood. Kemp recognized the variety of brushstrokes in La Grande Jatte and also that, in the absence of actual optical mixtures, Seurat's colors achieve "a special kind of elusive magic" (p. 318).

28 See for example Rodolphe Darzens, "Chronique artistique: Exposition des impressionnistes," La Pléiade (May 1886), pp. 88–91 (Seurat's Argus); repr. in Berson 1996, pp. 438–39.

29 Homer 1964, pp. 146–53. The palette used for Circus, found in Seurat's studio in 1891, is now in the Musée d'Orsay, Paris.

4 *La Grande Jatte* in the Eighth Impressionist Exhibition

La Grande Jatte made its first appearance in mid-May 1886, in *The Eighth Exhibition of Painting*, a deliberately neutral title for the last of the events that Impressionist artists had initiated in Paris in 1874.[1] Pissarro brought his son Lucien, Seurat, and Signac into the show. He had met Seurat the previous October, and he and Lucien began to adapt their techniques to his divided-color method. Pissarro praised Seurat and Signac to the Parisian dealer Paul Durand-Ruel, who incorporated both artists in two huge exhibitions of Impressionism in New York City in April and May 1886. No extended commentary survives from the New York showings of Seurat's paintings (and none was sold). These included the landscape canvas of La Grande Jatte (CAT. 60, p. 80), which had been hung in December 1884 with the Indépendants; *Bathing Place, Asnières*; and twelve panels mounted in one frame, including two early peasant images, four studies for *Bathing Place*, and two for *La Grande Jatte*.[2]

Martha Ward has analyzed the complicated politics of the Eighth Impressionist Exhibition, which swirled around competing ideas about independence not only from the official Salon but also from dealers.[3] Caillebotte, Monet, Renoir, and Sisley all abstained, and Pissarro had some difficulty in persuading his other colleagues to accept Seurat and Signac. He told Degas that Seurat's picture was "extremely interesting," to which Degas replied, "Oh, I would have noticed that myself, Pissarro, only it's so big!"[4] The only core Impressionists to participate in this event were Cassatt, Degas, Morisot, and

Pissarro. Other exhibitors, several of them recruited by Degas, included Marie Bracquemond, Gauguin, Forain, Guillaumin, Redon, Rouart, Schuffenecker, Tillot, Vignon, and Zandomeneghi. One reflection of internal dissension was the decision to display works by the Pissarros, Seurat, and Signac in a separate room. Seurat's large picture—flanked by *Le Bec du Hoc* (CAT. 84, p. 63) and *Roadstead at Grand-camp* (CAT. 82, p. 61)—occupied its own wall.[5]

The exhibition took place in rented rooms on the rue Laffitte, a fashionable location of notable café-restaurants and art dealers. The artists hoped to place their works before a knowing and well-to-do public, but their show drew relatively little notice in the press and only very modest attendance. Competition with the contemporaneous Salon and dealers' exhibitions, plus the absence of the well-known Monet and Renoir, may explain this meager response. Seurat's big picture was ignored or mentioned only derisively by many critics, but it was championed by a few young writers in the literary journals that were giving rise to Symbolism.[6] In the wake of the reviews, word of *La Grande Jatte* spread rapidly. Its large size, "primitive" figures, and controversial technique made it the most notorious single picture in the entire exhibition, although Degas's pastels of nudes were at least equally prominent in the reviews, their unabashed realism stirring much praise and some puzzlement. News of Seurat's painting spread to London, where Manet's friend George Moore, writing anonymously, concluded his review by saying, "Of the new-comers, Seurat strikes me as possessing the

most talent. His large picture, 'Un dimanche à la Grande Jatte,' looks like a modernised version of ancient Egypt."[7]

Seurat also exhibited four other canvases, one panel, and three drawings. Two of the drawings, *Acrobat by the Ticket Booth* (CAT. 31, p. 119) and *Sidewalk Show* (CAT. 32, p. 120), deal with the world of entertainment that also absorbed the attentions of the young writers whose circles he had recently joined. The artist had probably executed them two or three years earlier, because they contrast with the smooth modeling of drawings for *La Grande Jatte* and others of the same period, such as *Two Clowns* (CAT. 92, p. 119). Their subjects offer many analogies with contemporary journalistic illustrations, but this is not true of the exhibited third drawing, *Condolences* (CAT. 87, p. 120), which Huysmans lent. Most likely made the previous year, it is an obviously soulful, indeed Rembrandtesque composition that would have given the lie—if anyone noticed the drawing—to the idea that Seurat was merely concerned with mechanical and scientific rendering. In fact he must have chosen to exhibit these three drawings, as well as the little panel of fishermen he did in 1883 (CAT. 26, p. 121), precisely because he wanted to show the range of his art. Reviewers especially appreciated this panel as a skillful essay in the traditional painter's problem of *contre-jour*, the study of light coming from behind the subject. An anonymous critic who disliked *La Grande Jatte* declared *Fishermen* "the jewel of the exhibition. It seems impossible, with such primitive means, to

produce at a distance a more correct and surprising effect."[8]

The three seascapes Seurat had painted at Grandcamp the previous summer attracted the most favorable attention among critics. Reviewers almost uniformly admired them; Gustave Geffroy and Octave Mirbeau disliked *La Grande Jatte* but found a poetic melancholy in the lonely views of the Channel. They seemed not to be offended by Seurat's technique, because it was not yet as refined as that of *La Grande Jatte* and was more easily assimilated with Impressionism. Above all Seurat had applied it to landscape, not to the human form. *The Seine at Courbevoie* (CH. 1, FIG. 14) drew little comment, even though it possesses some of the controversial features of the large canvas.[9]

Many critics rehearsed the history of Impressionism, usually mentioning the absent Monet and Renoir before commenting upon Degas, the Pissarros, Seurat, and Signac. Because direct perception of nature was paramount in Impressionism, several writers deemed high-keyed color and broken brushwork more important than subject matter. From this vantage point, the works by the

CAT. 87

Condolences, 1885/86. Conté
crayon on paper; 24 x 31.7 cm
(9 ½ x 12 ½ in.). Collection
Michael and Judy Steinhardt,
New York. H 655.

CAT. 32

Sidewalk Show, 1883/84.
Conté crayon on paper; 31.7 x
24.4 cm (12 ½ x 9 ⅜ in.). The
Phillips Collection, Washington,
D.C., acquired 1939. H 668.

Pissarros, Seurat, and Signac, with roughly similar subjects, became extensions of Impressionism even if these artists' technique bore a new stamp. The critics generally liked Pissarro and treated his new manner as a logical extension of previous years' work, which indeed it was.

Most of the paintings Pissarro exhibited in May 1886 have disappeared. He subsequently repainted one of the remaining works, leaving only two unaltered. *In the Garden, Mother and Child* (FIG. 1) displays a smaller and tighter brushstroke than heretofore, with a sprinkling of very fine touches à la Seurat. These Pissarro must have added to the canvas, which he surely began earlier. The other

surviving painting is *Gathering Apples* (CAT. 104, p. 122)—his largest and most ambitious entry—which, like *La Grande Jatte*, required over a year to complete. The standing and kneeling women are familiar from Pissarro's paintings and drawings beginning in 1881. Compared with earlier work, the brushstrokes in *Gathering Apples* are more interwoven and the divided color comprises more oppositions, probably reflecting his familiarity with the work of Seurat and Signac. Otherwise, the technique is much like that in *Peasant Girl with a Straw Hat* (CAT. 101, p. 42) of 1881. More important for an understanding of *La Grande Jatte*, as we shall see, is the decorative aspect and "primitivism"

of Pissarro's composition, for these he developed independently of Seurat.

The conscious decorative appearance of *Gathering Apples* relies on a high horizon line, which let Pissarro tip up the foreground so that the huge shadow, surprisingly geometric in shape, looks almost like a rug. In the right corner, the shadows of leaves and a pair of fallen apples together form a pattern suitable to tapestry or wallpaper. Above, two furrows emerge from the shadow into sunlight with such regularity that one critic likened them to railroad tracks.[10] Across the top of the picture, fruit and leaves form a flat frieze, while in the foreground a large spray of leaves floats

on the surface and diminishes the sense of volume of the two main figures. Even the picture's square dimensions contribute to the decorative effect, distinguishing it from the verticals of figure painting and the horizontals of landscape. We would never confuse this work with *La Grande Jatte*, but its assertive composition and ornamental surface show just how much Seurat's picture owed to the shifts in Impressionism that were taking place before 1886.

Pissarro's primitivism is as obvious as his indulgence in the decorative. In 1886 he referred to his work as having "the cachet of *modern primitive.*"[11] Like those in the *La Grande Jatte*, Pissarro's figures do not follow conventions of proportion and space. In *Gathering Apples*, for example, the kneeling woman is too small, and the seated woman seems to lean against a rising slope, although the composition indicates flat ground. The three women also have a methodical stiffness; the one kneeling assumes a lumpy pose that Van Gogh would have admired. Like Seurat's island people, the figures here are psychologically separated from one another, although not as firmly outlined. The net effect is quite different, however, for, as one critic put it, Pissarro's painting projects a mood "of some quiet dream where joy is too sad to smile, and grief is too mild for tears."[12] Despite the work's dreamy lassitude, reviewers frequently emphasized Pissarro's healthy treatment of peasants, finding it more truthful and less insistent upon moral seriousness than that of Millet, with whom they regularly compared him.

Decorative character and primitivism also characterize Signac's chief painting in the exhibition, *Two Milliners* (FIG. 2). Although it is large and ambitious like Pissarro's and Seurat's major entries, it received little notice in the press, usually a brief comment on its striking palette. With the advantage of hindsight, we see Signac's canvas as a homage to Degas's subjects and to Impressionism's broken color, but these connections are overwhelmed by the composition's sharp-edged flatness. The cartoonlike silhouette of the worker behind the table, whose form is constricted by

the canvas's top edge, reduces any sense of her three-dimensionality. The canvas's decorative intent is expressed as well in the wallpaper, tablecloth, and strong geometry of the composition, as well as in the stark whites and reds that seem to float toward the viewer.

Signac's landscapes fared somewhat better with the critics, although they were praised only by a few who knew him personally. They distinguished him from Seurat by pointing to his stronger color contrasts and more energetic, divided brushwork. This was already true of Signac's paintings of 1883

FIG. 1

Camille Pissarro. *In the Garden, Mother and Child*, 1886. Oil on canvas; 39 x 32 cm (15 ⅜ x 12 ⅝ in.). Durand-Ruel Collection, Paris. PV 691.

CAT. 104

Camille Pissarro. *Gathering Apples*, 1885–86. Oil on canvas; 125 x 126.3 cm (49 ¼ x 49 ¾ in.). Ohara Museum of Art, Kurashiki, Japan. PV 695.

FIG. 2

Paul Signac. *Two Milliners*,
1885–86. Oil on canvas;
116 x 89 cm (45 ⅝ x 35 in.).
Foundation Emil G. Bührle
Collection, Zurich. FC 111.

at Port-en-Bessin, before he met Seurat; he further heightened his palette at Saint-Briac in Brittany in the summer of 1885. The juxtaposition of hot and cold colors in *Mariners' Cross at High Tide, Saint-Briac* (CAT. 113, p. 53) is more daring than any of Seurat's work from the same summer at Grandcamp, although Signac had not yet adopted his friend's more serried technique. He was still looking toward Impressionism that autumn, when he painted *Riverbank, Asnières* (CAT. 114, p. 125), not far from the site of Seurat's *Bathing Place*. Its subject and palette reveal his familiarity with the work of the Impressionist Guillaumin, who had long been depicting the commercial banks of the Seine.

In the Eighth Impressionist Exhibition, Signac showed several canvases from Saint-Briac, as well as other, more recent ones. *The Branch Line at Bois-Colombes* (CAT. 116, p. 124), done that spring, combines his Impressionist manner with areas of distinct strokes that acknowledge Seurat's technique without imitating it closely. (Paintings such as this impressed Van Gogh when he met Signac the next year.) Signac repainted *Snow, Boulevard Clichy* (CAT. 120, p. 125), begun in January 1886, shortly before the exhibition. He added small touches, many of them round enough to be called "dots." These are widely separated, one from the other, not integrated with the underlying paint structure, as in Seurat's work. Larger than either of these compositions and more thoroughly developed is *Gas Tanks at Clichy* (CAT. 117, p. 127), one of two industrial subjects (the other has since disappeared) Signac showed that had no counterpart

in Seurat's entries. The brushwork in *Gas Tanks* is more interwoven and smaller than in previous paintings, although varied to suit the subjects depicted: speckled for grass, horizontal for roofs, vertical for fences. Signac's themes and bold colors appealed to the naturalist critic Jean Ajalbert, who admired the artist's "blood-red roofs, livid suburbs," and saw in *Gas Tanks* that "the exalted light transfuses fresh blood into anemic roof tiles."[13]

While Seurat drew the industrial outskirts and painted them in *Bathing Place*, none of his contributions to the 1886 exhibition refers to commercial or industrial settings. Pissarro exhibited several 1884 etchings showing urban Rouen and its port, but the paintings, pastels, and gouaches he showed all depict peasants and rural landscapes. By comparison, Signac's homely suburbs and gas factories are closer to the themes of the naturalist writers he knew or favored, including Ajalbert, Caze, Darzens, and Huysmans. (Like Seurat, in the catalogue he listed Caze's widow and Huysmans as lenders of two of his drawings.) From this perspective, Signac would have seemed more modern than Seurat; yet his reviewers usually preferred his 1885 landscapes of Saint-Briac, probably because they suited prevailing assumptions about Impressionist subjects and technique.

Rounding out the exhibition room were works by Lucien Pissarro. The location today of the five oils he showed is unknown, but we can get an idea of them from *Church at Éragny* (CAT. 106, p. 128), executed later in 1886. While its subject is a site his father had painted two years earlier (*View of*

Éragny, private collection, PV 649), it is closer in spirit to the work of Seurat and Signac. Its horizon line is higher than in his father's composition, creating more pronounced surface shapes. These Lucien simplified further by eliminating the man and cows that populate the elder Pissarro's work; its shadows assume nearly autonomous shapes. The colors are more subdued than Signac's, but reflect

CAT. 116
Paul Signac. *The Branch
Line at Bois-Colombes*, 1886.
Oil on canvas; 33 x 47 cm
(13 x 18 ⅛ in.). Leeds City
Art Gallery. FC 116.

the same principles he and Seurat followed: blues multiply in the shade, yellow-tans and pale oranges in the sun. Lucien also exhibited three watercolors and two series of wood engravings, one for a novel by Octave Mirbeau (see FIG. 3), the other of rural figures. Critics mainly ignored his paintings and watercolors, but some noticed his wood engravings, always referencing their primitivism and "naiveté." Although they did not closely resemble Seurat's depictions of figures, their primitivism resonated somewhat with *La Grande Jatte*, so visitors to the show would have found this room full of largely compatible objects. Of the group, Seurat exhibited the fewest works: six paintings and three drawings; Signac showed fifteen oils and three drawings; Camille Pissarro nine oils, eleven pastels and gouaches, and five etchings; and his son five oils, as well as many watercolors and wood engravings. Nonetheless, *La Grande Jatte* dominated by its size and by the attention, albeit minimal, the press paid to it.

Seurat and the Critics

La Grande Jatte was adopted by young writers who were reformulating late naturalism into Symbolism, parallel to Seurat's reworking of Impressionism.[14] (Jean Moréas's manifesto had formally launched Symbolism in September.) The startling change in Seurat's rendering of people in his picture—flat silhouettes when compared to the sculptural seminudes of *Bathing Place*—is easier to understand when we comprehend the quite sudden alteration in his artistic and intellectual life.

By 1884 Signac had displaced Seurat's relatively conservative school chums (François Aman-Jean, Ernest Laurent, Alphonse Osbert, and Alexandre Séon) and had pulled him into more radical circles. By 1885, as we have seen, Seurat was socializing with naturalists such as Ajalbert, Alexis, Caze, and Huysmans; and by 1886 with nascent Symbolists like Adam, Fénéon, and Kahn. By no later than November 1886 and, in most cases, before the Eighth Impressionist Exhibition, all of those named owned works by him.[15] They were uniformly favorable to Seurat, and usually also to Pissarro and Signac.

Radical politics connected the mixed cohort of naturalists and young Symbolists. They were all pronouncedly anti-bourgeois, and by 1888 many were close to embracing anarchism: Ajalbert, Alexis, Christophe, Fénéon, Kahn, Lecomte, Verhaeren (this was already true of Fénéon and Camille Pissarro by 1886). By about 1888, both Pissarros, Signac, and Luce embraced the anarchist cause.[16] At the time *La Grande Jatte* was exhibited, leftist writers were familiar with its maker's socially aware early work, including *Bathing Place*, and were receptive to the entire range of his drawings and paintings. The elder Pissarro's celebration of rural labor and Signac's images of industrial suburbs confirmed Neoimpressionism in 1886 as a movement oriented toward socially conscious subjects. More than that, the writers could associate the new technique with progressive science, which they and the anarchists saw as central to reformulating the social order.

A number of modern writers have wanted to link *La Grande Jatte* with anarchism, but this is surely an anachronism and has depended upon superimposing over 1886 the associations of Seurat's friends, both artists and painters, in the years after 1888. In particular, Signac and Fénéon pushed the connection after Seurat's death for two reasons. One was that anarchism did not require images of poverty or of other iniquities of capitalism, but instead supported radical freedom in the arts, including freedom from any demands for social realism. A painting of progressive style, wrote Signac, regardless of its subject, could deliver "a solid blow of the pick to the old social edifice."[17] The other reason for Seurat's posthumous adoption by the anarchists was that his drawings and paintings had consistently favored the democratic and the popular. His last works, Signac wrote, embraced a critical view of their era as one of transition from decadent capitalism to the future workers' society.

By 1886 a growing disenchantment with the work of older naturalists like Zola and the Goncourt brothers had given rise to Symbolism. The words of praise that Adam and Fénéon lavished on *La Grande Jatte* refer to its visual qualities and reveal their preferences; in one guise or another, these same ideas still cling to the painting today. Seurat's figures were "essences" of life forms, "syntheses" that abstracted from nature by using the purposeful intellectual powers of the artist and the latest findings of modern science. He was not guilty, they believed, of the passive indulgence of the Impressionists, which made them mere copyists. He

screened nature by establishing "hierarchical" values, and gave to contemporary life the seriousness of early Renaissance art and "Pharaonic processions."

Seurat must have been pleased at the favorable terms used by his friendly reviewers, all the more so because they echoed Blanc's *Grammar*. We know that he spoke of Blanc to his friends, and acknowledged his debt to him in his autobiographical letter to Fénéon in 1890,[18] but we do not know if the Symbolists also appreciated the theoretician. He was conservative in ways that would have put them off, because he opposed naturalism, contemporary subjects, and anything that could be construed as mere fashion. Nevertheless, Blanc admired Delacroix and the "primitives" of the early Renaissance (he seldom referred to the Baroque), and much of what he wrote strikes familiar notes after one has read the Symbolists' praise of Seurat. This is logical, because Blanc had summarized the kernel of the classical aesthetic to which, in different ways, the Symbolists were returning. For Blanc, as for Joshua Reynolds a century earlier, raw nature consisted only of imperfect manifestations of the ideal. "To idealize the figure of a living being is not therefore to diminish life but on the contrary to add the accents of a more abundant and superior life in rediscovering characteristic traits of the being." His views implicitly condemned Impressionism, because, in his opinion, the painter's job is to sift through the vagaries of nature, avoiding the temptation to copy its sensual presence, and instead "seek the beauty of forms in their primitive essence."[19]

CAT. 117

Paul Signac. *Gas Tanks at
Clichy*, 1886. Oil on canvas;
65 x 81 cm (25 ⅝ x 31 ⅞ in.).
National Gallery of Victoria,
Melbourne, Felton Bequest,
1948. FC 117.

Lucien Pissarro. *Church at Éragny*, 1886. Oil on canvas; 50 x 70 cm (20 x 27 ½ in.). Ashmolean Museum, Oxford, presented by the Pissarro Family 1952.

The longest favorable reviews of Seurat's work published in the wake of the spring exhibition were those of Adam and Fénéon. Adam began his article by claiming that Impressionism was "a school of abstraction" because the painters, fixing on canvas only what they actually saw, relied upon subjective vision rather than upon a preexisting, memory-based conception of reality.[20] While this conflicted with Blanc's dislike of naturalism, Adam was also an idealist: "Modern philosophy has been converted to a unique substance, the idea-phenomenon; the impressionists endeavor

to translate its most characteristic manifestations." New literature, he wrote, sympathized with Impressionism because it renounced the externals of old novels in favor of insights into the most elemental ideas that characterize human life. In various guises, Adam's "idea-phenomenon" dominated Symbolism and underlay its adherents' admiration of Seurat. "The essential goal of our art," wrote Gustave Kahn in September, "is to objectify the subjective (exteriorization of the Idea) instead of subjectivizing the objective (nature seen through a temperament) [Zola's famous phrase]. Analogous reflections have created Wagner's multitonic tone and the latest technique of the Impressionists."[21]

Other Symbolists associated Seurat with the subjectivity of *wagnérisme*, a rival term for Symbolism, as we shall see in Chapter 5. Does this mean that Seurat also believed that reality lies in the mind, not in "nature?" Until the end of his short life, he referred to his readings of Blanc; undoubtedly, he agreed with the aesthetician's elevation of intellectual assessment and construction over mere description of the external world.[22] The traditional aesthetic idea of "imitation" stressed the artist's transformative powers over copying, and Blanc simply expressed this in a convenient form. The Symbolists (without necessarily knowing Blanc's writings) agreed that the artist's task was to transform nature, but in their rebellion against naturalism and Impressionism, they gave far greater emphasis to mental constructions: hence, the attraction they felt toward German idealism. Seurat's concepts may not have gone as far as the Symbolists

did toward solipsism (the belief that the self can only know its own formulations), but he read their praise of him, constantly couched in terms that stressed the "idea-phenomenon."

Adam, pursuing his insistence on the triumph of ideas over naturalism, declared that "the most advanced impressionists" used scientific color division, rejecting the "cuisine" of painting mixtures, as well as traditional compositional devices, and instead looked back to earlier arts. "The varied and melodious forms of the primitives suits the new generation," he wrote. "Extraordinary analogies are obvious between the drawing of old frescoes and that of certain impressionists." After reviewing the work of other exhibitors, Adam ended his partisan article with a glowing account of the work of Pissarro, Seurat, and Signac. He noted that Seurat's seascapes had met with general favor, and rightly so, but that "the beauty of the hieratic drawing" and the clarified composition of *La Grande Jatte* were misunderstood. Adam liked the figures' stiff, "stamped-out forms," which he deemed appropriate to contemporary life as well as to earlier art, for Seurat captured "the sound of the modern" with what the critic called "the pure drawing of the primitives." Like other Symbolists, he linked modernity with primitivism, a pairing that applied as well to the Pissarros and Signac.

Critics such as Adam and Fénéon understood *La Grande Jatte*'s modernity as vested in Seurat's "science," which they admired because they were rebelling against the view prevalent since Romanticism that confused abstract science with bourgeois

materialism. After all, Blanc had defined "optical mixture" in a pseudoscientific manner that linked rational procedures with art. Scientific rationalism was deeply embedded in nineteenth-century industrial culture, but it had usually been considered as the enemy of the romantic individualism that characterized avant-garde art. Fénéon, like Pissarro, Seurat, Signac, and many of the Symbolists, however, recognized the potential of science, which, rightly conceived, could be a servant to artistic creativity and not just the creature of bourgeois culture. Later in the decade, this also became a central tenet of anarchism, as formulated by Pierre Kropotkin and Jean Grave. The Symbolists redefined naturalism as a screening process, relying upon conscious human thought—Adam's "idea-phenomenon"—to provide perspective on the too-casual patterns of external reality associated with Impressionism. As Seurat's geometric certainties of form and his "scientific" divided color demonstrated, the highest reality lay in the mind. We now realize that, for a long time after 1886, his "science," supported by his own references to color theory and Fénéon's published explications, obscured the fact that his process grew slowly out of his practice and was predominantly a feature of his craft. Nonetheless, those who disliked his work and those who admired it all agreed that it was scientific.

Fénéon, more than any other, celebrated Seurat's science. In his article that spring, he defended the painter by defining his optical mixtures, firmly attaching his method to the world of science by referring not to Blanc, but rather to Rood. Seurat's scientific bent was also vested in the impersonal qualities of his style. He was fortunate to have Fénéon and other Symbolists as defenders because, despite the actual variety of his touch, the brushwork in *La Grande Jatte* seems nearly uniform from normal viewing distance, and this apparently mechanical aspect has always needed defense. It was attacked in 1886 and afterward as too automatic and soulless, but Adam, Fénéon, and others argued that it was an appropriate expression of the wedding of rational procedure to creativity.[23] Adam deplored Impressionist facture as a bag of tricks that conveyed romantic individualism. On the other hand, the regularity of Seurat's process bespoke conscious decisions, that is, rationality; hence, it was scientific because it removed technique from the merely fortuitous, superficial, and emotional. Fénéon praised his method as "monotonous and patient spotting, tapestry." In the fall of 1886 and in the following years, he would continue to use his synoptic wit to write about Seurat's technique as a quasi-scientific process.

Notes

1 For all eight Impressionist exhibitions, see Moffett 1986.

2 To display twelve panels in one frame was so unusual that, except for groupings of prints and of photographs, there is no known precedent in French exhibitions of the Impressionist era. Seurat listed them at the end of November with short titles that allow identification of nine panels. See Herbert et al. 1991, Appendix D. Five among the twelve are in the present exhibition: CATS. 6, 16, 19, 51, and 83. No reviewer of the New York shows mentioned the panels or the landscape. In the midst of short accounts that were at best lukewarm toward Impressionism (only Manet and Degas received guarded praise), *Bathing Place* was singled out for derisive remarks about its drawing and color (critics did note that it was the exhibitions' largest painting). See the anonymous reviews in *New York Herald Tribune*, Apr. 10, 1886; *New York Times*, Apr. 10 and May 28, 1886; and *Nation* 1085 (Apr. 15, 1886). For some of these references, I am grateful to Adrienne L. Jeske, Collection Manager and Research Assistant, European Painting, Art Institute of Chicago.

3 Ward 1986.

4 Camille to Lucien Pissarro, May 8, 1886, in CP 2, no. 334. For Pissarro's own art in 1885–86 and his relationship with Impressionism and younger artists, see the incisive article by Joachim Pissarro, "Pissarro's Neo-Impressionism," in Kochi, Museum of Art 2002, pp. 249–54.

5 Its own wall or partition ("un panneau entier"), Verhaeren stated later; Verhaeren 1891 (ed. 1927, p. 196).

6 For a careful study of the reviews, see Ward 1986.

7 Moore 1886 (Seurat's Argus); repr. in Berson 1996, pp. 435–36.

8 Anon., in *La République française* (May 17, 1886) (Seurat's Argus); repr. in Berson 1996, pp. 471–72.

9 In addition to the reviews reprinted in Berson, all in his Argus, Seurat had copies of several that are not listed in Berson and not referred to by later historians. These include, in longhand, a paragraph labeled "Court et Society Review, Londres, 3 juin 1886," whose anonymous author wrote (in French), "Seurat, a newcomer, exhibits a large painting, 'A Sunday on La Grande Jatte,' an interesting essay in synthesizing different elements of modern life, but I prefer his less ambitious works." Other reviews not in Berson include (often with Seurat's imprecise references, and always making only brief mention of the artist): Dolent in *La Revue contemporaine* (May); *Revue des journaux et des livres* (May 30); Savine in *La Revue littéraire* [Bordeaux] (June); [Alphonse?] Germain in *Le Coup de fer* (Aug. 1); Arsène Alexandre in *L'Evénement* (Aug. 23); Bertrand in *La Revue verte* (Sept. 10); Brinn-Gaubast in *Le Décadent* (Sept. 20); and Louis Jeannin in *Le Tam-Tam*; *Passant Romanet* [Perpignan].

10 Fèvre 1886, p. 148 (Seurat's Argus); repr. in Berson 1996, pp. 445–47.

11 Pissarro's phrase refers to his *View from My Window: Gray Day* (Ashmolean Museum, Oxford), shown in the May–June exhibition but later repainted; it appears in a letter to Lucien of July 30, 1886, in John Rewald, ed., *Camille Pissarro, Lettres à son fils Lucien* (Paris, 1950), p. 109. The relevant sentence (portions were inadvertently omitted in CP 2, no. 348) reads: "It seems that the subject didn't sell because of the red roof and the poultry yard, just what gives character to this canvas, which has the cachet of *modern primitive*."

12 Moore 1886 (Seurat's Argus); repr. in Berson 1996, pp. 435–36.

13 Ajalbert in *La Revue moderne*, June 10, 1886 (Seurat's Argus); repr. in Berson 1996, pp. 430–34.

14 The growth of Symbolism out of naturalism, and the continuing parallels between the older naturalist writers and younger Symbolists, are especially well treated in Zimmermann 1991 and more succinctly in Smith 1997.

15 In November 1886, Seurat listed owners of his work; see Herbert et al. 1991, Appendix D. Seurat's gifts were probably politic, encouraging writers to look well upon his art, and some seem to have been calculated to appeal to their recipients. He gave Caze, whose writings favored entertainers and street people, *Acrobat by the Ticket Booth* (CAT. 31, p. 119); to Huysmans he presented *Condolences* (CAT. 87, p. 120), appropriate to that writer's sober subjects.

16 For sensible accounts of Seurat's possible sympathy with anarchism after *La Grande Jatte*, see Zimmermann 1991, pp. 326–31; and John Hutton, "Georges Seurat," in Kochi, Museum of Art 2002, pp. 233–39.

17 "Un Camarade impressionniste" [Signac], "Impressionnistes et révolutionnaires," *La Révolte* 4, 40 (June 13–19, 1891), p. 4. We have to take into account that Luce, Pissarro, and Signac never mentioned Seurat's participation in their anarchist activities, and they seem never to have solicited it. Their letters imply that they considered him aloof from such engagement; indeed, the years from 1888 to his death constituted the period of his greatest withdrawal and secretiveness. It seems most likely that Seurat's beliefs were on the left, but probably not close to those of the anarchists.

18 Appendix B. The avant-garde did not entirely dismiss Blanc: Gauguin copied his color wheel and seems to have invented a supposed Turkish painter's manual, whose "sacrifice of Okraï" paraphrases of Blanc's "sacrifice of Iphigenia" (Blanc 1880, p. 487). Seurat borrowed and copied Gauguin's curious text. See Herbert et al. 1991, Appendix P.

19 Blanc 1880, pp. 667, 598.

20 Adam 1886 (Seurat's Argus); repr. in Berson 1996, pp. 427–30.

21 Gustave Kahn, "Répose des Symbolistes," *L'Evénement* (Sept. 18, 1886), p. 3.

22 Zimmermann 1991 and Smith 1997 pay particular attention to Blanc's idealism.

23 Blanc would have hated Seurat's technique as too radically modern, but he did prefer impersonal brushwork: "What it [the painter's touch] ought to reveal to us is not so much the personal character of the master as the character of his work" (Blanc 1880, pp. 574–75).

5 Seurat and *La Grande Jatte*, 1886–91

Seurat continued to frequent the island of La Grande Jatte after the Eighth Impressionist Exhibition, producing three easel paintings along the same shore, two in following months and one in 1888 (FIG. 2). In *Gray Weather on La Grande Jatte* (FIG. 1), he explored the Parisian basin's diffused, moist light, which does not produce strong shadows, an effect that had intrigued Monet as well (see for example CAT. 93, p. 99). *Gray Weather* possesses a typical Barbizon and Impressionist composition of a distant shore seen across a slanting foreground and a body of water. So does *The Bridge at Courbevoie* (FIG. 3), made from vantage point C on Signac's diagram (CH. 3, FIG. 4), but it is more crisp and flat, and looks forward to the geometry of *Parade de cirque* (FIG. 5). Seurat made a preparatory drawing (CAT. 89, p. 134) on the site; in the painting, he added the tall sail of a moored boat, two figures, and foreground shadows. The insistent verticals of masts and reflections— they tilt slightly to our left—in both drawing and painting are not, despite appearances, founded on any regular geometric scheme; furthermore, no two intervals have the same width. The image is particularly economical in its forms, probably because the artist conceived it as a study for a painting. It contrasts with an independent drawing of about the same time or slightly earlier, *Approach to the Bridge at Courbevoie* (CAT. 86), in which Seurat created a rich assortment of grays and blacks with his constantly moving crayon. He must have based this drawing on what he actually saw, because we cannot readily imagine that studio work alone

could result in such a convincing view of the river underneath the projecting arch of the bridge.

As for *La Grande Jatte*, it was displayed again at the second exhibition of the Indépendants, which opened on August 21, 1886, only two months after the closing of the spring Impressionist show. It was accompanied by the same Grandcamp seascapes the artist had shown in the spring, plus another from Grandcamp (CAT. 81, p. 60), an earlier canvas, *Field of Alfalfa, Saint-Denis* (CAT. 76, p. 55), a recently completed view of the port of Honfleur (Kröller-Müller Museum, Otterlo, the Netherlands, H 163), and two *croquetons* (H 116 and H 132). Although there were very few reviews of the Indépendants' show, probably because of the late summer doldrums and the recent flurry of attention given the Eighth Impressionist Exhibition, Fénéon elaborated his defense of Seurat that autumn. He not only wrote a major article for the Belgian journal *L'Art moderne*, in which he coined the term "Néo-Impressionnisme," but also included a revised version of his June essay in a separate brochure, *Les Impressionnistes en 1886*, published by *La Vogue*, the Symbolist review with which he, Kahn, and Henry were closely allied. For his autumn publications, Fénéon consulted Pissarro, who offered advice on Neoimpressionist technique but deferred to Seurat as its initiator (Fénéon seems not to have queried Seurat at this time).[1] Pissarro abstained from the Indépendants event, but Signac and Lucien Pissarro were joined by Angrand, Cross, and Dubois-Pillet, who were to form the nucleus of the Neoimpressionists. (Dubois-Pillet

was already using finely divided color, but Angrand and Cross only slowly adapted to the new technique in the coming years.)

Seurat spent the summer after the Eighth Impressionist Exhibition at Honfleur, the famous, once-bustling, old seaport at the mouth of the Seine that had long since receded into picturesque quietude. In addition to the picture shown in late summer with the Indépendants, he began six other canvases, which he completed in his studio in the following months. Small panel studies survive for four of them, each characterized by somewhat more regular strokes than those done at Grandcamp. The distant shore and boats in the study for *The Shore at Bas-Butin, Honfleur* (CAT. 91, p. 135) would not be decipherable if we did not have an extant canvas (FIG. 4) to compare it with, further proof that the artist was examining nature closely while finding ways to reproduce its colors, no matter how schematic they appear.

The intensity of Seurat's gaze, of course, does not explain how he framed his compositions with his habitual clarity, only that he based their persuasive effects on vision. Huysmans, who did not like *La Grande Jatte*, admired *Lighthouse and Mariners' Home, Honfleur* (CAT. 88, p. 137) when it was exhibited in 1887. Referring to the seascapes Seurat was showing, "especially his lighthouse," he wrote, "These clear and blond canvases, enveloped by a powder intoxicated with sunlight, disclosed a very personal and true grasp of nature." The writer detected romantic undercurrents in the artist's insistent modernity. "I find in them a fullness of expansive air, a siesta of a quiet soul, a distinction of wan indolence, a caressing lullaby of the sea that soothes and dissipates my weary cares."[2] Today, schooled by the love of abstraction, we are more apt to respond to the linear structure of the boat cradle in the lighthouse picture, or to the repeated verticals of the wood pilings in *Evening, Honfleur* (CAT. 90, p. 136) and to its echelon of clouds above, although we are aware of the Romantic precedents for its isolated rock.

Seurat was by no means the only artist on whom those alert to contemporary painting focused. Pissarro's established reputation gave his adoption of the new technique particular importance, although several critics and his dealer, Durand-Ruel, deplored the change. *Landscape at Éragny* (CAT. 105, p. 137) is typical of the paintings he did in stippled technique in 1886; here, he mitigated Seurat's and Signac's strong contrasts of warm and cool colors with his personal preference for more integrated tints. In watercolors and drawings, as well as in oils, he figured centrally in Neoimpressionism until later in the decade, when he gradually abandoned its strict method.[3]

Signac, as we have seen, was the group's most active proselytizer. He came into his own in the

summer of 1886 with a series of splendid landscapes painted at Les Andelys, along the Seine not far from Rouen. Four of these, together with *Gas Tanks at Clichy* (CAT. 117, p. 127) and other paintings from the Eighth Impressionist Exhibition, appeared at the Indépendants in August and September. One, *Les Andelys, Château Gaillard* (CAT. 115, p. 138), evokes both mid-century subjects and the Romantic personification of a site; nevertheless, its geometry

and systematic brushwork are defiantly contemporary. Signac exhibited more pictures from Les Andelys with the Indépendants in February 1887. *Riverbank, Les Andelys* (CAT. 119, p. 139) recapitulates familiar scenes along the Seine by the Impressionists, but departs from them with its strong patterning of warm and cool hues and cross-stitched technique. Similar color contrasts mark *Hillside from Downstream, Les Andelys* (CAT. 118, p. 140),

enhanced by the quiltlike pattern of the hill and the blue shadow of overhead foliage on the beach.

Signac accompanied Seurat to Brussels in February 1887 for the third and last appearance of *La Grande Jatte* during the artist's lifetime. His picture appeared in the annual exhibition of Les Vingt (The Twenty), a Belgian vanguard artists' society. Octave Maus, the group's chief organizer, and the writer Verhaeren asked him to participate. Both

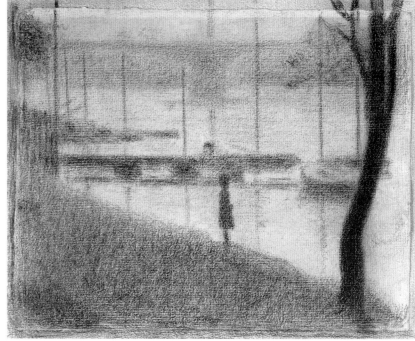

had visited Seurat the previous fall, when Ver-
haeren bought *Corner of the Harbor, Honfleur*
(1886; Kröller-Müller Museum, Otterlo, the Nether-
lands, H 163), Seurat's first sale, as far as we know.
Other French artists invited to exhibit that year
included Morisot, Pissarro, J.-F. Raffaëlli, and Rodin.
In addition to his big canvas, Seurat again exhib-
ited two seascapes from Grandcamp and four from
the summer of 1886 at Honfleur. Verhaeren bought
Lighthouse and Mariners' Home, Honfleur
(CAT. 88, p. 137), and a Belgian collector, Henri van
Cutsem, acquired *The Shore at Bas-Butin,*
Honfleur (FIG. 4).

By accompanying Seurat to Brussels, Signac,
although not an exhibitor, helped cement relations
with Belgian artists, including A. W. Finch and Van
Rysselberghe, who soon joined the growing band of
Neoimpressionists. Signac was far more accessible
than Seurat, and the example of his Les Andelys
paintings, exhibited with the Indépendants in late
summer 1886 and again in the late winter of 1887,
made him fully the equal of Seurat; he showed work
in the 1888 Les Vingt exhibition. Strong ties
between Paris and Brussels already existed, with
Fénéon contributing to progressive Brussels journals,
and Verhaeren to several in Paris. By the end of
the decade, Neoimpressionism could claim Brussels

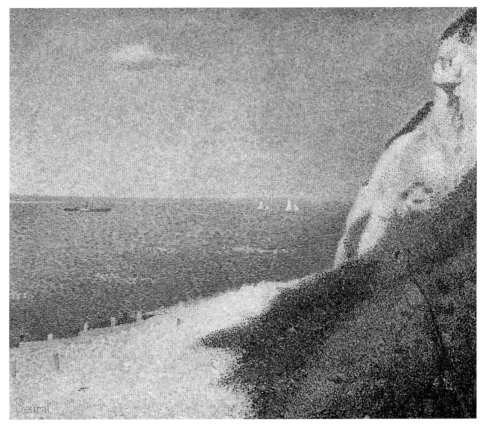

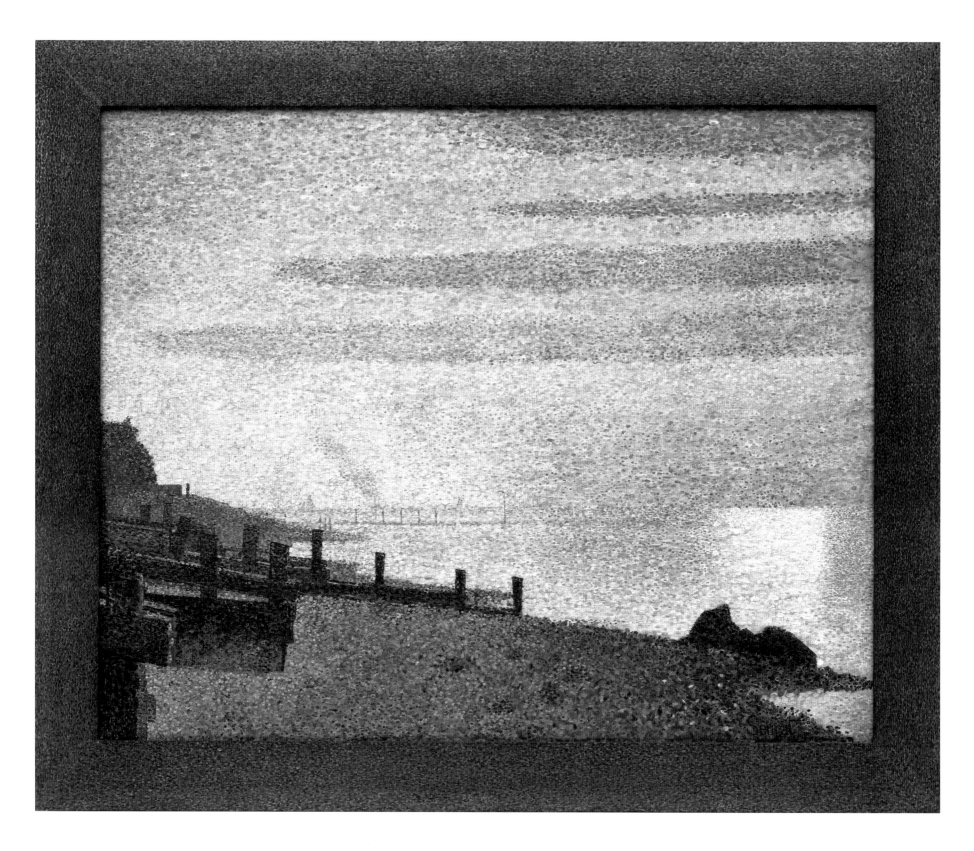

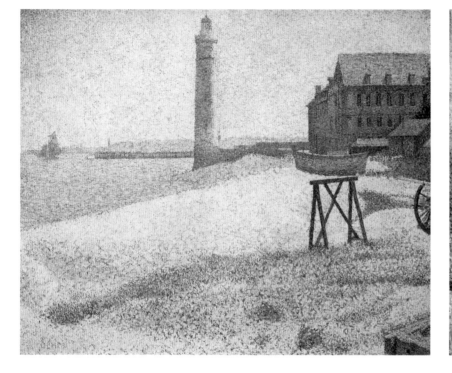

as a major outpost, with the addition of the painters Lemmen and Van de Velde, and generous attention in the Belgian press.[4] Seurat showed with Les Vingt in 1889 and 1891, and Signac again in 1891, by which time he had joined the society. Meanwhile, the Neoimpressionists in Paris had become the heart and soul of the Société des Artistes Indépendants. Dubois-Pillet was its most efficient organizer and Signac its leading propagandist. Seurat regularly attended the periodic banquets of the Indépendants; he took part in their meetings and in the installation of their shows. He and Signac were treated as the Indépendants' artistic leaders. In March 1890,

the two men showed French president Sadi Carnot through the society's exhibition, "explaining to him the methods and merits of the new school."[5]

After the Eighth Impressionist Exhibition, Seurat occasionally showed a few works in dealers' shops and at the premises of *La Revue indépendante* (which Fénéon edited), and continued to participate regularly at the annual exhibitions of the Indépendants. Every summer, except for 1887, when he had two large figure paintings under way, he painted along the Channel coast: Honfleur in 1886, Port-en-Bessin in 1888, Le Crotoy in 1889, and Gravelines in 1890. Each year he displayed a

group of these seascapes with the Indépendants, together with large canvases: *Parade de cirque* (*Itinerant Fair*) and *Poseuses* (*Models*) in 1888 (FIGS. 5, 9); *Chahut* (*Naturalist Quadrille*) and *Young Woman Powdering Herself* in 1890 (FIGS. 12, 6); and *Circus* in 1891 (FIG. 13).

Seurat's reputation grew apace in these years, carried along by the expanding vogue for Neoimpressionism. Already in 1886, artists such as Bernard and Schuffenecker essayed tightly controlled brushwork resembling Neoimpressionist technique. Befriended by Signac in 1887, Van Gogh executed paintings for several months in a modified

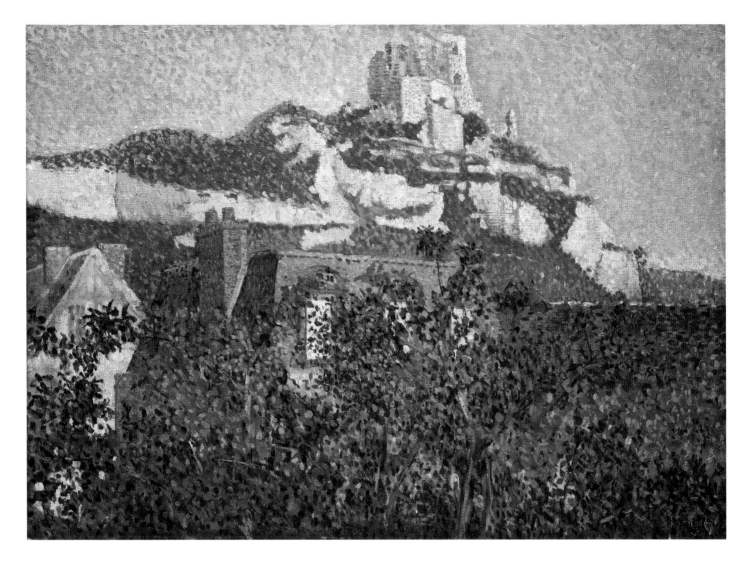

Neoimpressionist manner. His *Self-Portrait* of that spring (FIG. 7) makes bold use of color opposites and divided color; the characteristic energy of his handling is somewhat closer to Signac's than to Seurat's. In *Corner in Voyer-d'Argenson Park in Asnières* (FIG. 8), painted later that year, Van Gogh used subdued dotted and stitched brushwork rather like Lucien Pissarro's. Neoimpressionism was vital to Van Gogh, for its disciplined theory of color brought up to date one of his heroes, Delacroix, and gave him the courage to use saturated hues in separate strokes. He visited Seurat's studio once before his departure for the south of France, and

his letters from Arles make frequent reference to the artist, whose work he believed the young generation should study in preference to that of the older Impressionists.[6] *La Grande Jatte* remained fresh in his mind because, as Douglas W. Druick and Peter Kort Zegers have shown, in 1889 he referred to Bernard's *Breton Women in the Meadow* (FIG. 11) as "Sunday afternoon in Brittany," and noted the resemblance of Bernard's "elegant modern figures [to] the manner of ancient Greek and Egyptian art."[7]

Van Gogh's remarks and Bernard's paintings show the impact of the decorative and "primitive"

features of *La Grande Jatte*, even before there were reproductions of it to refresh artists' memories. One could readily retain an image of the painting's striking silhouettes, which Seurat's later pictures never entirely eclipsed. In 1888 a major article by Adam featured an embellished initial letter of the profile, reversed, of Seurat's *promeneuse* (p. 297); Seurat was the first painter Adam discussed in that piece. Of course Gauguin, Seurat's fellow exhibitor in 1886, knew the painting well. He, too, had apprenticed himself to Impressionism and had become friendly with Pissarro; Gauguin was equally concerned with the ways that color and line could

CAT. 115 (OPPOSITE)

Paul Signac. *Les Andelys, Château Gaillard*, 1886. Oil on canvas; 45 x 65 cm (17 ¾ x 25 ⅝ in.). The Nelson-Atkins Museum of Art, Kansas City, Missouri, purchase, acquired through the generosity of an anonymous donor. FC 120.

CAT. 119

Paul Signac. *Riverbank, Les Andelys*, 1886. Oil on canvas; 65 x 81 cm (25 ⅝ x 31 ⅞ in.). Musée d'Orsay, Paris, acquired through gift. FC 128.

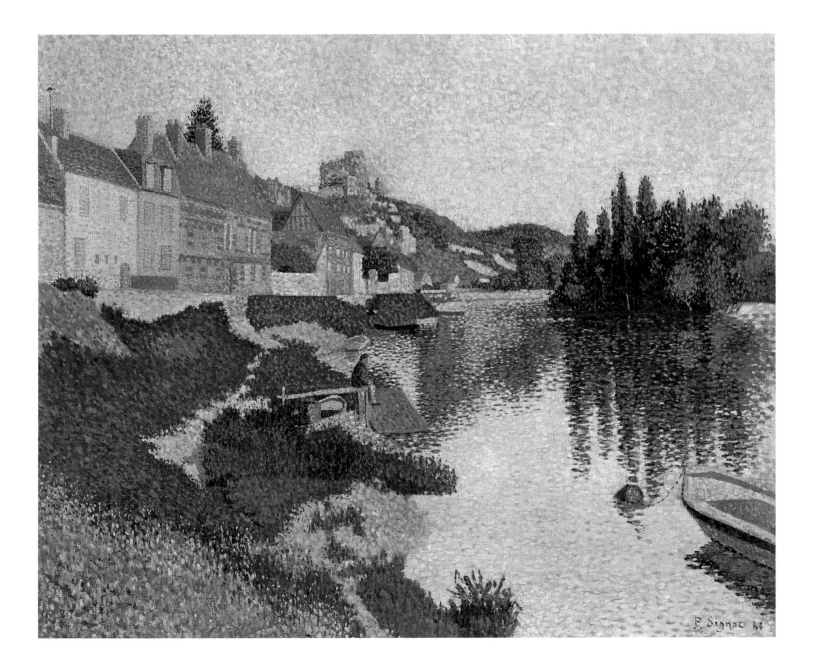

Paul Signac. *Hillside from Downstream, Les Andelys*, 1886. Oil on canvas; 60 x 92 cm (23 ⅝ x 36 ¼ in.). The Art Institute of Chicago, through prior gift of William Wood Prince. FC 125.

FIG. 5

Parade de cirque (Itinerant Fair), 1887–88. Oil on canvas; 99.7 x 149.9 cm (39 ¼ x 59 in.). The Metropolitan Museum of Art, New York, bequest of Stephen C. Clark, 1960. H 187.

FIG. 6

Young Woman Powdering Herself, 1889–90. Oil on canvas; 95.5 x 79.5 cm (37 ⅝ x 31 ¼ in.). Courtauld Institute Gallery, London. H 200.

transmit emotions. After 1886, however, Gauguin's subjects and techniques veered away from those of the Impressionists, and by 1888 he was using radically flat zones of color that are at a great remove from Seurat's busy textures. His primitivism, also, looked not just to Brittany, where he was working, but to exotic, non-European sources that had no parallel in Seurat's oeuvre.

Neither Van Gogh nor Gauguin gained prominence until the end of the decade; in fact it was Seurat who stood at the forefront of the young avant-garde from 1886 to 1890. Relations of the Neoimpressionists with their literary peers were honed in frequent meetings in various cafés and editorial offices; the writers often attended the periodic banquets of the Indépendants. By 1888 this phalanx of authors included Adam, Ajalbert, Alexis, Christophe, Fénéon, Kahn, and Verhaeren, as well as Jules Antoine, Dujardin, Charles Morice, Charles Vignier, and Téodor de Wyzéwa.[8] The last five named were only lukewarm about the movement, but the first group, which Lecomte joined in 1890, formed a veritable claque of ardent supporters, more numerous and cohesive than those who would become apologists for Picasso and Braque around 1910.

Although it is clear that a wide circle of writers knew Seurat's paintings, and a smaller one his aesthetic ideals, only Kahn repeatedly stated the reasons for the links between the Neoimpressionists and the Symbolists. In an 1887 article, he distinguished Seurat, Signac, and Pissarro from the earlier Impressionists (without naming the latter):

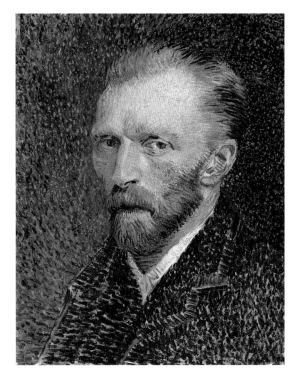

Armed with a new process (juxtaposition of small strokes [*points*]) permitting them to follow more exactly the subtlety of light and its effects, they prefer calm countryside, less troubled waters, and want to give to the landscape not just its current hour, but its day-long silhouette. Turning to the human figure, neglecting indifferent rhythms, they strive to re-create it synthetically: every contortion, every movement of joy or suffering being temporary, they suppress them and try to give to modern passers-by a little of the hierarchism and eternal aspect of antique statues.

He continued:

> In this their aims are allied with those of the new writers who also, in destroying the useless and familiar rules of writing, wish to make of poetry something possible only for real poets.... This fundamental meeting of minds among progressives of different arts is for everyone a proof of the truth of research, by their similarities and by taking the same path in the only possible aesthetic.[9]

"The same path" was pursued also by Henry, a mathematician and aesthetician. Henry, Kahn, and Laforgue had formed close friendships by 1879, and Fénéon became their intimate by 1885. Henry figured prominently among the Symbolists, who reviewed his books and published his articles. Kahn wrote that the concepts Henry put forth in an article entitled "Introduction to a Scientific Aesthetic" of 1885 were influential in Symbolist writings, and

FIG. 9

Poseuses (Models), 1887–88.
Oil and gesso on canvas; 200
x 250 cm (78 ¾ x 98 ⅜ in.).
The Barnes Foundation,
Merion, Pennsylvania. H 185.

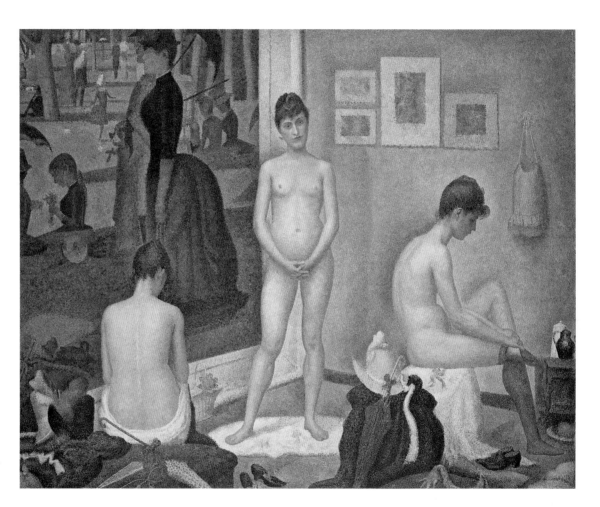

that "these theories are based on the purely ideal-ist philosophical principle that makes us reject any material reality and accept the existence of the world only as representation."[10] Seurat and Signac met Henry at the time of the Eighth Impres-sionist Exhibition, and one year later, when begin-ning his *Parade* (FIG. 5), Seurat copied on a sheet of studies several salient passages from "Intro-duction to a Scientific Aesthetic."[11] These excerpts came from a paragraph in which Henry wrote that scientific study of the subjective impressions of movement, color, and sound was retarded because prior generations ignored the "composi-tion of forces" (Henry's conception of interrelated rhythms) and the "decomposition of the spec-trum"—both phrases that Seurat copied. Seurat had little relation with Henry himself, but Signac became a close collaborator of the aesthetician. He made a colored poster for Henry's *Cercle chromatique* (1888), and over several years provided illustrations for Henry's lectures and publications.

What intrigued Seurat about Henry was the aesthetician's mathematical and theoretical substan-tiation of ideas that the artist had already encoun-tered in Blanc. In his *Grammar*, Blanc had drawn upon the arcane writings of D.-P.-G. Humbert de Superville to explain that upward-moving lines express gaiety, horizontal ones calmness, and down-ward ones sadness, that is, lines are "emotional signs" (see FIG. 14).[12] Henry identified these move-ments with physiological sensations that he said could be proved in experiments, and further that,

like colors, they obeyed rules of mathematical relationships. Seurat may not have understood all of Henry's points, but he saw the connection with Blanc and Superville, because the page of studies with Henry's words also includes an overlay of Superville's three schematic faces, indicating gaiety, calmness, and sadness.

Henry therefore did for Blanc's and Superville's theory of expression what Rood had done for Chevreul and Blanc: he brought their thinking up to date, making them eligible for Seurat's admira-tion. Did knowledge of Henry have anything to do with *La Grande Jatte*? The answer is no, both because the two met only at the time of the Eighth

Impressionist Exhibition and because there is nothing in the picture that evokes Henry's thinking. *Parade*, however, has a documented connection with the aesthetician, although just what Henry added to Blanc's and Superville's beliefs is unclear. The picture's internal proportions, like those in *La Grande Jatte*, are based on simple mathematical subdivisions and do not exhibit Henry-like rhythms. It is true that its dominant horizontals contribute to the picture's expression of calmness, but Seurat could just as well have derived this from Blanc, who headed a section on architecture in his *Grammar* with Superville's "calm" face and the words, "Monumental architecture in parallel planes expresses ideas of calmness, fatality, and duration."[13]

Egyptian art fit logically into the Symbolists' admiration for Seurat; it also inspired Gauguin. They may not have been aware of the similarity of Blanc's concepts to theirs, but their preference

for "essences" and permanence, in contrast to the fluttery moments that the Impressionists tried to capture, aligned them with Blanc. *La Grande Jatte*, we remember, was likened to Egyptian art; although *Parade* was not (it received hardly any mention), we recognize parallels with Egyptian art's extraordinary flatness, silhouetted figures, and sense of geometry. In his obituary of Seurat, Kahn wrote that the artist preferred "the hieratic arts, like the Egyptians and the primitives," but especially "more flexible art, like Greek friezes and Phidias's work."[14] We cannot insist that Seurat was responding directly to Egyptian art in *Parade*, but the calmness that the young artist ironically gave his painted entertainers must indicate his awareness of Blanc's associations with this ancient visual tradition. Once again, however, as in *La Grande Jatte*, "Egyptian" qualities are paralleled by elements seen in the popular arts. For decades there was a convention in the media for illustrating itinerant fairs as if from behind a group of spectators; over their heads, we see the entertainers arrayed in horizontal friezes. Seurat's ironic but serious intent, to show the vanity of human pleasures, and his nearly caricatural figures are closer to this tradition than to Egyptian art.

Parade was displayed in the 1888 Indépendants exhibition, together with *Poseuses* (FIG. 9) and eight drawings, four of them devoted to the café-concert. *La Grande Jatte* made another appearance, this time as a picture within a picture hanging on a wall behind the three young women in *Poseuses*. In his review, Adam, who, like Seurat's other friends, preferred this picture to *Parade*, recalled the notoriety attached to *La Grande Jatte* and contrasted the nudes, revealed in "nature's simplicity," to the costumed women in the painting on the wall, "stiff and stilted, solemn under summer's warm foliage, with gestures and bearings that assimilate them with Egyptians parading in pious theories on stelae and sarcophagi."[15] The foreground figures, however, are very different from those in *Parade*, not least because Seurat carefully modeled them to suggest their volume, as if he were determined to prove the efficacy of his technique by applying it to one of the key subjects of traditional art. Not only does the central figure recall his youthful drawings after the antique, but there is also a resonating echo of the well-known classical theme of the Three Graces. Puvis de Chavannes had made more than one painting of three nudes (the traditional "three-figure problem"), and Renoir's *Large Bathers* (FIG. 10), on which he worked from 1884 to 1887, features

FIG. 12

Chahut (Naturalist Quadrille),
1889–90. Oil on canvas; 170 x
141 cm (66 ⅞ x 55 ½ in.).
Kröller-Müller Museum, Otterlo,
the Netherlands. H 199.

the same grouping, based upon a famous sculpture
of 1670 by François Girardon in the gardens at
Versailles. Renoir had begun his "Ingres" or "Sour"
period in 1883, when he turned to prototypes of
"the great tradition." If Seurat had known *Large
Bathers* (perhaps he saw it when it was exhibited
in the summer of 1887), he would have regarded it
as old-fashioned, but he may have realized that he
was not the only one trying to make Impressionism
into an enduring art.

Another feature of *Poseuses* that ties it to tradi-
tion is the preparation of the canvas, for Seurat
painted it over gesso, a liquid white plaster, instead
of the white paint used by Renoir to undercoat
his pictures. Gesso was a way of combining the
Impressionists' white grounds with an ancient tech-
nique, although it evidently gave Seurat trouble.
He complained to Signac that the process was "very
discouraging. Can't understand a thing. Everything
stains—very heavy going."[16] By now his brushwork
consisted of very fine strokes, closer to the "dots"
he had been falsely accused of using in *La Grande
Jatte*. His fastidious technique, together with
the gesso, told contemporaries that he was deeply
plunged into "science."

If Seurat's nudes evoke tradition, his way of
treating them is decidedly modern. As Françoise
Cachin noted, *modèles* is the customary word in
French for such figures, not *poseuses*.[17] Thus,
the sense of the title, "models posing," strips them
of high-art attributes and makes them into hired
workers for the artist, at whom one of them gazes
frankly, albeit chastely. Naked they are, but their

FIG. 13
Circus, 1890–91. Oil on
canvas; 186.2 x 151 cm
(73 ¼ x 59 ½ in.). Musée
d'Orsay, Paris. H 213.

FIG. 14
Schematic faces from D.-P.-G.
Humbert de Superville, *Essai
sur les signes inconditionnels
dans l'art* (Leiden, 1827), p. 6.

sexuality is minimized by the absence of any vol-
uptuousness (even Puvis's nudes have more sex
appeal), a further indication of their matter-of-
factness as mere models. Their brilliantly colored
clothing in the foreground indicates their fashion-
ability, while the bustle harness on the wall rein-
forces their dialogue with the clothed women in
the painting behind them: nature and artifice are

brought together in the studio. In Leila Kinney's
words, Seurat "was recovering the body as the
primary unit of expression and scattering clothing
as mere raw material in the atelier, awaiting the
painter's synthesis."[18]

Modernity was even more securely located in
Seurat's technique. A new feature of his craft-cum-
science emerged in 1888. It is obvious that Seurat
did not resemble Gauguin, who worked in many
media: painting, sculpture, ceramics, printmaking,
and decoration. But within his limited realm, Seurat,
like Gauguin, wanted to begin art all over again,
including the framing of his pictures. *Poseuses* was
exhibited with two frames, a narrow one whose
colors contrasted with the adjacent ones on the
canvas, and a wider outer frame painted white. Sub-
sequently, the narrow surround was replaced by
a border painted on the canvas itself. From 1888
until his death, Seurat added borders to current
pictures and reworked older ones by restretching
canvases to allow room for these colored bands.
He enlarged both *La Grande Jatte* and its large
study for this purpose sometime after 1888. He
restretched them on their sides, but there already

was enough space on the top and bottom for the
additions. Seurat prepared the strips under the
added borders with a white undercoat.[19] To both
the sketch and finished picture, he then applied a
sprinkling of small dots of color to contrast with
the newly painted borders (see Fiedler, FIG. 10), a
curious feature from the vantage point of naturalism,
but a logical one in view of his constant wish to
interrelate color harmonies on his painted surfaces.

By adding these borders, Seurat aimed to over-
come the oddities of shadows cast on the canvas
by its exterior frame and to provide a bridge to it.
In doing so, he perhaps remembered Chevreul's
attention to framing interior wall panels in borders
of contrasting harmonies, but he was also conscious
of contemporary concerns. As early as 1879, Cassatt
had shown a painting with a vermilion frame and
another with a green one.[20] Seurat explained to
Verhaeren that his painted borders and frames were
like Wagner's darkening his theater at Bayreuth in
order to isolate the stage from its surroundings.[21]
Contemporary critics, well versed in *wagnérisme*,
embraced this as another sign of Seurat's vanguard
position. In his obituary of Seurat, Kahn wrote that
the painter was quiet in large gatherings, but that,
among friends and small groups, he spoke readily,
"seeking to compare the progress of his art with
that of the arts of sound, very concerned with find-
ing unity underneath his efforts and those of poets
or musicians."[22]

By 1888 Seurat was also applying contrasting
colors to the exterior frames, much to Fénéon's

annoyance. Seurat "punctuates [the frame] with orange or blue according to whether the sun is behind or in front of the spectator, therefore according to whether the frame is in sunlight or shadow; and the frame, although remaining white [in theory], acquires . . . an absurd reality."[23] Few have liked these borders; most were later destroyed by the paintings' owners. *La Grande Jatte*; *Evening, Honfleur*; *Le Crotoy, Upstream* (1889; Detroit Institute of Arts, H 194); and *Circus* (FIG. 13) are among the few that retain Seurat's painted

surrounds. Inventing these features and adding borders to earlier pictures took so much of his time that he did very few independent drawings after 1888. Because he did not exhibit *La Grande Jatte* again, we do not know what kind of frame he might have made for it, because the white frame that surrounds it in the background of *Poseuses* must not have fit after he restretched the canvas for its painted border.

Seurat showed his next large composition, *Chahut* (*Naturalist Quadrille*) (FIG. 12), at the Indépendants in 1890. Its upper border curves downward at the corners to contrast with the rising movements of the composition; it had a particolored frame (probably like the surviving one for *Circus*), which was subsequently discarded.[24] For *Chahut* we have to consider the now-familiar relationships: Blanc and Superville, Henry and scientific aesthetics, primitivism and popular arts. The *chahut* was a "naturalist quadrille," a sexually provocative dance originally performed in shady lairs but, by mid-century, enjoying slightly more respectable venues. Several of Seurat's critic friends invoked Henry in their reviews of *Chahut*; indeed, the upwardly swinging forms have a diagrammatic simplicity that reflects Henry's concentration upon line as the expression of movement.[25] Nonetheless, the tripartite bows on the dancers' shoulders are a direct reference to Superville's diagram of three upward lines that Blanc had reproduced, and the caricatured faces are foreshortened versions of Superville's image of gaiety. The exuberant rhythms

that animate the picture can be explained by reference to Superville and Blanc. In interviews with Verhaeren, Seurat spoke of Blanc, not Henry, so that once again we are left with the feeling that the latter's theories hover in the background as scientific support for earlier ideas still coming to the forefront. Moreover, Blanc discussed Egyptian art in terms the Symbolists could have used for *Chahut*:

> The lines are straight and long, the posture stiff, imposing, and fixed. The legs are usually parallel and held together. The feet touch or point in the same direction and are exactly parallel. . . . In this solemn and cabalistic pantomime, the figure conveys signs rather than gestures; it is in a position rather than in action.[26]

Circus, Seurat's last large painting, was on view in the Indépendants exhibition when he died, apparently of malignant diphtheria, on March 29, 1891, three months past age thirty-one. Like *Parade* and *Chahut*, it takes the viewer into the world of popular entertainment (here, a permanent circus building in Montmartre) and revealed Seurat to be a premier interpreter of popular culture. The composition shares with *Chahut* caricatured figures and upward-swinging rhythms, including the three-pronged motif associated with Superville's theory: the clown's hat and cuff, the acrobat's form, and portions of many of the figures in the stands. If anything, it is even more decorative than *Chahut*. In reality the grandstands were sharply curved (the one-arena space was tiny), but Seurat treated

FIG. 16

The Channel at Gravelines:
Petit Fort-Philippe, 1890.
Oil on canvas; 73.4 x 92.7 cm
(28 ⅞ x 36 ½ in.). Indianapo-
lis Museum of Art, gift of Mrs.
James W. Fesler in memory
of Daniel W. and Elizabeth C.
Marmon. H 208.

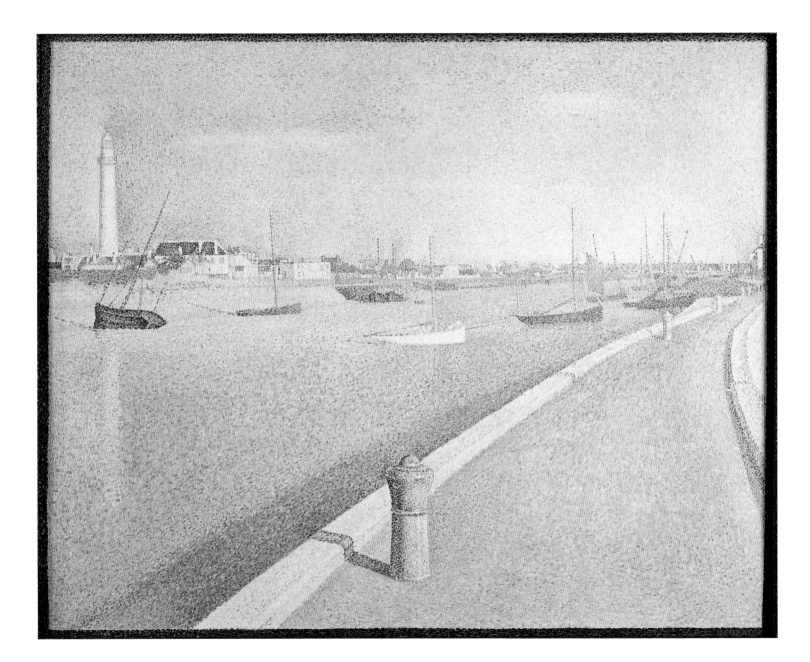

them as horizontals to create a flat backdrop for the dynamic foreground. Although earlier he may have looked to Egyptian art for its geometric order, now contemporary posters by Jules Chéret provide the nearest parallels (see FIG. 15) with both *Chahut* and *Circus*, as several reviewers pointed out. Chéret had a solo show in 1889, and we know that Seurat and his mother owned posters by him.[27] Seurat's early appreciation of popular and journalistic arts, reflected in *La Grande Jatte*, is embodied in the bubbly effervescence of Chéret's rhythms. "Chéret," wrote Verhaeren, "whose genius [Seurat] adored, charmed him by the joy and gaiety of his compositions. He studied them, hoping to decipher Chéret's expressive methods and to ferret out his aesthetic secrets."[28]

The excitable forms of *Chahut* and *Circus* do not respond directly to the abstruse theories of Blanc, Superville, and Henry, for, although the compositions are schematic, they are not abstract. They can instantly be read as identifying the world of popular entertainment that had loomed ever larger in Seurat's work since *La Grande Jatte*. We are now a considerable distance from that picture's stately procession and the subdued rhythms of an Impressionist park. Instead, we find ourselves in a world that would soon become familiar in the posters and paintings of Toulouse-Lautrec (another fan of Chéret) and other artists of the 1890s. "Poster style" and "Art Nouveau" are two terms applied to the look of that decade, which the work of Chéret and Seurat anticipated. Only a little more than ten years out of the École des Beaux-Arts, Seurat

had become a leading member of a generation that replaced classical heroines and heroes with the performers of Montmartre.

Seurat's last two large canvases fit well into vanguard enthusiasms of the later 1880s. The Symbolist press regularly chronicled circuses, music halls, theatrical revues, and café-concerts, another step in the continual co-opting of popular entertainments by modern artists. Seurat, for example, based *Chahut* on a drawing identified with Au Divan Japonais, a Montmartre cabaret.[29] Degas and Manet had treated the café-concert importantly in the 1870s, although they stressed the individuality of entertainers and spectators, whereas Seurat's late paintings depict puppets whose staccato movements acknowledge the increased commercialization of the genre. The perspicacious Meyer Schapiro saw this long ago:

Seurat's taste for the mechanical and his habit of control extend also to the human. The dancer and the acrobat perform according to plan, with an increasingly schematic movement. The grave Seurat is drawn to the comic as a mechanization of the human (or perhaps as a relief from the mechanical). The figures in the late paintings are more and more impersonal and towards the end assume a caricatural simplicity or grotesqueness in expressing an emotion. They have no inner life, they are mannequins capable only of the three expressions—sadness, gaiety and neutral calm—which his theory of art also projects on the canvas as a whole in the dominance of

the lines corresponding to the facial schemas of these three states—states which can be induced by the engineers of popular entertainment through the stimulus of the show in abstraction from individuals, counting rather on the statistical effect, the human average.[30]

We should add that there is something almost frantic in *Chahut* and *Circus*, whose mannequins grimace not so much in fulfilled pleasure as in frenetic attempts to realize it. *La Grande Jatte* has its puppets as well, but they are quietly stationed, and the ground lines controlling them are not quite as evident. They do not function so obviously as entertainment for the spectator as do the figures in *Parade*, *Chahut*, and *Circus*, and they are not so broadly caricatured either. Caricatures are a way of sharing a joke with the viewer at the expense of those depicted, even if done with the irony and bemused wit that Seurat displayed. We are kept at a distance from the artist's acrobats, dancers, musicians, and spectators not just because they are types but also because they move in stipulated rhythms, not like freely circulating, ordinary mortals.

The psychological remove of Seurat's performers has parallels with the four seascapes he did at Gravelines in the summer of 1890. "Penetrating melancholy" was a phrase applied by reviewers to his efforts of earlier years, like *Le Bec du Hoc* (CAT. 84, p. 63) of 1885, in which the viewer looks out from a lonely shore to the infinite sea. At this river port near the Belgian border, Seurat painted four canvases of greater sparseness than previous

sea views. Their austere mood results partly from the artist's sensitive rendering of a flat, sandy area crossed by a narrow river that resembles a man-made canal, and partly from his continuing predilection for large, geometric zones. In *The Channel at Gravelines: Petit Fort-Philippe* (FIG. 16), a lighthouse, the village, and boats form a horizontal strip, but the quay looms up in our faces in a forceful foreshortening that creates a strange mood, made the more strange by the outsized bollard. After only a moment's looking, we cannot avoid associating our bodies with this post, an inanimate object that Seurat treated as a kind of puppet. Its cast shadow, reminiscent of the pedestal-shadows in *La Grande Jatte*, points insistently to its position in the exact center, and the elongated shadow of the quay on the water likewise emphasizes the artist's calculated design. It is a landscape in which only the sky has been untouched by humans, and yet its delicate vibration of colors washes over an unruffled river, an unpeopled quay, and careened and moored boats without sailors. If the bollard makes us think of the art of Magritte, its vacuumed space has a De Chirico–like atmosphere into which we cannot really imagine walking.

The preceding sentence shows just how easy it is to approach Seurat anachronistically from twentieth-century referents, indeed, how difficult it is to avoid doing so. Seurat's late seascapes and figure paintings take the modern-day viewer to a less innocent realm than that of *La Grande Jatte*. In them the sense of order and control and of abstraction have odd psychological qualities that lack the comfort of his masterwork's beautifully manicured park, with its population of children, women, and men, who are like so many toys beneath toy trees. We cannot know where Seurat would have gone had he lived, but he certainly left the harmonies of *La Grande Jatte* far behind.

Notes

1 Pissarro to Fénéon, Sept.–Oct. 1886 (CP 2, nos. 350, 352, 354, 356).

2 J.-K. Huysmans, "Chronique d'art: Les Indépendants," *La Revue indépendante* 3 (Apr. 1887), p. 53.

3 For Pissarro's Neoimpressionism, see Ward 1996, esp. Chapter 3, "Pissarro and the New Technique."

4 For Neoimpressionism in Belgium, see Jane Block, "Seurat, Signac and the Vingtistes: Diffusion and Transformation of Neo-Impressionism in Belgium, 1886–1893," in Kochi, Museum of Art 2002, pp. 258–63.

5 Press clipping of Mar. 21, 1890 (Seurat's Argus).

6 Vincent to Theo van Gogh, June 1888, in *Complete Correspondence of Vincent van Gogh* (Greenwich, Conn., 1959), vol. 3, no. 500. Writing to Gauguin on Oct. 17, 1888, about *Bedroom at Arles* (Van Gogh Museum, Amsterdam), Van Gogh said he was emulating Seurat's color contrasts (red-green, purple-yellow, orange-blue), while adding a fourth, the white mirror and its black frame; ibid., no. B22.

7 Ibid., no. W16, cited by Douglas W. Druick and Peter Kort Zegers in *Van Gogh and Gauguin: The Studio of the South*, exh. cat. (Chicago, 2001), p. 223. For Van Gogh's and Gauguin's relations with Seurat, see also Mark Roskill, *Van Gogh, Gauguin and the Impressionist Circle* (Greenwich, Conn., 1970), pp. 90–96, 267–68.

8 Paul Alexis, *Cri du peuple*, Apr. 14, 1888 (Signac's Album); and Jules Christophe, "Symbolisme," *La Cravache* 8, 382 (June 16, 1888), n. pag.

9 Gustave Kahn, "La Vie artistique," *La Vie moderne* 9 (Apr. 9, 1887), p. 229.

10 Gustave Kahn, "Réponse des Symbolistes," *L'Événement* (Sept. 19, 1886), p. 3.

11 *Introduction à une esthétique scientifique*, published by *La Revue contemporaine* in 1885 (originally as an article in that review, Aug. 1885). For Henry and Seurat, see Herbert et al. 1991, Appendix L; and my essay, "*Parade de cirque* and the Scientific Esthetic of Charles Henry," in Herbert 2001. The only serious book on Henry is Francis Warrain, *L'Oeuvre psychobiophysique de Charles Henry* (Paris, 1931).

12 For Superville's *Essai sur les signes inconditionnels dans l'art* (Leiden, 1827–39), see Herbert et al. 1991, Appendix H; and Boime 1985.

13 Blanc 1880, p. 145.

14 Kahn 1891, p. 109.

15 Adam 1888, p. 229.

16 Seurat to Signac, Aug. 1887, in the Signac Archives.

17 Françoise Cachin, "*Poseuses*, 1886–1888," in Herbert et al. 1991, pp. 273–80. For a fuller interpretation of *Poseuses*, see Zimmermann 1991, pp. 322–44.

18 Kinney 1994, p. 299.

19 Langley and Zuccari recently found gold-colored pigment under the painted border of the large study for *La Grande Jatte*; see p. 195 n. 17.

20 For Seurat's frames, see Herbert et al. 1991, Appendix A; for painted frames of this era, see Eva Mendgen et al., *In Perfect Harmony: Picture and Frame, 1850–1920*, exh. cat. (Amsterdam, 1995). For Cassatt's frames, see Judith A. Barter et al., *Mary Cassatt: Modern Woman*, exh. cat. (Chicago, 1998), p. 53.

21 Verhaeren 1891 (ed. 1927, p. 199).

22 Kahn 1891, p. 107. For Seurat and *wagnérisme* following *La Grande Jatte*, see Smith 1997, pt. 3.

23 Fénéon, "Le Néo-Impressionnisme à la IVe exposition des artistes indépendants," *L'Art moderne* (Apr. 15, 1888), in Fénéon 1970, vol. 1, pp. 82–85. In contrast, Pissarro liked the painted frame he saw when he visited Seurat in his studio in 1887, and told Signac, "We're going to be forced to do the same. The picture is quite another thing in white or any other material. You truly have no notion of sunlight or cloudy weather without this essential complement"; Pissarro to Signac, June 16, 1887 (CP 2, no. 441).

24 Its owner, the art historian Julius Meier-Graefe, had Van de Velde replace it with one that suited other furnishings the artist designed for him.

25 *Chahut*, like all Seurat's large paintings, was subjected to analyses by several twentieth-century writers to show that it involved specific mathematical angles that Henry favored. However, if one projects reproductions of *Chahut* and the others to scale, these measurements, which seem convincing in small reproductions, no longer match those of the pictures.

26 Blanc 1880, p. 440.

27 See Robert L. Herbert, "Seurat and Jules Chéret," *Art Bulletin* 40, 2 (June 1958), pp. 156–58; repr. in Herbert 2001, pp. 164–69.

28 Verhaeren 1891 (ed. 1927, p. 200).

29 The drawing (H 690), was exhibited at the Indépendants in 1888; its present whereabouts are unknown.

30 Schapiro 1958, p. 52.

6 *La Grande Jatte* and Seurat, 1892–1965

In the spring of 1892, Seurat's death was commemorated in a retrospective, which included *La Grande Jatte*, staged within the Indépendants exhibition. Critics specifically remarked upon the dulling of the painting's colors, but it was somewhat eclipsed by *Chahut* and *Circus*. Friendly writers were more attracted to the artist's theory of linear expression than to color theory, for his late works appeared to them to be further removed from nature than his earlier paintings, closer to the decorative and to pure intellect. "Decorative" was the watchword of the 1890s, and the forms and technique of *La Grande Jatte* entered into the visual vocabularies of that decade. Denis, for example, used Neoimpressionist dots in a purely decorative way in his *Easter Mystery* of 1891 (FIG. 2), and the basic forms of his trees and figures owe a debt to *La Grande Jatte*. Bernard's *Breton Women with Parasols* (FIG. 1), painted the next year, is also beholden to Seurat's masterpiece. Denis belonged to the Nabis, a loose grouping of young artists who looked to the work of Gauguin rather than Seurat. After 1890 they became the newest avant-garde, rivaling Neoimpressionism, and as the decade progressed, they involved themselves more deeply in Art Nouveau.

The Nabis' syntheses do not resemble these of Monet and the Neoimpressionists. Lecomte, a friend of Pissarro and Signac, attacked the Nabis for being too far removed from what one can see, from the "natural decor"; he regretted as well their devotion to religious subjects. "With the pretext of synthesis and decoration, they cover canvases with flat tones

which do not at all restore the luminous limpidities of the atmosphere."[1] Among Seurat's heirs, the work of Cross and Signac reflects the new decorative impulses, but they still looked to nature and eschewed evocations of mystery and religion. By the early 1890s, Signac was blending a new decorative classicism with his fervent anarchist convictions. As Anne Dymond recently demonstrated, his huge painting of 1893–95, *In the Time of Harmony* (Mairie de Montreuil), acknowledges *La Grande Jatte* as well as the art of Puvis de Chavannes, while presenting a vision of pastoral utopia for which anarchist-communists strove.[2]

After 1892 *La Grande Jatte* was not shown again until a huge exhibition at *La Revue blanche* in 1900, where Casimir Bru bought it for his daughter Lucie Bru Cousturier. In the interim, Signac and Cross had become the leading "Neos," and Signac's *D'Eugène Delacroix au néo-impressionnisme* (1899) gave new currency to color theory by insisting upon harmonies of pure hue. The book became the color bible for many young artists, and Signac's role as leader of the Indépendants, with whom many of them exhibited, increased the reputation of his writings and paintings. Signac and Cross employed very large units of color (see FIG. 3), rather like the tesserae of mosaics, which increased the decorative aspect of their pictures. Several of the Fauves, most famously Matisse, adopted tessellated brushwork for a time. Nascent Cubists and Futurists, such as Delaunay, Metzinger, and Severini, also had important Neoimpressionist periods (see FIGS. 4, 6).

This second flowering of Neoimpressionism coincided with a European-wide surge of interest in the liberation of color from its former descriptive role. Italian Divisionism, which before 1900 was relatively independent of Neoimpressionism, now reflected greater interest in the French technique, while in Belgium, Germany, and the Netherlands currents of Neoimpressionism thrived through continued contacts with the French painters.[3] Seurat was regarded as a lamented older master, but his refined brushwork, three-dimensional modeling, and illusionistic spaces did not then seem as modern as Signac's and Cross's color blocks. *La Grande Jatte* appeared in retrospectives of Seurat's work in 1905 at the Indépendants and in 1908 at the Paris gallery Bernheim-Jeune (where Fénéon worked), but in these years Cézanne, Gauguin, and Van Gogh were more influential in Parisian art circles.

Around 1910, with the advent of Cubism and its "conceptual" approach, Cézanne loomed larger than

his contemporaries because of his supposedly non-natural and willful compositions, although this view did violence to the very origin of his art: the interpretation of nature through pure color. While Seurat assumed a lesser role, a photograph of *Chahut* hung on Braque's studio wall; when juxtaposed with Braque's and Picasso's monochromatic work of 1910–12 (see FIG. 5), its jagged shadows and the rippling folds of its figures' skirts make it suddenly seem contemporary. While Delaunay's colored-mosaic strokes of 1911–12 pay homage to Signac, Seurat's example underlay his intent to wed color science to art. Delaunay also emulated the artist by painting the frames of some pictures to react with the colors of his compositions. At the same time, Italian Futurists Balla and Severini used a modified Neoimpressionist technique; in Severini's paintings of café dancers, the dynamic structure of *Chahut* seems reborn (see FIG. 6). Additionally, during World War I, Picasso frequently dotted figure paintings and still lifes with a Neoimpressionist facture.

It was only after the war that Seurat's reputation rose to great heights; he enjoyed widespread posthumous fame in the 1920s. *La Grande Jatte* was included in another retrospective of his work at Bernheim-Jeune in January 1920, and although this was its last appearance in Europe—the Bartletts of Chicago acquired it in 1924—it was reproduced in a veritable flurry of articles and books from 1921 on (it had not been illustrated in any exhibition catalogue from 1886 to 1920). Seurat was constantly represented in shows in Paris, with four devoted to him alone from 1920 to 1928, and he occupied a

prominent place in eleven others over the decade. Elsewhere in Europe, he figured importantly in twenty-one exhibitions through 1929, and in the United States in eleven. A token of his international stature is found in the diary of Oskar Schlemmer, the Bauhaus artist: "Seurat! How often have I written this name on the wall of my studio!"[4] Such direct testimony, however, is not needed, for the art of Schlemmer and others clearly reflects awareness of Seurat. One of his spiritual descendants is Elie Nadelman, the Polish-born sculptor who, in the 1910s and 1920s, imbued his work with a mix of classical and popular elements, and displayed a similar penchant for condensed outlines and a comparable wit (see FIG. 7).

Seurat's newfound relevance in the 1920s was related to the fortunes of other artists, young and old. In his penetrating study of French art from 1914 to 1925, Kenneth Silver showed that the rhetoric of wartime mobilization and postwar reconstruction was intricately bound up with the terms of vanguard art, linked with ideas of order and rationalism that the French attached to their heritage from Greece and Rome. "Seurat's pictures offered the French an image of the world that they found reassuringly ordered, geometric, and much like the world that they themselves hoped to reconstruct on their own devastated territories."[5] Across Europe, in Russia and other nations, "constructivism" became a generalized term for the geometric styles that succeeded prewar Cubism. In France the word "construction," evoking postwar recovery, became the central idea of the broad artistic current called

the "Return to Order" or "Call to Order." Among the chief proponents of the Call to Order were the Purists Le Corbusier and Ozenfant. They had a veritable cult for Seurat, and featured him in a major article by Georges Bissière in the first issue of their new journal, reproducing *La Grande Jatte* and several other paintings in black-and-white, with *Young Woman Powdering Herself* (CH. 5, FIG. 6) shown in color.[6] In a letter to me, Le Corbusier pointed out that he and Ozenfant "published on the first page of the first issue, Seurat's painting 'La Toilette' in color (at this period, and we were poor!). The first sentence printed opposite this reproduction was this: 'L'Esprit Nouveau. There is

a new spirit. It is a spirit of construction and synthesis guided by a clear conception.'"[7] Léger was an ally of the Purists, and although he did not write about Seurat, a painting like his *Grand Déjeuner* (*Three Women*) (FIG. 8), as Silver demonstrated, descends from Seurat's *Poseuses* and *Parade*.

Silver also pointed out that, after the war, some critics elevated Seurat at the expense of Cézanne, whom they still admired but nonetheless associated with the individualism and spontaneity of Impressionism. They considered Seurat a true constructor, an engineer suited to the new machine age; Cézanne was only a mason. Silver quoted the Cubist critic André Salmon, who wrote that "Seurat was the first

to construct and compose," and characterized Cézanne as having "a certain sylvan vulgarity."[8] For Salmon, "All naturalistic literature falls into dust at the breath which blows through *La Grande Jatte*." By this he meant that Seurat dominated natural detail with his constructive powers, and thus found an alternative way to phrase Adam's "idea-phenomenon" of 1886. The figures in *La Grande Jatte* "are powerful plastic elements. They are the materials of the robust grace of a new architecture whose meaning had been lost and was rediscovered by Seurat."[9] Writing the next year, Severini, no longer a Futurist, echoed Salmon by claiming that Seurat was "our veritable precursor," whereas Cézanne, for all the beauty of his paintings, based his work on the worst thing of all: pure sensations. As for Van Gogh and Gauguin, their "disorder and insufficiency" prevented them from contributing to current art.[10]

In the shifting tides of vanguard preferences, Seurat was often linked with Renoir in the early 1920s. Renoir's classicizing art was embraced as fully modern at a time when prewar Cubism was being rejected for its excessive fragmentation. The Cubist painter and writer André Lhote, a great admirer of Seurat, wrote that Renoir was superior to Monet because the latter dissolved form, his *Water Lilies* being "the suicide of genius," whereas in the former's painting, "Impressionists' visual space is abolished and painters' intellectual space is reconquered."[11] Picasso painted a series of compositions directly invoking classical statues; Léger's *Grand Déjeuner* also recalls antique types. Periodicals during the Call to Order period frequently

reproduced examples of early Greek art, as well as paintings by Renoir, Seurat, and Corot, the latter appreciated now for his "constructive" early images.

In a small monograph on Seurat (1922), Lhote spoke for many other artists and critics when he made a triumvirate of Cézanne, Renoir, and Seurat.[12] Renoir and Seurat completed the task of making a more solid art of Impressionism, a process that Cézanne had only begun. Under the banner of "construction," Lhote gave *La Grande Jatte* the most penetrating and lovely description to that date. He wrote that, if only one work by Seurat survived, this one would suffice to reveal his genius. "The whole composition is established on the vertical and horizontal, hieroglyphs of stability and silence." To avoid monotony of straight lines, Seurat's light arcs of umbrellas and skirts "appear in places to animate this forest of calm forms, like wings of birds among the columns of a luminous temple." For Lhote nothing was more moving than this picture, "where a whole epoque is synthesized with its graces and some of its little absurdities, where two of the most opposed techniques—Quattrocento composure and Impressionist dynamism—are miraculously harmonized."

Lhote wrote more about Seurat's forms than his color, a viewpoint that was more openly expressed in 1923 by Walter Pach, the Paris-based, American writer.[13]

The effort of the twentieth century has been above all toward a deeper acquaintance with the properties of solids and it is this research that

makes us see, as we could not see at an earlier time, the deepest value of Seurat's art…, the extricating of essential, expressive form from the chaos which nature is when seen by our eyes.

Like other critics of this era, Pach restated the views of the Symbolists in the 1880s, often using their terms for Seurat, such as "modern primitive." Pach praised *La Grande Jatte* for its "hieratic purity of line and plane that gives to the feeling its reserve and dignity." He also published the first English translation of the synopsis of Seurat's theory from Christophe's article of 1890.[14] This synopsis, which Salmon and others critics reproduced, catered to the rapidly growing postwar current of abstraction, because it pushed subject matter into the background by concentrating on line, value, and color as emotional signs.

Seurat's rise in the 1920s was accompanied by a similar vogue for Henry. Le Corbusier and Ozenfant met the aesthetician in 1920 and in *L'Esprit nouveau* they published successive installments of his essay on the interrelationships of light, color, and form.[15] Henry's ideas, particularly on the ways that color and line transmit sensations, are everywhere present in Purists' writings of the 1920s. This is true also of the publications of Gleizes and Severini.

FIG. 6

Gino Severini (Italian,
1883–1966). *Dynamic Hiero-
glyph of the Bal Tabarin*,
1912. Oil on canvas; 161.6 x
156.2 cm (63 ⅝ x 61 ½ in.).
The Museum of Modern Art,
New York, acquired through
the Lillie P. Bliss Bequest.

In 1922 the Cubist critic Guillaume Janneau wrote an article about Henry.[16] His renewed presence in the avant-garde reinforced the perception that Seurat himself was virtually a scientist.

By the middle of the decade, Seurat's drawings, which he usually included in his exhibitions, were receiving increased attention, not as individual works but as proofs of the breadth of his art. The British writer Guy Eglington regarded the early drawings as "the first authentic works by Seurat that we have. And by authentic I mean *authentic Seurat*."[17] Eglington acknowledged Seurat's significance but was somewhat put off by his technique. By turning to drawings, he could report favorably on the artist's command of contrast in light and dark, that is, on luminosity without color. Eglington nonetheless admired *La Grande Jatte* for its mixture of "suffusion" and "intensification," the former associated with Monet, the latter with Piero della Francesca. (This is apparently the first comparison with that quattrocento master.) Like his French counterparts, Eglington liked *La Grande Jatte* for its constructive qualities, its architecture. "The top hat became a capital, the umbrella a dome. A dog sniffing the ground takes naturally the form of a buttress. Trees range themselves happily into colonnades."

In 1928 Christian Zervos became the first to isolate the drawings for *La Grande Jatte*. He published "Un Dimanche à la Grande Jatte et la technique de Seurat" in his avant-garde review.[18] He reproduced eleven drawings, eleven panels, the island landscape (CAT. 60, p. 80), and the whole

canvas, plus three details. It was a display of black-and-white illustrations rather than a sustained discussion (the text takes up only three pages). Like others writing in this decade, Zervos paid no attention to optical mixing and instead dealt with formal structure. He insisted that drawings preceded paintings in the picture's evolution, establishing "the rules of lighting" and stripping nature to its essentials. He was partly mistaken—many drawings, as we have seen, originated late in the painting's development—but he demonstrated the fundamental role of work in black and white.

Seurat entered the decade of the 1930s on a high plane from which he has never descended. He was commonly paired with Cézanne for having "restored" form to modern painting after it had been "lost" in Impressionism. Alfred H. Barr, Jr., devoted the 1929 inaugural exhibition of the new Museum of Modern Art, New York, to the now-canonical four Postimpressionists: Cézanne, Gauguin, Van Gogh, and Seurat. If further proof were needed of Seurat's stature, it was provided in 1932, when fifteen of his paintings and drawings featured in the *Exhibition of French Art, 1200–1900*, at the Royal Academy, London. This number equaled that of works by Cézanne and Renoir (although it is fewer than those by Corot and Poussin). *La Grande Jatte*, meanwhile, had become familiar to visitors to the Art Institute of Chicago, where it had hung since its donation in 1926 by Frederic Clay Bartlett for the Helen Birch Bartlett Memorial Collection. In 1933 visitors to Chicago's Century of Progress exposition could see it at the

Exhibition of Paintings and Sculpture Lent from American Collections (see Druick and Groom, FIG. 5). The increasing identification of Seurat's masterpiece with the Art Institute and with the city of Chicago is explored here by Neil Harris.

The first book devoted entirely to *La Grande Jatte* was published in 1935. The work of Daniel Catton Rich, an associate curator at the Art Institute and later its director, this slender volume reproduces in black and white twenty drawings and twenty-one oil studies for the big canvas.[19] Rich did not comment on the picture's darkened colors; like so many others, he believed that Seurat used only six primary and secondary hues. He was, however, very sensitive to the variety of brushstrokes in the finished picture, and played down the "scientific" element of the artist's technique. "Colors may carry on their own conversations, lines create their peculiar tensions, tones suggest mysteries far deeper than the immediate subject." Rich's principal concern was the formal structure of the picture and its studies, characterizing them principally as compositions of geometric and linear order, which he related to the French classical tradition. Faithful to the now-familiar view of the 1920s, he regarded Monet's Impressionism as "inspired improvisation," which Seurat surmounted by spurning nature-copying for "architectonic structure." He deemed *La Grande Jatte* to be superior to Cézanne's series of bathers because the older artist was ill at ease without actual models, although magnificent when directly addressing nature.

Rich's formalist view of Seurat was common among leading writers and museum professionals devoted to twentieth-century abstraction. Barr's legendary 1936 exhibition at the Museum of Modern Art, *Cubism and Abstract Art*, paid similar homage to Seurat. Impressionism was "too boneless and too casual to serve as more than a technical basis for the artists who transformed or abandoned its tradition." Barr divided modernism into two main currents: The "intuitional and emotional," or "romantic," strain could be traced from Gauguin, the Fauves, and Kandinsky on to Surrealism. The "intellectual, structural, architectonic, geometrical, rectilinear and classical" mode passed from Cézanne and Seurat to Cubism, then to the "geometrical and Constructivist movements." From this perspective, "Seurat's theory of art was as abstract as that of the later Cubists, Suprematists or Neo-plasticists."[20]

Return of the Subject, 1935–65

In 1935 Meyer Schapiro published an article critical of Rich's book on *La Grande Jatte*, a brilliant attack upon the prevailing view of Seurat as a quasi-abstractionist. Two years later, Schapiro wrote another article, this one triggered by Barr's *Cubism and Abstract Art*, in which he extended most of the ideas of his first essay, although this time with only brief reference to Seurat. So dominant was formalist art criticism—Schapiro's target—that his articles did not bear fruit among writers on Seurat until well after World War II. I will return to Schapiro in a moment, but first I should mention a few notable contributions to the Seurat literature after 1935.

In 1941 Robert Goldwater published an essay interpreting Seurat's style after *La Grande Jatte*, the first probing study of the artist's later work. He provided a new perspective on *La Grande Jatte* by showing how Seurat's art evolved after 1886. J. Carson Webster wrote a salutary essay in 1944 that debunked the idea that Seurat used only primary colors. Like Schapiro's articles of the 1930s, it had little impact at first, but gradually its lessons were incorporated into serious studies of the artist in which the role of "science" began to diminish. In 1943 John Rewald published the first full monograph on the artist, followed by revised editions in 1946 and 1948. His monumental 1946 *History of Impressionism* gives a good account of *La Grande Jatte* in the last Impressionist exhibition; exactly a decade later, he published *Post-Impressionism from van Gogh to Gauguin*, which incorporates a well-documented history of Seurat and the Neo-impressionists and their relations with the Impressionists, Symbolist writers, Gauguin, Van Gogh, and younger artists. Rewald deferred to Fénéon's and Signac's views of Seurat, and he wrote more as a defender of the vanguard of the 1880s than as a critical historian of it. Nonetheless, he provided most of the elements that would permit more varied and provocative interpretations, including those that paid more attention to social history and, more simply, to the subjects of Seurat's drawings and paintings. In 1959 he and Henri Dorra published a catalogue raisonné of Seurat's paintings, with generous excerpts from contemporaneous criticism of *La Grande Jatte* and other paintings.

This was followed in 1963 by César de Hauke's more complete catalogue raisonné of paintings and drawings, which incorporates Fénéon's earlier researches.

The formalist view of Seurat had meanwhile been continued and expanded by further studies of how *La Grande Jatte* and other paintings by Seurat owed a debt to Renaissance artists like Piero della Francesca, and by the continued publication of essays and books that focus principally on his "scientific" technique. Newer interpretations began to surface in the wake of the first major exhibition of Seurat's work in the United States. Organized by Rich, it opened at the Art Institute of Chicago (see Harris, FIGS. 11–12) and then traveled to the Museum of Modern Art in 1958. *La Grande Jatte* has never left Chicago since. The exhibition itself—not the catalogue, which is a pamphlet—stimulated new views, views that took into account Rewald's biographies and Schapiro's no-longer-dormant essays. Inspired by the 1958 retrospective, Schapiro himself published another intelligent article that elaborated upon the arguments of his writings from the 1930s.

In his 1935 and 1937 articles, Schapiro had argued against the view held by Barr, Roger Fry, Rich, and many others who thought that Impressionism lacked form and was devoted to immediate response to nature without the intervention of intellectual analysis. In this view, which assumed that the work of Seurat starkly opposed Impressionism, Seurat, as well as Cézanne, "restored" the form and the substance the movement lacked.

Schapiro pointed out that Impressionism indeed had structure, not of a lesser kind but simply different from Seurat's. Furthermore, he insisted on the links between artistic form and the ethical underpinnings that the formalists ignored. For Schapiro Impressionism had "a moral aspect. In its unconventionalized, unregulated vision, in its discovery of a constantly changing phenomenal outdoor world of which the shapes depended on the momentary position of the casual or mobile spectator, there was an implicit criticism of symbolic social and domestic formalities, or at least a norm opposed to these." The "urban idylls" of the Impressionists "presuppose the cultivation of these pleasures as the highest field of freedom for an enlightened bourgeois detached from the official beliefs of his class."[21]

By granting Impressionism its own forms and moral content, Schapiro was able to interpret Seurat with far greater nuance than earlier writers. He pointed out that Rich's attachment of Seurat to the classical tradition ignored the painting's naturalistic and informal aspects, and that *La Grande Jatte* was not so starkly separated from Impressionism as the formalists insisted. Seurat's people are not arranged in a centralized and symmetrical order and placed only in the foreground, as in the work of Poussin and other classicizing artists that Rich cited. Unclassical also are the preternaturally small figures on the picture's left side, the predilection for strict profile views, and the "irregular and grotesque line which appears in the *Grande Jatte* in the monkey and dogs, in

the jutting canes and parasols, and in the costumes." Furthermore:

> The very title of the picture, *Sunday on the Grande Jatte*—in its reference to a place and a time—expresses just this unclassical dependence of the figures on the moment and the surroundings. The figures are suffused with the time and the setting in their color; even their substance is perceived as a dense granular atomic matter like the total field with its particles of light. Above all, the setting fills the consciousness of the figures and determines their postures. They are shown as enjoying a given moment and point

in nature, a moment and point not accidentally encountered, as in Impressionist art, but recurrent, conventional, artificially appointed for this very purpose.[22]

Rich, wrote Schapiro, paid too little attention to the content of *La Grande Jatte* and its relation to form and technique when he compared Seurat with the Impressionists. In contrast to Monet's "permanent vacationers," Seurat's people "are drawn from the lower middle class and the workers, for whom such recreation is a planned and considered, exceptional experience of the single day of rest."[23] Seurat, he wrote,

> derived from the more advanced industrial development of his time a profound respect for rationalized work, scientific technique and progress through invention. He wished to rationalize painting, to make it an art of systematized construction. . . . Seurat was an earnest democratic spirit, a humble, laborious, intelligent technician, unlike the intellectually and artistically aristocratic and genius-conscious classicist artists, Poussin and Ingres, with whom Seurat is often compared.

In 1958 Schapiro returned to Seurat in a short article about technique, giving it a more nuanced description that shows the influence, since 1935, of modernists' concern for pattern and form. True to his lifelong interests, however, he integrated Seurat's processes with social and individual content. He countered the still-conventional view that

Seurat was a mechanizer of dots by describing his technique as having "the marvelous delicacy of tone, the uncountable variations within a narrow range, the vibrancy and soft luster, which make his canvases, and especially his landscapes, a joy to contemplate." His small strokes "are a refined device which belongs to art as much as to sensation; the visual world is not perceived as a mosaic of colored points, but this artificial micro-pattern serves the painter as a means of ordering, proportioning and nuancing sensation beyond the familiar qualities of the objects that the colors evoke."[24] Again, Schapiro likened Seurat to progressive industrial culture, this time in relation to the mechanization of human movement in his last paintings, and to rational engineering symbolized by the Eiffel Tower.

Schapiro's ideas were taking hold in the late 1950s when Abstract Expressionism had redefined the conception of "form" to admit Impressionism's fluid irregularities. Seurat had been one of the godfathers of geometric abstraction, but he was freed from its exclusive grasp once it lost its hegemony. Already the Surrealists had enlarged the perception of Seurat by admiring his drawings not for their geometry but for the mysteries that come from their crepuscular "nocturnal communion."[25] In 1958, building upon Schapiro's earlier essays, Leslie Katz wrote that attention to formalism and technique had obscured studies of Seurat's subjects, and proposed that *La Grande Jatte* and the other large paintings are allegories that deal importantly with contemporary life. He

It is entirely absent from the most extensive discussion of *La Grande Jatte* published to that point, by William Homer in his *Seurat and the Science of Painting* (1964). Appropriately, given his central concern with the artist's color theory, Homer's pages on the picture are devoted to how Seurat carried out the lessons he learned from his readings. Seurat is made to follow a "set of scientific principles," as though he were reading Chevreul and Rood as he worked, and this left no room to observe how much the panels evolved through trial and error and the craft of painting. By contrast, in my own book on his drawings (1962), I emphasized Seurat's subjects, as did John Russell in his monograph of 1965, a well-illustrated book that pays nearly equal attention to drawings and paintings. Russell reminded his reader that *La Grande Jatte*, like many of the artist's earlier paintings and drawings, pictured Paris's newly expanding suburbs:

> These were neither town nor country. The subject combined two elements which were, in sociological terms, on the point of explosion: the industrial suburb and the industrial Sunday. It was conquerable country, in more senses than one . . . and there were new social alignments to be studied, and new deformations of the social instinct to be set down as a warning, perhaps, to future generations.[27]

Russell did not follow up these prescient sentences, but they foretold the more developed views of T. J. Clark and others in the 1980s.

emphasized that Seurat "employed his method of optical mixture to intensify and affirm the esthetic of the 'ordinary,' and to exalt with science the realm and form of common experiences."[26] Katz continued:

> Only superficially does *La Grande Jatte* appear to banish life and movement from the canvas. The painting is full of life appropriate to a still medium in a scene of rest and relaxation. People in the painting are fishing, sailing, rowing, serenading, cooing, embracing, reading, smoking, running and strolling (as well as conversing and thinking, also legitimate and ordinary forms of active life).

The interest in Seurat's subjects and their social meanings was far from uniform in the next decade.

Notes

1 Georges Lecomte, "L'Art contemporain," *Revue indépendante* 23, 66 (1892), p. 29.

2 Anne Dymond, "A Politicized Pastoral: Signac and the Cultural Geography of Mediterranean France," *Art Bulletin* 85 (June 2003), pp. 353–70.

3 See Erich Franz, ed., *Signac et la libération de la couleur: De Matisse à Mondrian*, exh. cat. (Paris, 1997). For Italy especially, see Zimmermann 1995.

4 Quoted by Hans Hildebrandt, "Neo-Impressionisten," *Aussaat* 2, 3–4 (Aug.–Oct. 1947), p. 104.

5 Silver 1989, p. 337.

6 Georges Bissière, "Notes sur l'art de Seurat," *L'Esprit nouveau* 1 (Oct. 14, 1920), pp. 12–28.

7 Le Corbusier to the author, Dec. 23, 1954. Ozenfant wrote me at the same time (Dec. 20, 1954), saying that he had commissioned Bissière's article (note 6). "I illustrated it with what I think is the first color reproduction of a Seurat (Portrait of his girl friend, *La Poudreuse*, now at the Courtauld Institute, London). The painting itself was lent to me by Fénéon, friend of Seurat. Eventually, Fénéon offered to me to sell it (about 30,000 frs.). The dollar was probably 25 francs. I repeat it was in 1920. I had no money: too bad."

8 Silver 1989, p. 336, from Salmon 1920, pp. 120–21.

9 Salmon 1920, p. 122. Salmon's essay, with only slight variations, was republished in Brussels in 1922 and incorporated into his *Propos d'atelier* (Paris, 1923).

10 Gino Severini, *Du cubisme au classicisme* (Paris, 1921), pp. 19–20.

11 André Lhote, "Renoir et l'impressionnisme," 1920, repr. in idem, *Parlons peinture* (Paris, 1950), pp. 333–34.

12 Lhote 1922. Quotations from the book that follow are from pp. 8–11.

13 Walter Pach, *Georges Seurat* (New York, 1923). Quotations from the book that follow are from pp. 15, 24–25, 27.

14 The synopsis (Christophe 1890) was shorter and more accessible than Seurat's written statement (Appendix A), which remained unpublished until 1914.

15 The journal issued Henry's articles as a book, *La Lumière, la couleur et la forme* (Paris, 1922).

16 Gleizes and Juliette Roche-Gleizes became Henry's close friends in the early 1920s: author's interview with Juliette Roche-Gleizes, Mar. 15, 1969. Severini linked Henry and Seurat with his new "classicism" in *Du Cubisme au classicisme* (note 10), and quoted Henry frequently. Janneau's article, "L'Art et l'enseignement," appeared in Fénéon's journal *Bulletin de la vie artistique* 3, 22 (Nov. 15, 1922), pp. 511–14. Another token of Henry's second period of fame is the publication in 1930, four years after his death, of a special issue, "Hommage à Charles Henry," of *Cahiers de l'étoile*

(Paris, Jan.–Feb. 1930), with articles by Gleizes, Kahn, Janneau, Roche-Gleizes, Signac, Valéry, and others.

17 Guy Eglington, "The Theory of Seurat," *International Studio* 81 (May 1925), pp. 113–17; (July 1925), pp. 289–92. The words cited here are from pp. 289–90.

18 Christian Zervos, "Un Dimanche à la Grande Jatte et la technique de Seurat," *Cahiers d'art* 3, 9 (1928), pp. 361–75.

19 Rich 1935. In addition to the forty-one works, Rich included two drawings and two panels no longer considered studies for *La Grande Jatte*. One of the latter (H 116) was reproduced twice as different works, because Rich was given two radically different photographs of it. Rich's phrases quoted in this paragraph are from pp. 42, 45, 50.

20 Barr 1936, p. 22. Other phrases quoted here are from pp. 19–20.

21 Schapiro 1937, repr. in Schapiro 1978, p. 192.

22 Schapiro 1935, p. 13.

23 The citations in this paragraph are from Schapiro 1935, pp. 14–15.

24 Schapiro 1958, repr. (with minor revisions) in Schapiro 1978, p. 102.

25 Pierre Mabille, "Dessins inédits de Seurat," *Minotaure* 3, 11 (Spring 1938), p. 3.

26 The citations in this paragraph from Katz 1958 are on pp. 40 and 47.

27 Russell 1965, p. 143.

7 *La Grande Jatte* Interpreted since 1980

Between 1965 and 1980, a number of meritorious articles appeared that contributed to the commentary on Seurat's technique and the relation of *La Grande Jatte* to twentieth-century painting, but it was not until the early 1980s that significant new interpretations of Seurat's masterpiece emerged. By then the record of the artist's life and work was established by Rewald's publications, two catalogues raisonnés, significant exhibitions, and greatly increased numbers of color reproductions. Young writers now could build their ideas about *La Grande Jatte* upon an acknowledged foundation. But this did not mean agreements among them— far from it.

In 1980 John House closely linked the meaning of *La Grande Jatte* with *Bathing Place, Asnières*. He insisted that Seurat conceived them as an antiphonal pair. The two sites are located opposite each other across the same stretch of the Seine; figures in the earlier picture look toward the island, and in the later one over to Courbevoie. House believed that leisure and recreation were "natural" for the working-class boys and men of *Bathing Place*, but artificial and ritualized for the fashionable classes of *La Grande Jatte*. (He discounted the bas-relief poses found in *Bathing Place* when he described its figures as natural and relaxed, and did not explain his logic for associating leisure with workers.) House saw artifice and ritual in *La Grande Jatte* in its stiff forms, as opposed to the relaxed ones of the earlier painting; in other words, Seurat's style shifted when his subject changed. To demonstrate this dichotomy, the art historian

reproduced two paintings from the Salon of 1878 by the now obscure Roger Jourdain (FIGS. 1–2). *Sunday* shows two couples picnicking on the grassy shore of La Grande Jatte, while a man brandishing two bottles of champagne steps from a rowing craft.[1] The five are costumed as bourgeois-cum-*artistes*. In *Monday* laborers abstain from work to drink at a ramshackle wine stand somewhere on the river's edge. House did not suggest that Jourdain's paintings served as sources for Seurat, but used them to show that the social contrast of Seurat's two paintings was then current. Thereafter, most writers followed House's lead in considering Jourdain's pair when discussing *La Grande Jatte*.

In his provocative and influential 1984 book *The Painting of Modern Life*, T. J. Clark discussed both *Bathing Place* and *La Grande Jatte*, but not as pendants; instead, he posited that one succeeded the other with an increased awareness on the part of Seurat of the ironies involved in picturing suburban leisure. Taking cues from Russell and from a 1980 article by Fred Orton and Griselda Pollock,[2] Clark pointed to the location of Seurat's island in Paris's industrialized suburbs. He praised *La Grande Jatte* because, unlike most other paintings of these locales, "it attempts to find form for the appearance of class in capitalist society, especially the look of the 'nouvelles couches sociales,'" that is, the rising petty bourgeoisie comprising shopkeepers, salesmen, clerks, and the like.[3] As witness he referred to Christophe, who in 1886 had written that in *La Grande Jatte* Seurat was trying to seize the diverse attitudes of age, sex, and social classifications:

"*élégants* and *élégantes*, soldiers, nursemaids, bourgeois, workers."[4] Clark gave the back of his hand to paintings of leisure by Monet and Renoir because these images fudged the new social conditions that Seurat alone was willing to reveal.

Designating the social positions of Seurat's figures has been the starting point for interpreting *La Grande Jatte*, but these identifications are far from clear. Like Schapiro, Clark saw in the painting a range of social classes. He believed the reclining man in the lower left to be a worker, but Fénéon and Christophe, who were Seurat's friends, called him a canoeist or boatman (*canotier*).[5] His individualized and rugged features distinguish him from the generalized heads of the other figures, including the escort of the *promeneuse*, so one can see why Clark interpreted this figure as a worker. Rowing, nonetheless, was a rather broad-based sport, so the man could be first and foremost an athlete (some boatmen were instructors). Clark justifiably contrasted him with the top-hatted man seated nearby, whom he termed a "*calicot*," a derisive contemporary term for an upwardly mobile shop clerk; in 1886 one reviewer referred to him this way.[6] Surely, the two are willfully contrasted, the hyper-masculine sportsman in front of the dandy. The latter conforms to another topos, that of the artist who defied bohemian slouch by dressing meticulously: in today's slang, having a "cool" demeanor. Seurat, along with Angrand, Fénéon, and Signac, habitually dressed in top hats and dark clothing while out on the town, which is how their friends and acquaintances represented them. The *calicot*

may possibly be an artist, one of the *élégants* to whom Christophe referred, although his diminutive size tends to introduce a pejorative cast that makes the former term more appropriate.

Like other modern observers, Clark interpreted the prominent woman on the right as a *cocotte*, a high-class call girl or kept woman. In the 1880s, however, only one commentator used this word to describe her.[7] She does not resemble contemporary representations of "loose women," either in gesture or in dress; her outfit is like those widely advertised and bought by respectable middle-class women (see CH. 3, FIGS. 18–19). Seurat's artist and writer friends nowhere mentioned the woman as a prostitute in their private letters and diaries, where they could speak without inhibition, and neither did Signac or Kahn, who wrote of Seurat's social convictions shortly after his death. It is tempting to

question her morality because her pet, a monkey, sometimes emblemizes profligacy. Nonetheless, in the Goncourts' novel *Manette Salomon* (1864), a monkey named Vermillon, an important resident of the studio of the painter Coriolis, is never given the attributes of lust.

We must allow for the possibility that the *promeneuse* could have been construed as a kept woman and that friendly reviewers suppressed the association to avoid adding scandal to Seurat's reception, or simply preferred to give higher priority to other issues. Such ambiguities of interpretation are closely tied to the fashions that Seurat distilled into the composition, an issue I discuss in Chapter 8. Meanwhile, we can be sure that he was mocking the pretentiousness of this elegant couple, accompanied by a monkey and yapping pug. In several of the small panels, the woman appears

unaccompanied, so Seurat at one time thought of her as walking alone, courting notice with her exotic pet. By adding her consort, he took up the theme of the promenading couple, which appears in numerous contemporary illustrations and paintings. Indeed, some of these show kept women and their rakes, but in such cases the artist made this evident by pose, gesture, and costume. In other instances (see FIG. 3), we see elegance and pretension, current fashion and social parade, which I believe is all we can be certain of finding in *La Grande Jatte*.

Seurat may have been deliberately confronting other artists' homages to fashion, mocking them as well as the airs of his *promeneuse*. Manet's *Jeanne*, or *Springtime* (FIG. 4), a great success in the Salon of 1882, celebrates feminine beauty, fashion, nature, and springtime. The monkey in Seurat's panel of the lone female stroller (CAT. 59, p. 79) is

FIG. 3 (OPPOSITE LEFT)
A. Bertall. *In the Rue de la Paix*, from George Augustus Sala, *Paris Herself Again in 1878–79* (London, 1879), vol. 2, p. 333.

FIG. 4 (OPPOSITE RIGHT)
Édouard Manet. *Jeanne*, or *Springtime*, 1881. Oil on canvas; 73 x 51 cm (28 ¾ x 20 ⅓ in.). Private collection.

a send-up of such a type, and in the final composition her inflated self-view is reinforced by her arch solemnity. She stands somewhere between Manet's woman and contemporaneous cartoons satirizing the fad for bustles. In contrast, Signac's painting of milliners (CH. 4, FIG. 2), shown in the same room with *La Grande Jatte* in the Eighth Impressionist Exhibition, shares Seurat's primitivism; yet here, because the subjects are workers, these women are not on public display and hence not targets of mockery.

Is there then none of the socioeconomic diversity that Clark saw in *La Grande Jatte*? He could have pointed out—but did not—that the seated nurse would have belonged to the working class (the only figure in the painting that can be so labeled with certainty) and that the steamboats on the water with their tiny boatmen also signify labor. In fact, despite the uncertainty in identifying some of the figures, Clark's main point is convincing. Indeed, *La Grande Jatte* offers a diverse populace, one that gives pictorial structure to the evolution of suburban recreation and leisure. Whether or not he knew Russell's book, Clark dealt artfully with "the new social alignments" that Russell said were to be found in Paris's outlying communities.[8] Far more than any prior commentator, Clark insisted that in *La Grande Jatte* "the environs of Paris are recognized to be a specific form of life: not the countryside, not the city, not a degenerate form of either."[9] On Sundays the shopkeepers and clerks paraded about suburban riverbanks and parks, claiming their right to membership in the middle class by assuming, as Clark put it, the "forms of freedom, accomplishment,

naturalness, and individuality which were believed to be the keys to [the] bourgeoisie."[10]

The right to middle-class identity, Clark insisted, was a struggle that took place in new urban arenas, including public parks and the banks of the Seine. City dwellers' thirst for leisure altered the suburban landscape as much as growing industries, creating a distinctive new world.[11] "The crowds on the riverbank on Sunday afternoon, all moving about in identical dresses, all eager to be seen, were engaged in a grand redefinition of what counted as middle-class."[12] This was an artificial world, not just because the parks were human-made "nature," but also because they were stage sets that allowed the illusion of being in the countryside, far from the city. The uniform costumes that Seurat gave his figures exposed the fiction of individuality and freedom from urban conformity, and yet he distinguished his people as different types because of their variations upon the principle of simplified form that they all shared.

In other words, Seurat achieved profundity in the shapes he created for his humans. They inscribe his people in an epic arrangement that Clark characterized as "large in scale and positive in its overall attitude to the events it chooses; . . . certain, above all, that what was shown was somehow historical, a grand new ordering of the most important matters of the moment." Where others compared *La Grande Jatte* to Egyptian art solely in formal terms, Clark perceived a deeper connection. Seurat intended, he wrote, that "his strange mixing of the banal and the hieratic" give his contemporaries the

"rigid immortality" of the Egyptians. "Their stiffness may still prove their strength. They are the makers of history now." Although Clark did not mention Blanc, his argument gives credence to that writer's republican ideals. As Blanc declared, "The type condenses and epitomizes all joys, all sorrows; it is not one, it is all."[13]

Clark treated *La Grande Jatte* importantly, but his book's influence among art historians and critics owes much more to his analysis of prostitution in Manet's *Olympia* (1863; Musée d'Orsay, Paris) and *Bar at the Folies-Bergère* (1881–82; Courtauld Institute Gallery, London), presented as signifiers of class structure and the hypocrisy of Paris and modern capitalism. First published in articles in 1977 and 1980, Clark's views became so commanding that a number of writers began to see *La Grande Jatte* not as a decorous Sunday promenade but as a place of encounters among prostitutes and clients.[14] They pointed particularly to the couple on the right and, with much less reason, to the fisherwoman on the left. Richard Thomson, in his monograph of 1985, wrote that the couple on the right are a prostitute and her client, among other things claiming that the toylike dog was an attribute of a loose woman, but also, paradoxically, embodied society's upper crust, unlike the black dog, which stood for the working class. In that case, what should we make of the little canine that accompanies the strolling woman of *The Seine at Courbevoie* (CH. 1, FIG. 14)? No one has suggested that she is a prostitute. Thomson probably convinced fewer readers that the fisherwoman is a tart.

IN THE RUE DE LA PAIX. F. 515.

As evidence he turned to analogies with cartoonists who exploited the homophonous pun, *pêcher* (to fish) for *pecher* (to sin).[15] Such wordplay, however, depends upon a context of flaunted sexuality that is entirely absent from Seurat's figure, who is, moreover, accompanied by a woman. Dozens of illustrations in journals and a large number of Salon pictures depict women fishing, without a hint of impropriety. Thomson and others also posited sexual flirtation between the nurse (misidentified as a wet nurse) and the soldiers because of their frequent pairing in cartoons.

In her penetrating study of the reviews of the Eighth Impressionist Exhibition, published in 1986, Martha Ward examined the identifications of the foreground figures in *La Grande Jatte*. She treated Clark's interpretation as "compelling and convincing" in itself, but questioned the degree to which the reviewers in 1886 (other than Christophe, whom Clark quoted) revealed diverse social classes in the

picture.[16] Critics had no trouble seeing that the painting represents a diversity of *types*, but they wrote about them as a collective phenomenon of ritualized and parodied leisure and did not identify them individually as representatives of different social classes. Ward further pointed out that Fénéon's reviews, which became the basic explanation of Neoimpressionism, define radical innovation not in terms of social content but rather of technique. According to Ward, Fénéon did not set up parallels between empirical science and Seurat's work, a familiar kind of reasoning, but instead "treated science as a model of abstraction, an autonomous order that had authority for the new group."[17] To the dominance of Fénéon's writings we must add Seurat's known obsession with craft and theory (he wrote and spoke of little else), so, beginning in 1886, the meanings of *La Grande Jatte* were being vested principally in technique and form rather than subject.

Following Ward's circumspect study of the literature of 1886, the next reevaluations of *La Grande Jatte* appeared in 1989, in a special issue of *The Art Institute of Chicago Museum Studies* devoted to the painting (its eight articles include four papers delivered at a symposium held at the museum two years earlier). Both House and Thomson took up again, with minor modifications, the views they had expressed earlier of what lay behind Seurat's figures.[18] Among newcomers to studies of *La Grande Jatte* were the historians and feminists Hollis Clayson and Linda Nochlin, who acknowledged the views of earlier writers, but trained their critical lenses on new issues.

Clayson's essay was inspired by the fact that previous writers on *La Grande Jatte* had ignored gender. While class distinctions had been explored, no one had asked why the picture displays only one nuclear family (the couple with swaddled child, to the left of the running girl), and why it contains many more women than men. The presence of three males in the immediate foreground and fifteen further back at least lets both genders share the space, but any complete account of the painting, Clayson wrote, should recognize the predominance of "non-family" groupings. There are some pairings of mother and child, but one must ask why fathers are absent. In her view, Seurat therefore dealt with "two principal social themes—the day off and the family—and how they are interrelated."[19] Clayson introduced contrasts that others had ignored, such as that between the *promeneuse*, whom she construed as a prostitute, and the adjacent women

with the child and baby carriage to her right. She also believed that "the composition seems to emphasize the vulnerability of unaccompanied women and children," a deduction that flowed from her positing the full nuclear family as a kind of norm against which the images should be evaluated. Social reformers, whose views she documented carefully, stressed the unity of the family within the proper bounds of leisure, but in his painting Seurat broke this code, for "the fracturing of the family and the coexistence with strangers visible in the picture are not shown as emotional or psychological gains for these Parisians. Their release from family ties has won them freedom, but at a cost: it is freedom without relaxation, without apparent fun, without meaningful connections to one another." Clayson's analysis pits family against leisure, the latter portrayed at the expense of the former, "a fundamental mismatch between family-structured and day-off activities." Clayson concluded that the immobility of Seurat's people "records an emotional and social stalemate resulting from the tensions and conflicts between the determinedly upwardly mobile men and women in the painting." Those tensions are absent in *Bathing Place*, because its forms were appropriate to the men-only subject, but they arose when Seurat showed women on a Sunday afternoon. Their presence introduced the issue of family responsibilities, but the absence of fathers limited affectionate relationships to mothers and children.

Given Clayson's insistence that Seurat did not celebrate the nuclear family in *La Grande Jatte*, one might ask: Why should he have done so? Surely, it was not to have been expected in his generation. Contemporary paintings of leisure groups nearly always feature women and seldom show nuclear families. There are no whole families in L.-A. Dubourg's resort picture (CH. 3, FIG. 11), in Manet's *On the Beach at Boulogne* (FIG. 5), or in Renoir's many paintings; there is just one man in Monet's *Park Monceau* (1878; Metropolitan Museum of Art, New York), and only one in the foreground of his *Sunday at Argenteuil* (1872; Musée d'Orsay, Paris). Fathers are uniformly absent in such paintings of public recreation. The association of women and children with leisure and nature was normal in male-dominated society and art (even in most of Morisot's paintings), so Seurat was not unusual. Moreover, family groups are extremely rare in the naturalist literature with which Seurat was familiar. For Caze, Duranty, the Goncourts, and Huysmans, the intact family carried associations of the despised bourgeoisie and did not convey the truth about the fragmentations of urban-industrial society. For painters such as Monet and Seurat, representations of whole families would have resonated with the anecdotal preferences of the conventional art against which they were rebelling. Seurat's treatment of families and gender in *La Grande Jatte* is therefore a normal feature of vanguard renderings of society.

In her essay, Nochlin took some of the negative implications of Clayson's article much farther. She presented the startling thesis that *La Grande Jatte* is an anti-utopian allegory. As her point of departure, she introduced Ernst Bloch's *Principle of Hope* (1954), in which Sunday is interpreted in broad philosophical terms as the non-work day, utopia. Although others understood Manet's *Luncheon on the Grass* (CH. 3, FIG. 10) as a deliberate provocation to bourgeois expectations, Bloch saw it as "full of innocence, supreme ease, unobtrusive enjoyment of life." By contrast, for Bloch *La Grande Jatte* was the "negative foil" to Manet, an anti-utopia in which Sunday leisure is represented "in a scornful way." The picture shows

> sheer hapless idleness.... The result is bottomless boredom, a petit-bourgeois and infernal utopia of distance from the Sabbath in the Sabbath itself; Sunday proves to be merely a tormented demand, no longer a brief gift from the Promised Land. Such a bourgeois Sunday afternoon is the landscape of painted suicide.[20]

Agreeing with Bloch, Nochlin wrote that, among the Postimpressionists, Seurat was "the only one to have inscribed the modern condition—with its alienation and anomie."[21] His mechanical technique and cut-out figures oppose the romantic individualism of Impressionism and give visual form to the modern condition, whereas art of the later nineteenth and early twentieth centuries withdrew from Seurat's "negative and objectively critical position" into the subjective and the non-social. In other words, the anti-utopian *Grande Jatte* embeds a profound critical reading of capitalist society. Its sense of alienation, as well as Seurat's repetitious brushwork, expresses "the experience of . . . making a living in a market economy in which

exchange value took the place of use value and mass production that of artisanal production."

Nochlin's view, therefore, approached Clark's because she, too, considered *La Grande Jatte* an embodiment of the modern dilemma of social fragmentation. Clark, nonetheless, had a more positive take on Seurat's picture as an epic painting. Nochlin saw it as destructive of any kind of heroic form, as undermining any retention of classical elements that are "deliberately disharmonized, exaggerated into self-revealing artifice, or deliberately frozen and isolated. This is part of its anti-utopian strategy, its bringing of contradictions into focus." The painting's monotony, its "dehumanizing rigidity," denies the positive sense of the Symbolists' "essences," and the human qualities that contemporaries found in analogies with dolls and puppets. It also denies Rich's belief that Seurat's concision was a modern kind of classicizing, because for her it transformed "human individuality into a critical index of social malaise."[22] For Nochlin, his heirs are not mainstream modernists like Léger but anti-utopian artists such as the Cologne Progressives of the 1920s who, like Seurat, "used the codes of modernity to question the legitimacy of the contemporary social order."

By quoting Roger Fry on Seurat's having banished life and movement from his painting, Nochlin revealed her ties to the long-standing viewpoint that the stilted figures of *La Grande Jatte* lack life, compared to those of other artists. Huysmans, who admired aspects of Seurat's work, disliked the painting for this reason, and so have many commentators over the century since then. Even Lionello Venturi, writing a warm appreciation of Seurat in 1950, regretted *La Grande Jatte*'s figures, which for him were too much "like phantoms in an unreal world." He found them "too precise, we are too conscious of the solidity of the images—we cannot help feeling the contrast between their reality and their unreality. The silhouettes are characterized by an air of disillusion."[23] Bloch, Nochlin, and Venturi, no matter how different their views, all rely on the identification of Seurat's stripped-down forms with real persons of that era, and therefore see his figures as lacking individual and communal expression. It is as if they could not give up the tradition of descriptive content that Seurat had abandoned and thought that he should have interrelated his personages in narrative ways.

In 1991 the most comprehensive retrospective of Seurat's paintings and drawings since 1958 was shown in Paris and New York.[24] Although *La Grande Jatte* was absent, it was represented by thirteen panel studies, three canvases, and fifteen drawings. My catalogue entry on the painting necessarily abridged much earlier history and contemporary interpretations into nine pages, so it is only in the present volume that I am able to discuss others' analyses of the canvas. These include Michael Zimmermann's *Seurat and the Art Theory of His Time*, whose publication coincided with the exhibition and was therefore absent from its bibliography. Zimmermann thoroughly surveyed all aspects of *La Grande Jatte* and its studies in the most extended text ever devoted to the picture up to that time. He gave a detailed account of the relation of Seurat's naturalism to contemporary literature and, disagreeing with Nochlin, concluded that *La Grande Jatte* is a naturalist allegory of social harmony. For the most part, he agreed with Schapiro's and Clark's analyses but, with more pages, he was able to consider each issue in light of economic and social history. Along with an extensive discussion of Blanc, he interpreted Seurat's masterpiece as fulfilling enlightened republican goals, including the ways in which its methodical procedures and technique exemplified optimism in progressive science. Among his original observations, Zimmermann concluded that, in *La Grande Jatte*, Seurat (and therefore the viewer) was a distanced observer, not a participant as one usually is in relation to Impressionist

paintings. The formal coldness of his figures and their carefully considered placement imply that Seurat was himself aloof from them, just as his figures are removed from the observer.[25] Before the picture, we feel this remoteness because we are sheltered within the huge foreground shadow, as though looking out from the mouth of a large cavern.

In 1997 Paul Smith published the last monograph on Seurat to introduce new interpretations. Unlike Zimmermann and myself, he accepted the views of House and Thomson about the subject matter of *La Grande Jatte* (the fisherwoman as prostitute, and so forth). Even more than Zimmermann and I, he highlighted the preeminent role of Blanc's concepts in the evolution of *La Grande Jatte*. Despite Fénéon's claims of Rood's relevance, Smith believed that Rood's book played only a minor role, and that Blanc, Chevreul, Delacroix, and Impressionist practice suffice to explain Seurat's colors and technique. He noted that it was Blanc who introduced Seurat to Chevreul and Delacroix, praising both for placing ideas above attention to realism. Blanc's optical mixtures, exemplified in the art of Delacroix, were not destined for realistic effects, but for harmony and finesse. According to Smith, Blanc and Seurat did not consider "reality" the goal. It was instead the construction of an autonomous art, freed from the need to represent nature realistically.[26] Thus, Blanc's central ideals were a good match for the Symbolists' insistence that Seurat's distinction from Impressionism lay in his conversion of observable reality to new art forms.

Smith also wrote that, because Seurat accepted Blanc's idealist conception of harmony in art, he would have endorsed the aesthetician's linking painting with music. Blanc called "musical" the proportions of the simple four-by-six grid Seurat used for his large canvas (see Zuccari and Langley, FIG. 2), the analogy being with the mathematical subdivisions of a taut wire that yield the diatonic scale. Furthermore, Smith stated, "Blanc considered color 'harmony' analogous to musical harmony, and its relationship to line as analogous to the relationship of musical harmony to melody."[27] He pointed to the fact that Blanc incorporated both line and color in a symbiosis of contrasts and similarities in which both have "moral" effects, that is, both could themselves communicate emotional values (we recall that Blanc taught Seurat about Superville's theory of emotional signs). *Wagnérisme*, Smith reminded us, was an alternative name for Symbolism, and Seurat was familiar with *La Revue wagnérienne*, launched in 1886. Given the importance of music in Symbolist circles, Smith believed that Seurat was alert to contemporary ideas about the parallels among music, literature, and the visual arts. However, the evidence for this postdates *La Grande Jatte* and is far more convincing in relation to the painter's later work. For the years 1884 to 1886, *wagnérisme* is not as rewarding a lens as considering Seurat's blending of contemporary fashion with irony, which I take up in Chapter 8.

Notes

1 Jourdain's *Sunday* was sold at Sotheby's, New York, on May 22, 1891.

2 Russell 1965, and Orton and Pollock 1980. Orton and Pollock emphasized the fact that Seurat's painting was "part of the urban landscape, an aspect of public life in the capital."

3 Clark 1984, p. 261.

4 Christophe 1886 (Seurat's Argus); repr. in Berson 1996, pp. 436–37. In Christophe's lengthier list of the painting's characters (Christophe 1890), workers are not mentioned.

5 Fénéon, Sept. 1886b, and Christophe 1890.

6 Hermel 1886 (Seurat's Argus); repr. in Berson, pp. 455–59.

7 Moore 1886 (Seurat's Argus); repr. in Berson 1996, pp. 435–36.

8 Russell 1965, p. 143.

9 Clark 1984, p. 147.

10 Clark 1984, p. 204.

11 I dealt extensively with these changes in my book *Impressionism: Art, Leisure, and Parisian Society* (New Haven, 1988).

12 Clark 1984, p. 155. Clark's words quoted in the following paragraphs are from this page.

13 Blanc 1880, p. 446.

14 T. J. Clark, "The Bar at the Folies-Bergère," in *The Wolf and the Lamb: Pop Culture in France from the Old Regime to the Twentieth Century*, ed. J. Beauroy et al. (Saratoga, Calif., 1977); idem, "Preliminaries to a Possible Treatment of *Olympia* in 1865," *Screen* (Spring 1980). Hidden meanings were very much in the air that decade, stimulated especially by new interpretations of Dutch painting, notably the articles and books by Svetlana Alpers and E. de Jongh. Prostitution quickly became a key issue in the analysis of Parisian painting by contemporary feminist historians; see for example T. A. Gronberg, "Femmes de brasserie," *Art History* 7, 3 (Sept. 1984), pp. 329–44; and Hollis Clayson, "The Representation of Prostitution in Paris during the Early Years of the Third Republic," Ph.D. diss., UCLA, 1984 (rev. and published as *Painted Love: Prostitution in French Art of the Impressionist Era* [New Haven, 1991]). Their work followed closely upon the penetrating social history of prostitution in Paris by Alain Corbin, *Les Filles de noce* (Paris, 1978).

15 Thomson 1985, p. 124. My disagreements with Thomson should not diminish the value of his study of *La Grande Jatte*, which is particularly interesting on Asnières and Courbevoie, on the role of fashion in the painting, and on the differences between the picture's appearance in 1985 and its final surface. Our disagreements stem partly from Thomson's willingness to accept Coquiot's much embellished views, nearly four decades after the painting was first exhibited, of the island as a bawdy environment (Coquiot 1924).

16 Ward 1986, p. 435. Ward and Clark are the only modern historians who limited themselves to reviews and issues of 1886 when interpreting *La Grande Jatte*, avoiding the problem of superimposing over the painting the artist's later work and issues arising from it.

17 Ward 1986, p. 436.

18 In this volume, Inge Fiedler presented again, this time with excellent color details, her findings on the pigments Seurat used during his three periods of working on the picture. For her current views, see her essay in the present publication. Among other articles in the 1989 volume, mention must be made of Michael Zimmermann's very useful analysis of Blanc's eclectic idealism and how it cohabited in *La Grande Jatte* with the picture's modernism. The essays by Mary Mathews Gedo and Stephen F. Eisenman, although interesting, did not in my view offer new meanings for *La Grande Jatte*.

19 Clayson 1989, p. 160. Clayson's words quoted in the following paragraphs are from pp. 163–64.

20 Nochlin 1989, p. 133, from Ernst Bloch, *The Principle of Hope*, trans. N. Plaice, S. Plaice, and P. Knight (Cambridge, Mass., 1986), pp. 813–14. Bloch's view (originally published in 1954) was disputed by O. K. Werckmeister in *Ende der Aesthetic* (Frankfurt, 1971), pp. 50ff.

21 Nochlin's words cited in these paragraphs are found in Nochlin 1989, pp. 133–34, 139, 141, 147, 153.

22 Nochlin (1989) used Seurat's seated nurse as a leading example of his dehumanization, but she believed the woman a "wet nurse," rather than simply a professional nurse. Therefore, she declared, "There is no question . . . of her role as a nurturer, of a tender relation between suckling infant and 'second mother,' as the wet nurse was known" (p. 147).

23 Venturi 1950, p. 145.

24 Herbert et al. 1991. I was the principal author of the catalogue, with contributions from Françoise Cachin, Anne Distel, Susan Alyson Stein, and Gary Tinterow.

25 Zimmermann 1991, pp. 139–40, 148, passim. The second half of Zimmermann's book includes a lengthy analysis of Henry's ideas, which he interpreted convincingly as closely allied to Symbolism and not merely "scientific."

26 Smith 1997, pp. 23–48.

27 Smith 1997, p. 39.

8 Fashion and Irony

If we ask "What does *La Grande Jatte* mean to us now?" the only answer is that it means everything modern writers have said about it. There is no one meaning. I have summarized various views, often contradictory, in preceding chapters, but of course those summaries are colored by my own judgments. I now want to bring my own views more fully into the open, and I will do so by engaging two issues, fashion and irony, in both cases invoking other writers. Irony in *La Grande Jatte* has not been discussed often enough, but before I turn to it I must deal with the painting's links with fashion, a major component of nearly all critiques of the picture.

Seurat's mocking of contemporary fashion in *La Grande Jatte* was immediately noted in the press. Fèvre's review described "the stiffness of Parisian promenading, formal and shapeless, where even recreation amounts to posing." For Adam,

> even the stiffness of the people, with their cookie-cutter forms, helps give the sound of the modern, the recall of our cramped clothing glued to our bodies, the reserve of our gestures, the British cant imitated by everyone. We adopt attitudes like those of Memling's people. M. Seurat has perfectly seen, understood, conceived, and translated that with the pure drawing of the primitives.[1]

Adam and Seurat's other friends considered contemporary fashion to be entirely compatible with primitivism. They recognized the artist's ambition to merge contemporary life with timeless elements of style. He took a great risk in commemorating the most immediate elements of fashion, because this could make his painting seem more and more dated as time passed. By specifying the year 1884 in his title, Seurat must have been confident that he had turned time into something timeless.

In the early 1980s, as we have seen, historians such as Clark, House, and Thomson associated Seurat's use of fashion with artifice and ritual, vindicating Fèvre's and Adam's remarks by invoking costume to identify social class and types. Clark's interpretation, which connected fashion in Seurat's work with the upwardly mobile, petty bourgeoisie, has been the most influential. For him the painting reveals class structure and modernity in its figures' attempts to be natural and free in a cultivated park, a specific modern setting that was neither city nor suburb. Both the social meaning and the comedy in the picture lie in its "grand and restrained" forms, not just in its subject.[2]

The fullest examination of the role of fashion in *La Grande Jatte* is that by Leila Kinney, first in public lectures in 1983 and 1987, then in published form in 1996.[3] Kinney reminded us that fashion had preoccupied the vanguard since the time of Baudelaire. Mallarmé had founded a fashion magazine in 1874; many writers, including Adam (whose 1883 novel *The Happiness of Women* centers around a Parisian department store), Caze, Duranty, and Zola gave prominence to contemporary fashion. So too did Manet and Alfred Stevens, the latter making current dress into the expressive nucleus of his paintings. Kinney noted that Seurat's maternal uncle Paul Haumonté-Faivre owned a fancy goods shop, and that his friend Lucien Pissarro worked for a time in fabric commerce.[4] Signac's large picture of milliners (CH. 4, FIG. 2) is devoted to workers in the fashion trade, so Seurat's environment provided him with a ready context for the costumes he featured.

Kinney documented the rise of ready-made clothing in Seurat's generation and its widespread availability. High-fashion knockoffs became a staple of the recently established department stores, so the "new social classes" took advantage of cheaper clothing to mask their true status while moving about in society with others of higher station. Ambiguity resulted, for how was one to determine the class of individuals if they could all dress similarly? Fashion, as Georg Simmel so brilliantly observed, mixes advanced taste with conformity.[5] One proclaims adherence to the new as if to make an individual statement and avoid conformity to the ordinary, and yet, in doing so, one conforms to a group, to a fashion elite. The Impressionists had painted middle-class people fashionably at ease but had featured their individuality. For Kinney, as for Clark and Nochlin, Seurat's juxtaposition of current fashion with his figures' mannequin stiffness and their uniformity of presentation was a critical perception of society's artifice. Sunday, we know, was the one day of the week in which diverse classes could display themselves in public places, performing the rituals of unhurried life. Leisure had once been the prerogative of the wealthy, but now was enjoyed by the lower middle class, often, as has been said, in parks and gardens that earlier had belonged to royalty, nobility, and church, hence the

frequent references in art and literature to the aristocratic *fête champêtre*.

Seurat illustrated the very meaning of fashion: the mingling of individuality with conformity. He repeatedly clothed his store-dummy forms in examples of contemporary style. And, as we have seen, he paired many of his figures, but each one seems to exist in his or her own realm. Seurat's people assume roles in a collectivity; yet because they barely communicate with one another, their actual isolation is revealed. This dialogue of cohesion and separateness constitutes a convincing reading of *La Grande Jatte*, but it cannot stand by itself because it requires further interpretation. To some critics, Seurat's pictorial pattern, with its repetitive rhythms, is tantamount to endorsing actual social conformism, while the stiffness and psychological isolation of the figures argue for disjunction. Others, like Nochlin, interpreted this dualism as Seurat's attempt to expose conformity, not endorse it. Perhaps here we have nothing other than the dilemma of modern urbanites under industrial capitalism, analyzed not only by Marx but also by Émile Durkheim, Simmel, and such later thinkers as David Reisman.[6] Everyone is unique and yet must also bend to society's will by accepting limits on personal behavior, with varying degrees of constraint depending upon the individual and external conditions.

Many reviewers have regarded Seurat's repetitive forms and systematic technique as a kind of coercion, which they regret because they yearn for an expression of individualism, the central ideology of modernity. Clark was perceptive, I think, in

denying that *La Grande Jatte* lacks distinctions among its figures:

> The critics were right in 1886: there is an appearance of uniformity to *La Grande Jatte*, at least on the surface, but that very fact makes difference more salient when it happens; it makes us attend to the signs of "age, sex, and social class" in a special way, with a sharpened sense of their oddity and separateness. The comedy that results from this is *formal*: it is grand and restrained, and does not give rise to ironic point-making at the petit bourgeois's expense. The characters are not for the most part meant to be funny—let's leave aside the soldiers and the monkey—but the general pattern of constraint and distinction certainly is.[7]

Most of this characterization seems right on the mark except for the denial of irony. Clark was obviously correct to see comedy in the painting; indeed, we laugh at puppet shows and at least smile at *La Grande Jatte* because, in the stiffness of its mannequin-like figures, we find amusement: they lack our own individual freedom to act and move at will. But there is more to our reaction than this kind of amusement, and this is why we need to consider irony. The dialogue between the painting and the viewer is too complex to be satisfied by the term "comedy," and for this reason "irony" is the better concept. In fact it has been a missing feature of most interpretations of *La Grande Jatte*.[8] I have already discounted Bloch's and Nochlin's views that the painting presents a dystopia. Their unwillingness

to see Seurat's irony prevented them from accepting the artist's conception of social harmony. As I shall hope now to demonstrate, a perfect society is not incompatible with irony: think of Molière, Mozart, Austen, Gilbert and Sullivan, and Offenbach.

Caricature, which we see in *La Grande Jatte*, is not the same thing as irony but can be incorporated within it. For a working definition of the latter, we could begin with the portion of its explication in the 1996 *Merriam-Webster's Collegiate Dictionary*, in which literature, as is often the case, is the realm assumed for irony. It is defined as "incongruity between a situation developed in a drama and the accompanying words or actions that is understood by the audience but not by the characters in the play." This succinct definition needs the expansion offered by Wayne Booth for literary irony, which I adapt for *La Grande Jatte*.[9] First, viewers have to reject the precise meaning of what they see (Seurat did not present us with realistic individuals). Next, they should think of alternatives that, according to Booth, will "in some degree be incongruous with what the literal statement seems to say—perhaps even contrary." (these mannequins are too stiff to suggest relaxation).[10] Then, onlookers must posit the views of the artist, for in order to make sense of the alternatives, they have to assume that he rejected literal meaning. With this in mind, viewers can feel more secure that their interpretation is in line with his. Such readings are seldom fixed and certain, but waver among several possibilities. "In Seurat's case," wrote Joan Halperin, "one can wonder whether the 'mechanical stiffness'

FIG. 1
Claude Monet. *Luncheon
on the Grass*, 1865–66. Oil
on canvas; 248 x 217 cm
(97 ⅝ x 85 ⅜ in.). Musée
d'Orsay, Paris.

of his figures is the *target* of his irony, or whether
that stiffness is the *means* by which he questions
and contradicts the new mobility of individuals
and the increasingly flexible social structure of
urban society."[11]

In looking at *La Grande Jatte*, we conspire
with Seurat to find amusement in his characters'
rigidity, in "their mock-gravity and their deadpan
theatricality,"[12] but we cannot imagine that they
share the joke. Irony is more subtle than comedy,
and Seurat let us understand that he, not nature,
was the creator and master of the illusions before
us. We stand with him on a superior level, looking
down at his marionettes. Through his ironic struc-
ture, he exploited Parisians' hopes to find nature
in the park, but also their inability to leave the city
behind. They may wish to emulate the romantic
poet lost in the absorption of nature, but they need
the company of other Parisians, all of whom crowd
this island in order to take part in a communal
ritual while believing themselves to be distinctive
individuals. The park, of course, is a manicured set-
ting, so its distance from untouched nature is itself
ironic. Among its columnar trees and regulated
patches of sun and shade, the figures are puppets
whose forms combine seriousness with comedy—
our comedy, not theirs. They could not be aware
that they are absurd, that they recall Egyptian and
Greco-Roman art, which Clark believed ennobles
them but in which one can as readily find irony.
Their connection to popular art (toys, cartoons,
advertising) is another kind of ironic reference that
converts them into serio-comic dolls, as well as, in

the context of Seurat's ambitious composition, participants in high art.

In the only extended discussion of Seurat's irony, Halperin distinguished it from satire. "Unlike satire, which is grounded in a context of normative standards and works to communicate a single meaning, modern irony holds different meanings in suspension, goes back and forth between various possible or impossible conclusions. It continually poses questions but does not seek to resolve them."[13] For this reason, *La Grande Jatte* is a descendant of Manet's *Luncheon on the Grass* (CH. 3, FIG. 10), in which modern people assume the poses of Renaissance gods, as distinct from Monet's painting of the same subject (FIG. 1), whose bourgeois people are seriously, not ironically, observed. In fact Seurat's picture is a mocking commentary upon both paintings, all the more so to us because it appeared in the last Impressionist exhibition (even if both those painters were absent). His irony is even more obvious if considered with figure paintings by Pissarro or Cézanne. Pissarro's yearning for social cohesion among *le peuple* precludes irony, and Cézanne's lack of it makes Seurat seem all the more like a young urban upstart.

The familiar comparison with Puvis de Chavannes (see CH. 3, FIG. 13) also highlights Seurat's distinctive expression. Despite the attraction of Puvis's work, the avant-garde considered classicism to be dead. If it was used at all, it had to be used ironically.[14] Critics in 1886 recognized in *La Grande Jatte* the cohabitation of popular forms with antique references; some disliked or were puzzled by this,

while others welcomed it as Seurat's own. For Maurice Hermel, Seurat searched for "the absolute synthesis of the suburban promenader. A fisherman, a simple clerk [*calicot*] seated on the grass are fixed in the hieratic attitude of ibises on obelisks; the Sunday-best strollers under the shade of La Grande Jatte take on the simplified allure of a procession of pharaohs."[15] Irony, like comedy, can be subversive, but it is always deeply conservative. It may undermine conventional beliefs, but it does so by positing a whole society to whom it offers its humor and its lessons. Molière, Mozart, Austen, Gilbert and Sullivan, and Offenbach: all ironists, none a revolutionary. The irony of *La Grande Jatte*, like that of Offenbach, is only fully comprehensible from within Parisian culture or a knowledge of it. To judge by comments overheard in the gallery where the painting hangs today, some viewers find the picture simply a lovely scene in a park. They are immune to its mockery, because they are not students of French history. Irony requires the viewer and the artist to share, or at least be knowledgeable of, the same culture.

Seurat's irony, therefore, his mocking of pretension, does not deny that his picture proposes a social harmony. To quote him once again: "Art is harmony. Harmony is the analogy of opposites" (see Appendix A). *La Grande Jatte* is not an unthinking utopia, but a peaceful realm that allows for witty insights into human foibles, into oppositions between aspirations and their imperfect realizations. If we think of the sounds that could emanate from the picture, we hear the putt-putts

of steamboats, the swish of rowers' oars, the brassy blare of the vulgarian's horn, the yapping of the pug. It is not a dreary piece of social rhetoric, but a spirited harmony that asks us to take an ironic and bemused distance as we watch this human parade. To those who wish to treat the picture as a disharmony, as a revelation of social discord, we need only point out the painting's actual harmony of artistic structure. Each form has its counterpart in a beautifully balanced assortment of shapes, colors, positions, and subjects. The tip of one figure's parasol touches the skirt or legs of the next person; the arcs of parasols respond to the swelling curves of women's bustles and bosoms; diagonal and horizontal shadows serve as pedestals, and often substitute for legs, always for feet; columnar bodies resemble slightly animated tree trunks; nearly every vertical finds its horizontal, nearly every figure finds its same shape in nearby or distant ones. Seemingly unique individuals are matched by their opposites—boatman vs. dandy, squat nurse vs. tall mother, large dog vs. small one—so they are integrated by visual dialogues.

By removing the most mundane aspects of reality (no wine bottles, no picnic debris), by eliminating conflict while admitting contrast, by generating memorable types rooted in current fashions, Seurat created an allegory of modern summertime, a procession of contemporaries that he hoped would earn him the rank of Phidias. His wit gave him the distance that he needed in order to treat his people like puppets. It spared him the

ponderous weight the term "classical" can evoke. The same wit separates his picture from Monet's and Renoir's paintings of leisure-seekers. We can find pleasure in their images, but never Seurat's humor, tinged as it is with his distinctive brand of mockery. "Irony," wrote D. C. Muecke, "is an art closely related to wit; it is intellectual rather than musical, nearer to the mind than to the senses, reflective and self-conscious rather than lyrical and self-absorbed."[16]

Seurat's huge picture has been granted the status of a classic in the modern era, but did he achieve his goal to be the Phidias of Postimpressionism? I do not think so. Cézanne's painting seems to me to be more certainly a classical art. Seurat's classicism is not as much in dialogue with the Parthenon frieze as with the ubiquitous images of modern commercialized culture. We can look with more than a little irony upon the ease with which his great painting has infiltrated the world of designer fashion. *La Grande Jatte* has become one of the most frequently reproduced paintings for advertisers and designers who wish to evoke summer leisure, uncontaminated by work and worry (see Harris, FIG. 17). If we often regret that our era is indissoluble from the hucksterism of commerce, we can at least take comfort in seeing how Seurat figured the popular culture of his day while creating a memorable painting worthy of being placed alongside the greatest art of the past. The painting's decorative clarity, although a century old, lends itself to today's graphic reproduction; it entertains as much as it instructs. *A Sunday on La Grande Jatte—1884* is a neatly planned harmony for city dwellers in which amusement cohabits with relaxation, and irony with approbation, both in the picture's images and in our responses to them.

Notes

1 Fèvre 1886 and Adam 1886 (both in Seurat's Argus); repr. in Berson 1996, pp. 445–47, 427–30, respectively. The association of fashion with high art was common in this era. Huysmans, writing in 1886, said that dressmakers' dummies were infinitely superior to Greek art and that when one saw them, Greek art ceased to exist. See "Croquis parisiens," in J.-K. Huysmans, *Oeuvres complètes* (Paris, 1929), vol. 8, pp. 137–40.

2 Clark 1984, p. 266 and passim.

3 Kinney 1996. Kinney kindly sent me the text of her 1983 lecture, and it entered into my own considerations from that time. For penetrating social histories of fashion in Seurat's era, see Michael B. Miller, *The Bon Marché: Bourgeois Culture and the Department Store, 1869–1920* (Princeton, N.J., 1981); Rosalind Williams, *Dream Worlds: Mass Consumption in Late Nineteenth-Century France* (Berkeley, 1982); and Lisa Tiersten, *Marianne in the Market: Envisioning Consumer Society in Fin-de-Siècle France* (Berkeley, 2001).

4 Kinney 1996, p. 291.

5 Georg Simmel, "Fashion," 1904, repr. in *On Individuality and Social Forms*, ed. Donald N. Levine (Chicago, 1971), pp. 291–323.

6 In addition to the voluminous writings of Durkheim and Simmel, see David Reisman, *The Lonely Crowd* (New Haven, 1950).

7 Clark 1984, p. 266.

8 For one of the rare comments on irony in *La Grande Jatte*, see the perceptive paragraph in Zimmermann 1989, p. 209.

9 Booth 1974, pp. 10–12.

10 Booth 1974, p. 11.

11 Halperin 2002, p. 9. I am grateful to Professor Halperin for sending me her manuscript in advance of publication. Her intelligent study of Laforgue and Seurat deals in parallels, not influences, despite the temptation to bring them closer together (Seurat knew Laforgue, who was an intimate friend of Henry and Kahn). For broad studies of irony, see Muecke 1969 and Booth 1974.

12 Kinney 1996, p. 295.

13 Halperin 2002, pp. 1–2.

14 Seurat made a rough sketch (1881; Musée d'Orsay, Paris, H 6) after Puvis's Salon painting of 1881, *The Poor Fisherman* (Musée d'Orsay, Paris). By misspelling the name "Puvisse de Chavannes," he may have intended to mock the painter.

15 Hermel 1886 (Seurat's Argus); repr. in Berson 1996, pp. 455–57.

16 See Muecke 1969, p. 6.

Technical Investigations of *La Grande Jatte*

Seurat's Working Process: The Compositional Evolution of *La Grande Jatte*

FRANK ZUCCARI AND ALLISON LANGLEY

The many drawn studies and painted sketches related to *A Sunday on La Grande Jatte—1884* stand as a testament to Seurat's exacting working process, with its roots in academic technique. The artist used these studies to determine poses, figure groups, and details, as well as to develop the overall composition. Although the large compositional sketch from the Metropolitan Museum of Art was clearly the departure point for the final canvas, it is also evident that Seurat continued to make changes and refinements as he worked on the Chicago picture. In the course of its execution, he modified many details and altered the contours of a number of the figures, in some cases more than once. He appears in a few instances to have made the changes on the sketch as well as on the final canvas, indicating that the former was not a static model for the latter but evolved at least partly alongside it.

In our recent reexamination of *La Grande Jatte*, we used infrared reflectography and X-radiography to study Seurat's process. We employed a computer-graphics program to outline significant features of infrared, X-ray, and high-resolution color images of the painting, and to graphically overlay them to facilitate comparison. The infrared images (see Fiedler, FIGS. 1, 14) delineate the artist's varied brushwork and late revisions, but reveal no underdrawing, leaving us to speculate about Seurat's technique for laying in forms.[1]

The fifty-nine undated studies for *La Grande Jatte* have been loosely grouped here chronologically by Robert Herbert; although the exact sequence of the works remains unclear, technical evidence

provides some interesting clues to their order (see Related Works). Examinations of the painting and a number of the studies have uncovered interesting trends in their relative sizes and proportions. A height-to-width ratio of two to three appears in many of them, including almost all of the small painted sketches on wood panels, the Metropolitan sketch, and the Chicago painting. Grids visible on several of the studies and new evidence of grid markings along the edges of *La Grande Jatte* itself suggest Seurat's system for enlarging and transferring the composition.

X-rays provide valuable information about Seurat's progressive development of the key elements of the painting, offering insight into his use of the studies and further clarifying the relationship between the Metropolitan sketch and the Chicago painting. They reveal areas where, beginning in October 1885, Seurat reworked portions of the painting using dots and dashes in what has been designated by Inge Fiedler the "second campaign" of painting (see Fiedler, pp. 200–02). We could also discern figural adjustments and alterations made in the early stages of Seurat's work, prior to the

FIG. 1 (OPPOSITE)
Comparison of the contours
and placement of the figures
in the large (Metropolitan)
sketch for *La Grande Jatte*
(CAT. 64; in red) and in the
finished painting (CAT. 80;
in green).

FIG. 2
La Grande Jatte with an
overlay of the grid structure
indicated by tack holes and
hatch marks found on the
canvas. The outer dotted lines
mark the original dimensions
of the painting.

FIG. 3 (BOTTOM)
The Metropolitan sketch with
an overlay of the drawn grid
structure found beneath the
paint surface. The outer
dotted lines mark the original
dimensions of the painting.

completion of the "first campaign" in March 1885.
Also of note is Seurat's apparent use of many conté
crayon drawings to enlarge and develop the figures
for the final canvas *after* he had completed the
Metropolitan sketch. These drawings appear to have
been used as tonal studies and in some instances
bear a strong resemblance to the early figural forms
visible in the X-rays of *La Grande Jatte*.

Enlargement of the Composition

The 1884 Metropolitan sketch and *La Grande
Jatte* correspond very closely to each other. This
was made particularly clear when we digitally
traced, rescaled, and laid the main outlines of the
sketch over the Chicago painting; a comparison of
the contours reveals close registration of most key
features (FIG. 1). The accuracy of the enlargement
from the sketch to the full version, which is three
times as large, was achieved with the aid of a
grid system.

The grid beneath the paint surface of the Met-
ropolitan sketch (see FIG. 3) has been described by
Charlotte Hale, Paul Smith, and Robert Herbert.[2]
The presence of grid lines—dividing the composi-
tion into rectangular quarters and square sixths—
implies that the design was transferred to this
support from another source, perhaps a now-lost
sketch of the whole composition formerly in the
collection of Paul Signac (H 141; see Related Works).
The grid structure of *La Grande Jatte* (see FIG. 2),
which originally measured 200 x 300 cm, divides
the composition evenly into twenty-four squares of
one-half meter each.[3] The uniform sections would

have provided a system to facilitate enlargement
and transfer; as Smith noted, the vertical lines
also may have served as axes for the positioning of
significant compositional features.[4]

Smith hypothesized the use of a grid in the
Chicago painting, but we only recently discovered
supporting physical evidence. A series of marks
and holes corresponding to a one-half-meter-square
grid were found along three sides at the original
turn-over edge of the painting (the edge before
Seurat expanded the painting and added the border
in 1888/89): the top and right edges have tack holes
(some evident on the surface but others detectable
only in X-rays), while the left edge has three

distinct red marks visible on the surface at half-meter intervals. These marks appear to have been incised into the ground layer and then coated with red pigment (see FIG. 4). Additionally, one small horizontal section of a red grid line has been detected with magnification in a thinly painted area at the center left edge, where the reeds grow out of the water.[5] The marks along the bottom edge are indistinct and may have been covered up in subsequent painting. The best hypothesis to account for the tack holes on the top and right edges, the clear marks on the left side, and the absence of marks or holes on the bottom is that Seurat used string as a guide for the lines, possibly a chalk snap line fixed with a nail at one side and held at the other until it marked the canvas. The red color of the line may explain why a complete grid was not detected in reflected or transmitted infrared imaging.[6]

There is also a drawn grid on the related oil study *The Couple* from the Fitzwilliam Museum, Cambridge (see FIG. 5), as well as hatch marks along the edges of the conté crayon drawing of the same subject from the British Museum, London (see FIG. 6).[7] The grid structures indicated on these studies correspond almost exactly to that which divides the Chicago canvas into the twenty-four squares described above. These two works are thus particularly important among those related to *La Grande Jatte* in the information they provide about Seurat's process of transferring and enlarging. Conservator Kate Stonor noted the presence of tacks and holes on the tacking edges of the Fitzwilliam oil that accord with the grid, and suggested that these may have served to stretch string across the face of the painting to facilitate the drawing of the lines.[8] The string grid may also have been applied after painting to aid in transferring the design to the larger, final canvas.[9]

The Fitzwilliam study depicts the right half of the composition in a larger format than that of the Metropolitan sketch. Although it is generally thought to predate the Metropolitan work, its greater scale suggests that it may have been executed later, as a progressive step toward the final canvas.[10] It should also be noted that the grids on the Fitzwilliam and British Museum studies correspond more closely to that of the final painting than to that of the Metropolitan sketch.

The Fitzwilliam study is thinly painted with loose, open brushwork on a preprimed canvas with an off-white ground that is visible in many areas (see Fiedler, FIG. 7).[11] As Herbert suggested, it may have served as a test for laying in the colors for the Chicago painting, which was also painted on an off-white ground.[12] The Metropolitan sketch, in contrast, was executed on an a very finely woven canvas with a thin, off-white ground; it thus retains an overall reddish brown cast, similar to that of the wood supports of the small oil studies.[13] The British Museum drawing probably served a different purpose, investigating dark and light tonalities for the right half of the composition.

Landscape Studies

Landscape, Island of La Grande Jatte (CAT. 60, p. 80), which was painted before the Metropolitan sketch, may have had a practical function, as a stage set against which Seurat could hold up the smaller works to test out various figural arrangements.[14] He would have been able to change the perceived scale of the figures relative to the landscape by varying the distance between the oil sketches and backdrop. One can further theorize that the superimposition of a grid over the canvas with string allowed Seurat to use it as a guide for marking the figures in the sketches for enlargement to the scale of the landscape.[15]

This landscape study is painted on a scale close to that of the Metropolitan sketch, but they differ in their proportions; the landscape measures 65 x 81 cm, whereas the sketch was 66.6 x 100 cm before the painted borders were added. A conté crayon study of the same scene (CAT. 63, p. 79), probably postdating the painted landscape, illustrates Seurat's technique of rescaling and altering the image to fit the two-to-three proportion that he would use for the Metropolitan sketch and *La Grande Jatte*.[16] He cropped elements from the top and bottom of

the oil study in executing this drawing, which more closely approximates the proportions of the Metropolitan sketch and the final painting. Interestingly, the Metropolitan canvas itself was modified to fit a two-to-three proportion. Hale hypothesized that Seurat purchased a standard-size marine canvas measuring 73 x 100 cm, but only used 66.6 x 100 cm of the surface for the painting.[17] Seurat must have had the final 200 x 300 cm canvas for *La Grande Jatte* in mind (he had used the same size for *Bathing Place, Asnières* the year before), and painted the Metropolitan sketch to have the same proportions (at one-third the scale) as the final painting.

Drawings

The scale of most of the conté crayon studies is between that of the Metropolitan sketch and the Chicago painting. In many of them, the figures are smaller than in the final work and roughly twice the size of those in the sketch, suggesting that they represent an intermediate step between the two. Seurat does not appear to have adhered to a particular dimensional scheme as he worked on these studies.[18]

The sizes of the figures in several drawings, however, are close to those of their counterparts in the painting. For instance, the figure in *Seated Woman with a Parasol* (CAT. 71, p. 94) is approximately the same height as her double in the Chicago canvas. The drawn figure also corresponds closely to the initial form seen in the X-rays of the painting. A similar correspondence is found in the drawings *Seated Woman* (CAT. 69, p. 94) and *Three Young Women* (CAT. 75, p. 91). Close examination of the

X-rays indicates that the figures were originally painted with longer backs and lower waists, as in the drawings. The underlying green of the grass is visible in two areas of superficial paint loss along the contours of these figures, confirming that Seurat later extended them over the landscape. Three other conté crayon studies were found to have figures very close in size to those in *La Grande Jatte*: *Head of a Young Woman* (CAT. 70, p. 93), *Fisherman and Tree* (H 616; see Related Works), and *Raised Arm* (FIG. 37).[19] Seurat perhaps made these drawings after the composition was enlarged and used them to refine the forms and details of certain figures.[20]

Development of the Composition

Examination of the X-rays of *La Grande Jatte* and the use of overlays and tracings of high-resolution, detailed images of both the X-rays and the painting allowed us to understand Seurat's initial approach to the large canvas and to see numerous alterations he made as he painted it (see FIG. 7). The shadows and trees of the landscape, as well as the large figural groups in the foreground, appear dark in the X-ray, indicating that Seurat reserved space for them from the outset. He delineated these major compositional elements early on and did not change their placement, as evidenced by the presence of

FIG. 7
The main figural painting
stages of *La Grande Jatte*:
figures highlighted in blue
were introduced into the com-
position in the first stage,
figures in green were painted
in the intermediate stage, and
figures in red were added in
the final stage.

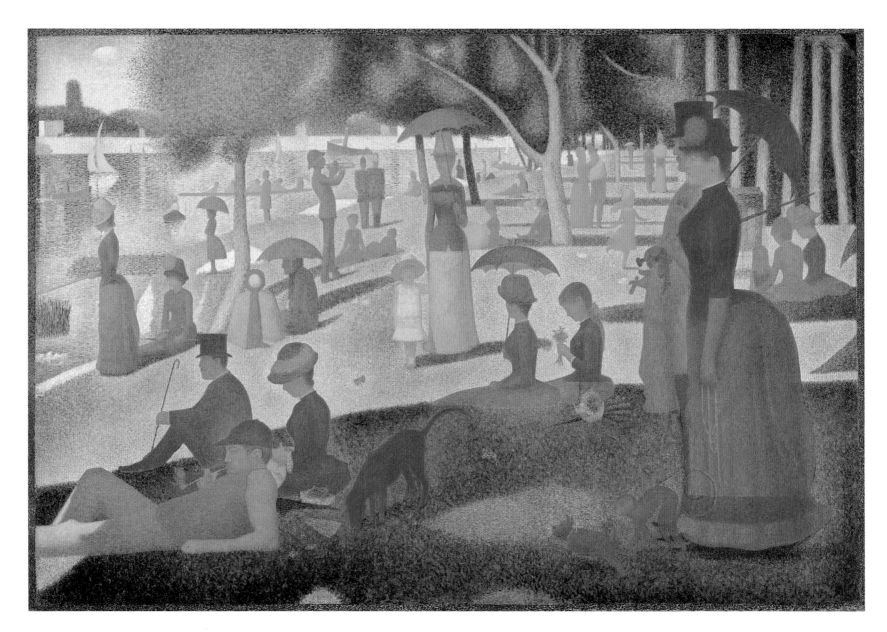

clearly demarcated borders between the figures
and the landscape (visible in X-rays). Contours that
were revised in the painting process tend to be
less distinct.

A number of smaller figures were clearly added
over the landscape, since shadows and grass are
visible through their forms: the running girl in red
and the couple with the white umbrella to her right
were painted at an intermediate stage. The X-ray
of the Metropolitan sketch shows that Seurat also
introduced the corresponding figures over the
finished landscape (see FIG. 8). This suggests that
he may have worked out the figures on both can-
vases simultaneously.

Seurat added other characters to the Chicago
painting at a very late stage in the process: he
painted the monkey, not visible in the X-ray, over
the finished grass, and executed several of the
small figures at the shoreline over the water. One
interesting later addition to both the Metropolitan
and Chicago paintings is the small boat with a tri-
color flag near the water's edge, to the left of the
forked tree trunk; it was painted over the completed
water in the former and at some intermediate stage
in the latter. The boat is often mentioned as an indi-
cation of the close relationship between *La Grande
Jatte* and *Bathing Place*, which features a nearly
identical vessel. It is thus interesting to note that
it was in fact a latecomer to the Chicago canvas,
not included in its original conception.[21] In both the
Metropolitan and Chicago works, the boat was
painted over the form of a brown cow or horse—
a figure visible in the Fitzwilliam version of *The*

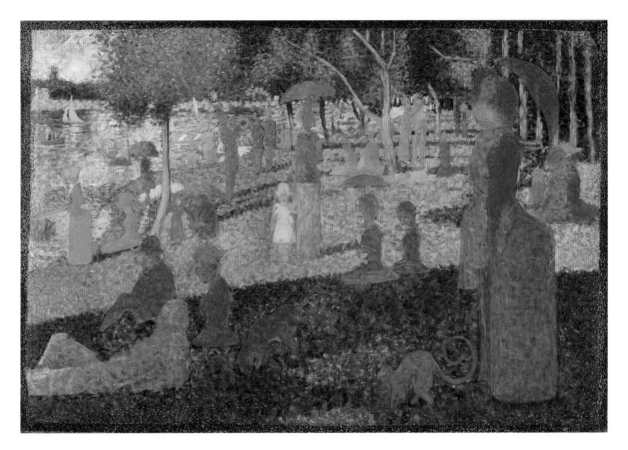

Couple (CAT. 62, p. 84) but never before associated
with the sketch or *La Grande Jatte*.[22]

While the overall arrangement of most of the
forms and landscape was established from the begin-
ning and remained constant, Seurat made numer-
ous minor modifications. In the course of painting,
he widened the contours of some tree trunks and
of many figures. His alterations are often subtle,
suggesting that he debated the nuance of each fold

and curve. Many of the figures visible in the X-ray
resemble those in the studies, particularly those in
conté crayon, indicating that they were important
means for experimentation and refinement of the
key elements of the composition.

We undertook a detailed exploration of the inter-
play between Seurat's painted and drawn studies,
the Metropolitan sketch, and the Chicago canvas,
with the aim of clarifying the artist's working

process and the sequence of the studies. The similarities and differences between the Chicago painting and the Metropolitan sketch and between their respective X-rays demonstrate that Seurat's approach was empirical, at once systematic and flexible, enabling him to make refinements at every stage in the process. By looking carefully at a few particular figural groups, the complexity of the evolution of *La Grande Jatte* becomes clear.

Promenading Couple

The difficulty of establishing a firm chronology for Seurat's many drawings and studies related to *La Grande Jatte* is demonstrated in an investigation of the large promenading couple in the foreground (see FIG. 9). The X-ray of the pair in the Chicago painting illustrates the type of refinements that Seurat made to the figures after establishing their initial positions. Several modifications are evident, particularly in the contour and width of the woman's skirt. The garment had at least two distinct shapes before March 1885, predating Seurat's late revision of the painting with dots and dashes (see FIGS. 10–11). Originally, the woman's form was slimmer, with a thin waist and a straight skirt with a sharply sloping bustle, much like that in the Metropolitan sketch.[23] In the course of executing the Chicago painting, the artist expanded the back with a rounded, protruding rear bustle, added a curve of fabric to the front, and raised the hem—changing its original edge into a dark, loosely defined shadow. As Seurat modified the outline of the skirt, he appears to have added definition and folds to the fabric that

differ from those visible today. The X-ray reveals several internal lines and shapes suggestive of the drawing *Skirt* (CAT. 67, p. 89), which probably functioned as a study for an intermediate variation of the garment. The painted panel *Woman with a Parasol* (CH. 2, FIG. 3) depicts the figure in an entirely different dress and hat, but the skirt has width and internal detailing similar to that visible in the X-ray.

In the second painting campaign, when Seurat reworked the canvas using dots and dashes, he expanded the width of the skirt once again, covering portions of the finished grass and neighboring figures. He left the horizontal black band near the bottom undisturbed, giving an idea of the garment's width before he added its final flared back. The artist also widened and redefined the woman's torso at this time to balance her proportions. In her final form, she strongly resembles the figure in *Woman Walking with a Parasol* (CAT. 68, p. 89). This unusual drawing, probably done in the studio with a model, varies significantly from the other tonal studies, which have much more simplified silhouettes. The similarity of the skirt as well as the collar (other studies include a white ruffle absent in the final version) suggests its use to define the ultimate profile of the *promeneuse*.[24]

Seurat also altered the contour of the same figure in the Metropolitan sketch (FIG. 12), but in a different manner. The X-ray reveals that she was initially depicted with a long skirt and a rounded bustle similar to that in the British Museum and Fitzwilliam studies (see FIG. 13). The artist later

painted over the neighboring grass to widen, simplify, and streamline the profile (see FIG. 14). He straightened the back of the skirt, eliminated curves, and made the lower portion of the figure more cylindrical; in fact the progression of the profile is contradictory to what we see in the X-ray of the final painting. Interestingly, another study for this figure, *Woman with a Monkey* (CAT. 59, p. 79), shows a skirt that is an amalgam of the varied styles depicted in the British Museum drawing, the Fitzwilliam study, and the Metropolitan sketch.

Seurat adjusted the form and size of the woman's parasol as well. The X-ray of the Metropolitan sketch reveals that it was originally conceived as small and compact. The artist later enlarged the parasol, painting a sweeping, curved form pointing toward the ground; this change is visible as a pentiment. The larger parasol resembles that in *La Grande Jatte*, the X-ray of which shows no changes to this area during painting.

X-rays of the promenading man reveal alterations similar to those of his female companion. Three stages are evident—two distinct figural profiles were painted prior to March 1885 and a final expansion of the form took place after October 1885. The man's chest, coat, and legs initially looked similar to the forms in the Metropolitan sketch; he was thinner and his coat more tailored in shape. At an intermediate stage, Seurat expanded his chest and coat, probably as he was widening the woman's skirt. Finally, using dots and dashes, he made the man's chest more rounded, gave the coat hanging on his arm a more curvilinear outline, and strengthened

FIG. 9

Detail of promenading couple in *La Grande Jatte*.

FIG. 10

X-ray detail of promenading couple in *La Grande Jatte*; the green lines indicate the contours of the figures in the final state of the painting.

FIG. 11

Comparison of the contours of promenading couple in *La Grande Jatte* in the initial state visible in X-ray (red), the intermediate state visible in X-ray (blue), and the final state (green).

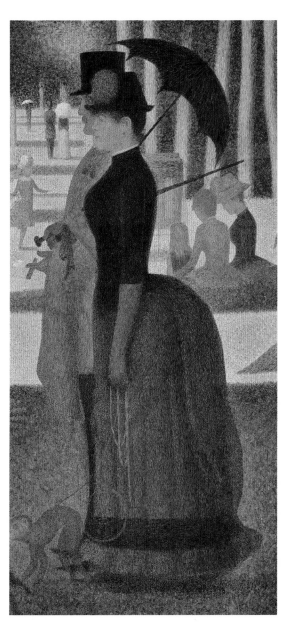

and the conté crayon drawing from the British Museum—is difficult to establish. Herbert argues in this catalogue that the two *Couple* works are preparatory studies for the Metropolitan sketch (see p. 79); this has long been the accepted order. There are a few factors that support the placement of the Fitzwilliam work after the Metropolitan sketch, however: the figures are larger in the former than in the latter, and this increase in scale suggests to us a progressive step toward the final canvas; the white ground used in *The Couple* is consistent with that of the Chicago canvas; the technique employed in the former resembles the kind of underpainting used on *La Grande Jatte*; and the grid structure of the Fitzwilliam study is closer to that of the final painting than it is to the Metropolitan sketch.[25]

It is clear from X-ray evidence that many of the early features of the Metropolitan sketch were originally consistent with the Fitzwilliam painting and were only later revised to resemble the Chicago canvas. Therefore, the Fitzwilliam painting loosely represents the initial appearance of the Metropolitan sketch. Seurat appears then to have worked out changes to the composition on the Chicago and Metropolitan canvases simultaneously—adding, deleting, or expanding elements on the Metropolitan sketch as *La Grande Jatte* progressed. It is thus possible to imagine that Seurat executed the Metropolitan sketch, then painted the Fitzwilliam canvas to help him enlarge the composition, and then, while working on the final painting, made further changes to the Metropolitan work (but not to the Fitzwilliam piece).[26]

his chin. One of his hands and his cigar were painted at a very late stage, over the nearly completed landscape; his other hand, holding the cane, was marked in at an earlier stage, over an initial layer of grass. The early painted sketch *Standing Man* (CAT. 43, p. 74) depicts the man alone with a long, slim cane or umbrella held at his side and pointed toward the grass behind him. In the X-ray of the Metropolitan sketch, the umbrella extends

toward the ground in front of the figure as in the Fitzwilliam sketch, but Seurat later painted it over in the former. In the final work, he gave the man a cane once again, but this time held in his left hand and angled up at his side.

The chronological relationship between the Metropolitan sketch, the Chicago painting, and the two main studies for this portion of the composition—the painted sketch from the Fitzwilliam Museum

FIG. 15
Detail of monkey and pug dog in *La Grande Jatte*.

FIG. 16 (BOTTOM LEFT)
X-ray detail of monkey and pug dog in *La Grande Jatte*; the dog is visible at the bottom left (its contour is indicated in green), but the monkey is absent.

FIG. 17
Detail of monkey in the Metropolitan sketch.

FIG. 18 (BOTTOM RIGHT)
X-ray detail of monkey in the Metropolitan sketch. The red line indicates the contours of the animal in the initial stage of the sketch.

There are some indications that the British Museum drawing postdates the Metropolitan and Fitzwilliam works, and may have been a transitional step toward the final canvas. Its grid markings match up with those of the Fitzwilliam study and *La Grande Jatte*. The figure of the running girl (added relatively late in the process to the Metropolitan sketch) is suggested by a dark spot in the drawing. Also, the group of seated figures to the right of the strolling couple is tightly clustered in the Metropolitan and Fitzwilliam works, but spread apart in both the British Museum drawing and the final painting. The promenading woman's parasol, smaller and more compact in both the Fitzwilliam painting and the X-ray of the Metropolitan sketch, contrasts with the larger and more sweeping form in the British Museum drawing and the final canvas.

The two young women seated to the left of the promenading couple—visible in both the Fitzwilliam and British Museum images—complicate our hypothetical chronology. In both of these studies, a shadow extends behind the women's heads, whereas in the Metropolitan sketch and *La Grande Jatte* a shorter shadow ends at the shoulder of the figure on the right. Herbert cited this modification as evidence that the Metropolitan sketch came last in the sequence of these late studies, since Seurat tended to use shadows as structuring elements that remained unchanged during the course of painting (see p. 82). Though it is possible that this shadow was altered in the Metropolitan sketch at a later time, we did not find definitive physical evidence of this.[27]

Monkey and Dog

The X-ray of the monkey and the pug dog in the Chicago painting (see FIGS. 15–16) presents a somewhat puzzling situation: the dog, for which there are no known drawn or painted studies, is well defined, while the monkey is not at all visible, either in its current position or in the area further to the left, where it is situated in the Metropolitan sketch (see FIG. 17). The monkey clearly was painted after the landscape and figures were completed; it actually overlaps the man's feet and the woman's dress. The landscape is built up around the pug dog, however, indicating that this animal was introduced at an early stage in the painting process.

In contrast, the pug is totally absent from both the Metropolitan sketch and its X-ray (see FIGS. 17–18), while the monkey was clearly included in Seurat's earliest conception of the composition, since the landscape does not extend beneath it. Additionally, the monkey appears in two early studies for *La Grande Jatte*: a small, now-lost compositional study (H 141; see Related Works) and *Woman with a Monkey* (CAT. 59, p. 79). In essence, the little canine entered the composition in the earlier stages of the final canvas in roughly the position of the

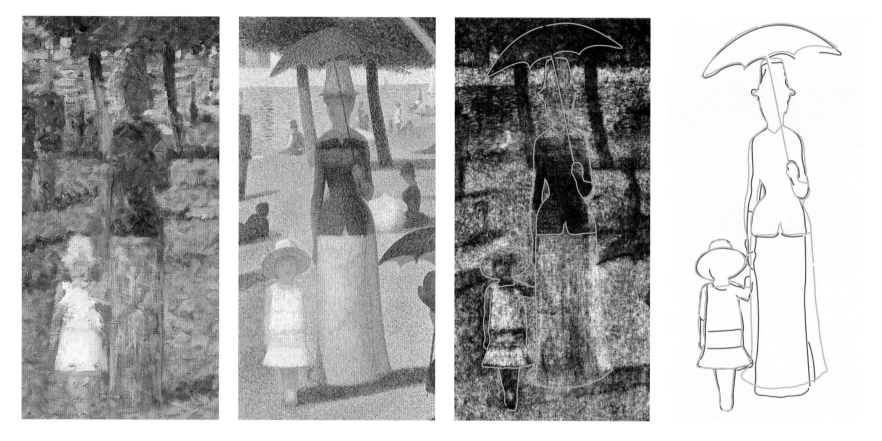

monkey in the Metropolitan sketch. The monkey was then reintroduced at a later stage, after the landscape and figures were painted. Neither animal is found in the Fitzwilliam study or the British Museum drawing.

Woman and Child

In the case of the centrally placed woman and child, there are a number of differences between the Metropolitan sketch (see FIG. 19) and *La Grande Jatte* (see FIG. 20). In the sketch, a strong shadow is cast by the significantly narrower and more columnar woman but only vaguely by the little girl; in the final composition, a shadow begins at the foot of the child and extends across and in front of the woman, in effect bringing the position of the girl forward. The woman's arm holding the parasol is more upright in the sketch, while in the final version the forearm projects forward.[28] It is difficult to interpret the very broadly rendered girl in the sketch, but it appears that her arm is upraised, reaching toward the woman's hand.[29] In the final painting, her upper arm is extended horizontally and her forearm hidden by her companion's dress, making it unclear whether they are holding hands. The child's hat in the sketch lacks the broad brim of the final canvas; in its original form, it resembles an upside-down flower pot, much like the woman's hat in the Chicago painting.

The X-ray of *La Grande Jatte* (FIG. 21) shows that in its initial stages the woman and child

FIG. 23

Detail of two seated women in *La Grande Jatte*.

FIG. 24

X-ray detail of two seated women in *La Grande Jatte*; the green lines indicate the contours of the figures in the final state of the painting.

FIG. 25

Comparison of the contours of the figures of two seated women in the drawing *Seated Woman with a Parasol* (CAT. 71; black), and in the X-ray (red) and final state (green) of *La Grande Jatte*.

FIG. 26 (BOTTOM LEFT)

Detail of seated group at lower left in *La Grande Jatte*.

FIG. 27 (BOTTOM RIGHT)

X-ray detail of seated group at lower left in *La Grande Jatte*; the green lines indicate the contours of the figures in the final state of the painting.

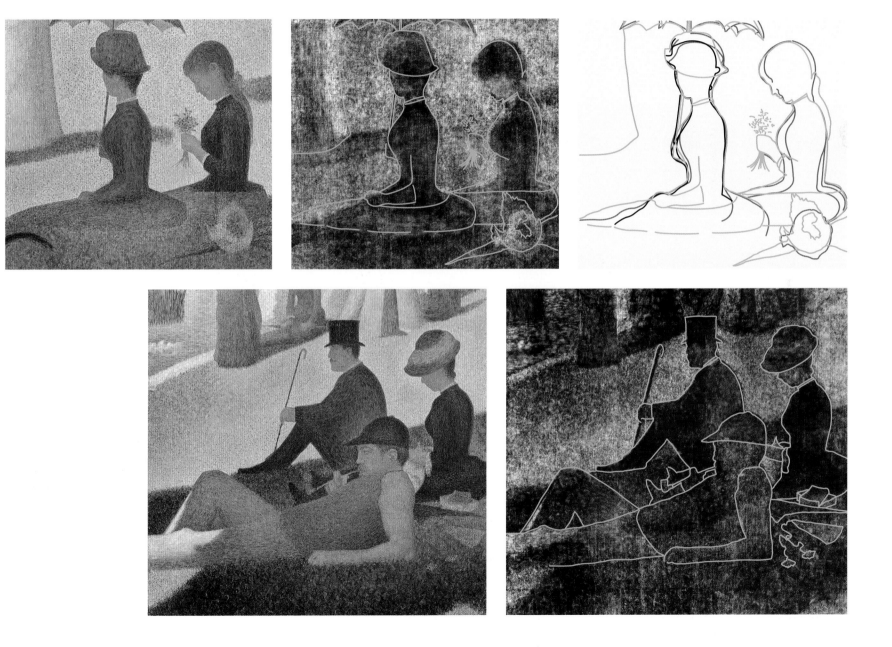

FIG. 28

Detail of woman fishing in *La Grande Jatte*.

FIG. 29

X-ray detail of woman fishing in *La Grande Jatte*; the green lines indicate the contours of the figure in the final state of the painting.

FIG. 30

Comparison of the contours of the figure of the woman fishing in *La Grande Jatte* in the X-ray (red) and the final state (green).

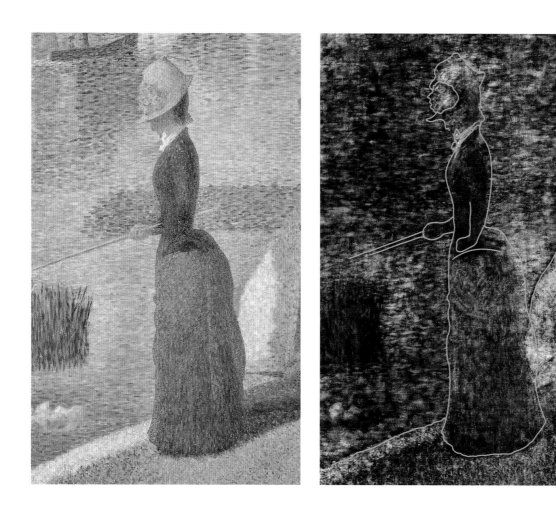

correspond to the sketch very closely. It was only later that Seurat repositioned the woman's arm and expanded her form (see FIG. 22). The woman in the sketch is situated slightly to the left of the painting's central vertical axis. By widening the figure by about one-and-one-half inches along its right side in the

final painting, Seurat in effect moved it closer to the center of the composition. The changes to the hem of the woman's dress (which is shorter than it was originally) and the alteration mentioned above to the surrounding shadow create the peculiar illusion that she is hovering a few inches above the ground.

Two Seated Women

An examination of the two young women seated to the right of the woman and child (see FIG. 23) uniquely illustrates Seurat's use of the conté crayon drawings in the development of *La Grande Jatte*. The woman on the left holding the umbrella is similar

FIG. 31

Detail of woman fishing in the Metropolitan sketch.

FIG. 32

X-ray detail of woman fishing in the Metropolitan sketch; the green lines indicate the contours of the figure in the final state of the sketch.

FIG. 33

Comparison of the contours of the figure of the woman fishing in the Metropolitan sketch in the X-ray (red) and the final state (green).

in size to that in the drawing *Seated Woman with a Parasol* (CAT. 71, p. 94), and both the final form of the figure and the earlier painted version visible in X-rays (see FIG. 24) share contours with the drawing (see FIG. 25). In the drawing and the earlier stage of the Chicago canvas, however, the woman has a smaller head and hat, as well as a less voluminous skirt. The back of the skirt once had the shape depicted in the smaller drawing of the same figure (H 628; see Related Works). Seurat enlarged the hat and extended the skirt on both sides during his first campaign on the painting. The artist further extended the front of the woman's skirt over the landscape when he revised the painting with dots and dashes.

Her companion, seated to the right, underwent a few changes as well. The X-ray of this figure shows a form similar to that in the drawing on which she was likely based, *Young Woman* (CAT. 72, p. 94). The shape of the woman's back in the final painting mimics the contour of the drawing, but to this basic form Seurat added details such as the extended hand and the ponytail; he also gave her a wider skirt and enlarged the hat at her side.

Seated Group at Lower Left

The figures in the lower left corner of *La Grande Jatte* (see FIG. 26) differ in minor respects from the group in the Metropolitan sketch. For instance, the bare arms of the reclining man in the finished painting are covered with shirtsleeves in the sketch. The X-ray of the Chicago canvas (see FIG. 27) reveals some reworking in this area, indicating that the change may have happened during the course of painting (although the same figure appears to be sleeveless in a small compositional sketch [H 141; see Related Works]). Changes to the other two figures appear to have been present from an early stage. The seated woman retains her posture and positioning from the Metropolitan sketch; the addition of books at her side, the newspaper or sewing materials in her lap, and a different style of hat occurred early, since all of these elements are visible in the Chicago X-ray. Strong similarities between the drawing *Seated Woman* (CAT. 69, p. 94) and the X-ray of the figure point to the drawing's use for the final painting. The counterpart in the sketch to the seated dandy, holding a cane and sporting a top hat in *La Grande Jatte*, wears a bowler hat and has no cane. Their accouterments are distinct in the X-ray of the Chicago canvas; thus, there is no indication that the previous figural type was ever portrayed in the final painting.

Seurat shifted back the hind legs of the black dog to the right of the group after the initial blocking-in of the form; these changes are visible as pentiments on the painting's surface. He enlarged the entire form during the second campaign by adding a band of small dots to the outer edges of the body. Overall, the posture and position of the dog remained unchanged and are consistent with those of the dog in *Landscape, Island of La*

FIG. 34

Detail of woman and man with baby in *La Grande Jatte*.

FIG. 35

X-ray detail of woman and man with baby in *La Grande Jatte*; the green lines indicate the contours of the figure in the final state of the painting.

FIG. 36

Comparison of the contours of the woman and man with baby in the drawing *Raised Arm* (FIG. 37; black), and in the X-ray (red) and final state (green) of *La Grande Jatte*.

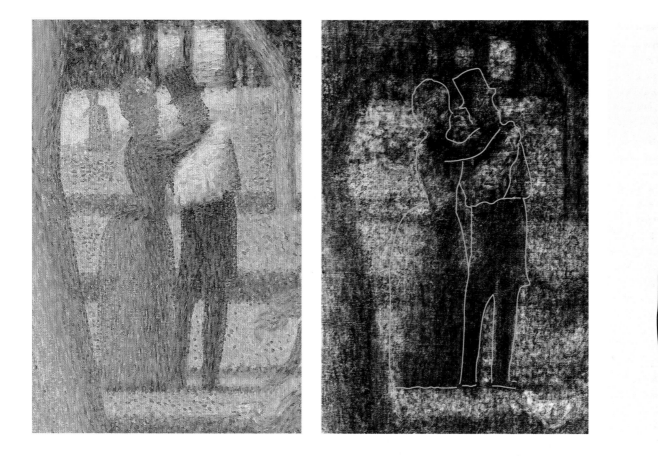

Grande Jatte (CAT. 63, p. 79). The canine in the Metropolitan sketch is more angular and sketchy, and it lacks the arched tail seen in the other two works.

Woman Fishing

The woman fishing on the left bank in *La Grande Jatte* (see FIG. 28) has a skirt similar to that in the Metropolitan sketch, although her upper torso is narrower and she is significantly larger overall.

In the Chicago painting, she began as a thinner, sleeker figure, although the X-ray shows early detailing of the skirt fabric that the artist appears to have simplified prior to March 1885 (see FIGS. 29–30). During the painting campaign begun in October 1885, Seurat widened the skirt, giving the figure a rounded, exaggerated bustle introduced over the neighboring water. The fisherwoman in the sketch (see FIG. 31) was similarly altered (see FIGS. 32–33). A conté crayon drawing of the figure (CAT. 28, p. 88) is closer in appearance to the final image than to the slimmer form visible in the *Grande Jatte* X-ray. It seems unlikely, however, that this drawing was created as a preparatory study for *La Grande Jatte*; it was more likely executed as an independent work around 1883 (see Herbert, p. 85).

Woman and Man with Baby

Using tiny dots and dashes, Seurat expanded the skirt of the woman in the background on the right (see FIG. 34) over the adjacent landscape. The transition from a thinner, straight skirt to one with a more rounded bustle is illustrated in X-rays of the image (see FIGS. 35–36). The Metropolitan sketch features the same woman with a loosely painted skirt that Seurat did not change. The figure in *Raised Arm* (FIG. 37), thought to be a model for the woman, has approximately the same measurements as the final figure in *La Grande Jatte*. Though the authenticity of this work has been questioned, it is consistent in terms of handling and scale to the final figure and shares a number of qualities with other accepted preparatory drawings.

Conclusion

While our research has resulted in expanding our knowledge of Seurat's working process, elaborating upon his use of a grid system and demonstrating the previously unknown complexity of the relationship between the Metropolitan sketch and the final version of *La Grande Jatte*, it has also opened the door for further study. Our hypotheses about how Seurat used his painted sketches and conté crayon drawings to enlarge and transfer major figural groups can only be confirmed or refuted by intensive examination of these many works. Our findings demonstrate that the evolution of *La Grande Jatte* was anything but linear; that the nuances of Seurat's complex artistic process in some ways continue to evade us only adds to the enigmatic status of his enduring masterwork.

Acknowledgments

We wish to thank Robert Herbert for his support and encouragement of this study and for sharing his insights on Seurat. We are also indebted to Charlotte Hale of the Metropolitan Museum and Kate Stonor of the Hamilton Kerr Institute, Cambridge, Eng., for generously exchanging information and research materials. Thank you to Ashok Roy of the National Gallery, London, for allowing access to research prior to its publication. Thanks also to Dr. Antje Birthälmer of the Von der Heydt Museum, Wuppertal, and to Aprile Gallant of Smith College for providing detailed measurements of their drawings. Appreciation also goes to Inge Fiedler for her ongoing technical research on Seurat, and to Douglas Druick and Gloria Groom for their support. Finally, a special debt of gratitude must go to Alan B. Newman and his Imaging Department staff for their involvement throughout this project.

Notes

1 Infrared (IR) reflectography is a technique used for viewing underdrawing and early paint stages of a work using a camera equipped with an infrared-sensitive detector.

2 Hale and Smith differed in their descriptions of the grid on the Metropolitan sketch. Hale examined the painting with infrared imaging and a binocular microscope in 1990; see her Technical Examination Report, 1990, Metropolitan Museum of Art, New York. She described the grid as follows: "If one ignores the painted borders, which were not a part of the original sketch, it can be seen that the format has been quartered and divided into thirds vertically in a very precise manner, thus forming grids of rectangular quarters and square sixths." Our recent reexamination of the painting with IR confirmed her description. Smith scrutinized the painting with infrared imaging in 1980 and published his findings in 1997; see Smith 1997, pp. 19–20. He described a grid that forms twenty-four even squares. Herbert also discussed the grid of the Metropolitan work, basing his description on Hale's comparison; see Herbert et al. 1991, p. 211.

3 Seurat changed the dimensions of *La Grande Jatte* in 1888/89 when he restretched the canvas and enlarged the stretcher in order to add the painted border. The painting now measures 207 x 308 cm. It remains on the original stretcher, which Seurat expanded by attaching wood strips to all four edges.

4 Smith 1997, pp. 19–20.

5 The small horizontal section of the grid line matches up precisely with the incised mark at the center left edge. The line segment appears drawn or painted, not incised into the ground like the edge marks; this suggests that there may be additional grid lines under the paint which we are not able to detect.

6 Infrared reflectography detects graphite and other carbon-based materials that absorb in the IR region and that therefore appear dark. Colored underdrawing materials, including red chalk or paint, are generally not detectable with IR.

7 Smith 1997, pp. 19–20. The grid on the Fitzwilliam painting was thoroughly described by conservator Kate Stonor (Conservation Examination Report of *The Couple*, n.d., Hamilton Kerr Institute, Cambridge, Eng.): "The grid divides the canvas into 12 (approximately 20 cm x 20 cm) squares and 4 (approximately 20 cm x 5 cm) rectangles. The four slim rectangles seem to be an artefact of the dimensions of the commercial canvas."

8 See Stonor (note 7).

9 An analogous process for transferring images was used for *Circus* (CH. 5, FIG. 13), which has an underlying diagonal and horizontal grid visible in infrared. Two studies on paper for *Circus* appear to have played a role in the enlargement of the composition. The drawing *Head of a Clown* (Woodner Family Collection, New York, H 709) is marked for transfer with a diagonal grid and with vertical and horizontal lines that intersect the diagonals, except for the center vertical line that is offset to the left. Although the drawing matches the final painting closely in scale and design, neither the construction lines nor the drawing aligns exactly with the final painting. The watercolor *Clown and Ringmaster* (Musée du Louvre, Paris, H 710) is more closely associated with the oil sketch for *Circus* (Musée d'Orsay, Paris, H 212). The scale of the figures in the watercolor is the same as that in the painting; both works correspond closely in design. Thus, we can surmise that Seurat used the watercolor to enlarge the oil sketch to the size of the final painting. For a discussion and reproductions of the various studies for *Circus*, see Anne Distel, "*Cirque*, 1890–1900," in Herbert et al. 1991, pp. 363–69. For another series by Seurat of drawn and painted works with visible grid lines, see Zimmerman 1991, pp. 70–71.

10 The Fitzwilliam sketch is on a standard no. 25 figure format (81 x 65 cm). It is the same size as two paintings in the collection of the National Gallery, London: *Le Bec du Hoc* (CAT. 84, p. 63) and *The Channel at Gravelines: Grand Fort-Philippe* (H 205) of 1890; see Stonor (note 7), p. 7. It is also the same size as the canvas used for *Landscape, Island of La Grande Jatte* (CAT. 60, p. 80). See Fiedler (pp. 196–97) for more information on Seurat's canvases. See also Kirby et al. 2003.

11 Stonor (note 7).

12 Herbert et al. 1991, p. 202.

13 The canvas has a count of 30 x 29 threads per centimeter; see Kirby et al. 2003, p. 19. Our recent reexamination of the Metropolitan sketch revealed the presence of a calcium carbonate ground layer; previously, the work was thought to be executed on unprimed canvas. The ground appears to be very even and thin, with areas of abrasion where the dark canvas threads show through. Since the priming appears to be confined to the image plane and does not continue onto the original vertical tacking edges, it was probably applied by the artist. For more

on Seurat's grounds, see Fiedler (pp. 196–97).

14 We know *Landscape, Island of La Grande Jatte* (CAT. 60, p. 80) was finished before *La Grande Jatte*, as it was exhibited in December 1884 with the Indépendants; see Herbert et al. 1991, p. 204.

15 In other words, Seurat could then have transferred the corresponding portions of the landscape grid onto the oil-on-panel studies, either with string or with actual lines. Since most of the *croquetons* were not examined in this investigation, evidence supporting or refuting this hypothesis will only come with future research.

16 Herbert et al. 1991, p. 206. See also Herbert in this publication (p. 78).

17 The Metropolitan sketch currently measures 70.5 x 104.1 cm. The lined painting is no longer on its original stretcher, so we do not know the exact dimensions of the original canvas, although Charlotte Hale (note 2) proposed that it corresponded to landscape format no. 40 (73 x 100 cm). We agree with Hale's suggestion that Seurat utilized only a portion of the larger canvas for the Metropolitan sketch, leaving unpainted strips above and below the composition. In our recent examination of the painting, we noted that the ground continues under the top and bottom painted borders but not along the sides. This is consistent with the old tack holes on the sides (observed by Hale in X-rays), which indicate that Seurat painted the border on the extended side tacking margins. At the top and bottom, he had sufficient room to add the border without extending the canvas. We also discovered the presence of a gold-colored layer (identified as brass; see Fiedler, note 11) beneath the painted border along the top and bottom, revealing Seurat's treatment of the unfinished strips before the addition of the final border. Seurat's reason for applying the metallic paint is as yet unknown.

18 Leighton and Thomson contended that Seurat may have bought larger sheets of paper of a standard size and cut them down to create preferred formats; see Leighton and Thomson 1997, pp. 18, 17 n. 8.

19 *Head of a Young Woman* is only 2 cm smaller than the figure in the final painting; the figure in *Fisherman and Tree* is the same size as his counterpart in the final painting, though the tree itself is smaller; the woman in *Raised Arm* is slightly larger in the drawing.

20 As Leighton and Thomson noted, Seurat used some of the drawings for *Bathing Place, Asnières* in a similar manner: he executed them after the final painting was under way in order to refine figural forms; see Leighton and Thomson 1997, pp. 64–65.

21 The boat with the tricolor flag was also a late addition to *Bathing Place*; see Leighton and Thomson 1997, pp. 74–75.

22 The identity of the brown form in the Fitzwilliam sketch as a cow or horse grazing in the distance became clear during our research; its size, placement, and character tie it to the vaguely defined brown animal seen in two oil-on-panel studies: *Standing Man* (CAT. 43, p. 74) and the now-lost small sketch of the whole composition (H 141; see Related Works). While this creature is not seen in either the Metropolitan sketch or the Chicago painting, examination of each established that it was included originally. Its form is visible in the X-ray of *La Grande Jatte*, and close scrutiny of the same area of the sketch reveals a small semicircular sliver of brown paint visible behind the blue water and the small boat.

23 Herbert postulated that "in its first stage the Chicago canvas had the more slender, rather wooden shapes of the present [Metropolitan] sketch and would have appeared less graceful, more 'primitive'"; see Herbert et al. 1991, p. 210. This hypothesis is largely confirmed by the X-ray of *La Grande Jatte*.

24 Herbert believes that Seurat executed this drawing in his studio using a model; see his description in this catalogue (p. 86).

25 *The Couple* has been cited as an illustration of Seurat's technique for initially blocking in forms and colors; see Fiedler 1989, p. 176. See also Herbert in this catalogue (p. 79).

26 The X-ray of the Metropolitan sketch shows the man holding an umbrella at an angle pointed toward the ground, a feature that Seurat retained in the Fitzwilliam study but eventually painted out in the sketch. Figures such as the young girl in red and the tiny couple with the white umbrella, absent in the Fitzwilliam study, were likely added on top of the landscape to the Metropolitan sketch and *La Grande Jatte* around the same time. These changes can be interpreted in a number of ways, but they do not preclude either of the proposed chronologies.

27 Microscopic examination indicated traces of darker green paint under the lighter green grass, where one would have expected to find evidence of the longer shadow, but there was not enough information to draw a firm conclusion. X-ray details of the Metropolitan and Chicago paintings are also unclear; there is no delineation of the shadow, although the area appears very dense in the Metropolitan detail.

28 In *Rose-Colored Skirt* (CAT. 51, p. 76), the woman's arm projects forward at an angle across her torso, in a manner slightly different from the motif in the Metropolitan sketch and *La Grande Jatte*. Although the figure is reversed, she has the dress and left-tilting umbrella of the two later works and as such seems to be the image from which the artist developed the final figure.

29 A conté crayon drawing of the little girl (CAT. 73, p. 93) is very close to the form of the girl in the X-ray and is similarly unclear in the area around her arm. Also, she wears the same wide-brimmed hat and drop-waist dress seen in *La Grande Jatte*.

La Grande Jatte: A Study of the Materials and Painting Technique

INGE FIEDLER

The exhibition that occasioned this publication provided us with the opportunity to reexamine Seurat's *Sunday on La Grande Jatte—1884*, making use of technological advances that were not available when the painting last underwent extensive technical analysis in 1982.[1] At that time, we inspected the picture in order to study the evolution of Seurat's technique. We took pigment samples to determine the artist's palette and to ascertain the types of unstable pigments he reportedly used in reworking this painting.[2]

For this study, a variety of other investigative methods were employed to provide us with new information about Seurat's masterwork. Infrared (IR) reflectograms of the entire painting were captured directly into the computer and composited digitally for closer examination and for comparison of the earlier stages to Seurat's final composition.[3] In the case of *La Grande Jatte*, infrared reflectography shows fairly clearly the different types of brushwork Seurat employed, revealing many of the artist's compositional changes (see FIG. 1). We also took additional paint samples, including cross-sections; these disclosed multiple layers of paint that attest to the complexity of Seurat's technique. Examining the samples with the aid of a reflected light/fluorescence research microscope and a scanning electron microscope equipped with an energy-dispersive X-ray spectrometer, we determined the pigment mixtures specific to each layer. Binding medium analysis was conducted on a select group of samples.[4] We also took photomicrographs with a surgical stereomicroscope equipped with a special

floor stand, giving us greater flexibility to examine and document the work. In addition, spectrophotometry undertaken by color scientist Roy S. Berns allowed for accurate reflectance measurements of a range of colors used by Seurat, including the discolored paints (see Berns). The most comprehensive study of Seurat's painting materials and technique, recently undertaken by the National Gallery, London, and the Courtauld Institute of Art provided us with important additional information on Seurat's working methods.[5] All of this research, old and new, is enlisted here to give the most thorough survey of the materials and painting technique employed by Seurat in *La Grande Jatte*.

Support and Preparatory Layers

By the late nineteenth century, commercially prepared canvases had become increasingly popular and were available in a variety of fabric types with standard sizes, weaves, and surface textures. In France such preprimed canvases were generally mounted on stretchers whose dimensions were determined by eventual use: there were different formats for portraits, landscapes, and seascapes.[6] Because of *La Grande Jatte*'s monumental scale, Seurat probably had to order a special, oversized canvas.[7] This consisted of a single piece of coarse, plain-weave linen commercially primed mainly with lead white tinted with a small amount of carbon black and mounted on a seven-member stretcher frame.[8] The combination of a roughly woven canvas and a thin ground layer created a relatively grainy surface. Despite Seurat's reworking of many

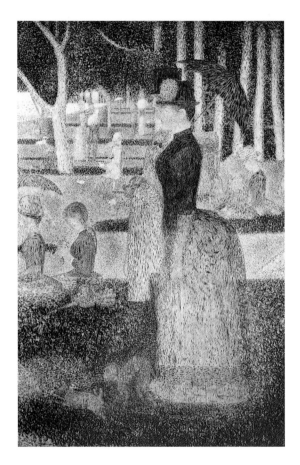

areas, the paint layers are generally thin and the texture of the linen is discernible through them (see FIG. 9). Close examination also shows that the priming layer is visible in many areas, particularly in those not heavily reworked in subsequent painting campaigns. Recent research conducted on Seurat's first major work, *Bathing Place, Asnières*, disclosed that it was also executed on a single piece of coarse linen commercially primed with

lead white tinted with carbon black. Its size is identical to that of *La Grande Jatte* before the latter was enlarged by Seurat in 1888/89 to accommodate the painted border. Both canvases were probably purchased from the same supplier.[9] In contrast to *La Grande Jatte*, however, *Bathing Place* was built up with many layers of paint that are more evenly blended together, so that the priming is no longer visible except in areas along the edges of the canvas.[10]

Other works on canvas related to *La Grande Jatte* have somewhat different types of supports and grounds. For instance, although the final compositional study in the Metropolitan Museum of Art has long been regarded as unprimed, recent examination and sampling confirmed the presence of a thin, off-white calcium carbonate ground over a fine, plain-weave canvas.[11] Seurat probably applied it, since only the top and bottom edges of the border have a ground layer; the sides, which were extended when the artist added the border, do not. *Landscape, Island of La Grande Jatte* (CAT. 60, p. 80) was painted on a plain-weave linen canvas, commercially primed with a mixture of lead white, a small amount of carbon black, and trace amounts of silicates and calcium that is similar in composition to that used in the final canvas. The oil-on-canvas study *The Couple* (CAT. 62, p. 84), was executed on a support primed with a single off-white layer consisting of lead white, calcium carbonate, charcoal black, and some yellow ocher and red earth pigments. The measurements of both *Landscape, Island of La Grande Jatte* and *The Couple* correspond to

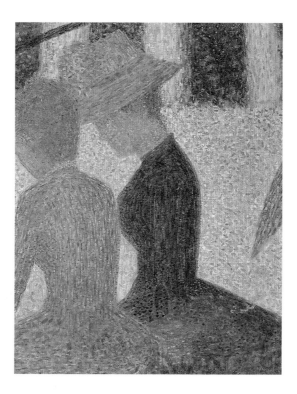

a no. 25 figure format (81 x 65 cm). Seurat seems to have favored this size, as many of his paintings have similar dimensions.[12]

Seurat's Painting Technique

Seurat painted *La Grande Jatte* in three distinct "campaigns," and close examination of the work reveals the complexity of his technique.[13] As we know from written documentation by the artist, he began painting it in May 1884 and reworked it between 1885 and 1886; he added the painted borders sometime in 1888/89. Seurat's brushwork varied significantly according to the types of forms

FIG. 3

Photomicrograph of yellow-green underlayer revealed by paint loss in grass and skirt of seated woman (see FIG. 2). This view shows the extension of the skirt over the landscape, also evident in IR (see FIG. 1). Some of the woven canvas fibers and the priming layer are visible within the skirt. Original magnification 3.5X.

FIG. 4

Cross-section taken from skirt of seated woman (see FIG. 2). The bottom layer is lead white priming. Just above are, on the left, a thin yellow-green underlayer (viridian, chrome yellow, emerald green, and lead white), and on the right, yellow layers (lead white, chrome yellow, and traces of vermilion). Above these are strata of dark blue, lighter blue, and purple. At the top, red lake is mixed with lead white and a few ultramarine blue particles. Original magnification 200X.

FIG. 6

Cross-section taken from shadowed grass area below black dog (see FIG. 5). The priming is missing in this sample but the fairly thick greenish yellow underlayer, consisting of chrome yellow, viridian, emerald green, and lead white, is visible at the bottom. Above this is a mixture of cobalt blue, lead white, and emerald green, and alternating thin layers of green (similar in composition to the underlayer) and red lake. Another blue layer is followed by a lighter green in which whole emerald green spherulites are visible. Original magnification 200X.

FIG. 7

Detail of *The Couple* (CAT. 62) showing how Seurat roughly sketched in the composition. Much of the priming layer is visible between the broad, rectangular brushstrokes.

he was depicting and throughout the development of the picture.

First Campaign

In preparation for painting, Seurat probably roughly sketched or blocked in the overall composition. This can be seen in several small areas in the grass and in some of the figures where later paint layers were lost, revealing a thin underlayer in different shades of green (see FIGS. 2, 5). Seurat used yellow-green in sunlit grass and a yellow-green to dark green in shadow (see FIGS. 3–4, 6).[14] While the exact manner of Seurat's paint application and the extent to which it originally covered the canvas cannot be fully ascertained (since only a very small fraction of underpainting is visible and sampling of the painting was limited), it seems that he used a technique similar to that of some of his preliminary studies for *La Grande Jatte*—in particular, *The Couple* from the Fitzwilliam Museum. In this small canvas much of the priming layer is readily visible between the broad and sketchy rectangular brushstrokes used to lay in the composition (see FIG. 7). *The Couple* shares not only stylistic affinities with the earliest layers of *La Grande Jatte*, but also a corresponding grid system; it likely played a significant role in the transfer and enlargement of the composition (see Zuccari and Langley, p. 180). Recent examination of *La Grande Jatte* revealed reddish orange markings along the edges of the painting at intervals corresponding to the long-hypothesized grid system (see Zuccari and Langley, FIG. 4). Under magnification,

a line that corresponds to a mark at the center left edge is visible extending beneath a portion of the tall grass (see FIGS. 10–11).[15] This is the only place within the painting that a grid line is evident.

Seurat's first-stage brushwork varied significantly according to the types of forms depicted. His paint application was often directional; for instance, he painted most of the foliage and grass in short, crisscross brushstrokes; he rendered the water in disconnected, horizontal bands; and he used abbreviated, vertical, multicolored lines to represent tree trunks and some parasols. To create the figures and animals, he employed a combination of ellipses, broken lines, and slashes, which follow the contours of the figures, serve to delineate details, and indicate highlights and shadows. Most of the brushstrokes are linear, though there are some that curve to follow the shape of forms. An example of first-stage technique can be seen at the upper left of *La Grande Jatte*, where there is minimum coverage by subsequent additions (see FIG. 8). While Seurat's method here is similar to that of the Impressionists, he rendered the objects more precisely. The sky and the wall on the opposite bank of the river are painted in a series of blended, crisscross strokes, while the water consists of short, horizontal bars of blue and various reflected colors (see FIG. 9). Seurat depicted the vegetation in the water behind the woman fishing with short, horizontal dashes, whereas he used longer, vertical strokes for the tall grass (see FIGS. 10–11). The boats also feature dashes that correspond to their individual shapes, and a prominent

white sail comprises blended strokes that follow its curve. Some second-stage dots and dashes are apparent in areas such as the foliage above the embankment, along the top edge of the wall, around the edges of the sails, outlining the woman fishing, and in the adjacent water plants. The band of dots within the painting at the far left edge (see FIG. 10) was added during the creation of the border.

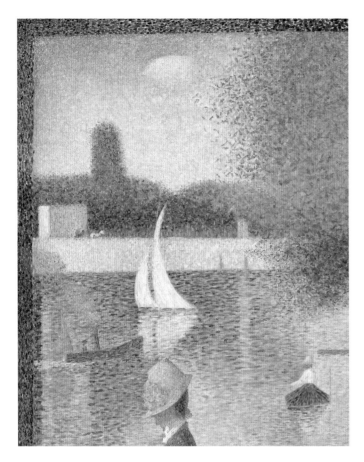

Second Campaign

In October 1885, Seurat started repainting *La Grande Jatte* based on his recently developed color theory; he modified his technique as well as his palette to conform to these new ideas (see Herbert, pp. 113–16). During this time, the artist applied additional paint over existing layers, with differing degrees of coverage, and added dots of color to the work's surface. In actuality, these dots should be considered small brushstrokes, for they are not always perfectly round and they vary in size and shape depending on the subject depicted. Seurat chose to use this technique as the best means to achieve optimum optical mixing effects.

Many aspects of Seurat's first-stage process are also present in the second campaign; this makes it difficult, in some cases, to easily distinguish one stage from the other. He often used a combination of dots, dashes, and lines to outline or delineate existing first-stage features, as in the strolling couple in the far background (see FIG. 12) or the couple holding the baby (see Zuccari and Langley, FIG. 34). The pink line that silhouettes the figures is partly covered or repeated by regularly spaced blue, dark green, and pink dots, which enhance the contours and serve to depict shadow. These outlines are among the few essentially continuous linear features Seurat employed. Most are in pink, although he sometimes used blue. Additionally, the artist added long dashes to define the edges of some of the forms. This can be seen in the skirts of many of the seated figures (see FIGS. 2, 5) and also in the bustle of the woman with the monkey. Seurat

altered the silhouettes of a number of the figures by adding dots and dashes, often enlarging the forms and giving them more rounded contours, as discussed further by Zuccari and Langley (pp. 183ff). These changes are especially evident in the skirt of the woman fishing and in the bustle of the woman with the monkey (see FIGS. 1, 15). He dramatically modified the figure of the central mother, increasing the width of both of her arms and expanding her skirt, especially on the right side (see FIGS. 13–14).

The woman fishing includes several different types of second-stage additions; not only is there pink outlining (evident along the bodice) and a slight expansion of her form (most noticeable in the skirt), but there is also much internal pointillist addition (see FIGS. 15–18). Sometimes, Seurat used smaller dots applied very close together. The face of the seated woman at the far right, for instance, is made up of tiny pastel-hued dots comprising pigments mixed with a large amount of white (see FIGS. 19–20). Here, the artist initially applied the paint thinly, since much of the priming is still visible (he probably used it as an underlying skin tone). Seurat added the more blended dots of pink, blue, yellow, and orange to capture the effect of the cast shadow.

Though Seurat modified the contours and character of his figures using his new painting style, the majority of his additions at this stage were motivated by purely coloristic concerns, utilizing the concepts of scientific color division derived from his readings of Charles Blanc, M.-E. Chevreul, James Clerk

Maxwell, and Ogden Rood (see Herbert, esp. CHS. 1, 3). The artist placed much emphasis on the juxtaposition of complementary colors, reflecting Chevreul's ideas of simultaneous and successive contrasts. Simultaneous contrasts are achieved by placing complementary colors side by side, thus exaggerating their differences and increasing the brilliance of both. Successive contrasts are the natural result of retinal fatigue, in which a complementary after-image of a color is retained in the eye even after one has ceased looking at it, creating momentary, complementary haloes around objects (see Herbert, p. 32). Seurat sought to exploit these effects with spectrally pure hues minimally mixed on the palette; he applied these colors in small, adjacent strokes intended to fuse in the eye to create the desired vibrancy. Some of the techniques Seurat used to achieve ideal optical mixing effects are

FIG. 11

Photomicrograph of section of tall grass. The long, multicolored, vertical brushstrokes illustrate Seurat's first-stage technique. Although coverage is fairly complete, here the underlying priming is visible, as is the reddish orange grid line that runs horizontally beneath portions of the grass. Original magnification 5.5X.

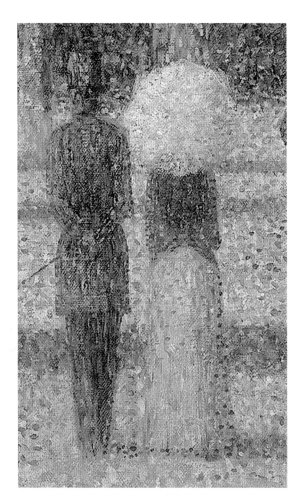

illustrated in a detail of the bottom left corner of *La Grande Jatte* (FIG. 21). Throughout the sunlit grass, the artist painted dots ranging from yellow to orange representing solar reflections. The shadowed grass was originally composed mainly of a dark green layer; in order to enhance the shadow effect, Seurat added blue slashes and dots to complement the illuminating color, orange, which was meant to represent the effect of reflected sunlight. To the same end, he applied similar blue dots to the reclining man's trousers and pink dots as highlights. He also employed thin green dashes in the darker sections of the man's pants to depict local color reflections of the surrounding grass. Clearly, Seurat wished to give the greatest luminosity to sunlit areas with an abundance of light yellow dots, and lesser luminosity to the lighter portion of the shadows with the use of orange dots; he excluded such highlights altogether from the darkest shadows. The many light yellow and yellow-green dots in the brightly illuminated areas of the grass have shifted to yellow-brown and olive green (see below); a concentrated band of such dots is present where the sunlit and shadowed grass meet (see FIGS. 22–23).

Though successive contrast occurs naturally because of the physiology of the eye, Seurat wished to heighten its effect by actually painting complementary haloes around his figures, thus separating them optically from their surroundings. This is seen where the darker portion of a figure meets a medium or dark tone in the background or in an adjacent figure, but is absent where very light surroundings provide adequate contrast. This type of enhancement is particularly clear around the torso of the woman with the monkey (see FIG. 27). Here the halo is visible as a band of yellow-orange dots following her contour. Deeper orange and blue dots that represent the ubiquitous solar highlights and shadows follow the three-dimensional curve of her shoulder.

Third Campaign (The Border)

Sometime in 1888, Seurat formulated the idea of colored borders and frames, and began adding painted edges to most of his pictures, including many of his earlier works. With these additions—usually consisting of colors approximately complementary to the adjacent areas of the painting proper (see FIG. 8)—he wished to provide a visual transition between the interior of the painting and its frame.[16] In order to add a painted border to *La Grande Jatte*, Seurat had to restretch the canvas, exposing portions of the support that had originally been part of the tacking margins.[17] The top and left tacking edges were unprimed, so after Seurat enlarged the surface, he applied a layer of lead white to the entire border as a substrate for the colored dots. In addition to covering the existing tacking holes, the white layer also allowed for greater paint luminosity. The brushstrokes that make up the border are composed of simple mixtures, usually of single colors: predominantly blue and red with some orange and yellow (see FIGS. 24–25). Many sections of the border are accompanied by a series of large dots within the painting itself, most of which are orange or yellow, though

FIG. 13

FIG. 14

Detail of central woman in *La Grande Jatte*. Second-stage additions are visible on both sides of the figure. Seurat increased the width of her arms with the addition of multicolored dots, mainly along their outer edges. He also added blue, green, pink, and yellow dots to the original orange-red bodice. The yellow-green background and white parasol can be seen through gaps between the dots.

IR composite of central woman and child in *La Grande Jatte*. Second-stage additions are especially evident in the shadows on the woman's left side. The original, thinner appearance of her right arm is also clear.

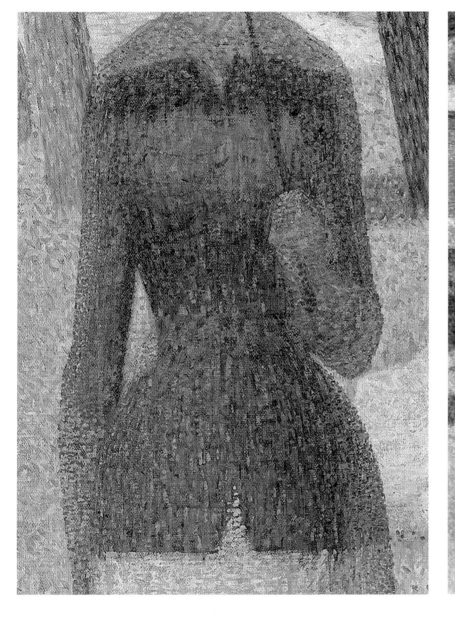

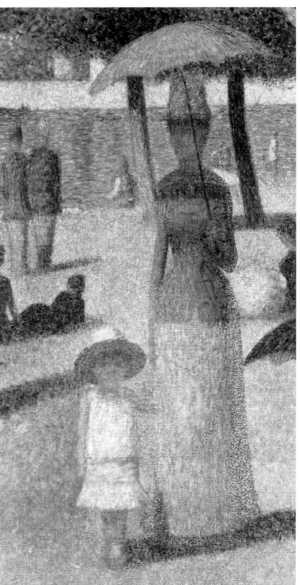

FIG. 15
Detail of woman fishing in
La Grande Jatte. Seurat
expanded the skirt over the
water and added linear con-
tours to the front of her body
using a thin pink outline. He
then added small dots of dif-
ferent colors (blue, green,
yellow, orange) on top of the
outline, as well as within the
addition.

FIG. 16

Photomicrograph of pink outlining on chest of woman fishing, and
adjacent area of vegetation (see FIG. 15). The outlining is one of
the few continuous linear features Seurat used. The multicolored
dots employed to enlarge the figure partly cover the line. Some
of the dots overlap one another, and part of the priming is still
apparent, along with traces of first-stage painting. The green water
plants are from the first stage, with a considerable amount of
priming left visible. Original magnification 6X.

FIG. 17

Photomicrograph of dress of woman fishing (see FIG. 15). The
second-stage blue, pink, and orange dots were applied over the
earlier orange painting layer. Original magnification 6X.

FIG. 18

Photomicrograph of juncture of hat of woman fishing and water
(see FIG. 15). Among the visible second-stage additions are
reddish brown and ocher-colored dots, which were originally orange
and bright yellow before the zinc yellow pigment deteriorated.
These almost circular dots are a good example of Seurat's pointillist
brushwork, and can be compared with the more blended first-stage
strokes used for the water at the left. Original magnification 6X.

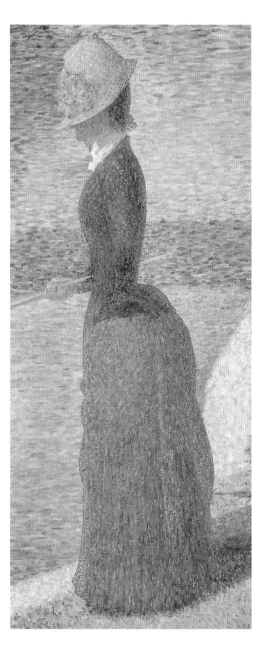

FIG. 20

Photomicrograph of face of seated figure at far right (see FIG. 19).
The small, nearly fused dots are composed of pigments mixed
with a large amount of lead white, creating pastel shades. Although
coverage is fairly complete, some of the white priming is visible.
Original magnification 6X.

a fraction are blue or green (see FIGS. 10, 26). This band of dots is not present along the entire border, and its width and density varies.

Surface Appearance

The matte surface of *La Grande Jatte* seems to have been intended by Seurat to enhance the effects of scientific color division. Such a surface displays the proper spectral colors from all viewing directions, whereas overcoating with a glossy varnish often alters the relative saturation values of many of the pigments and results in glare.[18] Another detrimental effect of natural varnishes is their tendency to yellow with age. A yellow layer would significantly change or mask the color interrelationships that form a pointillist image. The Neoimpressionists, well aware of the color-value distortion, glare, and darkening caused by varnish, specifically recommended against its use, preferring a matte finish.[19] Influenced by Camille Pissarro, many of the artists

FIG. 21
Detail of lower left corner of
La Grande Jatte, showing
Seurat's second-stage additions
of dots representing solar
reflections in sunlit and shad-
owed areas of the grass.

FIG. 22
Detail of grass at far right showing discolored dots at juncture
between shadowed and sunlit grass.

FIG. 23
Photomicrograph of discolored dots at juncture between shadowed
and sunlit grass (see FIG. 22). The ocher-colored and olive green
dots were originally bright yellow and emerald green before the
darkening of the zinc yellow. The underlying first-stage brushwork
is evident as well. Original magnification 5.4X.

in Seurat's circle experimented with an alternative
to varnishing by framing their paintings under glass.[20]
Overall, *La Grande Jatte* has darkened with time,
due to the natural aging of the oil medium; how-
ever, the effect is not as drastic as it would have
been had Seurat applied a natural varnish (see Berns
essay for more on the darkening of the painting).

Painting Materials

The types of pigments found in *La Grande Jatte*
reveal the progression of the work and how Seurat's
evolving technique reflected contemporary writings
and ideas about color (see TABLE, p. 208).[21] For
instance, when Signac saw *Bathing Place* at the
Indépendants in May 1884, he noted that Seurat
had used ochers and browns in addition to pure
colors and that "the picture was deadened and
appeared less brilliant than those the Impressionists
painted with a palette limited to prismatic colors."[22]
He supposedly convinced Seurat, in the spring of
1884, to exclude earth colors from his palette and
to use only those pigments that attempt to dupli-
cate the solar spectrum. Samples from the first
stage of *La Grande Jatte* reveal that the artist at
this point still continued to employ colors such as
iron oxide yellow and burnt sienna, as well as small
quantities of black, and had not yet made the tran-
sition to a palette consisting solely of spectrally
pure hues. Seurat used actual black pigments very
sparingly, however; mostly, only trace amounts were
found in his paint mixtures. Instead, he combined
ultramarine blue and red lake in various proportions
to create the black color perceived in some pas-
sages of *La Grande Jatte*: the large dog, the dark
blue-black bodice of the *promeneuse*, her parasol
and hat, and her companion's hat and cane.[23] In
his paint mixtures from this time, Seurat typically
combined four or five components (but sometimes
up to eight) to achieve the exact color he desired.
For example, a first-stage brown tone from the small
triangle in the upper right corner incorporates
burnt sienna, iron oxide yellow, ultramarine blue,
red lake, vermilion, lead white, and some black; an

FIG. 24

Photomicrograph of border. The large, elongated dots and dashes are typical of Seurat's brushwork in 1888–89. The larger strokes, running parallel to the picture's edge, are covered occasionally by smaller, rounded dots. Original magnification 7X.

FIG. 25

Cross-section of yellow-orange dot from border with overlapping paint layers: cadmium yellow mixed with some chrome yellow in the uppermost layer; a reddish orange stratum of mainly vermilion mixed with cadmium yellow and chrome yellow or possibly orange beneath that; and a thin bottom layer of cobalt blue over the lead white that Seurat added to the border area. Original magnification 200X.

FIG. 26

Photomicrograph of area within painting adjacent to the border. The dots are simple mixtures; the orange dot, for instance, consists of brushstrokes of chrome yellow and vermilion combined with lead white. Original magnification 11X.

area of light blue-green water is composed mainly of lead white, with some viridian, emerald green, and a trace of ultramarine blue.

Second-stage mixtures generally involve fewer pigments, in accordance with Seurat's color theories. A light bluish purple dot in the leaves of the tree at the left consists of lead white, ultramarine blue, and a trace of red lake. Seurat consistently used a mixture of ultramarine blue, red lake, and lead white to create a purple color, varying their proportions depending on the shade needed. Another example of a simple mixture is the combination of chrome yellow and vermilion used for many of the bright orange dots in the shadowed grass area. As noted

above, Seurat intended the colors of his painting to be combined optically on the retina of the viewer rather than on the canvas itself. Thus, he used spectrally pure hues that he mixed only minimally before application.[24] In addition to eliminating earth colors and black from his palette, Seurat incorporated a variety of yellows and reds to achieve a more complete duplication of the solar spectrum. Microscopic identification has determined that he added zinc yellow as well as several red and chrome yellow pigments in more than one hue. The red lakes range from a very pale pink to a deep red. Vermilion is present in two forms: larger crystals yielding a red color and a smaller, red-orange variety. Chrome

yellow occurs as light lemon yellow and as deeper yellow-to-orange. The range of pigments employed in the second stage seems to correspond to a description of Seurat's 1891 palette as having a row of eleven pure colors, another row directly underneath of the same pigment combined with white, and a third row of pure white for additional mixing.[25]

Recently taken cross-sections have provided us with even more information about Seurat's paint mixtures and their sequential application, since they allow us to isolate the different layers of paint and identify their properties. Analysis of three of the sections revealed Seurat's use of an additional yellow pigment: cadmium yellow.[26] He applied it in

Comparison of pigments in *La Grande Jatte*

	Stage 1 (1884–85)	Stage 2 (1885–86)	Stage 3 (1888/89)
Vermilion (mercuric sulfide)	•	•	•
Organic Red Lake (unidentified)	•	•	•
Burnt Sienna (calcined iron oxide)	•		
Iron Oxide Yellow (hydrated iron oxide)	•		
Chrome Yellow (lead chromate)	•	•	•
Chrome Orange (basic lead chromate)			•
Zinc Yellow (zinc potassium chromate)		•	
Cadmium Yellow (cadmium sulfide)	•	• (trace to minor)	•
Viridian (hydrous chromium oxide)	•	•	
Emerald Green (copper acetoarsenite)	•	•	
Ultramarine Blue (sodium aluminum sulfo-silicate)	•	•	
Cobalt Blue (cobalt aluminate)	•	•	•
Lead White (basic lead carbonate)	•	•	•
Black—Charcoal (carbon) **or Bone** (carbon with calcium phosphate)	• (trace to minor)		

small quantities, mixed with chrome yellow, in the first stage. On the border, Seurat used it in both the upper layer mixed with traces of chrome yellow or possibly orange and in the red-orange layer just beneath consisting of vermilion and some chrome yellow or orange (see FIG. 25). While it is conceivable that Seurat also employed it in the second campaign, this has not been verified.[27] Cadmium yellow has also been detected in the early and final stages of *Bathing Place* and in *The Couple*. Although the artist used a wide variety of yellows, it seems that chrome yellow, in various shades, was his favorite, since it has been identified in all of the paintings examined to date.[28]

We also conducted medium analysis on four recent samples.[29] Zinc yellow taken from the book next to the sewing woman was found to include starch, barium sulfate, and some lead in a heat-bodied linseed oil medium. A cross-section of the dark green grass from the bottom right corner consists of three layers of different pigments, all in an oil medium: a yellow-green upper layer of emerald green, a darker green layer of viridian and chrome yellow, and a bottom priming layer of lead white and some black.[30] The third sample, taken from the paint loss in the yellow-green grass on the right, comprises three main strata: the upper, olive green one composed mainly of lead white and emerald green and an unidentified yellow in a heat-bodied (or partially heat-bodied) linseed oil binding medium; that in the middle of mainly lead white in non-heat-bodied linseed oil; and an incomplete thin yellow-green bottom layer of emerald green, a chromate pigment (probably lead chromate), and barium sulfate in a heat-bodied linseed oil medium. The fourth sample, taken from the border at the left, includes thin layers of cobalt blue and chromate-based orange pigment over lead white bound in an oil medium.[31]

Investigation of Unstable Pigments

In *La Grande Jatte*, the many solar reflections, luminous highlights, and effects of reflected light that Seurat created by adding yellow, orange, and green dots have been seriously affected by major changes in the pigments, which occurred soon after the work's completion. In an 1892 review of Seurat's memorial exhibition, Fénéon observed, "Because of the colors which Seurat used [in *La Grande Jatte*] toward the end of 1885 and in 1886, this painting of historical importance has lost its luminous charm: while the reds and blues are preserved, the Veronese greens are now olive-greenish, and the orange tones which represented light now represent nothing but holes."[32] Examination of the painting corroborated Fénéon's comments. The substance zinc yellow, in the chemical form of zinc potassium chromate, changed significantly, adversely affecting all colors mixed with the pigment. Dots composed mainly of zinc yellow, which were originally a bright yellow, have become a yellow-brown similar in color to a yellow ocher; zinc yellow mixed with vermilion, which had been orange, has turned to warm brown; and green dots, composed mainly

FIG. 27

Detail of torso of *promeneuse* in *La Grande Jatte*. The "halo effect" is clearly evident. This detail shows the halo as a band of yellow-orange dots following her contour.

FIG. 28

Detail of butterfly and grass in *La Grande Jatte* showing crisscross brushwork and discolored dots.

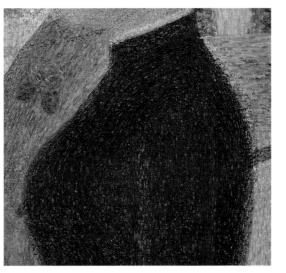

of zinc yellow with varying amounts of emerald green, have shifted to olive.[33]

These shifts have heightened the contrast between the altered dots and the surrounding field of color and are especially pronounced in the sunlit grass, where the darkened yellows and greens now stand out strongly against the light green underpaint (see FIG. 28). Analysis indicated that zinc yellow is responsible for the darkening in all cases; its alteration was probably caused by oxidative changes in the chromium.[34] It is also interesting that the zinc yellow is consistently associated with starch. Starch grains mixed with zinc yellow are visible in a cross-section taken from the foliage of the leftmost tree near the top edge of the canvas (see FIG. 29). The exact significance of the starch is uncertain, but it was probably added to the paint as an extender or filler, or to modify the oil medium.[35] Whether or not it contributed to the zinc yellow's change in color is under investigation.

There is very little contemporary information about zinc yellow. It first became available commercially in 1847 in shades ranging from pale yellow to marigold. Because of the changes, it is difficult to determine which variety Seurat used, although it is likely that it was originally a lemon color.[36] The pigment is only briefly mentioned in manuals on artists' materials, indicating that it was not as popular as, for instance, chrome or cadmium yellow. Herbert suggested that Seurat purchased the unstable pigment from a certain "Maître Édouard" upon the advice of Pissarro.[37] It is likely

many artists were unaware of zinc yellow's tendency to darken, since as late as 1892 it was still listed by J. G. Vibert in his *Science of Painting* among the pigments "that may be used with perfect certainty."[38]

It has long been suspected that emerald green, used in making the green dots, was partly responsible for their shift to olive (see FIG. 30). Emerald green (or Veronese green, as it was called in France) was extremely popular in the nineteenth century because of its unusual, brilliant blue-green color, though many artists expressed concerns about its instability. A copper compound, it was known to have a propensity to darken or blacken when in contact with pigments containing sulfur (such as cadmium yellow) or with sulfur compounds in the air.[39] Our recent analysis, however, confirms that the

Cross-section of darkened zinc yellow dot from foliage in upper left corner. The upper yellow layer is composed mainly of zinc yellow and starch grains, along with some vermilion and barium sulfate (commonly used as an extender for paints). The green layer below is mainly emerald green (with its characteristic spherulitic grains) and some lead white with traces of black. Below the green are thin layers of chrome yellow and vermilion, and a bit of white priming. Original magnification 200X.

FIG. 30

Cross-section of darkened green dot in sunlit grass on left. A thick layer composed of zinc yellow, emerald green, and many transparent, irregularly shaped starch grains dominates. A concentrated area of emerald green is visible in the lower portion of this layer. Two small layers of light purple and white can be seen on the right; these probably relate to a portion of the painting adjacent to the green dot. Some priming is also visible. Original magnification 200X.

zinc yellow was primarily responsible for the change in the green dots (see Berns, p. 222).

Interestingly, *Bathing Place*, reworked by the artist in 1887, was also affected by a detrimental color change commented upon by Seurat's contemporaries. As Signac wrote in his diary, "On [*Bathing Place*], which dates from '83, Seurat added, around 1887, small touches, in order to fill in missing elements. (In this painting done for the Salon, he had made concessions as far as Divisionism went.) The last brushstrokes, done with colors from the wretched Édouard, [have] completely blackened, while the

background has remained pure."[40] Research conducted on *Bathing Place* has shown that the added brushstrokes referred to by Signac were also painted with zinc yellow or zinc yellow and emerald green mixtures. Because starch grains were also found associated with the zinc yellow in *Bathing Place*, it is believed that Seurat used the same paint for both pictures.[41] Recent investigation has found that the artist also employed a similar zinc yellow in the oil version of *The Couple* and *The Bridge at Courbevoie* (CH. 5, FIG. 3); some discolored yellow areas, along with starch, have been reported in the

latter work.[42] Further research into the cause of the darkening of the zinc yellow, including the effect, if any, of the starch additive, is currently under way.

Conclusion

As a result of this study, which takes into account important recent investigations by the National Gallery, Courtauld Institute, and Metropolitan Museum, we have gained considerable knowledge of Seurat's working methods and the variety of materials he used in *La Grande Jatte* and related paintings and studies executed between 1883 and 1890. Much of what the artist wrote regarding the time frame in which the painting was created, as well as the observations made by Fénéon and Signac about color changes, was corroborated by our research, resolving questions that had been unanswered for many years. The precise cause of visual changes in the second-stage yellows, oranges, and greens has been mainly isolated to a single substance (zinc yellow) that spontaneously darkened. Since we have been able to identify the cause of the discoloration, this research paved the way for the work of color scientist Roy Berns (see his essay), who approximated the original appearance of the now-darkened colors. For the first time, we are able to steal a glimpse of the luminous work Seurat intended.

Acknowledgments

I am indebted to Ashok Roy of the National Gallery, London, for sharing the results of the museum's research on Seurat prior to its publication. I am also grateful to Catherine Higgitt, Raymond White, and Marika Spring of the National Gallery for their analysis of our samples and to Kate Stonor of the Hamilton Kerr Institute, Cambridge, Eng., for making her research available to us. Appreciation also goes to Charlotte Hale of the Metropolitan Museum of Art, New York, for providing important new information on its painting.

Notes

1 In October 1982, *La Grande Jatte* came to the Art Institute's Conservation Department for examination and analysis while a white frame replicating that which Seurat originally designed for the painting was constructed for its rehanging. At that time, we thoroughly examined the work using infrared (IR) reflectography, ultraviolet fluorescence, and X-radiography. We took and analyzed pigment samples to determine the overall palette and the different materials Seurat used in three painting campaigns. In addition, stereomicroscopy enabled us to document Seurat's technique. The results were presented in Fiedler 1984 and Fiedler 1989. The present study is a revised version of the latter essay, incorporating recent research.

2 For the research conducted in 1982, 180 microscopic pigment samples were removed with the aid of a surgical scalpel (the large size of *La Grande Jatte* precluded adequate sampling near the center of the canvas). The samples were transferred to microscope slides and permanently mounted in a special medium whose properties assisted us in our subsequent analysis. To determine the exact types of pigments present, we used polarized light microscopy. We also employed other analytical methods, such as microchemical tests, electron microprobe, X-ray diffraction, and microspectrophotometry to provide supplementary data on a number of samples.

3 IR reflectography employs a camera equipped with an infrared-sensitive detector to capture reflected IR energy. This energy is converted into a visible image that can be recorded digitally or on film. IR reflectography penetrates through the upper layers of a painting and allows us to see underdrawing and early paint stages.

4 The cross-sections were examined with reflected light/UV fluorescence microscopy. Elemental analysis was conducted by Joseph Rebstock, McCrone Associates, Westmont, Illinois, using scanning electron microscope/energy-dispersive X-ray spectrometry (SEM/EDS). The scanning electron microscope, coupled with an energy-dispersive X-ray spectrometer, provides topographical, structural, and elemental information. The National Gallery Scientific Department very generously did medium analysis on four samples using Fourier-Transform Infrared (FTIR) microspectroscopy and gas chromatography/mass spectrometry (GC-MS). FTIR-microscopy reveals the chemical bond structures of organic and inorganic materials. GC-MS analyzes molecular structure.

5 Kirby et al. 2003.

6 Anthea Callen, *Techniques of the Impressionists* (Secaucus, N.J., 1982), pp. 58–61; idem, *The Art of Impressionism* (New Haven, 2000), pp. 30–49; and David Bomford et al., *Art in the Making: Impressionism* (London, 1990), pp. 44–50.

7 According to Callen, it was necessary for nineteenth-century painters to special-order canvases suitable for large-scale commissions (*grandes machines*); see Callen 2000 (note 6), p. 21.

8 Elemental analysis of the priming layer by SEM/EDS reveals it comprises mainly lead white with traces of calcium carbonate, aluminum silicate, barium sulfate, and some carbon black. This cross-section (taken from the dark green grass at the lower right corner) contained the entire ground layer and included some canvas fibers. SEM/EDS analysis shows what may be two layers of priming: a finer lead white layer close to the canvas, and coarser lead white particles and the trace materials above. Analysis of the priming layer by FTIR-microscopy of a sample from the same location indicated what appears to be an oil medium.

9 Leighton and Thomson 1997, p. 68; and Kirby et al. 2003, pp. 5, 19. Callen noted that gray grounds—often a warm gray tone that included the addition of a small amount of yellow ocher to the lead white and black mixture—were popular among the Impressionists in the 1870s; see Callen 2000 (note 6), pp. 72, 82. Yellow ocher was not detected in either *La Grande Jatte* or *Bathing Place*. Callen also stated that the use of pure white grounds, which heighten luminosity, became more common with the Impressionists after 1880.

10 Leighton and Thomson 1997, pp. 68–69; private communication with Ashok Roy.

11 This painting was examined in October 2003 by Charlotte Hale, Allison Langley, and Frank Zuccari. In addition to confirming the presence of a ground, their investigation revealed a previously unidentified gold-colored layer on top of the ground beneath the top and bottom painted borders. The ground in two cross-sections analyzed by micro-Raman spectroscopy was found to be calcium carbonate. EDS analysis of the metallic layer identified it as a low-zinc brass (copper with about 11 percent zinc); private communication with Charlotte Hale. The purpose of this layer is unknown.

12 See Herbert et al. 1991, pp. 233–36. On *The Couple*, see Kate Stonor, Conservation Examination Report, n.d., Hamilton Kerr Institute, Cambridge, Eng.

13 Besides *La Grande Jatte*, three other works by Seurat were previously

examined and sampled to help establish patterns in his use of pigments and application of paint: the compositional study for *Bathing Place, Asnières* (CAT. 20, p. 44), *Sketch with Many Figures* (CAT. 48, p. 74), and *Landscape, Island of La Grande Jatte* (CAT. 60, p. 80). The palettes of the first two are similar to the 1884–85 stage, except for the absence of emerald green in the *Bathing Place* study and the presence of only a minor amount of it in *Sketch with Many Figures*, possibly added later; see Fiedler 1984, pp. 44–46. The landscape was executed in stages that correspond stylistically and coloristically to *La Grande Jatte*'s three campaigns. It lacks zinc yellow, however, and was not as heavily reworked in the pointillist technique. The results of this research have been presented at numerous professional meetings.

14 Cross-sections taken from three areas of the grass disclosed a number of different underlayers: medium greenish yellow in the shadowed grass below the black dog; dark green in the shadowed grass at the bottom right corner; and green-yellow to yellow in a paint loss in the skirt of the woman with a bonnet seated at the far right. A sample from the sunlit grass on the left, near the embankment, also has the very thin yellow-green underlayer.

15 A cross-section taken from the center left mark that includes the reddish orange layer was analyzed by SEM/EDS and FTIR-microscopy. This layer is very loosely bound and consists of a mixture of iron oxide red, red lead, calcium carbonate, and aluminum silicates. Glue and wax were detected by FTIR-microscopy. The glue is most likely from the adhesive that was applied to the canvas to seal the fabric before priming, and the wax from a 1957 conservation treatment by Art Institute conservator Louis Pomerantz (see note 17). Polarized light microscopy indicated the reddish orange material to be a mixture of red ocher, red lead, chalk, carbon black, and lead white.

16 Dorra and Rewald 1959, pp. 96, 102–03.

17 Seurat expanded the overall dimensions of the stretchers by adding four wooden strip moldings to the existing stretcher members. It was noted during conservation treatment in 1957 that small, white, gesso-filled holes appear within the painted border area at regular intervals; see Louis Pomerantz, Conservation Examination and Treatment Report, 1957, Conservation Department, Art Institute of Chicago (hereafter referred to as AIC). X-rays taken in 1982 confirmed the existence of tacking holes in the borders; see Fiedler 1989, p. 179, fig. 3.

18 In May 1958, at the request of Art Institute conservator Louis Pomerantz, five prominent painting conservators— Caroline Keck, Sheldon Keck, Murray Pease, David Rosen, and George Stout— examined *La Grande Jatte* in order to make a recommendation on the advisablity of varnishing the work. The examinations took place in New York, where the painting was on loan to the Seurat retrospective at the Museum of Modern Art. Based on the opinions expressed by the conservators (preserved in letters in the Department of Conservation, AIC), it was decided to keep *La Grande Jatte* unvarnished and framed behind glass.

19 See David Miller, "Conservation of Neo-Impressionist Painting" in *The Aura of Neo-Impressionism: The W. J. Holliday Collection*, exh. cat., ed. Ellen Wardwell Lee (Indianapolis, 1983), pp. 29–30; and Callen 2000 (note 6), pp. 209–12.

20 Although limited by the cost and available sizes of clear flat glass (the maximum size at the time was 122 x 91 cm), the Neoimpressionists liked the results of glazing their works. Critics such as Fénéon were impressed by the effect of glass on the paintings, noting that "their flatness disappears under glass as under varnish"; see Callen 2000 (note 6), p. 212.

21 On Seurat's knowledge of color theory, see Herbert (pp. 32–34). See also Gage 1987; and Alan Lee, "Seurat and Science," *Art History* 10, 2 (1987), pp. 203–26.

22 Signac, cited in Rewald 1956, p. 76. Recent pigment analysis of *Bathing Place* disclosed that Seurat used earth colors (red, red-brown, and yellow-brown) primarily in the lower paint layers, with only a small amount in the upper layers (such as in the hair of the central figure). The other pigments identified are cobalt blue, French ultramarine, vermilion, a pinkish red lake, viridian, chrome yellow, cadmium yellow, and lead white.

Zinc yellow, emerald green, cobalt blue, vermilion, and lead white were employed for the minimal reworking in the pointillist technique; see Leighton and Thomson 1997, pp. 76–83; and Kirby et al. 2003, pp. 22–23, 36–37.

23 This mixture is noted in many of Seurat's other works; see Kirby et al. 2003, p. 37; and Leighton and Thomson 1997, p. 76.

24 Linda Nochlin, ed., *Impressionism and Post-Impressionism, 1874–1904* (Englewood Cliffs, N.J., 1966), p. 118. See also Robert L. Herbert, *The Neo-Impressionists*, trans. Chantal Deliss, ed. Jean Sutter (Greenwich, Conn., 1970), pp. 23–34.

25 See William I. Homer, "Notes on Seurat's Palette," *Burlington Magazine* 101, 674 (May 1959), pp. 192–93; and Homer 1964, pp. 146–53.

26 SEM/EDS analysis detected cadmium yellow mixed with chrome yellow and in a purple-blue layer of a cross-section taken from the skirt of the seated woman at the far right. A cross-section from the sunlit grass area also revealed trace amounts of cadmium yellow in the medium yellow layer.

27 Trace amounts of cadmium yellow were also detected by elemental analysis in samples from the light orange skirt of the fisherwoman, a light yellow-orange in the seventh tree from right; and in the hat of the nurse. In all cases, it was mixed with chrome yellow, but it is unclear whether the pigments were combined by the artist or by the paint manufacturer.

28 Recent analysis of other paintings found that Seurat used yellows besides those mentioned: barium chromate, strontium chromate, unidentified organic yellows, and an unidentified yellow dyestuff mixed with calcium chromate; see Kirby et al. 2003, p. 36.

29 Medium analysis for all of the four paint samples was provided by Catherine Higgitt and Raymond White at the National Gallery, London. Marika Spring, also of the National Gallery, provided EDX and cross-section work. FTIR-microscopy was used to identify pigments and to characterize the types of binders present. GC-MS was used to specify the exact type of oil binder. Although medium analysis was limited to only four samples, the results have given us some indication of the types of paints Seurat used. Of particular importance is the identification of the binding medium for the zinc yellow, which corresponds to that found in *Bathing Place*.

30 A small fragment of mainly the bright green paint was used for GC-MS analysis, and the results indicated a heat-bodied (or partially heat-bodied) linseed oil was used as a binding medium. This sample also contained a trace of beeswax that is most likely from the edge-lining process.

31 There is a pinkish material at the bottom of the sample containing some lead white and canvas fibers; we detected protein in this area and possibly a little oil.

32 Fénéon 1970, pp. 212–13.

33 Microspectrophotometric comparison of fresh zinc yellow and emerald green standards to the pigments in the painting were made by Michael Bayard for the 1982 study. The shape of the absorption curve of the zinc yellow from the painting was found to be more characteristic of a dull brown tone than a bright yellow or yellow-orange; see Fiedler 1984, p. 48.

34 See Fiedler 1984, pp. 47–49; and Leighton and Thomson 1997, pp. 82–83. For information on zinc yellow, see Rutherford J. Gettens and George L. Stout, *Painting Materials: A Short Encyclopaedia* (New York, 1966), p. 178; and Hermann Kühn and Mary Curran, "Chrome Yellow and Other Chromate Pigments," in *Artists' Pigments: A Handbook of Their History and Characteristics*, ed. Robert L. Feller (Washington, D.C., 1986), vol. 1, pp. 201–04. Since 1935 zinc yellow has been used primarily in corrosion-resistant primers, because of its ability to slowly release chromate ions due to its water solubility; see Emmet Lalor, "Zinc and Strontium Chromate," in *Pigment Handbook*, ed. Temple C. Patton (New York, 1973), vol. 1, pp. 847–59.

35 The starch has been identified by polarized light microscopy as either a wheat or a corn type. Nineteenth-century English painting manuals and handbooks note the practice of using various mediums or vehicles, such as starch, to modify oil paint mixtures; see Leslie Carlyle, *The Artist's Assistant: Oil Painting Instruction Manuals and Handbooks in Britain, 1800–1900* (London, 2001), pp. 101, 110. It is conceivable this was also a practice in France at this time.

36 Leighton and Thomson 1997, p. 82. Recent sampling in a paint loss from *The Bridge at Courbevoie* revealed undiscolored yellow paint beneath the surface; see Kirby et al. 2003, p. 24. Sampling of a discolored dot from *La Grande Jatte* also revealed a brighter lemon yellow color underneath, suggesting that the discoloration of the zinc yellow may occur only close to the surface.

37 Robert L. Herbert, *Neo-Impressionism*, exh. cat. (New York, 1968), p. 112.

38 See J. G. Vibert, *The Science of Painting*, trans. from the 8th ed. (London, 1892), p. 64. Some authors of artists' handbooks from this period, however, did recognize the instability of zinc yellow. William Muckley, for instance, in his 1893 presentation of the results of a twelve-year investigation into the effects of light exposure on pigments, noted that the zinc yellows he tested had "all greatly changed" to the point that "no trace of yellow can be discovered"; see Carlyle (note 35), Appendix 26, p. 523, for this and other contemporary assessments of zinc yellow.

39 Gettens and Stout (note 34), p. 113. See also Inge Fiedler and Michael Bayard, "Emerald Green and Scheele's Green," in *Artists' Pigments: A Handbook of Their History and Characteristics*, ed. Elisabeth West Fitzhugh (Washington, D.C., 1997), vol. 3, pp. 219–71.

40 Signac, cited in Rewald 1949, pp. 170–71. According to Callen 2000 (note 6), p. 104, Édouard's colors "were the most widely favoured by the Impressionists. Although Édouard had retired in 1867, his highly respected colours were still being marketed under his name. His successors, Mulard and later Moisée, thus traded on his reputation."

41 See Leighton and Thomson 1997, p. 82; and Kirby et al. 2003, pp. 24–25.

42 See Kirby et al. 2003, pp. 25, 36; and Stonor (note 12).

Rejuvenating Seurat's Palette Using Color and Imaging Science: A Simulation

ROY S. BERNS

It has long been known that Seurat's *Sunday on La Grande Jatte—1884* does not have the appearance that the artist originally intended. Like any painting, the work has changed with the passage of time—the oil medium Seurat used has darkened and yellowed, and the coarse linen support he employed has also darkened. As was first noted by Félix Fénéon in 1892, there was also an unexpected and rapid deterioration of a number of colors Seurat used in his "second campaign" of painting. Inge Fiedler was the first to identify the particular unstable pigment at fault—zinc yellow—which is present in a number of paint mixtures.[1] Seurat added yellow, green (ranging from green to yellow-green), and orange dots that included the zinc yellow pigment to indicate points of reflected light; these later shifted to an ocherlike color, drab olive, and reddish brown, respectively. These changes have dramatically influenced the painting's luminosity (for this and other color-science terms, see Glossary, p. 225).

While these alterations cannot be corrected physically on the actual canvas, we were able to manipulate high-resolution digital images of the painting in order to reinstate the colors that Seurat intended and recapture to some extent its initial effect. We arrived at an approximation of the original appearance of the painting following a two-step process. First, we digitally "un-aged" the painting as a whole, correcting for the natural yellowing and increased translucency of the paints. Then we corrected for the deterioration of the zinc yellow in its various paint mixtures. This

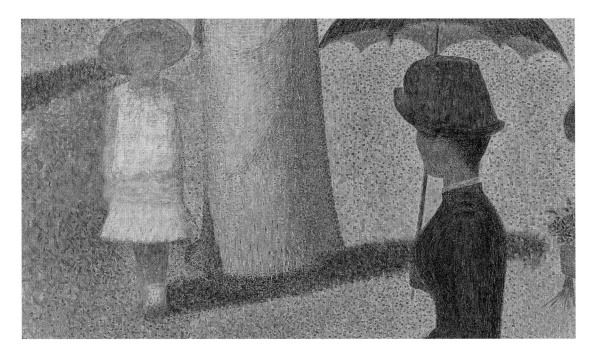

essay explores the elaborate process—taking nondestructive spectral reflectance measurements, re-creating Seurat's paint mixtures, capturing the painting with digital photography, and image editing with Adobe Photoshop—used to achieve this reinvigorated digital version of a portion of *La Grande Jatte* (see FIG. 1).

In Situ Analysis of *La Grande Jatte*

The first step in realizing the simulation of the original colors of *La Grande Jatte* was measuring the spectral reflectance of a number of different dots—focusing mainly on the discolored ones—of paint throughout the work.[2] These measurements

can be performed nondestructively, that is, without the need to remove samples from the painting. Spectral reflectance, measured with an instrument called a spectrophotometer, indicates the amount of light reflected or absorbed by an object at the different wavelengths of the visible spectrum, and is a characteristic of the pigmentation of the object. In general, color is determined by absorption in complementary wavelengths: yellow absorbs blue; green absorbs magenta (a combination of blue and red); blue absorbs yellow (a combination of green and red). We took approximately fifty measurements; thirty of these spectral "fingerprints" are shown in FIG. 2. They have been categorized

FIG. 1
Portion of *La Grande Jatte*
before rejuvenation (opposite)
and after (below).

as blues, greens, oranges, purples, pinks and reds, whites, and yellows. The yellows, oranges, and greens include the dots containing darkened zinc yellow. These spectra can be used to help identify the specific pigment types Seurat used and, as described below, to define color. For example, the relatively high reflectance in the part of the spectrum near 730 nanometers (nm) of the blue curves (see FIG. 2B) indicates the use of cobalt blue. The stepped shape of the curves of the orange spectra (see FIG. 2D) reveals that Seurat produced orange with a mixture of red and yellow pigments, rather than using a single orange one.

These curves are directly related to the absorption and scattering properties of the pigments, paint medium, and ground. For instance, a pigment appears white if it reflects (scatters) most of the light that hits it, that is, nearly 100 percent. The white spectra in the case of *La Grande Jatte* (see FIG. 2G) are much lower than 100 percent, because of an increase in paint transparency, which decreases scattering. The spectra also absorb in the violet wavelengths, a result of the yellowing of the paint medium.[3]

Since the 1940s, color technologists have been able to relate spectral reflectance of paint films or batches of paint to the pigmenting agents needed (either singly or in mixtures) to replicate that exact same color, based on knowledge about the absorption and scattering properties of the paint's constituents.[4] This sort of technology is used today in the custom paint-dispensing systems often found in paint and hardware stores. A sample a customer desires to

match is measured using a spectrophotometer, and a paint recipe is generated that, when mixed, applied to a surface, and allowed to dry, has a similar spectral fingerprint and color. This ability to determine the color that results from a mixture of pigments dispersed in a medium enabled the digital rejuvenation of Seurat's palette, as is described below.

An object does not truly have color until it is illuminated and viewed by an observer. A colored object's reflected light is absorbed by our visual system's three color-receptors (cones). Following complex physiological and cognitive processes, the hundreds of wavelengths of light are reduced to three responses. This fundamental property of color vision, known as trichromacy,[5] was first theorized in the nineteenth century, and the color theorists who influenced Seurat were well aware of it.

Colors scientists at the beginning of the twentieth century wished to find a way to quantify our perception of color. They aimed at developing something as sensitive as the human eye but standardized, thus allowing for "colorimetric specification" derived from numerical and instrumental methods. This research forms the basis of colorimetry.[6] A three-dimensional color space for specifying and visualizing colors called CIELAB (see FIG. 3) was developed in 1976, onto which the properties of every color can be plotted. In addition to two perpendicular horizontal axes measuring redness-greenness (a*) and yellowness-blueness (b*), there is also a vertical axis measuring lightness (L*). Following the selection of a standardized light source and a standardized observer, spectral data (such as that shown in FIG. 2) can be converted

A

to CIELAB coordinates.[7] This color space (only one among many such spaces that have been created) is based on opponent color-vision theory, first developed by Ewald Hering in the 1870s, which postulates that our color vision has opponent perceptions of black or white, red or green, and yellow or blue (see FIG. 4).[8] CIELAB allows us to assign numerical designations to specific colors. For instance, a pure (100 percent reflecting) white would have a value of 100 on the lightness scale (L*) and a value of 0 on the redness-greenness (a*) and yellowness-blueness (b*) scales.[9] Black, which is 0 percent reflecting, would have a value of 0 on all of the scales. The rectangular CIELAB coordinates can also be transformed to cylindrical coordinates that describe the hue (h_{ab}) and chroma (C^*_{ab}) of a color. Chroma is the

FIG. 2

In situ spectrophotometric
measurements of thirty spots
on *La Grande Jatte* (A).
The measurements have been
divided up into groupings of
blue (B), green (C), orange
(D), purple (E), pink and red
(F), white (G), and yellow (H).

FIG. 3

CIELAB color space. Like a traditional color wheel, CIELAB is divided into axes of paired complementary colors: the a* axis measures redness-greenness while the b* axis measures yellowness-blueness. CIELAB also has a vertical axis (L*) that allows us to plot the relative lightness or darkness of a color. Shown here is the color gamut, or range, of a typical CRT color display, like that of a computer monitor. The large range of colors can be compared with that of *La Grande Jatte,* shown in FIG. 11.

FIG. 4

Ewald Hering's color wheel. It shows the psychological mixing of adjacent primaries of red, yellow, green, and blue.

FIG. 5 (BOTTOM)

In situ measurements of thirty colors sampled from *La Grande Jatte* (top) and those same colors after subtracting the aging spectrum (bottom). While there is a general brightening in all of the examples, the greatest change is visible in lighter colors, such as the yellows, creams, whites, and lightest pinks.

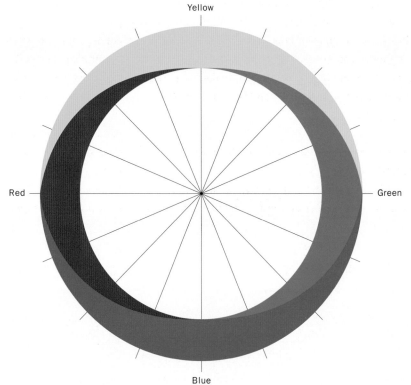

degree of departure of a color from a gray of the same lightness. So, for instance, a tomato and a brick may have the same lightness, but the tomato has greater chroma; that is, the tomato is a more chromatic (often described as "intense") red color than the brick. Colors that appear luminous, as Seurat intended his to be, are simultaneously light and high in chroma.[10]

Measuring the Color of *La Grande Jatte* Using Imaging

As noted above, we were able to determine the CIELAB coordinates for each of the measurements

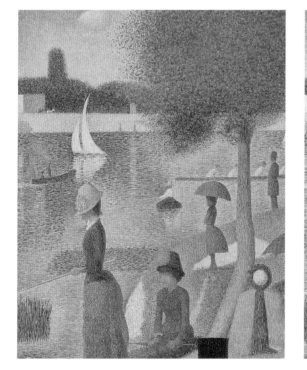

from *La Grande Jatte* by using a spectrophotometer. This provided valuable information about particular parts of the painting but measured a very small percentage of the work as a whole. In order to perform the ultimate correction and digital rejuvenation of *La Grande Jatte*, we needed measurements of all of the colors in the painting. Therefore, we estimated their CIELAB coordinates with a color-managed digital camera.[11] The Art Institute's Imaging Department created use-neutral files that were equivalent to a 1:1 representation of the painting. Because the camera captures 8,000 x 5,344 pixels at its highest resolution—corresponding to only 4 percent of the

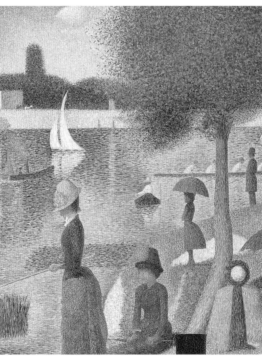

total size of the painting—we employed a mosaic system to image the entire work. We captured twenty-five discrete image tiles, five across and five down.[12] Like the human visual system, the color camera is trichromatic, so each of the more than one billion measurements corresponded to three filtered channels referred to as red, green, and blue (RGB).[13] However, depending on the specific color filters and built-in color processing, the quality of the color image can vary considerably. Therefore, we created a custom color profile that converted this RGB information into CIELAB coordinates.[14]

The CIELAB image measurements of *La Grande Jatte* are plotted in FIG. 11. The overall darkening of the painting is evident, since the maximum lightness is below what can be achieved with fresh lead white in linseed oil (about an L* of 97). We also see that the range of yellows is rather limited and that the greens are dark. Compared with the colors achievable with fresh oil paints, the color gamut of the painting is modest.

Digitally "Un-aging" *La Grande Jatte*

The CIELAB coordinates for the range of colors in the painting are necessary for realizing our larger goal of recapturing the appearance of *La Grande Jatte* during the late 1880s, before the zinc yellow began to deteriorate. A contribution to the change in the appearance of the zinc yellow is the overall darkening of the painting. In order to measure the degree to which the natural aging processes have affected the entire painting, we took a spectral measurement of an area of the work containing

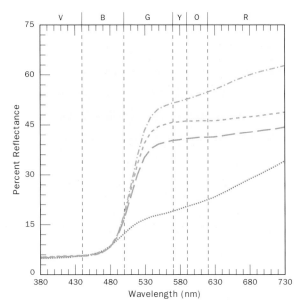

FIG. 7

Reflectance spectra of averaged yellow dots before and after rejuvenation. All the spectra have nearly identical reflectances below the transition wavelength (the point at which the curves begin to part, about 470 nm). Replacing the darkened zinc yellow with fresh zinc yellow greatly increases reflectance. Incorporating the first campaign results in an intermediate spectrum. Un-aging increases reflectance, resulting in the "rejuvenated" yellow.

········· Average yellow dot

—·—·— Undarkened average yellow dot

— — Undarkened average yellow dot with 25% showthrough of underlying paint

— — — Undarkened and un-aged average yellow dot with 25% showthrough of underlying paint

pure lead white—the sail of the boat in the top left corner. We compared this spectrum with a fresh paint-out of lead white in linseed oil. The spectral difference between the two generated the "aging spectrum" for the picture as a whole.[15] The aging spectrum can be added to the spectra of fresh pigments to simulate the aging of Seurat's palette. More importantly, it can be subtracted from in situ measurements of *La Grande Jatte* to un-age colors throughout the painting.

The aging spectrum was subtracted from each of the spectral measurements shown in FIG. 2 and their CIELAB coordinates were recalculated. As a result, the colors underwent an increase in lightness and a slight increase in chroma (see FIG. 5). The extent of change caused by un-aging varied depending on the particular color's spectral properties; in general, however, lighter hues were more affected than darker ones.

Using this information, a digital image of the upper left portion of *La Grande Jatte* was processed with Photoshop, arriving at the simulation of its un-aged appearance (see FIG. 6).[16] Compared with the painting in its current state, there is a clear increase in lightness and chroma: it has become brighter, more luminous. There is also an increase in contrast, making the differences between light and dark passages more distinguishable. In particular, the complementary haloes surrounding many of the figures are more noticeable.

"Undarkening" the Spectra of Dots Containing Zinc Yellow

While digital un-aging enables us to correct for the natural process of overall darkening and yellowing of paint films over time, it cannot compensate for the unusual deterioration of the zinc yellow, which was caused by a chemical change in the pigment (see Fiedler, p. 209). Conceptually, in order for the brushstrokes of paint containing the darkened zinc yellow to be "undarkened," we must replace the failed yellow with one that only underwent normal aging, like the rest of Seurat's palette. To do this, we first had to identify the spectral properties of the particular zinc yellow used, as well as the color strength of the pigment and its concentrations in the mixtures with emerald green or vermilion. In order to get estimates, we took paint samples from the same dots that were measured spectrophotometrically. Inge Fiedler determined the paint mixtures microscopically and estimated the proportions within each. However, it is extremely difficult to relate microscopic analyses to macroscopic reflection properties, and it was not feasible to take a sample of every darkened dot. We thus used a theoretical color-mixing model as an analytical tool to determine the amount of darkened zinc yellow in any given mixture in order to replace it with the proper amount of "fresh" (chemically unaltered) zinc yellow.

Art Institute conservators prepared reference samples (paint-outs) of fresh zinc yellow, emerald green, vermilion, chrome yellow, and lead white thinned with linseed oil and painted on a single panel with a white ground. After the paint-outs dried, conservators measured their spectral reflectances. We referred to these samples to understand how colors would have looked out of the tube on Seurat's palette.

Because zinc yellow was available in a variety of hues ranging from greenish yellow to reddish yellow, we had to determine if the zinc yellow prepared at the Art Institute had the same spectral properties as the one used by Seurat. In addition to measuring the spectral reflectance of the fresh zinc yellow, we also measured six darkened zinc yellow dots from *La Grande Jatte* and averaged the results (see FIG. 7).[17] When the spectra of the fresh and darkened yellows were compared, it became clear that the Art Institute samples were too green; to correct for this we simply shifted its spectrum until the transition wavelengths of the two nearly matched (the transition wavelength determines the shade of yellow). In this manner, we estimated the spectral properties of the zinc yellow that Seurat used. This revealed that this particular pigment lacked a green or red tint; as such it has a distinct place among the range of hues he employed.

Changes in concentration or tinting strength alter the level of light absorption. Below 470 nm, the amount of reflectance is due to absorptions by the yellow pigment and aging. This principle enabled

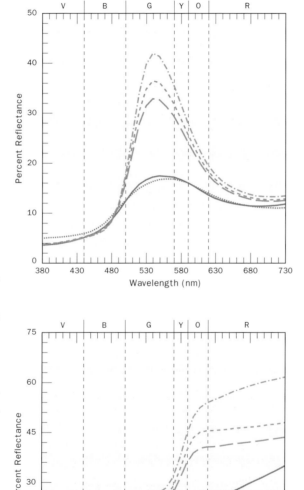

FIG. 8

Reflectance spectra of the averaged green dots before and after rejuvenation. Also shown is the match to the averaged darkened dots, made using the darkened zinc yellow, fresh emerald green, fresh lead white, and the aging spectrum.

.......... Average green dot

——— Match to average green dot

–·–·– Undarkened average green dot

— — Undarkened average green dot with 25% showthrough of underlying paint

– – – Undarkened and un-aged average green dot with 25% showthrough of underlying paint

FIG. 9

Reflectance spectra of the averaged orange dots before and after rejuvenation. Also shown is the match to the averaged darkened dots made using the darkened zinc yellow, fresh vermilion, fresh lead white, and the aging spectrum.

.......... Average orange dot

——— Match to average orange dot

–·–·– Undarkened average orange dot

— — Undarkened average orange dot with 25% showthrough of underlying paint

– – – Undarkened and un-aged average orange dot with 25% showthrough of underlying paint

FIG. 10

The colors of the averaged green (left), yellow (center), and orange (right) dots. The top row shows them in their current state; the second, after undarkening; the third, after undarkening and taking into account effect of underlying paint layers. The bottom row shows the dots in the third row after un-aging. The colors are surrounded by the average hue of the sunlit or shadowed grass excluding these dots. In the fourth row, the backgrounds also have been un-aged.

us to estimate the strength of Seurat's zinc yellow. The fresh zinc yellow was scaled[18] so that its spectrum, when added to the aging spectrum, most closely matched the six zinc yellow dots' average spectrum between 380 and 470 nm (see FIG. 7). This manipulated curve simulates a measurement of Seurat's original zinc yellow before darkening.

The zinc yellow dots from *La Grande Jatte* reflect significantly less light beyond the transition wavelength than fresh zinc yellow dots would, thus making them appear darker. The spectrum for the darkened zinc yellow is in fact quite similar to that for a yellow ocher mixed with black.

Although we know that emerald green can also darken over time, research by Fiedler indicated that the zinc yellow was the primary cause of the darkening of the green dots in *La Grande Jatte*; spectral reflectance and colorimetric analysis confirmed her findings. Six green dots were measured spectrophotometrically and their spectra averaged (see FIG. 8). The dots were also analyzed microscopically, revealing that they contain various proportions of zinc yellow and emerald green and, in some cases, small amounts of lead white. We thus attempted to match the spectrum of the averaged darkened green dots by combining the averaged darkened zinc yellow (see above), fresh emerald green, fresh lead white, and the aging spectrum. The close similarity between the in situ measurement of the darkened green dots and the match that we created (using *darkened* zinc yellow but *fresh* emerald green) provides further confirmation that the emerald green was not responsible for the darkening.[19] Using the same approach employed to undarken the zinc yellow dots, we determined an appropriate concentration of fresh zinc yellow. The correct concentrations of fresh emerald green, fresh zinc yellow, and fresh lead white, plus the aging spectrum, produced the spectrum the green

dots would have possessed had they not undergone the unusual darkening.

We performed the same procedure used to undarken the yellow and green dots on the orange dots containing vermilion and zinc yellow. Three dots were measured spectrophotometrically and analyzed microscopically, revealing a range in the proportion of the pigments. We averaged the spectra and then matched them with darkened zinc yellow, fresh vermilion, fresh lead white, and the aging spectrum (see FIG. 9). Finally, we replaced the darkened zinc yellow with the fresh equivalent in order to arrive at the spectrum for the orange had it not deteriorated.

Before applying these undarkened dots to the digital image of the painting, we had to take into account one last variable: the translucent nature of paint. A paint layer is seldom perfectly opaque, and thus its surface color may be influenced by the color of the substrate on which it lies. This effect is often heightened in older paintings. In the case of *La Grande Jatte*, the result of this translucency is that the underlying paint layers of the artist's first campaign on the work affect the perceived color of the dots. In the paint-outs, the bright white substrate is visible; thus, the undarkened dots based on the paint-outs are lighter and higher in chroma than they would really appear on the painting.

To compensate for this, we needed to account for the influence of the underlying paint on the tone of the darkened dots. Fiedler determined that the first-campaign grass is composed primarily of

FIG. 11

The image measurements of *La Grande Jatte* plotted on CIELAB. The color gamut (range) is shown as a color solid, here viewed from four different perspectives. When compared with the color gamut of a typical CRT computer monitor (see FIG. 3), the range and variety of colors employed in *La Grande Jatte* is quite limited.

FIG. 12 (BOTTOM)

Four different perspectives of the CIELAB color gamut of *La Grande Jatte* after rejuvenation. Compared with *La Grande Jatte* before rejuvenation (see FIG. 11), there is a clear increase the range of colors. There is an overall lightening and an extension of the yellows and reds in particular.

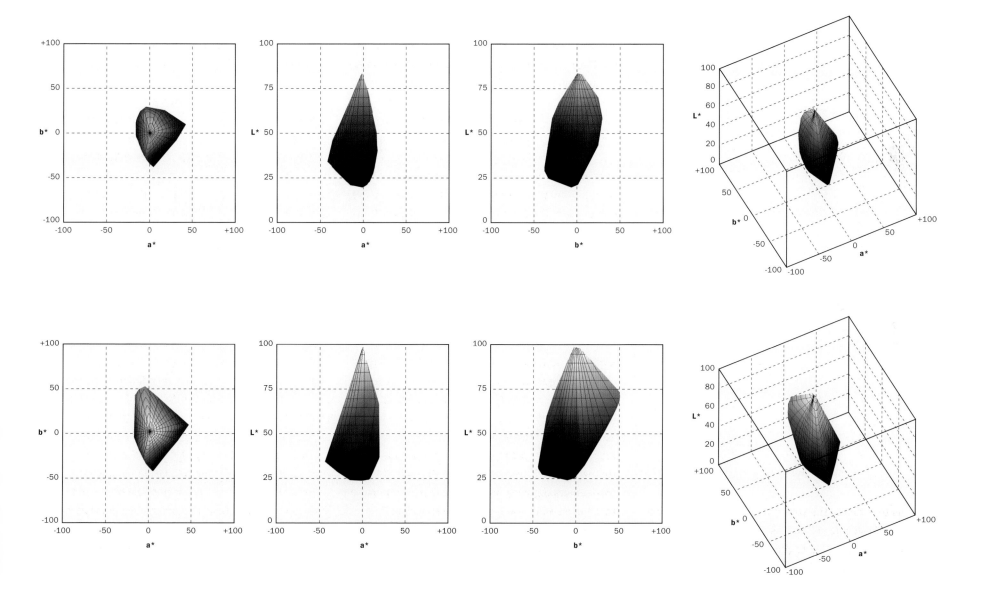

chrome yellow, emerald green, and lead white. Using the theoretical paint-mixing model, we found the concentrations of these fresh pigments, and applied the aging spectrum; this generated a spectrum matching the CIELAB coordinates of the average first-campaign sunlit grass. We then arrived at revised paint-out spectra (the spectra of the zinc yellow, emerald green, and vermilion had they been painted over the first-campaign sunlit grass color rather than white) by mixing the spectra of the sunlit grass and the paint-outs in a one-to-three ratio.[20] This ratio, selected subjectively, allowed for a 25 percent show-through of the underlying paints. With these new paint-out spectra, we repeated the undarkening calculations for each average colored dot, and subtracted the aging spectrum from each (see FIGS. 7–9). We used these revised spectra to calculate CIELAB coordinates, which were rendered as an image using Photoshop (FIG. 10). The drab ocherlike dots become a vivid yellow, the olive dots turn a vibrant yellowish green, and the reddish brown ones are now a lively light orange. These results are consistent with early observations about the colors and luminosity of the painting.

Digitally Rejuvenating the Dots Containing Zinc Yellow

Before the dots could be rejuvenated, they needed to be isolated from the entire image. The Imaging Department at the Art Institute used the tool Select Color in Photoshop, which can find all image areas with a similar color, to select and replace the darkened yellow, green, and orange dots on a reduced-resolution composite image of the entire painting. This heightened the painting's luminosity and significantly increased its overall color gamut (see FIGS. 11–12).

While the Select Color tool was useful in rejuvenating the image at a low resolution, the Imaging Department found that its accuracy on full-resolution image tiles was insufficient. The tool particularly had trouble differentiating second-campaign green dots from the first-campaign grass and, in some cases, yellowish green from yellow dots. Therefore, in refreshing a single image tile from *La Grande Jatte* (see FIG. 1), we used the option Magic Wand, which allows one to select contiguous image areas with similar color. This process provides a dot-by-dot mapping of the painting, but because it is so labor-intensive it was only feasible to apply it to a small portion of the work.[21] For each selected set of dots, Photoshop was used to change the CIELAB coordinates of each dot to their rejuvenated coordinates.[22]

The most dramatic change in this portion of the painting is in the sunlit grass, where the dark speckle has become points of brilliant yellow and yellow-green that increase the luminosity of the landscape. In the darker areas, vivid orange highlights sparkle within the shadows. These dots now appear playful, providing a sense of movement. The overall brightening of the sunlit grass increases the contrast between light and dark passages: the shadow cast by the little girl is more apparent, and there is a greater sense of depth between the seated woman with the umbrella and the little girl.

Conclusion

Although we took a scientific approach here to arrive at the appearance *La Grande Jatte* would have had in the 1880s, the results are still speculative. The darkening of the zinc yellow mixtures and the aging of the painting as a whole are undeniable, but the exact extent of the changes is still under investigation. The results of our efforts do seem reasonable, however, since the effect of the rejuvenated painting is consistent with descriptions of Seurat's masterwork before it underwent its unfortunate color change.

FIG. 13

The center panel is *La Grande Jatte* in its current state. In the left panel, lightness contrast has been increased. In the right panel, color contrast has been increased.

FIG. 14 (BOTTOM)

Colors of constant hue organized by lightness and chroma. The left-most column depicts neutrals. Moving to the right, chroma increases.

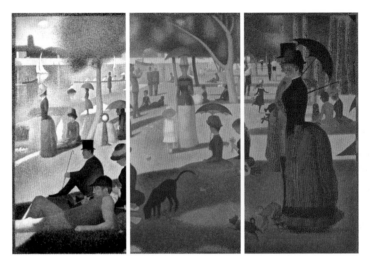

Glossary

ABSORPTION: one of the possible modes of interaction of light and matter in which all the energy of the incoming light interacts with the bulk of the material and it is all dissipated into it, that is, it is absorbed.

CHROMA: the degree of departure of a color from a gray of the same lightness (see FIG. 14).

COLOR SPACE: colors are usually described by three variables. These can be organized in a three-dimensional fashion forming a color space. The position of a color within a color space, when defined numerically, provides an unambiguous color specification. CIELAB is an example of a color space: when variables L^*, a^*, and b^* are used, the organization is rectangular; when L^*, C^*_{ab}, and h_{ab} are used, the organization is cylindrical.

COLOR GAMUT: the range of colors of a coloration system, usually defined by a standardized color space. The color gamut of an object, such as *La Grande Jatte,* can also be determined (see FIGS. 11–12).

CONTRAST: attribute by which a perceived color is judged to be distinct from neighboring colors (see FIG. 13). When the distinction is caused by differences in hue and chroma, it is color contrast. When the distinction is caused by differences in lightness, it is lightness contrast.

HUE: the similarity of a color to one of the colors, red, yellow, green, and blue, or to a combination of adjacent pairs of these colors considered in a color wheel.

LIGHT: radiation is a form of energy, part of the family that includes radio waves and X-rays, as well as ultraviolet and infrared radiation. Radiation we can see is called light. We can see wavelengths between about 400 nm (violet/blue) and 700 nm (red).

LIGHTNESS: the equivalency of a color to one of a series of grays ranging from black to white (see FIG. 14).

LUMINOSITY: attribute by which a perceived color is judged to have the property of a light source. For colors to appear luminous, they must be simultaneously light and high in chroma.

OPAQUE: when the scattering of a material is sufficiently large that light cannot pass through (some absorption is often present), the material is said to be opaque.

SCATTERING: one of the possible modes of interaction of light and matter in which the direction of the incoming light changes.

SPECTRAL REFLECTANCE: the ratio of the reflected light to the incident light under specified geometric conditions as a function of wavelength.

TRANSLUCENT: when some but not all of the light passing through a material is scattered, the material is said to be translucent.

TRANSPARENT: when light passes through a material without changing its direction, the material is said to be transparent.

WAVELENGTH: electromagnetic radiation can be described quantitatively either as energy of photons or as energy of waves; in the latter case, wavelength is the unit for measuring that energy. The nanometer (nm) is a convenient unit of length. One nanometer is 1/1,000,000,000 meter.

Lightness

Chroma

Acknowledgments

I wish to thank Francisco Imai, Mitchell Rosen, and Lawrence Taplin of the Munsell Color Science Laboratory for their assistance in creating the camera profile, Photoshop custom curves, and 3-D CIELAB renderings. At the Art Institute, I am grateful to Francesca Casadio, Inge Fiedler, Allison Langley, and Frank Zuccari of the Conservation Department for providing the paint samples and additional measurements of *La Grande Jatte*. Thank you also to Alan Newman, Chris Gallagher, and Siobhan Byrns of the Imaging Department for performing the digital photography and labor-intensive color selection and rejuvenation. Finally, my appreciation goes to Robert Herbert for his many helpful comments and enthusiasm.

Notes

1 Fiedler 1984.

2 The measurement of spectral reflectance is central to the study and practice of color science as it exists today. Color science, simply stated, quantifies our perceptions of color in a standardized fashion. Two instruments were used to measure *La Grande Jatte*: a Gretag-Macbeth Eye-One and a Gretag-Macbeth SpectroEye, both with 4.5 mm circular measurement apertures.

3 The maximum reflectance is limited by the aging of the painting. The minimum reflectance, in the case of *La Grande Jatte* of about 5 percent, is a function of the surface roughness that can contribute to the overall scattering of light. A highly varnished Old Master painting, for example, could have a minimum reflectance approaching 0 percent.

4 The seminal work was published by D. R. Duncan, "The Colour of Pigment Mixtures," *Journal of the Oil Colour Chemist Association* 32 (1949), pp. 296, 321. Because of computing limitations, instrumental-based color matching was not practiced until the 1960s.

5 Trichromatic theory is usually associated with Thomas Young ("On the Theory of Light and Colours," *Philosophical Transactions* 12–48 [1802]) and Hermann von Helmholtz (*Treatise on Physiological Optics,* trans. from the 3rd German ed., ed. James P. C. Southall, [Rochester, 1924]).

6 "Colorimetry" is a synthesis of two words: "color" and the Greek word *metrein,* meaning "to measure." Color specifications using numerical and instrumental methods were first standardized in 1931 by the Commission Internationale de l'Éclairage (CIE), resulting in standardized light sources, spectrophotometers, and an average observer. Today, the following publication (or its most current revision) governs colorimetry: CIE No. 15.2, *Colorimetry,* 2nd ed. (Vienna, 1986). See Roy S. Berns, *Billmeyer and Saltzman's Principles of Color Technology,* 3rd ed. (New York, 2000), to discover more about the many industrial uses of colorimetry.

7 CIE illuminant D50 and the 1931 standard observer (see note 6) were used for all the colorimetric calculations. D50 was selected for two reasons: first, for color printing, D50 is a graphic arts standard; second, D50 represents sunlight.

8 Ewald Hering, *Grundzüge der Lehre vom Lichtsinn* (Berlin, 1920), trans. Leo M. Hurvich and Dorothea Jameson as *Outlines of a Theory of the Light Sense* (Cambridge, Mass., 1964). This results in a color wheel with these opponent colors opposite one another, as shown in FIG. 4. Perceptually, these hues are unique and unambiguous. All other hues can be defined as ratios of adjacent ones. An orange might be 50 percent each of red and yellow. When creating a color scale between opponent colors, the midpoint is neutral. These complements are psychological, not physical, based on either light or colorant mixing. Physical primaries can result in very different complements, and hence the many different color wheels.

9 Although CIELAB is based on opponent color-vision theory, its axes do not correspond exactly to the unique hues. As a consequence, experience is required to relate CIELAB coordinates with specific color perceptions. The color space is used most frequently to describe differences in color (e.g., lighter, redder, higher in chroma) rather than their absolute perceived color.

10 This property cannot be achieved with all pigments, but red lake, zinc yellow, and emerald green would certainly achieve luminosity.

11 The camera used was the German Eyelike Precision M11 by JENOPTIK. We lit the painting with four Hensel strobes. A spectral camera would have been the best instrument for making these measurements. It would have provided us with an image of the painting at every wavelength, and if the camera had high spatial resolution, each dot would have many measurements since each measurement corresponds to a pixel. When *La Grande Jatte* was analyzed, however, a system was not yet ready for such a large undertaking. Developing artwork spectralimaging systems is a research topic on which I am currently working; see Rochester Institute of Technology, "Art Spectral Imaging," http://www.art-si.org.

12 The Imaging Department drew a chalk line parallel to the picture plane and used dual plumb bobs on either side of the camera to ensure the accuracy of the planes. Markers along the outside of the painting's perimeter were used as a guide.

13 Depending on the specific color filters and built-in color processing, the quality of the color image can vary widely with respect to treating the imaging system as an analytical instrument, in similar fashion to the small-aperture spectrophotometer measuring a sample's CIELAB values; see Roy S. Berns, "The Science of Digitizing Paintings for Color-Accurate Image Archives: A Review," *Journal of*

Imaging Science Technology 45 (2001), pp. 373–83.

14 We used two targets to verify our results: a GretagMacbeth ColorChecker DC consisting of 240 color patches, and a 60-color-patch custom target consisting of the 30 chromatic pigments of the Gamblin Conservation Colors mixed with titanium white at two different proportions. We measured each target with a spectrophotometer and calculated the CIELAB coordinates for each color. We used the image and spectrophotometric data of the ColorChecker DC to create a mathematical transformation that converted the RGB data to L*a*b*. The profile consisted of three nonlinear functions that transformed the encoded camera signals to linear photometric signals. These functions were similar to typical gamma curves of about 1/2.2, a common camera encoding. A (3 x 4) transformation matrix converted the linearized signals to CIE XYZ tristimulus values for illuminant D50 and the 1931 standard observer. This matrix incorporated an offset. The average performance of this profile was 2.6 and 2.7 CIEDE2000 for the ColorChecker DC (characterization target) and artist paints (verification target), respectively. For a numerical example, see Berns (note 6), appendix.

15 The scaling was based on the absorption and scattering properties, not the direct spectral reflectance properties. The color-mixing model employed for all the spectral calculations was the single-constant

Kubelka-Munk equations. Nonlinear optimization was used to determine concentrations that resulted in specific CIELAB coordinates or reflectance spectra as required in order to achieve the objective of rejuvenating Seurat's palette. These mathematics are an integral component of instrumental-based color matching, such as routinely performed in paint stores.

16 We derived functional relationships so that the un-aged colors, defined as CIELAB coordinates, could be predicted from the in situ measurements. We then used these to build custom Photoshop curves. These curves were an approximation, since the relationship between spectra and colorimetry is complex; however, the colors un-aged by Photoshop were very similar to those un-aged by subtracting the aging spectrum. The success of this approximation resulted in part from the limited color gamut of the painting.

17 Microscopic analysis revealed that these dots were greater than 97 percent zinc yellow with small amounts of vermilion and trace amounts of lead white and several dark particles. Their spectra did not show absorptions caused by the presence of the vermilion or other pigments. Therefore, these pigments were assumed to have a negligible affect both spectrally and colorimetrically and were not further considered.

18 See note 15.

19 See Fiedler 1984, p. 49.

20 Strictly, the paint-outs for the orange dots should have been recalculated using the estimated spectrum for the shadowed grass; however, the resulting spectrum was nearly the same lightness as the darkened orange. Consequently, we implemented the same technique used for the yellow and green dots.

21 Work is currently under way to perform the dot-by-dot digital rejuvenation on the painting as a whole. The Art Institute hopes to incorporate it into the exhibition that occasioned this publication.

22 The darkened colors were rejuvenated by translating CIELAB coordinates, an additive shift in values. These translations were implemented in Photoshop by creating custom curves, one for each dot color. There is of course a range of colors within each of the three types of dots, due to varied proportions in the mixtures and the thickness and opacity of the paint used. We verified these ranges by statistically evaluating the CIELAB values of each color on the images of the painting. The translation operation maintains the color range. The limitation to this approach is the assumption that the gamut of colors is independent of the average color; in other words, that as colors were undarkened, they would have the same color variability. Theoretically, this assumption is false, since the range of colors that can be made from pigments has fixed endpoints of black and white. As colors become very dark or light, their range, by definition, reduces. Fortunately

none of these three colors was very dark or very light, so the assumption was reasonable in this case. Furthermore, performing the translation on the CIELAB coordinates rather than on the camera signals also improved the rendering, since CIELAB has a perceptual basis.

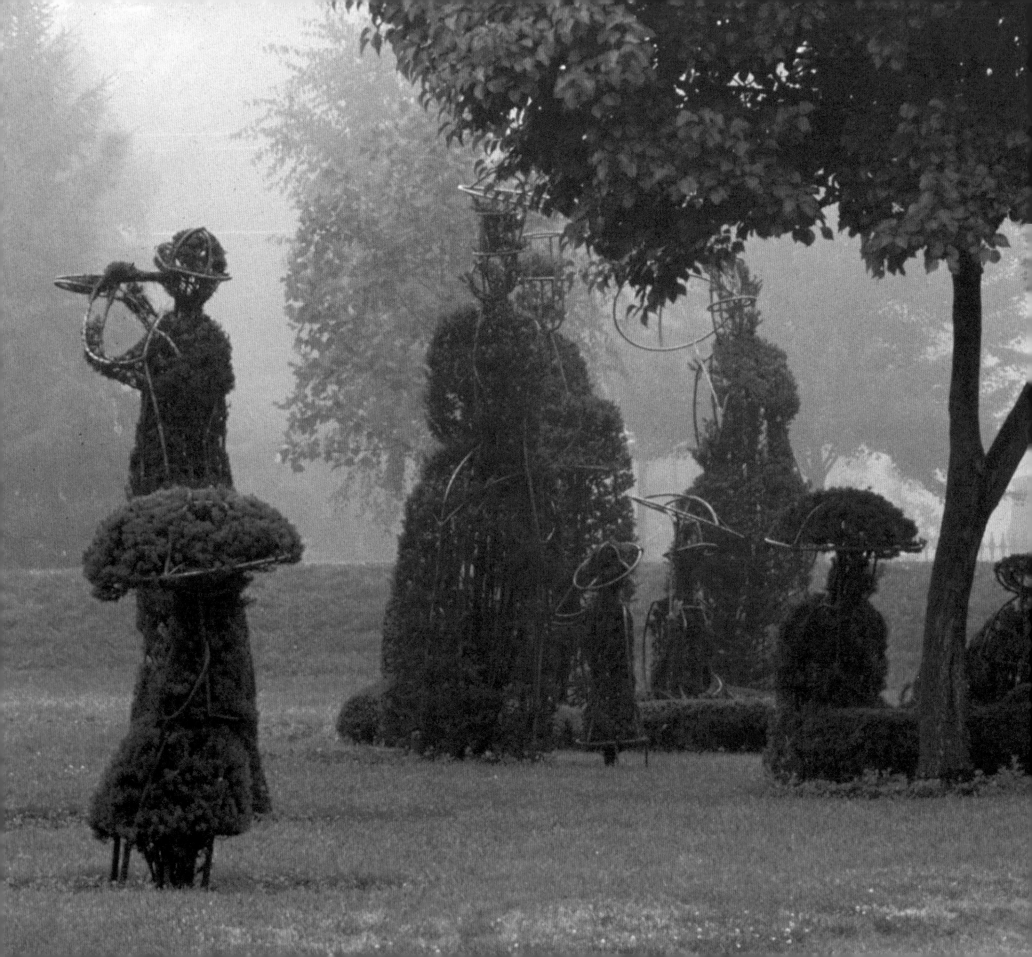

The Park
in the
Museum

The Park in the Museum: The Making of an Icon

NEIL HARRIS

For eighty years, more than two-thirds of its life, *A Sunday on La Grande Jatte—1884* has hung in the Art Institute of Chicago (see FIG. 1). Indeed, the Art Institute itself is barely older than the painting, and the building that has housed it all this time is a few years younger. This Seurat–Chicago connection, a long affiliation, has had marked consequences for both the museum and the city.

The relationship between urban reputation and art possession is of course neither new nor peculiarly American. But circumstances about this picture and this city make the linkage especially significant and revealing. Great pictures live out several lives. They live in the responses and experiences of those who encounter them. They live in the works of critics and historians who analyze them. They live in the reproductions and objects meant to recall them. And they live in the museums that eventually receive and exhibit them, helping these institutions to shape their practices and expectations. These same museums have an interest in creating reputation and significance for their own art, and perform an important role in securing a status for their objects. The part played by a single artwork in the life of a museum and the way in which a museum can enhance that object together form a subject that merits attention, one that can be addressed only by considering them in a continuing interaction.

Well before art museums became conventional parts of the national cultural establishment, Americans had begun to notice the importance of masterworks

to the civic, economic, and social health of their respective communities. There was ample precedent for this, going back millennia. To focus just on Europe, art objects, as trophies of war and conquest, entered the triumphant plunder of Roman victors. Christian Europe sustained these procedures (the treasured bronze horses Venetians took from the sacking of Constantinople is one of many examples), but starting in the early Middle Ages, they were supplemented by another category: the lively commerce in holy relics, perceived to be public possessions, in whose ownership and security all had a stake. Relics were a source of profit to communities. They became sites of pilgrimage, and pilgrims were consumers of room, board, and souvenirs in the active traffic patterns that developed across Western Europe. Urban economies depended on their presence.

The competition for relics and anxiety about their retention prepared the way for a new scenario, this one centered specifically on art. By the seventeenth and eighteenth centuries, the city-states of the Italian peninsula and the communes and cities of the Low Countries were filled with astonishing art collections. Connoisseurs offered works of art the same veneration that religious relics had inspired among the masses. Like relics, art seemed to merit special protection. In 1603 the grand duke of Tuscany issued a ban on the export of art without special permission. And shortly thereafter, the Papal States took an even firmer stand by establishing a number of museums. Once art objects entered these institutions, they could never be sold.[1] Among

the earliest of their kind in Europe, these museums also suggested civic awareness of the need to care for and preserve art. Throughout the continent, artworks had economic value, as a source of tourist income if nothing else.

But still more was at stake in these struggles, involving the link between identity and the possession of art. This broader vision became still clearer with the rise of democratic nationalism in the eighteenth century. The idea of the nation, a sacred community held together by a common heritage, would power much of western history over the next one hundred years. It was to some body called "The People" that poets, courts, and legislators paid homage. And it was in the name of "The People" that a set of new institutions was established.

Nothing symbolized this shift better than the national libraries and art museums that began to dot European cities. No longer viewed simply as the possession of dynastic families, art objects assumed a place within a larger, communal self-consciousness.[2] The French Revolution prompted the transformation of the Louvre from a royal palace to a publicly owned museum. And so, in unexpected ways, did the Napoleonic conquests that soon followed. For Napoleon Bonaparte, art looter that he was, claimed to be a people's emperor. His Italian conquests took away, at least briefly, great art from cities such as Florence and Venice, to enhance the glory of Paris and the French nation. But much of this art was clearly identified with the cities and population that suddenly lost

FIG. 1

Visitors to the Art Institute of
Chicago in front of *La Grande
Jatte*, December 1963.

it, and the Napoleonic booty set off the most serious rethinking about art and collective ownership that had taken place for centuries. Treaties forced the French to return much of the art after Napoleon's final abdication and exile; the need for international diplomacy and warfare to define ownership suggests the larger interests involved.

It was just after this period of nationalistic self-awareness that Americans began seriously to comment upon issues of art possession. Initially, this came about as a result of tourism, the source of so much national exposure to the history of art. Well

before the Civil War, thousands of Americans had developed the habit of making annual pilgrimages to Europe, in search of encounters and experiences unavailable at home. Such trips were dominated by visits to museums and galleries, as well as to churches and archeological sites; their impact was recorded in voluminous correspondence, as well as printed journals and travel books.[3]

These musings on art experiences provided a reservoir of justifications for the wealth and energy that Americans would eventually dedicate to collecting art, and for the philanthropic impulses that

resulted in the founding of the nation's museums. Exposure to the treasures of Europe underscored the impact of the direct experience of an original. A physician, Walter Channing, traveling in the 1850s, confessed his astonishment that actual works could do things unattainable by copies. "As soon as you see the original . . . you feel that the whole story is told. A copy must be a failure. . . . There can be no copy of a true painting—a true work of art." "How few good original paintings we possess!" mourned Isaac A. Jewett on his European journey. Visitors to Europe, like the Reverend Orville Dewey, after viewing the Laocoön and the Apollo Belvedere in the Vatican, could assert that authentic marbles were "far more powerful than any casts I have seen."[4] But such casts would have to suffice American institutions, many thought, for an extended period to come. Who had the money to buy art of the sort produced by canonical figures such as Raphael, Titian, Correggio, and Velázquez?

During the 1870s and 1880s, decades when a number of great American art museums were founded (among them the Art Institute of Chicago), such questions seemed unanswerable. Few if any Americans collected Old Masters; contemporary art, European or American, was deemed safer, since it was easier to avoid the imposture of forgeries. The structures going up were, in many instances, far more impressive than what they contained (see FIG. 2).

In its first Michigan Avenue building, the Art Institute in the 1880s and early 1890s served curious art lovers, and its school's students, with a

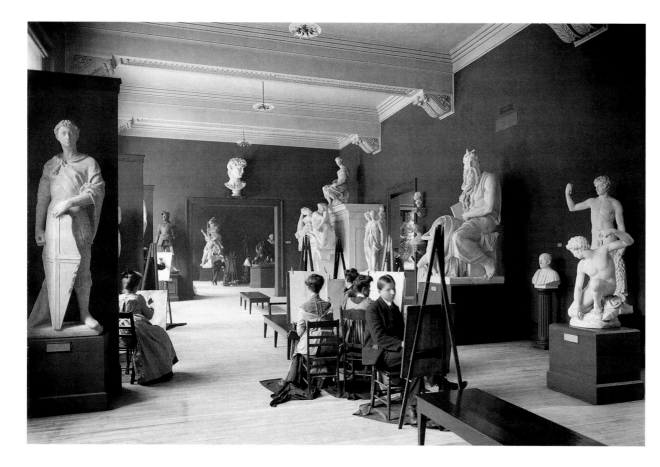

melange of special exhibitions and loans. With Chicago's population approaching one million, this level of art presentation attracted crowds large enough to justify considering a much bigger and better-planned space. Future-oriented, like much of the country, Chicagoans anticipated ambitious cultural needs, and magnificent gestures in the 1880s and 1890s resulted in the creation of perma-nent institutions and splendid buildings. As yet,

however, there were few famed artworks in either the Art Institute or the city as a whole, nothing with which to identify or to attract tourists.

The World's Columbian Exposition of 1893 allowed Chicago to claim what was, at least for a moment, the most celebrated landscape ensemble in the country, perhaps in the world: the White City. Relentlessly photographed, painted, and drawn, the fair's exhibition halls, lagoons, fountains, and

promenades constituted the best publicized site of the century. By the autumn of 1893, with its closure drawing near, there were campaigns to try to retain it. In the palaces of the fair, Chicago had finally achieved a level of art possession that entitled it to boasting privileges and economic advantages. While fires, non-durable construction materials, contractual obligations, and long-standing plans nullified any efforts at permanence, the mere presence of this extraordinary concentration of monumental architecture and the art it contained whetted the appetite of city boosters for more. The debate over the fairground's future suggested the existence of a deep-rooted, if vaguely expressed, aesthetic desire.

The most immediate benefit of such thinking, of course, was the Art Institute's new home, con-structed in part with fair subsidies to host the down-town congresses, but always intended to function ultimately as the city's permanent art institution (FIG. 3). The Beaux-Arts building could accommo-date greater numbers of visitors and artworks than the museum's previous home. But where would the artworks come from, and what would they be? No one had immediate answers to this, but the fair had sharpened ambitions. The names chiseled into the new structure—Rubens, Rembrandt, Gainsborough, Van Dyck—represented aspirations that few expected would be fulfilled, at least in the near future, by the actual collection.

One impressive response to this larger need was the creation of the Ferguson Fund in 1905. Benjamin Franklin Ferguson had made his fortune in lumber,

and left the bulk of his estate to provide income for the erection of public monuments in Chicago. The trustees of the Art Institute became responsible for selecting the artists, subjects, and sites. Chicagoans expected that, in time, with a wisely invested and intelligently expended fund, the local landscape would teem with the kind of art that Americans so admired in Europe, and the city given assets that would enable it to compete with historic shrines abroad.

Transforming Chicago into "A Paris of the Prairies" did not seem impossible to people like Ferguson or to backers of the Burnham Plan, which appeared just four years later. Everyone recognized that nineteenth-century Paris had inspired this ambitious design, with its broad boulevards, uniform cornice heights, and climactic plazas—reshaped, of course, by a park-lined lake front that was Chicago's special feature. "People from all over the world visit and linger in Paris," the Burnham Plan authors observed in its penultimate paragraph. "No matter where they make their money, they go there to spend it.... The cream of our own earnings should be spent here, while the city should become a magnet, drawing to us those who wish to enjoy life. The change would mean prosperity, effective, certain, and forever continuous."[5]

The Ferguson Fund, the Burnham Plan and the commission that supervised its implementation, the Wacker Manual (which describes the city's beautification and was distributed to the schools), and Kate Buckingham's 1925 gift of the "world's greatest fountain," which sits in Grant Park, all were part of early twentieth-century Chicago's efforts at achieving cultural distinction and obtaining aesthetic respect, attributes slow to come to a place widely derided for its dirt, materialism, and crime. Local boosters were continually at war with this image.

For much of its history, the Art Institute had played a central role in Chicago's pursuit of civic reputation, and indeed served as a broader stand-in for midwestern cultural claims. "In the aesthetic awakening of America, the founding of art museums by the people is unique in history and potent for culture of the masses," ran a typical newspaper claim in the early 1920s. "Art Institute Chicago's Real Melting Pot," crowed the *Chicago Tribune* in 1920. "Who goes to the Art Institute?" it asked. "Everybody," responded Trustee Frank Logan, "from the poor man to the plutocrat."[6] For decades its massive membership, clear popularity (the best-attended art museum in America, through the early 1920s), central location, and extensive community involvement formed a source of local pride.[7]

Membership dues were kept constant for a very long time, in a deliberate effort to cultivate a broader base; a series of clubs, associations, and social organizations, some of them with only the faintest claim to art connections, met regularly in the museum's rooms. Yet the tension between the desire for popularity and democratic service and the urge to improve and refine public taste continued to be expressed in a number of ways. In 1890 a group of trustees, led by Charles Hutchinson, put

together a purchase fund and secured a group of paintings from one of the Demidoff princes living in Italy. Its most beloved work, *Young Woman at an Open Half-Door*, then believed to be by Rembrandt van Rijn, is now thought to be by a follower. In 1906, however, the trustees acquired, with significant donor help, an unqualified masterpiece, El Greco's *Assumption of the Virgin* (FIG. 4), hailed at various moments as the museum's most valuable single work of art. The addition was an adventurous step, for El Greco had not yet entered the American museum canon; the altarpiece was probably the first great example by this artist to become part of a public collection. Respected and admired as it was, and much reproduced, it failed to excite widespread devotion, despite periodic efforts to demonstrate its value and significance.[8]

If there was an icon in the Art Institute, it was not the expensive and well-regarded *Assumption* but rather Jules Breton's *Song of the Lark* (see FIG. 8), which had hung in the museum since the end of the World's Columbian Exposition. Its fame was assured by Willa Cather; this nineteenth-century painting had inspired her to give the same title to her 1915 novel. As we shall see, the public's love for this romanticized image of a young fieldworker was neither a passing fancy nor a local perversity. During the 1920s, several art critics complained about the corrupting impact of popular icons like the canvas by Breton. "It is impossible to estimate how different America's idea of art might be," a 1927 issue of *Art News* quoted critic Walter Pach as saying, if the Metropolitan Museum of Art had excluded from its walls Emanuel Leutze's *Washington Crossing the Delaware*, Rosa Bonheur's *Horse Fair*, or Ernst Meissonier's *Friedland*. Crowds might have been smaller, he admitted, but they would have learned more.

> Such pictures have, in the main, done nothing but harm.... The authority which the bad pictures gave to venal or ignorant artists ... and the pressure brought to bear on the minds of the vast majority ... make up a thousand times for any good they may have done in attracting visitors.[9]

Even while critical complaints proliferated, museums such as the Art Institute had become decidedly more selective. The trustee minute books during this decade reveal a series of refusals, particularly of reproductions and replicas, even when offered by important patrons. In January 1925, the Committee on Painting and Sculpture declared to Trustee Wallace DeWolf that lack of gallery space forced them to refuse his offer of Old Master copies, and they could not accept, without staff inspection and approval, a portrait of himself to hang in the gallery he had funded. They also turned down the purchase of a replica of Benjamin West's celebrated *Death of General Wolfe*, and, a few months later, the gift of a Max Pam head of Benito Mussolini. They rejected Lorado Taft's suggestion, however, that the museum deaccession its plaster casts and donate them to a proposed structure in Jackson Park modeled after the Trocadéro in Paris, which then, as now, houses similar material.[10]

It was during the 1920s that the Art Institute, like other American art museums—but far more intensively—received as gifts or legacies some of its most dazzling (and popular) works of art. Beginning with the Potter Palmer bequest of 1922 (which included unparalleled Impressionist gems acquired in the late nineteenth century by Bertha Honoré Palmer), and continuing with the Deering bequest, the Munger Collection, the Worcester Collection, and the pictures of Mrs. L. L. Coburn, the period climaxed in 1933 with the formal presentation of the single most important gift in the museum's history: the Mr. and Mrs. Martin A. Ryerson Collection. In the space of little more than ten years, the Art Institute's holdings were definitively transformed and its character as an art repository fixed. Old Masters and nineteenth-century works alike included popular favorites that no art critic would need to apologize for or agonize over. In their report for the year 1927, the trustees declared that they were not content to administer

> an accretionary museum which . . . seems to move forward under its own power, gaining somewhat in impetus and girth, but wabbling perhaps from time to time in direction. They feel that they should plan not for today nor tomorrow, but for the titanic city which inevitably will arise at the southern tip of Lake Michigan.[11]

After only thirty-some years in the 1893 building, they felt the need for still more dramatic expansion.

During the early 1920s, the Art Institute benefited as well from the provocative idea of a new kind of patron: Joseph A. Winterbotham.[12] Presenting the Art Institute with a $50,000 gift, Winterbotham dedicated its interest toward the purchase of European paintings, with a limit of thirty-five works. Once that number was reached (twenty-five years later, in 1946), individual works of art could be sold or exchanged for better examples. No language in the gift required that the art be modernist, but Art Institute staff and the Winterbotham family were sympathetic to this cause, and the first purchase with the fund was a painting by Matisse, executed just two years before. There followed, over the next ten years, acquisitions of examples by Gauguin, Toulouse-Lautrec, and Braque, along with lesser works that were eventually withdrawn, exchanged, or sold. What the Winterbotham Fund did, aside from assuring the Art Institute a steady supply of important twentieth-century art, was create a living collection that assumed no final judgments and admitted the fallibility of even the most expert taste. This eased the air of inflexibility about entry to a museum collection and gave curators the opportunity for second and third chances. It was an appealing notion, and in one form or another it paralleled or influenced other patron strategies at about the same time, including, for example, the Preston Harrison gift to the Los Angeles County Museum and in Chicago the plan that would be developed by Art Institute Trustee Frederic Clay Bartlett (see Druick and Groom, pp. 13, 15).[13] It meant that the Art Institute could exploit a dual approach,

receiving time-tested masterpieces from collectors, and applying a more innovative strategy for acquiring recent art.

In the midst of this transformation and wholesale absorption of significant paintings, Bartlett made his great gesture, and *La Grande Jatte* arrived as part of the Helen Birch Bartlett Memorial Collection. The Seurat painting joined a newly crowded field of distinguished artworks at a moment of high interest in recent European art. But few could have imagined in 1924, when the painting was first exhibited at the Art Institute, that it would outdistance all its immediate competitors in celebrity and popular adulation. To begin to understand why requires a more detailed examination of the picture's institutional life.

Just how did *La Grande Jatte* get to Chicago? By 1924, when the Bartletts (see Druick and Groom, FIG. 1) bought it, *La Grande Jatte* was already a celebrated canvas, generally considered Seurat's masterpiece. Given the painter's short career and the importance of the painting for European artists and critics in the late nineteenth and early twentieth centuries, it was clearly a prize. Bartlett and his wife, Helen, had earlier attempted to purchase Seurat's *Circus* (CH. 5, FIG. 13), but were beaten out in this effort by the New York collector John Quinn. The loss evidently made them all the more eager to obtain another example by the artist. Bartlett seems to have known the smaller version of *La Grande Jatte* now in the Metropolitan Museum of Art, New York, then owned by New

York collector Adolph Lewisohn and earlier exhibited in Chicago. The reasons why Bartlett pursued the monumental painting so intensely are examined here by Douglas W. Druick and Gloria Groom.

In fact *La Grande Jatte* had been the object of collectors' attention for some time. Other possible purchasers included, years earlier, the Metropolitan Museum and, a bit later, the English economist John Maynard Keynes. He claimed in a 1935 letter to Art Institute Director Daniel Catton Rich to have "all but bought" *La Grande Jatte* when it was "still in the hands of [the artist's] family." A letter eighteen years later from English art critic Quentin Bell supports the account, recalling that a group of friends had tried to persuade Keynes to make the purchase. But the fact that the economist believed that Seurat's family still had the picture, when, in fact, it was then owned by Lucie Bru Cousturier, casts some doubt on his recollections.[14]

Despite the otherwise well-documented history of Bartlett's acquisitions, the actual purchase remains somewhat mysterious.[15] In the early 1930s, while Bartlett was still active, several stories circulated in the national press. In one, versions of which survive largely unscathed to the present, a prominent local art critic, Eleanor Jewett, spun a fairly elaborate tale.[16] Beginning with the dramatic rise in *La Grande Jatte*'s value, Jewett went into uncommon detail. She had the Bartletts eating in a Parisian tea shop and being shown the picture by its female proprietor. Fascinated, they determined to buy it, but their offers were refused. A series of unsuccessful visits followed until, hearing that the woman needed

money to take her ailing son to the south of France (another version of the story has her wishing to create a personal pension fund on which to retire), they returned and determined to raise the necessary money. "Five o'clock in the morning saw Mr. Bartlett at the tea shop," and after considerable haggling and the handing over of $20,000, *La Grande Jatte* was theirs. A "romantic story," Eleanor Jewett admitted, but one that contained some plausible particulars, along with some obvious errors (writing in 1930, she had the purchase take place ten years earlier). At any rate, it was destined to survive.[17]

Whatever the encounter, by June 1924 Bartlett was bound for home on the SS *Homeric*. In a recently recovered letter (see Druick and Groom, FIG. 2), he excitedly related to Art Institute Director Robert Harshe his happy news, the purchase— "almost by a miracle"—of "what is considered to be almost the finest modern picture in France." Bartlett could barely control himself: "11 x 7 feet and every inch of it is *superb*." Not only that, it was larger than the artist's *Bathing Place, Asnières*, which the Courtauld Fund trustees had just purchased for the Tate Gallery, London.[18] Thus, *La Grande Jatte* did not arrive obscure and unheralded in Chicago, although legend has it that some Art Institute trustees greeted it with skepticism. Roger Fry, writing on Seurat in 1926 for the *Dial*, commented that the purchase indicated Seurat was finally coming into his own, even though he argued ("against the widely expressed opinion of my fellow critics") that the Courtauld Fund's recently acquired *Bathing Place* was perhaps a greater

painting.[19] In 1928, writing for *Art and Archaeology*, Morton Dauwen Zabel declared *La Grande Jatte* "undoubtedly . . . Seurat's masterpiece, the one complete record of the method and viewpoint which he mastered so patiently during his short career."[20] The painting, moreover, was quickly sent to Minneapolis and Boston for brief exhibition appearances. And Bartlett himself—wealthy artist, collector, and part of a family with unusual influence upon American museum establishments—attracted his own attention.[21] For many he seemed to be the city's most adventurous collector since the late Arthur Jerome Eddy, the modernist champion who had purchased extensively from the 1913 Armory Show, which he had helped bring to Chicago.

Critics had been commenting, not always favorably, upon the Bartletts' paintings since they first appeared in the Art Institute in the fall of 1923. Seizing on a piece in the museum's newsletter which stated that Cézanne, Van Gogh, and Gauguin were often quarrelsome, Jewett observed that "no placid individual could evolve some of those peculiar compilations." "What kind of men are these?" she asked. "Brutal, primitive, childish—why should we wonder at the same strains underlying their pictures?"[22]

La Grande Jatte did not join the other Bartlett paintings until the following fall, when the collection was again displayed, for six or seven weeks. It never seemed to attract the irritated scorn that the collection's other Postimpressionist art did. In October 1924, as the short exhibition was ending, the Art Institute published its first official photograph—a black-and-white shot taking up one-third

FIG. 5

Crowds on the Art Institute's Grand Staircase during the *Century of Progress Exhibition of Painting and Sculpture*, June 1933. The show ran from June 1 to November 1 of that year.

of a page—of the new acquisition in its *Bulletin*, noting it as one of several pictures that had been added to the Birch Bartlett Collection since its 1923 showing. The *Bulletin* introduced both the painter and the work to the members, describing the technique of pointillism for the uninitiated and further arguing that few of Seurat's followers "commanded the grasp of the third dimension and the organization of design" that he possessed. This talent differentiated his larger works from the broader pointillist oeuvre.[23]

In the fall of 1925, the Birch Bartlett pictures returned for showing in the galleries one last time before the gift became final, in January 1926. The October 1925 *Bulletin* again returned to *La Grande Jatte*, which dominates the illustrations included of works in the collection, and refers to it as Seurat's "masterpiece among the paintings he has left to the world."[24] After the announcement of the memorial gift (Bartlett dedicated it to his second wife, Helen, who died in 1925), the *Bulletin* again presented members with a photograph of the painting, pointing to its added significance in light of the Musée du Louvre's recent acceptance of *Circus* (see CH. 5, FIG. 13) as a gift from the late John Quinn.[25] The fact that the museum had agreed to hang a work by Seurat gave *La Grande Jatte* new importance and, more significantly for the public, new monetary value. Bartlett, himself, in a letter to his fellow trustees, boasted that the Louvre's decision had increased the painting's worth to at least double the $20,000 he had paid. Noting the Winterbotham, Potter Palmer, and Ryerson gifts, Bartlett went on to

observe, "We can justly feel that we have a stronger collection of modern art along these lines than any other museum." He added, "Our thought has been that Chicago, the most forward-looking and advancing of all cities, should have an adequate expression of modern art."[26] In letters later that year, Bartlett modified his gift somewhat, choosing to make the Birch Bartlett group a small selection of "paintings of proven merit" rather than a representative sampling of recent art.[27] Support for modernism at the Art Institute was, he argued, so great that it might tip the whole collection unduly in that direction. The quality and integrity of his own donation—which he wished to have installed separately within the museum—took on increasing importance, as local newspapers noticed. The *Chicago Tribune* ran a reproduction of "Sunday Afternoon on the Grand Jetty," with the caption observing that the Helen Birch Bartlett Memorial Collection took up a special room, and declaring, "Another Work by the Noted Modernist, Was Recently Accepted by the Louvre, Famous Gallery in Paris."[28]

By 1930 Bartlett's spirits were buoyed even more by an offer of $400,000 he claimed to have received from the French government for *La Grande Jatte*. The museum's trustees, following Bartlett's advice, refused the offer.[29] The story, however, was quickly released to the press, and became part of *La Grande Jatte*'s growing reputation as a work of phenomenal value whose presence in Chicago, as indicated by French desires to get it back, represented a real coup.

Not everyone greeted the Birch Bartlett pictures with unalloyed enthusiasm, although criticism, compared with the onslaught of negativity with which Chicago had received the famed Armory Show just over a decade earlier, was muted. The city had changed. While the Chicago collector Eddy (whose avant-garde collection the museum exhibited, in a posthumous tribute, in 1922) was a misunderstood pioneer in the 1910s, Bartlett's ambitions, however estimable, seemed less audacious by the mid-1920s to Marguerite B. Williams. Writing for the *Chicago Daily News*, she argued that the modernist cause had triumphed and had become "the vogue with the elite of America." In her vague and somewhat curious response to the 1925 showing of the Bartlett pictures, Williams declared the collection "fragmentary." The artists it included had apparently moved too far for her into either color or form. The most "complete" pictures for this writer were landscapes by Derain and Hodler, although she allowed that Seurat and Gauguin came close to harmonizing "spontaneity" and "balance." Again, the Seurat escaped any Chicago hostility. In the same column, Williams also reported that the 1925 International Exposition of Modern Decorative and Industrial Art in Paris, celebrated today as an engine for Art Deco enthusiasm, was generally regarded as a failure, and quoted Art Institute officials who called it "stupid" and a "hodgepodge."[30] Assessment and evaluation among critics and museum officials were far from foolproof.

Once installed, *La Grande Jatte* and the rest of the Birch Bartlett pictures settled into an

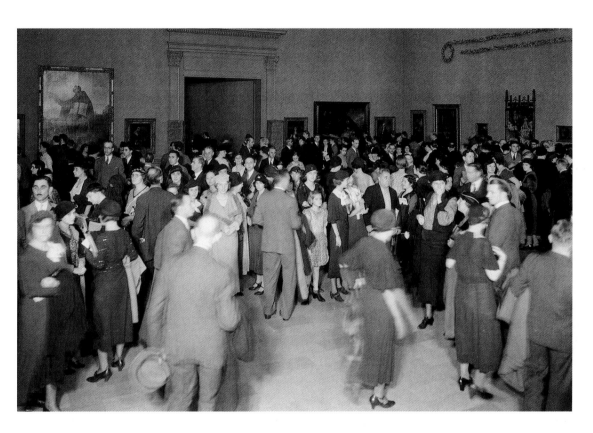

institutional routine. Part of the Art Institute's impressive holdings of nineteenth- and early twentieth-century art, they were visited regularly, but without garnering much special notice. In 1930 the museum produced its first color postcard of *La Grande Jatte*, and from then on there was probably never a time when a reproduction of the picture could not be easily purchased. Nevertheless, these were relatively peaceful years for the painting, quietly retaining its position as one of the Art Institute's important works, but hardly preeminent.

The significance of *La Grande Jatte* was reasserted, however, when its location in the museum changed in 1933, the year that the Art Institute hosted what was probably the most celebrated and certainly best-attended exhibition in its history.[31] The Century of Progress Exposition took place a mile or so south of the museum, on the lakefront; instead of the fair staging its own art show, as had the White City of 1893, the Art Institute determined to fill the need itself. While the museum presented a much smaller group of artworks than the Art Palace of 1893 had done—one-sixth the number of paintings and one-tenth the amount of sculpture, according to the *American Magazine of Art*—it nonetheless attracted enormous throngs.[32] In the 163 days that the art was on view, an estimated 1.6 million visitors crowded the museum (see FIGS. 5–6). More than seven hundred thousand paid the twenty-five-cent fee to enter; the exhibition occupied twenty-eight galleries, taking up the entire second floor. On certain days, thousands were turned away. The average

time spent at the show was calculated at two and one-half hours, an unusually lengthy stay in an art exhibition. Estimates from the final, frantic week, improbable as they may seem today, assert that between thirty and forty thousand people entered the building daily, and police had to supervise the lines outside. In 1933 overall, the Art Institute claimed an attendance of more than two million, doubling its usual figure.

The show's theme was, in effect, A Century of Progress for American Collecting, and the evidence it presented for a massive shift of art housed in North America, and not in Europe, proved compelling. On display was an unparalleled assemblage, the holdings of museums and private collectors from all over the United States, with the exception of one work—Whistler's iconic 1871 portrait of his mother (see FIG. 7)—lent by the Louvre. The museum's administrators decided to move *La Grande Jatte* out of its accustomed place in the Birch Bartlett gallery, in order to juxtapose it with contemporaneous works (see Druick and Groom, FIG. 5).[33]

Indeed, in a revised direction for the Art Institute, after the fair closed museum officials reorganized the entire painting collection. The new arrangement no longer reflected the donors. Instead, the galleries indicated a sequence of historical schools.

The only patron still honored in the old way was Bartlett, for, although he understood that his collection might not always remain in a single setting, he believed his works looked best together (see Druick and Groom, p. 17). His attitude, wrote historian Stefan Germer, emblemized "an approach that regarded art as autonomous and understood its development principally in formal terms."[34] Such a view lay behind Bartlett's insistence that the room featuring his collection be stripped of all decoration and the paintings placed within plain, white frames (see Druick and Groom, FIG. 4). He even turned his attention to other galleries, urging successfully for the removal of the Tiffany screen that had enhanced the elaborately installed Henry Field Collection. The museum administration acquiesced here, considering individually decorated galleries to be obstacles in the path of a uniform system of professionally governed installation. But the larger goal of organizing the collection along broad historical lines, thus obscuring the provenance of the art and the specific aesthetic criteria of individual collectors, reflected tension between Bartlett and the curators, which the 1933 fair exposed.[35]

Since the fair exhibition included masterpieces from institutions and collectors throughout the country, it may not have been reasonable to expect *La Grande Jatte* to hold a position of absolute dominance. And by all accounts, it did not, although Director Harshe placed it on his top-ten list, along with Rembrandt's *Aristotle Contemplating a Bust of Homer* (1653; now Metropolitan Museum of Art, New York), a Vermeer, and a Titian. Dudley Crafts Watson (see FIG. 7), a popular art lecturer and member of the museum's Education Department, declared that three paintings were asked for repeatedly: Whistler's portrait of his mother, Titian's *Venus and Lute Player* (1565/70; now Metropolitan Museum of Art, New York) and Duchamp's famed icon from the 1913 Armory Show, *Nude Descending a Staircase* (1912; now Philadelphia Museum of Art). Watson, unlike Harshe, did not mention Seurat.[36]

C. J. Bulliet, art critic for the *Chicago Daily News* (and the local journalist most friendly to

modernism), acknowledged the immense popularity of Whistler's painting—the subject of consuming press attention during its American stay—by treating it in the first of a series of daily articles. *La Grande Jatte* was number twenty (of a total of fifty-nine) in a popular book Bulliet published after the fair closed, *Art Masterpieces in a Century of Progress Fine Arts Exhibition at The Art Institute of Chicago*. In his brief text on the painting, the critic declared *La Grande Jatte* the pride of the Helen Birch Bartlett Memorial Collection, and spent some time detailing its rising monetary value. Bulliet allowed that it had cost "a lot less than has been paid in Chicago for some pretty stupid stuff." He also went on to highlight what he stated to be a $500,000 offer made in the 1930s by an official French syndicate, "hard up as is the French government," eager to see the painting placed in the Louvre. But the "even harder up Art Institute won't sell!" Bulliet's brief essay was about reputation. While all of Seurat's great paintings were "masterly," Bulliet acknowledged, *La Grande Jatte* was "the masterpiece.... This is the 'consensus of opinion.'"[37] In effect he rested his case on the authority of its soaring cash value and the opinions of experts.

Once the fair closed, *La Grande Jatte* returned to its accustomed place among the Birch Bartlett paintings. But in 1934, the Art Institute determined to repeat the triumph of the previous year in a new loan exhibition. Again combining its own collections with works borrowed from major institutions and private collectors, it now featured American paintings far more extensively. This was in response to

criticism that the Century of Progress show had been a testament to francophilic taste and modernist prejudices. French modernists and Old Masters were by no means absent in the 1934 version—indeed grumbles about Gallic domination continued—but Harshe went out of his way to secure a significant number of important American pieces, and special attention was paid to Whistler in this, the year of his centenary.

Unlike the 1933 event, in which the portrait of Whistler's mother reigned supreme, the 1934 display had no single dominating canvas.[38] But it did have a controversy, revealing continuing strain between the Art Institute and some of its constituencies. Shortly before the first loan show in 1933, Harshe had quietly removed from view Breton's *Song of the Lark*. He considered it sentimental and unimpressive, a reminder of taste that had been outgrown. People "would not expect the conductor of a great orchestra to include 'Swanee River' in his symphony programs at frequent intervals just because it is a favorite song with sentimental appeal," Harshe told a reporter.[39]

For a time, apparently, no one noticed the work's absence. But by the spring of 1934, mutterings began to surface, led by a emphatically indignant *Chicago Daily News*. Adopting retrieval of the canvas as a sacred cause, the newspaper almost single-handedly forced the return of the painting to public consciousness, and onto the museum's walls.[40] It announced a contest to select the "most popular picture in America," which the Art Institute reluctantly agreed to cosponsor. Harshe nominated

five paintings, by Giovanni Bellini, Titian, Brueghel the Elder, El Greco, and Rembrandt. The *Chicago Daily News* proposed a somewhat different group, among them Bonheur's *Horse Fair*, Leutze's *Washington Crossing the Delaware*, and, not surprisingly, *The Song of the Lark*. Harshe's suggestion of El Greco's *View of Toledo* also made the newspaper's list, along with a sleeper, Stanislaw Batowski's 1933 *Pulaski in Battle at Savannah* (today in the Polish Museum of America, Chicago).[41] Nominated by a group of Polish Chicagoans, this work made the final cut by appealing to ethnic loyalties among the voters. In the end, *The Song of the Lark* won overwhelmingly; it was unveiled by Eleanor Roosevelt, who visited the show in the early summer of 1934 as guest of Art Institute President Chauncey McCormick (see FIG. 8).[42]

A cross between an event and a pseudo-event, the *Lark* debate, along with the furious letters it provoked and the editorials penned across the country, suggests that, if any one painting was associated with the Art Institute at this time, it was not *La Grande Jatte*, and also demonstrates that sentimental, narrative pictures, however disliked by curators and connoisseurs, still had a place in the permanent collection. It was, in a sense, a revolt against professional authority. A number of commentators wondered aloud just whom the museum belonged to, and demanded that administrators listen more carefully to the voice of the public.[43] The Art Institute had reinserted El Greco's *Assumption* into the 1934 Century of Progress show, declaring it to be its single most valuable

and curator James Thrall Soby was impressed by the museum's liveliness and its French painting collection, calling Bartlett's purchase of *La Grande Jatte* "the most brilliant act of connoisseurship of our century."[44] Visitor responses such as this, filled with superlatives, appeared sporadically in the press during these years.

Increasingly, *La Grande Jatte* came to represent a great moment in the Art Institute's collecting history, one that would look more golden still as the years passed. After 1933 collections came to the museum at a slower pace than during the previous decade. Depression, war, and postwar recovery meant that the Art Institute had to put on hold ambitious building and expansion plans, after assiduously cultivating publicity for them. The representation of Impressionism and Postimpressionism, nonetheless, was strengthened by occasional gifts, and by the extended loan of the Chester Dale Collection starting in 1941, although it would eventually go to the National Gallery of Art, Washington, D.C.

While the general thrust of these additions may have reinforced the significance of *La Grande Jatte* as the crown jewel in an ever-increasing collection of nineteenth- and early twentieth-century French art, perhaps more significant for the picture's status was the growing influence of the museum's associate curator of painting and sculpture, Daniel Catton Rich (see FIG. 11). Rich had played a key role in organizing the two World's Fair loan exhibitions (although Harshe got the credit, receiving medals and honorary degrees); even more significantly, his special area was modern French art. In

1935 Rich produced *Seurat and the Evolution of "La Grande Jatte,"* the first monograph devoted to the painting. Published by the University of Chicago Press, it was hardly a bestseller, but it revealed the continuing scholarly life of the masterpiece, setting off debates among specialists, and creating still another venue for reproductions. In his introduction, Rich invoked a small group of indisputable masterpieces—Delacroix's *Massacre of Chios*, Courbet's *Burial at Ornans*, and Cézanne's *Card Players* among them—that challenged the Old Masters while proclaiming the future. "To this limited company," he went on, belongs "*La Grande Jatte*."[45] Rich's study appeared three years before he assumed the directorship of the Art Institute, upon the death of Harshe (to whom he dedicated the book). It also prepared the way for Rich to organize an epochal exhibition of the art of Seurat almost a quarter of a century later.

During the 1930s, 1940s, and into the early 1950s, *La Grande Jatte* continued to hold a place of honor in the Art Institute collections; it was visited by celebrities changing trains in Chicago and making the ritualistic stop at the Art Institute in search of photographic publicity (see FIG. 10). But it was only one of a number of art works so honored. And there were some surprises. In 1941, when *Life* magazine ran an elaborate story on the museum, reproducing thirteen paintings (including the El Greco and a number of French Impressionist pieces), *La Grande Jatte* was not even mentioned, much less illustrated.[46] In December 1955, when Frederic Clay Bartlett, Jr., the son of the patron, died in

possession, but many Chicagoans failed to recognize it as their own, or identify it with the museum.

By the time the 1934 loan exhibition ended, *La Grande Jatte* had been on permanent display at the Art Institute for nearly nine years; over the next quarter century, it would continue to attract the attention of faithful visitors and fascinated scholars. Upon visiting the Art Institute in 1952, the author

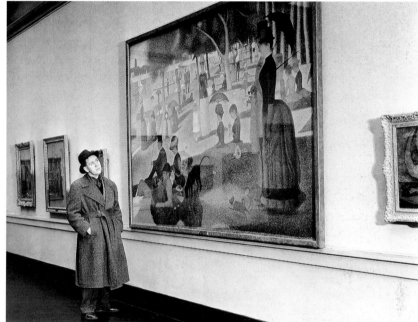

New York City, a *Chicago Sun-Times* obituary observed that his father was a noted artist and architect, and "donated a collection of some 20 paintings to the Art Institute."[47] That was all. No Seurat. No *Grande Jatte*.

And there were also some new challengers to the primacy of the Seurat. Almost from the moment that Grant Wood's *American Gothic* (FIG. 9) entered the Art Institute in 1930, it was the subject of consuming interest. This image of austere Iowa farmers was seized upon by admirers and detractors alike as evidence of something fundamental in contemporary American art, and other institutions were soon clamoring for its loan. Wood's *Daughters*

of Revolution, on display at the 1934 loan exhibition, was soon receiving brickbats and accolades as well, and if postcard sales were any indication, it could well have been the most popular picture in the exhibition.[48] Certainly, it added to the celebrity of *American Gothic*, which became a permanent rival to *La Grande Jatte* as an identifying symbol for the Art Institute. However, its critical status as a landmark in modern art history could not really compete with that of *La Grande Jatte*. For some, the celebrity of Wood's painting seemed a continuation, albeit in a different vocabulary, of visitors' delight in *The Song of the Lark*. But unlike the image by Breton, the broad popularity of *American*

Gothic endures to the present day, although its critical status does not compare with that of Seurat's composition.

Public interest in and enthusiasm for *La Grande Jatte* nonetheless remained evident, and institutional promotion continued. In 1951, addressing a luncheon at the Union League Club and defending the Art Institute's long history of support for modernism (and justifying it, in part, by its rising market value), Rich featured the Birch Bartlett Collection, singling out *La Grande Jatte*: "Mr. Bartlett had acquired this mural-like picture in 1923 at a sum of about $22,000. In 1930 the trustees were offered $400,000 for it by a syndicate of French

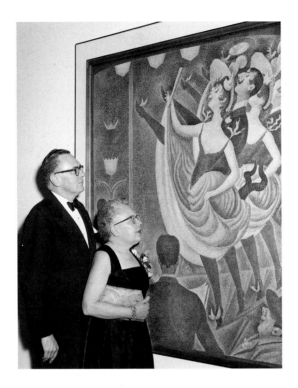

dealers."[49] Just one month earlier, in the first of a series the *Chicago Tribune* printed describing "places of unique interest, beauty, and importance in Chicago," a large photograph shows Rich seated before "Sunday Afternoon on Big Bowl Island." The caption refers to the canvas as one of the Art Institute's "most valuable paintings," and the accompanying feature, on the museum and its "150 million dollar" collection, pays special tribute to the painting, citing several incorrect facts (according to the article, it had cost the Bartletts $21,000, and the French offered $459,000 for it in 1937). "Today, institute officials estimate it would bring three

times that, but it is not for sale."[50] This article was part of the promotional effort supporting the coming retrospective exhibition devoted to Seurat, an exhibition that would, in terms of publicity and adventure, open a new chapter in the public life of *La Grande Jatte*.

Plans for the 1958 Seurat retrospective had a lengthy history, given Rich's long-standing interest in the artist. Depression and war limited possibilities after his book appeared, but in 1949 Rich, assuming that an exhibition would soon be mounted in Chicago in conjunction with the Museum of Modern Art, obtained Bartlett's permission to send *La Grande Jatte* to New York, allowing the picture to leave the Art Institute just this once.[51] Without this permission, Rich declared, the very idea of such an undertaking was impossible. The exhibition would open in Chicago in late 1951, followed by the New York showing in January or February 1952. For various reasons, costs principal among them, several years elapsed without further action, although in early 1955 letters between the Art Institute and the Museum of Modern Art discuss the spring of 1956 or possibly 1957 as the target date. Finally, by the fall of 1955, scheduling details were basically agreed upon, and the opening date of early 1958 established.

The complex and sometimes tortuous negotiations with a series of other institutions and private collectors to bring together sketches, watercolors, and large oil paintings from many sources were by no means unique to this exhibition. But rarely has a retrospective been so dominated by a single can-

vas. While Rich and the Art Institute had achieved a coup in obtaining *Chahut* (see FIG. 11) from the Netherlands, *Circus* (CH. 5, FIG. 13) from the Louvre, and *Young Woman Powdering Herself* (CH. 5, FIG. 6) from the Courtauld Institute, *La Grande Jatte* constituted the indispensable centerpiece, and its reproduction accompanied practically every news article that previewed or described the show.[52] Chicagoans who had never seen or heard of the painting, but who read newspapers with any regularity, could not miss the extensive coverage. And Art Institute members who perused the museum's *Quarterly* magazine learned from the director that the canvas had "gradually been recognized as not only one of the few paintings of the nineteenth century which in scope and originality can challenge the masterpieces of the past but as a turning point in modern art, reaching out and influencing many of the movements of our own day."[53]

Fresh on the heels of a spectacular and highly successful show of works by Picasso in honor of his seventy-fifth birthday, and amid extensive renovations and building plans, the Art Institute pulled out all the stops for the Seurat exhibition. Journalists and art critics peppered the public with biographical summaries of Seurat's life, explanations of pointillism, and summaries of *La Grande Jatte*'s Art Institute history and increasing value. In the *Chicago Tribune*, Edith Weigle promised those bewildered by the Picasso show that they would enjoy Seurat; his exhibition "no more needs explaining than the moonrise in the eastern sky.... Seurat painted nature and men and women as he saw them; and

FIG. 12
La Grande Jatte on view in the
Art Institute's Gunsaulus Hall
during the Seurat retrospective
exhibition, 1958. To the right
of the doorway is *Landscape,
Island of La Grande Jatte*
(CAT. 60, p. 80) and through
the doorway is *Chahut* (CH. 5,
FIG. 12).

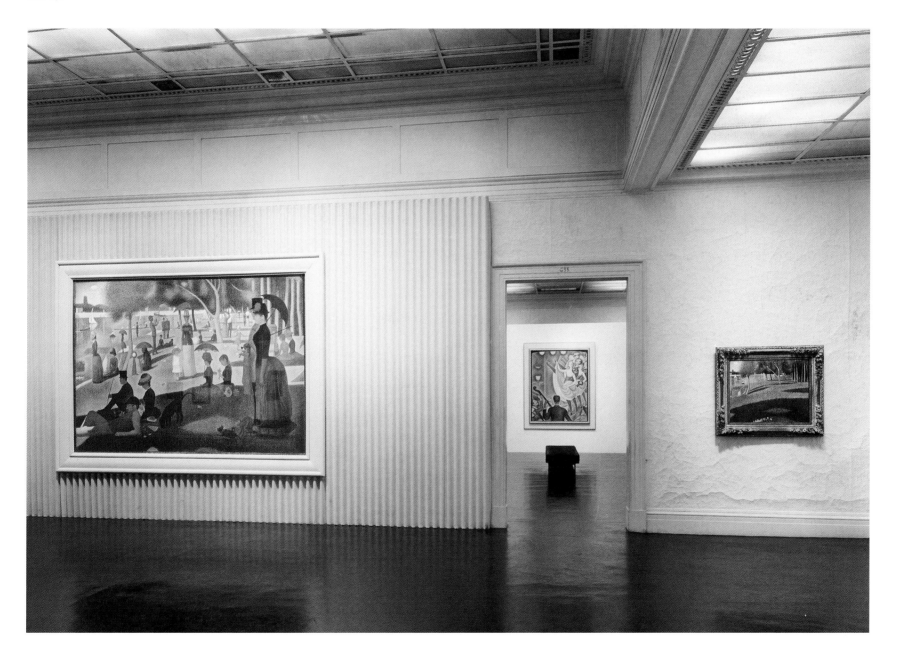

he saw them whole."[54] Occupying center stage in the main gallery of the exhibition (see FIG. 12), the painting stimulated admiration and local pride. "Chicago owns the champion!" commented one Wheaton housewife, approvingly quoted in the *Chicago Sun-Times*. "Would you pay a million dollars for a painting?" asked the *Chicago Daily News*, running a full-page reproduction with a headline that inquires: "Art Institute's Most Valuable Painting?"[55]

A string of fashionable parties at Chicago clubs and a set of dinner parties throughout the city preceded the January opening, along with some faint anticipations of the marketing methods prevalent today. The Art Institute's food director chose a special French menu, and newspapers recommended it to visitors who wanted to "get in the mood for this exhibit, gastronomically."[56] Polka-dot balloons decorated the opening dinner in homage to pointillism. Three actors from the Goodman Theatre posed among the paintings on display, wearing modern hats. This was for contrast rather than continuity: "The derbies and stovepipes sported by 19th Century Parisian dandies in Seurat's works are a far cry from the trim shapes in style for 1958 Chicago."[57] Innocent as they appear, in comparison with their successors, these promotional ploys were the seeds of an aggressive museum merchandising program that would flower in the following decade.

Beneficiary of glowing reviews and high attendance, the Seurat show, along with *La Grande Jatte*, moved to the second act of this drama, which turned out to be more momentous than the first.

Chicagoans grudgingly acknowledged their subsidiary cultural status in relation to New York, although not without occasional rancorous protest. The brain and talent drain to the East had been steady since the late nineteenth century, and while there were occasional victories for the Midwest's unofficial capital (like the 1893 Exposition) and occasional defining moments, such as the so-called

Chicago Renaissance of the 1910s and 1920s, New York critics, newspapers, and institutions more generally made or broke Windy City reputations. Now Chicago's most celebrated work of art was traveling to Gotham. Its stay was destined to be brief, but sensational.

Once Chicago closed the retrospective, *La Grande Jatte* was carefully packed up for the

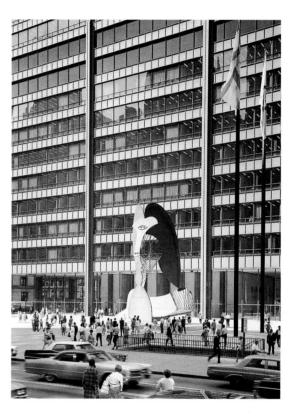

FIG. 14
Pablo Picasso (Spanish, 1882–1971). *Head of a Woman*, 1967, in Daley Plaza, Chicago.

journey. The Art Institute fed the press details about the remarkable care being exercised, and lavished on the canvas's trip to New York the attention normally given the travels of a head of state. The glass and frame were removed and shipped separately, while the crate containing the painting was one hundred six inches high, nineteen inches higher than the canvas. The general manager of Railway Express in Chicago reported that only two cars in the country had doors high enough to admit the box. Erie Number 2 left Chicago on March 17 at 6:10 p.m. *La Grande Jatte* was accompanied by the museum's conservator, Louis Pomerantz; in addition the train carried an armed guard. All arrived safely in Hoboken, N.J., just before 7 p.m. the next day.

The Art Institute carried a special insurance policy of one million dollars for the picture, so it was natural that the *New York Times* used the figure when describing its arrival and the elaborate precautions taken against theft or damage.[58] Accompanied by a detective, Museum of Modern Art officials supervised its transfer to a specially insulated truck, and had police escort it to the museum. Once there it was eased out of its crate and shifted to a dolly. Both motion-picture and still cameras recorded every step, in order to determine if and when any damage occurred. As *La Grande Jatte* was uncrated and removed from a special protective rubber rim, all nearby were required to remove their shoes, to guard against stirring dust that might settle on the unvarnished picture. Reframed and reglazed, the pride of the Art Institute awaited its New York viewers and reviewers.

The Museum of Modern Art was thronged with visitors in March, many of them excited and informed by stories run in the national news magazines, which treated the exhibition (and the journey of *La Grande Jatte*) as a significant event. "At last" a major show, exclaimed *Time* in a lengthy story on Seurat and his color theory, weeks before the exhibition opened in New York.[59] Labeling Seurat one of the "fathers" of modern painting, Frank Getlein declared in the *New Republic* that anyone with an interest in him had "better catch the show [in New York], because it is extremely unlikely that anything remotely resembling it will ever appear again." *La Grande Jatte* was making its last excursion from Chicago; after it returned, Getlein warned, "It's . . . to stay."[60] Everything seemed in place for an unqualified triumph. And then, on Tuesday, April 15, midway through the exhibition's run, disaster struck. Workmen had been installing a new air-conditioning system on the second floor— something that had concerned the museum's registrar months earlier when arrangements were being made—and combustible painting materials lay nearby. During a lunch break, a fire suddenly erupted and spread rapidly. While astonished shoppers and midtown workers gaped, firemen rushed to the scene, and staff members began carrying out imperiled works of art (see FIG. 13), taking them immediately to the Whitney Museum of American Art, then located just across 53rd Street, or to an adjoining office building.[61]

There were casualties and severe losses. An electrician was killed, and dozens of firemen were injured (along with a few visitors). A number of works were damaged and some destroyed, most noteworthy among the latter an eighteen-foot-long Monet water lily canvas that the Modern had acquired just a few years earlier. Since most of the permanent collection had been removed from the second floor before the show, and because of prompt staff action, the impact was much less than it might have been.

The fire drew national and international attention, since the holdings of the Museum of Modern

FIG. 15

Act 1 of workshop production of Stephen Sondheim's musical *Sunday in the Park with George*.

FIG. 16

Cover of *Playbill, National Theatre Magazine* 2, 7 (Apr. 1984), for *Sunday in the Park with George*, music and lyrics by Stephen Sondheim, book by James Lapine.

Art were world famous. But in Chicago all eyes were on *La Grande Jatte*. Rich and Pomerantz grabbed the first plane to New York, and local newspapers featured the story (and photographs) on their front pages. "Chicago's million dollar painting, 'A Sunday Afternoon on the Island of the Grande Jatte,' escaped damage today when a hot smoky fire swept the second floor," was the way the *Tribune*'s article began. The *Sun-Times*'s headline read, "City Art Treasure Safe in New York Fire."[62] Chicagoans, after all, had special experience with the destructive capacities of fire. The Great Fire of 1871 was one of the formative events of its history, helping to shape the modern city. Now its most prized possession had been exposed to danger and emerged unscathed—another level of notoriety placed on an already venerated object.

In response to pleas from New York Governor Nelson Rockefeller and others, and after careful inspection (and approval from the insurance

companies), Art Institute officials agreed to allow all their loans, including *La Grande Jatte*, to remain in New York. After a two-week interruption, the Seurat show again went on view, drawing even larger crowds than before. Nervous Art Institute trustees ordered new examinations of their fire procedures, and vowed that *La Grande Jatte* would never again leave Chicago. Staff practiced emergency evacuations, and reexamined hanging methods. And in May, with precautions similar to those that had accompanied its March departure, the painting arrived safely home.[63] Like many a tourist, it had survived the perils of New York, with a colorful story to prove it.

With the great retrospective exhibition behind it, *La Grande Jatte* settled into its accustomed place in the Birch Bartlett gallery. But the following year was the one hundredth anniversary of the artist's birth. Celebrations of various kinds, some sponsored by the Art Institute, marked the event: a black-tie dinner dance, the "Sensational Seurat Soiree"; the display of a special collage autographed by the governor of Illinois and of a famous ballerina's pink ballet shoes, speckled "Pointillist-style"; and special exhibitions by local artists.

The Art Institute itself, however, was about to enter a more turbulent era. Weeks after the triumphant Seurat exhibition closed, and only months after the immense success of the Picasso retrospective, Rich, who had run the Art Institute for twenty years, announced his resignation and acceptance of the directorship of the Worcester Art Museum in Massachusetts. This news, greeted with stunned surprise and regret, had a special bite, because it coincided with a reprise of the high art/popular art controversy that had embroiled Rich's predecessor a quarter of a century earlier. Now it concerned the paintings of Winston Churchill. The Art Institute had refused to display the work of this famous amateur, infuriating the local press and some trustees, and touching off a lively public debate about the responsibilities of art museums. Rich denied that this contentious situation had anything to do with his departure, and there is evidence to support his claim.[64] Nonetheless, the coincidence, if coincidence it was, revealed that boundary disputes would continue to vex the administrations of American cultural institutions. *La Grande Jatte* was safely high art, but it demonstrated clearly that popular notoriety and critical adulation are not mutually exclusive. For that reason alone (along with many others), its possession proved an invaluable asset for the Art Institute.

Thirty-three years of institution-generated promotion, critical admiration, and, new, exciting experiences had given *La Grande Jatte* a special status. "Cleveland," sighed one tourist, "doesn't quite have things like this." "There it is!" cried a sixteen-year-old, on spotting it in Gallery 229.[65] It was big, it was modern, and it was enigmatic. It was a picture to be studied and argued about, making it a perfect teaching instrument for the Art Institute's ever-expanding educational programs. At just this time, during the 1960s, a visitor, John Pope-Hennessy, then director of the Victoria and Albert Museum, London, watched a group of students and teachers discussing "that most impenetrable of paintings, Seurat's 'Grande Jatte,'" and concluded that the Art Institute was "the most progressive museum" in existence, inviting children to walk about "inside the painting," and encouraging them to become active participants in the art experience.[66]

Big, modern, and enigmatic might also be appropriate adjectives for a new local rival, brought to Chicago in the summer of 1967. Only this was bigger, more modern, and still more puzzling. The 272,000-pound bronze head of a woman (or is it something else?) created by Picasso to adorn the Civic Center plaza was quite possibly the first major piece of frankly modern sculpture to adorn an American public space (FIG. 14). It initiated the Loop's monumental sculpture parade, and its unveiling touched off an active round of controversy and creative derision, recalling, in some of its details, the city's reception of the 1913 Armory Show. It soon settled in to become a popular

favorite, another icon whose features would evoke among millions the name of its host city. French modernism, albeit with a Spanish twist, had again invaded the heart of Chicago.

Such competition for public attention was, as we have seen, not new for *La Grande Jatte*. It had happened with Breton, and again with Wood, and now new favorites among the museum's visitors, such as Hopper's *Nighthawks* or Caillebotte's *Paris Street; Rainy Day*, both of which emerged as contenders for iconic primacy. But none of them possessed the complexity and distinction of Seurat's masterwork, and none received the lead in what may have been the first musical drama written about a modern work of art. In 1984 *La Grande Jatte* was about to enter still another chapter of its illustrious career.

As critics and historians have pointed out, using the stage as a vehicle to re-create well-known artworks was a firmly established tradition long before the twentieth century. In 1762 the Comédie Italienne in Paris featured a tableau representing a painting by Greuze that had recently been on exhibit at the Louvre. There were some other contemporaneous instances of tableau portrayals, although it was not until the following century that the custom became common and spread to America. By the 1830s and 1840s, wrote Jack McCullough, tableaux vivants inspired by famous paintings and sculpture "had become a familiar and popular entertainment form in the New York theatre."[67] The genre included versions of Leutze's *Washington Crossing the*

Delaware and Trumbull's *Death of Warren at the Battle of Bunker Hill* (1786; Yale University Art Gallery, New Haven).

In the twentieth century, festivals like Laguna Beach's annual Pageant of the Masters (started in 1932), were organized around living, if static, re-creations of art works. An occasional musical incorporated a tableau into its staging: for example, *1776* features Trumbull's *Signing of the Declaration of Independence* (1818; U.S. Capitol Rotunda, Washington, D.C.). The scale and detail of *La Grande Jatte* were suited to ambitious tableaux vivants (although Laguna Beach did not select it for inclusion until 1996). Impact depends on audience recognition; only pictures that are broadly known constitute possible subjects, and while *La Grande Jatte* had clearly achieved this position well before the 1980s, Laguna Beach waited on Broadway.[68]

But the tableau is only an incident in the 1984 musical created by Stephen Sondheim and his collaborator James Lapine (see FIGS. 15–16). It was not so much the painting itself as the painter, Seurat, the technique he developed, and his commitment to it and to art that concerned the authors.[69] In this they were true innovators, treating the painting as the basis of a much larger problem involving issues of sacrifice and human relations. As part of their work, Sondheim and Lapine visited Chicago and spent several days looking at the painting (it was Sondheim's first actual encounter with the original), talking with curators, and listening to visitor comments.[70] They absorbed the legends that had gathered about the picture and its acquisition and

turned their attention to exploring its social world. The show's star, Mandy Patinkin, also visited the Art Institute and took classes at the Art Students League in New York to better understand his role as Seurat.

Sondheim played with pointillist methods in both music and lyrics. Witty, probing, evocative, *Sunday in the Park with George* was compared by some admirers of Sondheim's work with Shakespearean plays like *The Tempest* and *Winter's Tale*; *New York Times* critic Frank Rich, its most prominent champion, called it "perhaps the first truly modernist work of musical theater that Broadway has produced."[71] In certain respects, then, the role of *Sunday in the Park* resembled that of *La Grande Jatte* itself, an inventive masterwork that straddled traditional form and future trends, a landmark for students of the genre. The musical ran on Broadway for more than six hundred performances between 1984 and 1985. While it was a mixed success in financial terms, and it received Tony Awards only for lighting and scenic design, it won a Pulitzer Prize for drama, and soon was entertaining audiences throughout the world.[72]

What *Sunday in the Park* does with its pictorial subject, then, differs fundamentally from traditional theatrical displays of artworks. Far more than a gesture to familiarity, or a shock of recognition, the play explores how the artist's social role and aesthetic function shaped one another. Its philosophical depth may have distinguished it from other commercial spectacles, but like many of them it enjoyed a lavish Broadway production and attendant national

publicity. At a minimum, it induced many who still, for whatever reason, remained unfamiliar with *La Grande Jatte* to become acquainted with its features and larger significance.[73]

In selecting their subject, Lapine and Sondheim obviously assumed broad public awareness of the painting. But theirs was, in retrospect, the first major non-institutional promotion on behalf of *La Grande Jatte*. Until then the stories, monetary

valuations, and foundation myths that swirled around the picture had been publicized primarily through the museum's own efforts. Coverage of its ordeal by fire was a news story shaped by the accident at the Museum of Modern Art, but the Art Institute, as soon as possible, took over its management. *Sunday in the Park with George* created a new identity and quite possibly a new public, who were now experiencing the original in much the

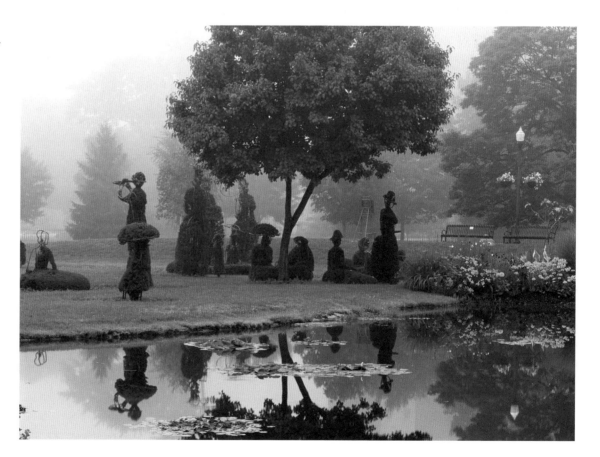

same way that tourists might visit a historic site, eager for rich associations. The fact that the picture resided uninterruptedly in Chicago added to the intensity of these encounters.

The painting attracted notice even in its absence. The retrospective of the artist's work in 1991, which commemorated the centennial of his death and took place at the Grand Palais in Paris and the Metropolitan Museum of Art, New York, conspicuously lacked several major works, most notably *La Grande Jatte*, which could not leave Chicago, given its centrality to the Art Institute's identity. It was, one journalist complained, like "attending a fancy dinner party at which there is no main course." While some saw such absence as a sign of the times—the result of high insurance premiums and fear of theft or damage—Françoise Cachin, cocurator of the exhibition, explained that the painting was "so important to Chicago" that the trustees could not permit it to leave for four months. "It is normal that museums become more

attached to the paintings that bring in the public," she went on, predicting that the era of the blockbuster had ended.[74]

Sondheim and Lapine had, along with others, so promoted the picture that even isolated details could be used as material for marketing and artistic purposes alike. The musical coincided with a period of museum merchandising unprecedented in its vigor, and with an era of masterpiece marketing and parody that was similarly astounding in its range, although it enjoyed lengthy precedents.

Advertisers have employed popular artworks since the late nineteenth century and the celebrated purchase by Pears Soap of Sir John Everett Millais's 1886 painting *Bubbles* for use in promoting its products. This was a controversial but successful exploitation, one that tried to capitalize on the painting itself, rather than to caricature or parody it (in effect critics of Pears Soap provided the caricatures).[75] There are other examples in the late nineteenth and early twentieth centuries, more in

Europe than America. In his exhaustive study *Becoming Mona Lisa*, Donald Sassoon argued that the 1911 theft of Leonardo's famous portrait increased its promotional value, and soon it was being used to advertise a French clothing store, Italian bottled water, hand cream, and in the United States, a corset. By the 1950s, the list of products the painting enhanced included oranges, cheese, cigars, chocolates, condoms, and matches, to cite a small number.[76]

Few if any paintings can match the *Mona Lisa* in universality of appeal, but the needs of advertisers dictated the use of well-known images for the benefits of broad recognition and at times for implicitly suggested endorsement. New federal legislation in the late nineteenth century restricted the use of presidential faces in product advertising—a growing practice—and early privacy law revolved around the unauthorized deployment of personal photographs. Then came a series of twentieth-century court cases that upheld the ownership rights of

comic-strip creators. Their characters—Mutt and Jeff, Alphonse and Gaston, Buster Brown, Barney Google among them—had been brandished by makers of shoes, toys, dolls, and other products.[77] During the 1930s, the Walt Disney Company began to realize large gains by franchising its characters to manufacturers and distributors.

In the mad scramble for profits, the few artworks that enjoyed widespread fame were swept aside by icons of mass culture. But in the years after World War II, the expansion of color photography, the growth of higher education, and an increase in museum visiting, along with an explosive market for collectibles and consumables, defined a new area for exploitation: the museum masterpiece.[78] Even in the nineteenth century, there had been complaints that extensive reproduction cheapened the impact of art encounters, but twentieth-century applications moved far beyond this. Museums were complicit in this strategy, with their budgets battered by inflation, physical renovation needs, and rising service

costs. Their responses, in the 1960s and 1970s, were multiple: cultivation of blockbuster exhibitions, lobbying (successfully) for more governmental aid, embarking on major fundraising campaigns, and undertaking a spate of strategic planning efforts that included the assertive merchandising of everything from food services and posters to franchised replicas of art objects. Expanded museum stores (and satellites) became simultaneously instruments of education, systems of orientation, and engines of economic growth.[79]

The combination of a taste for branded collectibles and museum needs was supplemented—indeed, validated—by new art forms that had at their center, not simply the appropriation of earlier artworks, but their transgressive incorporation. Pop Art and several other movements raised important questions about the boundaries separating art from various mass-produced objects.[80] Meanwhile, patterns of consumption and their cultural meaning were attracting their first extended histories. Art posters

and T-shirts multiplied, servicing purchasers who often employed them to provide a host of identity signifiers, from political ideology and gender definition to tourist experience and celebrity worship.[81]

Onto this fertile ground stepped a handful of museum art works, many of them already celebrated and extensively reproduced.[82] These became, in effect, mediated superstars, stamping their features on to a bewildering range of items, many distributed by museums themselves. Museum-store purchases could validate aesthetic commitment, but marketing was not confined to museums. Later, the internet would rapidly develop into a warehouse for these talismans of art and consumption.

Not unexpectedly, given its years of institutional promotion, critical debate, journalistic ballyhoo, and dramatic translation, *La Grande Jatte* emerged at the end of the process securely ensconced within this small and highly select group of world masterpieces. In the 1980s and 1990s, particularly, the painting became a source of visual quotation

FIG. 20

J. B. Handelsman (American).
Cover of the *New Yorker*
(June 18, 1990), combining
elements of *La Grande Jatte*
and Millet's *Gleaners* (1857;
Musée du Louvre, Paris).

that found its way, however improbably, onto a string of unrelated consumables, as well as inspiration for anyone seeking to marry the familiar with the unfamiliar (see FIG. 17).

It is not astonishing that fans of tableaux vivants would find *La Grande Jatte* appealing, but that the composition also became the basis for a topiary monument can only be called startling.[83] The site is downtown Columbus, Ohio, in Old Deaf School Park, the "only topiary interpretation of a painting in existence," its sponsors proudly declare (FIG. 18). Comprising fifty-four topiary people, eight boats, three dogs, a monkey, a cat, and an actual pond, it was developed by the Columbus Recreation and Parks Department, and designed and created by a local sculptor, James T. Mason. The topiary park took two years to realize. Mason admired the painting as "an icon of Western civilization" and a variation on the "Arcadian myth." His effort, he explained, amounted to little more than a "large pun—a landscape of a painting of a landscape." As such, he meant it to explore the connections among art, nature, and civilization. The site has its own organization of friends, hosts annual events (including a tea), contains memorial trees and picnic tables, and, naturally enough, boasts its own museum store.[84]

No representation of *La Grande Jatte* can match the scale of Old Deaf School Park (one of its figures is twelve feet tall), but there are other impressive testaments to the picture's worldwide reputation. In Kyoto's Garden of Fine Arts, designed by the noted architect Tadeo Ando and completed

June 18, 1990 **THE** Price $1.75
NEW YORKER

in 1994, *La Grande Jatte* is one of eight master-
pieces (including Leonardo's *Last Supper*) rendered,
in actual size, in ceramic tile; an image of water
lilies by Monet is presented on the floor of a reflect-
ing pool. Several *New Yorker* covers have played
with *La Grande Jatte*, perhaps the ultimate tribute
to this Chicago-owned art work (see FIG. 20). In
addition to the products developed by or for the
Art Institute's Museum Shop, the museum receives
innumerable requests annually for permission to use
(or abuse) the image, and still others appropriate
it without permission. The composition, or some
portion thereof, graces a bewildering variety of prod-
ucts, from beer, book jackets, catalogue covers,
and jelly beans to dinner ware, dress fabrics, under-
wear, and umbrella stands (see FIG. 22).[85]

La Grande Jatte's celebrity rests, then, on its
capacity to meet many needs: its museum owner,
nurturing legends and stoking publicity organs; its
urban host, engaged in a long-term campaign for
cultural respectability; critics and art historians,
pondering its meaning and reassessing its signifi-
cance; commodity merchandisers, eager to exploit
its almost universally known features. But, like
Seurat himself, the ultimate basis of its continuing
popularity defies simple explanation, or is open to
so many that choice becomes arbitrary. Do museum
goers respond primarily to its size and color? To its
idiosyncratic technique? To its creator's short life
and uncommon diligence? To its spatial complexity
and extensive cast of characters? To its scientific
aspirations? To its suggestions of urban alienation

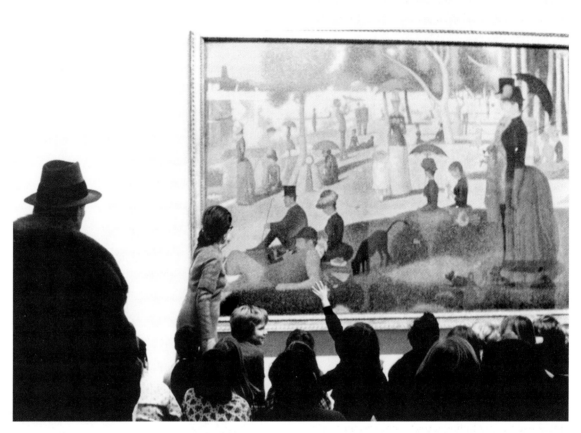

and introspection? To its financial value? To its
sly satire? To its focus on leisure? To the layers of
reputation and association built up over so many
decades? To the mystery of who everyone is and
what they are doing? Or to all of these?

The Art Institute of Chicago is located in a park;
its visitors are often on vacation, out of school,
or simply enjoying leisure time. *La Grande Jatte*

brings the park into the museum. For many it can
emblemize their entire museum tour.[86] In a matter-
of-fact way, the picture enters just about every film
or photographic essay that treats the Art Institute.
The movie *Ferris Bueller's Day Off* (1986) (see
FIG. 19) is far from its only appearance. Poets, com-
posers, and essayists have penned their own trib-
utes.[87] Famous (see FIG. 21) and not-so-famous

artists travel from far and wide to study the Seurat. Chicago artists have claimed special kinship and inspiration, offering their own gestures of respect and admiration.[88] If a fifth star is ever added to the city's flag (the first four commemorate, respectively, a massacre, a fire, and two fairs), it might well represent *La Grande Jatte*, so central has the painting become to its cultural economy. As a Museum of Modern Art correspondent expressed his relief upon learning that *La Grande Jatte* had survived the fire, "After all, there might have been civil war with Chicago!"[89]

All of this has developed alongside a dense discourse of critical commentary, whose evolution is described here by Robert Herbert. The two spheres are not absolutely impenetrable, of course. But it may be safe to argue that the popular realm has been less affected by the scholarly domain than the reverse. Art historians know that the painting they describe has an enormous following. Most museum visitors, however, appear largely oblivious to the debates about Seurat's politics, ideology, or stylistic antecedents.

The riddle of such universal popularity stubbornly resists easy solution, however much it invites inspired speculation. No formula can be definitive deciphering such magic. And commercial success feeds on itself, as being known for being known complements any earlier reasons for exploitation. Nonetheless, it is clear that broad celebrity for art work can be cultivated and nurtured, that it does not appear simply as a response to inherent quality. The miracle of *La Grande Jatte* is its coincidence of critical distinction and popular celebration. High, low, mass, and popular cultures meet in mutual delight, continuing to revel in the mysteries of that Parisian Sunday.

Notes

The author thanks David Spatz and Michael Wakeford for their help in researching this essay.

1 Francis Haskell, "The Dispersal and Conservation of Art-Historical Property," in *History of Italian Art* (Oxford, 1994), vol. 1, pp. 314–69. This essay was published originally in 1979.

2 An immense body of literature is devoted to this subject. See, among others, Tony Bennett, *The Birth of the Museum: History, Theory, Politics* (London, 1995); Carol Duncan, *Civilizing Rituals: Inside Public Art Museums* (London, 1995); Andrew McClellan, *Inventing the Louvre: Art, Politics and the Origins of the Modern Museum in Eighteenth-Century Paris* (Cambridge, Eng., 1994); and Marcia Pointon, ed., *Art Apart: Art Institutions and Ideology across England and North America* (Manchester, Eng., 1994).

3 For more on the nineteenth-century American tourist experience and reflections on art, see Paul R. Baker, *The Fortunate Pilgrims: Americans in Italy, 1800–1860* (Cambridge, Mass., 1964); and Neil Harris, *The Artist in American Society: The Formative Years, 1790–1860* (New York, 1966), chs. 5–6.

4 Walter Channing, *A Physician's Vacation; or, A Summer in Europe* (Boston, 1856), pp. 342–43. Isaac A. Jewett, *Passages in Foreign Travel* (Boston, 1838), vol. 1, p. 6. Orville Dewey, *The Old World and the New* (New York, 1836), vol. 2, p. 106.

5 Daniel H. Burnham and Edward H. Bennett, *Plan of Chicago* (Chicago, 1909), p. 124.

6 "Chicago Art Institute," *Christian Science Monitor*, Apr. 23, 1923. *Chicago Tribune*, Apr. 26, 1920.

7 The *Chicago Daily News*, Nov. 25, 1928, noted that Art Institute membership in 1928 had reached 18,000, far beyond the Metropolitan Museum's 13,690, the next largest. For examples of midwestern loyalty to the Art Institute, see the drawing by Frederick Polley and the brief article in the *Indianapolis Star*, Nov. 18, 1928.

8 Many stories appeared in the 1920s, 1930s, and later, declaring the *Assumption of the Virgin* to be the most valuable object in the collection. See for example, "Art Objects Valued at Millions Viewed by Thousands in Institute," *Chicago Post*, Oct. 27, 1931, in which the worth of the El Greco was estimated at two million dollars, and the work treated as "most famous," along with "the greatest Constable in the world," *Stoke-by-Nayland*, and Manet's *Christ Mocked*. As late as 1957, Art Institute officials continued to make this assertion; see Frank Holland, "Priceless Canvas Defies Time," *Chicago Sun-Times*, Aug. 4, 1957.

9 "Walter Pach and the Museums," *Art News* 25 (June 11, 1927), p. 6, citing an article by Pach in *Harper's*.

10 See minutes of the Committee on Painting and Sculpture, Mar. 19, 1925, and Apr. 9, 1925, Trustee Minute Books, vol. 9, Art Institute of Chicago (hereinafter referred to as AIC) Archives; and idem, Sept. 21, 1925. For more on the Art Institute's plaster casts, see Pauline Saliga, *Fragments of Chicago's Past: Collection of Architectural Fragments at The Art Institute of Chicago* (Chicago, 1990).

11 *Art Institute Forty-Ninth Annual Report for the Year 1927* (Chicago, 1928), p. 15.

12 For more on the Winterbotham Collection, see Lyn Delliquadri, "A Living Tradition: The Winterbothams and Their Legacy," *Art Institute of Chicago Museum Studies* 20, 2 (1994), pp. 102–10. This issue is devoted to the collection.

13 For more on Preston Harrison (son of Mayor Carter Harrison and brother of Mayor Carter Harrison, Jr.), and his system of purchase and replacement, see Neil Harris, "William Preston Harrison: The Disappointed Collector," *Archives of American Art Journal* 33 (1993), pp. 13–28.

14 Keynes to Daniel Catton Rich, London, Mar. 13, 1935, AIC Archives. Quentin Bell to John Maxon, Jan. 11, 1973, AIC Department of European Paintings files.

This letter was cited in Brettell 1986, p. 112. For more on Keynes as a collector, see Mary Ann Caws and Sara Bird Wright, *Bloomsbury and France: Art and Friends* (Oxford, 2000), pp. 95–105; and Robert Skidelsky, *John Maynard Keynes: A Biography* (London, 1992), vol. 2, p. 29.

15 For Bartlett's collecting, and for *La Grande Jatte* in particular, see Courtney Graham Donnell, "Frederic Clay and Helen Birch Bartlett: The Collectors," *Art Institute of Chicago Museum Studies* 12, 2 (1986), pp. 85–101; and Brettell 1986. Brettell, who offered the most detailed analysis, suggested that the Bartletts relied on an "anonymous intermediary," for they made none of their other art acquisitions privately.

16 Eleanor Jewett, "Painting Cost $20,000; Now It's $400,000," *Chicago Tribune*, Mar. 5, 1930. The astonishing history of this story can be traced in vol. 57 of the AIC Scrapbooks. The article, or extracts from it, along with large photographs of *La Grande Jatte*, ran almost simultaneously in major newspapers in Atlanta, Boston, Denver, Oklahoma City, and elsewhere, and weeks later made its way into smaller papers like the *Fort Wayne News Sentinel*, Apr. 4, and the *Waterbury Republican*, May 4. A typical header ran: "Art Institute Refuses Offer of $400,000 for This Painting"; see *Boston Globe*, Mar. 18, 1930, which also illustrated the Seurat.

17 For a slightly later variant, see Walter J. Sherwood, "The Famous Birch Bartlett Collection," *Chicago Visitor* (Oct. 1932), pp. 16–17, 40, according to Brettell 1986, pp. 104, 112. Brettell did not cite the earlier version. Continuing echoes of the story can be found in Stephen Sondheim's description of his encounters with *La Grande Jatte* as preparation for writing *Sunday in the Park with George*; see Mark Eden Horowitz, *Sondheim on Music: Minor Details and Major Decisions* (Latham, Md., 2003), p. 100.

18 Bartlett to Robert Harshe, June 13, 1924, Secretary of the Corporation file, AIC Archives. Bartlett originally dated the letter July 13, but this was crossed out to read June 13, apparently by another hand. Internal evidence suggests that Bartlett simply wrote July instead of June. *Bathing Place, Asnières*, to which Bartlett referred, went to the Tate Gallery, but later was transferred to the National Gallery, London. Brettell 1986, p. 109, argued that Bartlett, just after buying *La Grande Jatte*, may have competed with Samuel Courtauld for *Bathing Place*. But *Bathing Place*'s purchaser was not Courtauld personally—he would in fact acquire another Seurat for his collection—but rather the administrators of the fund he set up for Britain's national galleries to purchase recent

French art. Of course he may well have been involved with the decision to buy *Bathing Place*.

19 Roger Fry, "Seurat," *Dial* 81 (Sept. 1926), p. 229.

20 Morton Dauwen Zabel, "An American Gallery of Modern Painting: The Helen Birch-Bartlett Memorial in the Art Institute of Chicago," *Art and Archaeology* 16 (Dec. 1928), p. 232. The article was preceded by a full-page black-and-white photograph of *La Grande Jatte*.

21 One of Bartlett's sisters, Florence Dibbell Bartlett, helped establish the International Folk Arts Foundation and its museum in Santa Fe, New Mexico, to which she left a trust fund of more than one million dollars; see *Chicago Tribune*, Mar. 12, 1955. Another sister, Maie, was married to Dwight G. Heard, and active in founding the Heard Museum in Phoenix, Arizona.

22 Eleanor Jewett, "November Holds First Promise of Art Activities," *Chicago Tribune*, Oct. 21, 1923.

23 *Bulletin of The Art Institute of Chicago* 18, 7 (Oct. 1924), pp. 90–91.

24 Ibid. 19, 7 (Oct. 1925), p. 82.

25 Ibid. 20, 4 (Apr. 1926), p. 53.

26 Bartlett to Trustees, Jan. 26, 1926, Birch Bartlett folder no. 6, box 1, Office of the Registrar, AIC Collection Records.

27 See minutes of the Executive Committee, Mar. 26, 1926, Trustee Minute Books, vol. 9, AIC Archives.

28 *Chicago Tribune*, Apr. 27, 1926.

29 See minutes of the Board of Trustees, Jan. 15, 1930, Trustee Minute Books, vol. 11, AIC Archives.

30 Marguerite B. Williams, "Modernist Display Now at Art Institute," *Chicago Daily News*, Sept. 17, 1925.

31 For a prediction and preview, see Charles Fabens Kelley, "Art at the Chicago Exposition," *Christian Science Monitor* (Chicago ed.), Feb. 20, 1933. For local coverage, see Ernest L. Heitkamp, "'33 Fair Art Show to Be Greatest Ever," *Chicago Herald and Examiner*, Feb. 15, 1933; and "Art Institute Becomes Part of '33 World's Fair," *Chicago Daily News*, July 18, 1932. The celebrated art works featured in the exhibition received national coverage. See for example, "Famous Titian Going to Chicago," *New York Post*, Feb. 28, 1933; "Institute to Show $50,000,000 Art during World Fair," *Dubuque Daily Tribune*, Jan. 17, 1933; and *New York Times*, Feb. 28, 1933.

32 Dudley Crafts Watson, "What Chicago Learned: The Art Institute of Chicago Appraises the World's Art Exhibition," *American Magazine of Art* 27 (Feb. 1934), p. 79.

33 See Julius Rosenthal, "Seurat Painting Feature of Fair Art Exhibition," *Chicago Times*, Apr. 7, 1933. Rich was interviewed for this article. For reaction to the new installation, see Eleanor Jewett,

"New Order of Paintings Heightens Value of Stroll through Art Institute," *Chicago Tribune*, Feb. 11, 1934. For a slightly more ambivalent response—favorable but regretting the loss of donor personality—see Ernest L. Heitkamp, "Permanent Exhibits of Art Institute Are Rehung in a New Way," *Chicago Herald and Examiner*, Dec. 23, 1934.

34 Stefan Germer, "Traditions and Trends: Taste Patterns in Chicago Collecting," in *The Old Guard and the Avant-Garde: Modernism in Chicago, 1910–1940*, ed. Sue Ann Prince (Chicago, 1990), p. 190.

35 See the discussion in Richard R. Brettell and Sue Ann Prince, "From the Armory Show to the Century of Progress: The Art Institute Assimilates Modernism," in ibid., pp. 221–25.

36 Watson (note 32), pp. 77–79.

37 C. J. Bulliet, *Art Masterpieces in a Century of Progress Fine Arts Exhibition at The Art Institute of Chicago* (Chicago, 1933), no. 20. The opening pages of the book contain tributes to the impact of the exhibition from a number of museum directors and art specialists. For more press comments, see James O'Donnell Bennett, "Glories of Art World Await Fair Visitors," *Chicago Tribune*, May 31, 1934; India Moffett, "World Fair Art Preview Draws 5,900 to Exhibit," *Chicago Tribune*, June 1, 1934; Inez Cunningham Stark, "American Art Show Dazzling

to Home Critic," *Chicago Herald and Examiner*, June 2, 1934; and "Second Fair's Art Show to Beat '33's," *Grand Rapids Press*, Mar. 9, 1934.

38 For more on the second exhibition, see "Another Great Exhibit for World's Fair," *Literary Digest* 118 (Aug. 4, 1934), p. 24.

39 "Famous Painting Is Scrapped by Art Institute of Chicago," *Christian Science Monitor*, Apr. 6, 1934. After the fracas ended, Harshe suggested that *Lark* and similar pieces be hung in a separate room labeled "Favorites of Our Grandfathers," allowing sentimentalists to view once-popular work "which we no longer think of great importance"; see "Outdated Favorites," in ibid., Sept. 12, 1934. This never happened.

40 With typical idiosyncrasy, C. J. Bulliet argued that *The Song of the Lark* was technically a better painting than Whistler's portrait of his mother. He dared the Art Institute trustees "to let some commercial outlet have 'The Song of the Lark' for exhibition in the vicinity of the museum for a 25-cent admission price—the price of the whole 'official' show!" C. J. Bulliet, "American Art Faces Crisis This Summer," *Chicago Daily News*, May 12, 1934.

41 For a sample ballot, see *Chicago Daily News*, June 22, 1934; for a later, close-to-final version, see ibid., July 2, 1934. *Horse Fair* (1853–55), *Washington*

Crossing the Delaware (1851), and El Greco's *View of Toledo* (c. 1600) are all in the Metropolitan Museum of Art, New York.

42 There was massive coverage. See for example, "Mrs. Roosevelt to Unveil Fair's Prize Picture," *Chicago Daily News*, July 3, 1934; Sterling North, "Winning Picture Is Ready for Unveiling by Mrs. Roosevelt," *Chicago Daily News*, July 7, 1934; and *Chicago Tribune*, July 11, 1934.

43 "Art directors like to tell people what they should look at, not what they like to look at. . . . Perhaps, if Breton's canvas is unwanted, Chicago might be induced to give it to Boston. We feel that it will find welcome here"; *Boston Post*, repr. in *Jackson Patriot*, Apr. 15, 1934. See also *Ithaca Journal*, Apr. 29, 1934, which had the Art Institute giving the canvas "a flunking grade."

44 James Thrall Soby, "The Fine Arts," *Saturday Review* (Feb. 2, 1952), p. 40.

45 Rich 1935. *Massacre of Chios* (1824) is in the Museé du Louvre, Paris; *A Burial at Ornans* (1849–50) is in the Museé D'Orsay, Paris; and *Card Players* (1892–95) is in the Courtauld Institute Gallery, London.

46 "The Chicago Art Institute," *Life* 11 (Sept. 8, 1941), pp. 54–60.

47 *Chicago Sun-Times*, Dec. 15, 1955.

48 *Daughters of Revolution* is in the Cincinnati Art Museum. For more on this painting and on *American Gothic*,

see Wanda M. Corn, *Grant Wood: The Regionalist Vision*, exh. cat. (New Haven, 1983).

49 Daniel Catton Rich, "Chicago and Modern Art," *Men and Events* 28 (Dec. 1951), pp. 4–5.

50 Clay Gowran, "One Million a Year View Its Wonders," *Chicago Tribune*, May 1957. The date of the article is unclear from the microfilm in the AIC Scrapbooks, but it is vol. 90, p. 114. Other aspects of the Art Institute received mention, including Brancusi's *Leda*, the Thorne Miniature Rooms, the Goodman Theatre, and the Ryerson and Burnham Libraries.

51 See Andrew C. Ritchie (then director of the Museum of Modern Art) to Bartlett, New York, Dec. 15, 1949, Committee on Painting and Sculpture file, AIC Archives, requesting the loan of *La Grande Jatte*; and Rich to Ritchie, Chicago, Dec. 21, 1949, AIC Archives, indicating that Bartlett, who was in Chicago, had agreed to lend it. At this point, the opening in Chicago was planned for the fall of 1952. Bartlett suffered a stroke in the late 1940s and died in 1953.

52 There were two great disappointments. The Tate refused to lend *Bathing Place, Asnières*, despite a special request made by John Hay Whitney (then the American ambassador to Britain) and a letter from Museum of Modern Art founder Alfred H. Barr, Jr., to Sir John Rothenstein

(director of the Tate), New York, Mar. 12, 1957, copy in Committee on Painting and Sculpture file, AIC Archives. Even more infuriating was Stephen Clark's refusal to allow *Parade de cirque* (CH. 5, FIG. 5) to be shown in Chicago, despite the fact that he was a trustee of the Museum of Modern Art. The latter made Rich so angry that, after discussions with staff and trustees, he threatened to keep *La Grande Jatte* from traveling to New York. In the end, he backed off this position. See Rich to Frank B. Hubachek, Chicago, Oct. 10, 1957, AIC Archives.

53 Daniel Catton Rich, "The Place of Seurat," *Art Institute of Chicago Quarterly* 52 (Feb. 1, 1958), p. 2.

54 Edith Weigle, "You'll Like the New Show of Seurat's," *Chicago Tribune*, Jan. 19, 1958.

55 *Chicago Sun-Times*, Jan. 17, 1958; *Chicago Daily News*, Feb. 8, 1958. The piece sustained the legend that the painting was bought in 1920 by the Bartletts in a tea shop, common at least since Jewett's story of 1930 (see note 16).

56 *Chicago American*, Jan. 14, 1958.

57 Henry Greene, "There Is an Art in Hat Styling," *Chicago Sun-Times*, Feb. 18, 1958.

58 "$1,000,000 Seurat Painting Sent to Museum Here in a Rail Car," *New York Times*, Mar. 19, 1958. See also ibid., Mar. 28, 1958.

59 "The Science of Seurat," *Time* (Jan. 20, 1958), p. 70.

60 Frank Getlein, "Seurat's Lonely Crowd," *New Republic* (Jan. 27, 1957), p. 21.

61 The most extensive description can be found in Russell Lynes, *Good Old Modern: An Intimate Portrait of The Museum of Modern Art* (New York, 1973), pp. 359–76.

62 *Chicago Tribune*, Apr. 16, 1958; this page-one account was written by Harold Hutchings. *Chicago Sun-Times*, Apr. 16, 1958; this lead article prominently features the Bartletts and the legendary stipulation that *La Grande Jatte* would leave the Art Institute only this once. The front-page story in *Chicago Daily News*, Apr. 15, 1958, does not mention *La Grande Jatte* specifically, but implies, mistakenly, that the Art Institute owned all of the Seurats in the exhibition.

63 See minutes of the Executive Committee, Apr. 18, 1958, Trustee Minute Books, vol. 23, AIC Archives. For coverage see "Modern Museum Opens to Crowds," *New York Times*, May 2, 1958. See minutes of the Executive Committee. Apr. 28, 1958, Trustee Minute Books, vol. 23, for a discussion of the proposed reforms in fire prevention and security. Trustees debated the policy of quick removal of valuable works in case of emergency, but at a meeting of the Executive Committee, July 27, 1958, Trustee Minute Books, vol. 23, museum official Allan McNabb

stated that this requirement posed numerous challenges; he reported that it had taken six workers several hours to remove the El Greco from the wall. When *La Grande Jatte* returned from New York, three policemen on motorcycles escorted it from the Railway Express yards at Roosevelt and Clark Streets to the Art Institute; see *Chicago Tribune*, May 17, 1958.

64 John Smith, "The Nervous Profession: Daniel Catton Rich and The Art Institute of Chicago, 1927–1957," *Art Institute of Chicago Museum Studies* 19, 1 (1993), p. 78.

65 Both cited by Ann Marie Lipinski, "Impressions among the 'Jatte' Set," *Chicago Tribune*, Dec. 1984.

66 John Pope-Hennessy, *Learning to Look* (New York, 1991), pp. 181–82.

67 Jack W. McCullough, *Living Pictures on the New York Stage* (Ann Arbor, 1983), p. 16.

68 For more on the Laguna Beach festival, see Bruce Watson, "What's Wrong With This Picture?" *Smithsonian* 31, 8 (Nov. 2000), pp. 131–38. Tableaux vivants were also created closer to home; see Stevenson Swanson, "Naperville Festival Has 'Living Pictures,'" *Chicago Tribune*, Sept. 17, 1985.

69 For more on this musical, see Stephen Banfield, *Sondheim's Broadway Musicals* (Ann Arbor, 1993), ch. 11; Stephen Citron, *Sondheim and Lloyd-Webber:*

The New Musical (New York, 2001), pp. 289–99; and Horowitz (note 17), pp. 91–118.

70 Sondheim recalled first seeing a reproduction in an undergraduate art history course at Williams College taught by that famous trainer of museum directors, Lane Faison; Sondheim to Harris, July 23, 2003.

71 The Shakespearean comparisons are those of Frank Olley, "A Cathedral to Art," in *Reading Stephen Sondheim: A Collection of Critical Essays*, ed. Sandor Goodhart (New York, 2000). This book also quotes Frank Rich's article "A Musical Theater Breakthrough," *New York Times Magazine*, Oct. 21, 1984, p. 53.

72 It played in Chicago for the first time in the 1986–87 season at the Goodman Theatre; see *Chicago Tribune*, June 29, 1986.

73 Many stories on the show, as well as reviews—good, bad, and indifferent—mention that the painting hung in the Art Institute. See, for example, Carol Lawson, "Summer's Hottest Ticket?" *New York Times*, June 17, 1983; and John Russell, "Can Great Art Be the Stuff of Drama?" ibid., May 13, 1984. Tour guides touted the "must-see" painting as the inspiration of the Pulitzer Prize–winning musical; see "The Friday Guide," "Chicago's Top 40," *Chicago Tribune*, Aug. 18, 1989.

74 Quoted in Sharon Waxman, "A Blue Period for Curators of Major Art Shows," *Chicago Tribune*, Apr. 28, 1991.

75 For more on this episode, see Mike Dempsey, ed., *Bubbles: Early Advertising Art from A. & F. Pears Ltd* (London, 1978).

76 Donald Sassoon, *Becoming Mona Lisa: The Making of a Global Icon* (New York, 2001), pp. 259–68.

77 For more on this, see Neil Harris, "Who Owns Our Myths? Heroism and Copyright in an Age of Mass Culture," *Social Research* 52 (Summer 1985), pp. 241–67.

78 One source of evidence for the increasing familiarity of postwar college students with *La Grande Jatte* comes from art history textbooks. It is not accidental that Helen Gardner, who taught the history of art at the School of the Art Institute of Chicago, was the first to include it, in the second edition of her *Art Through the Ages* (1933). The subsequent editions of her book, as well as two other widely used texts, Frederick Hartt's *Art: A History of Painting, Sculpture, Architecture* and H. Harvard Arnason's *History of Modern Art*, all contain illustrations of the work (in color, in most editions), as well as discussions. *La Grande Jatte* adorned the cover of *Art Through the Ages'* fourth edition (1959). On the other hand, H. W. Janson's *History of Art* included a reproduction only in its fifth edition (1995), while neither Hugh Honour and John Fleming's *World History of Art* nor E. H. Gombrich's *Story of Art* reproduces or

discusses it at all. Nonetheless, thousands of undergraduates have been exposed to the painting as part of their classroom experience, through slides as well as textbooks. I am grateful to Brandon Ruud for this information.

79 For comments on this, see "U.S. Museums: Victims of Their Own Success," *U.S. News and World Report* 86 (June 18, 1979), pp. 57–59; William McDougall and Micheline Maynard, "Is 'Showbiz' Ruining America's Big Museums?" ibid. 98 (Feb. 25, 1985), pp. 64–65; and Judith H. Dobryznski, "Art (?) to Go: Museum Shops Broaden Wares, at a Profit," *New York Times*, Dec. 10, 1977.

80 For suggestive musings on this and other subjects, see the essays (particularly the introduction) in Arthur C. Danto, *Beyond the Brillo Box: The Visual Arts in Post-Historical Perspective* (New York, 1992).

81 Historians, sociologists, and anthropologists combined, in the 1980s and 1990s, to produce an enormous array of articles, monographs, and syntheses dealing with "consumer culture." A set of anthologies, in order of appearance, captures some broader trends: Richard Wightman Fox and T. J. Jackson Lears, eds., *The Culture of Consumption: Critical Essays in American History, 1880–1980* (New York, 1983); Simon J. Bronner, *Consuming Visions: Accumulation and Display of Goods in America, 1880–1920* (New York, 1989); and Jennifer Scanlon, ed., *The Gender and Consumer Culture Reader* (New York, 2000). For more on identity, collectibles, and display, see Neil Harris, "American Poster Collecting: A Fitful History," *American Art* 12 (Spring 1998), pp. 11–39.

82 See Monica Bohm-Duchen, *The Private Life of a Masterpiece* (Berkeley, 2001), for an examination of eight art works that have achieved this status. *La Grande Jatte* is not among them, but it certainly fits within this group.

83 For more on this project, see Janet Mason, "An American Place: Horticultural Homage," *Life*, n.s. 18 (May 1995), pp. 100–01.

84 For more information, see Friends of the Topiary Park, "The Topiary Garden: 'A Landscape of a Painting,'" www.topiarygarden.org.

85 In an article in the *Chicago Tribune*, Aug. 23, 1998, the Museum Shop is cited as declaring *La Grande Jatte* its best-selling postcard, followed by Monet's *Water Lilies*, Renoir's *Two Sisters*, Hopper's *Nighthawks*, and Caillebotte's *Paris Street; Rainy Day*. *American Gothic* ranks eighth on this list.

86 And for non-residents as well, it remains a symbol of the museum: "There is no one painting that represents the Guggenheim the way, say, Van Gogh's 'Starry Night' represents the Museum of Modern Art or Seurat's 'Sunday on La Grande Jatte' the Art Institute of Chicago." Deborah Solomon, "Is the Go-Go Guggenheim Going, Going...," *New York Times*, June 30, 2002.

87 See for example Delmore Schwartz's epic poem, "Seurat's Sunday Afternoon Along the Seine," written in 1959, probably prompted by the 1958 retrospective. For an excerpt, see *Transforming Vision: Writers on Art*, selected and intro. by Edward Hirsch (Chicago, 1994), pp. 20–25.

88 One example is Michael Hurson, a Chicago artist who, for many years, has worked in New York; see Roberta Smith, "Art in Review," *New York Times*, Sept. 13, 1992.

89 As quoted in Lynes (note 61), p. 359.

Related Works

Appendices

Checklist

Selected Bibliography

Lenders

Index

Photography Credits

Catalogue of All Known Works Related to *La Grande Jatte*

No secure sequence can be established for the paintings and drawings related to *La Grande Jatte*, but by comparing technique, location of compositional shadows and figures, and similarity to the Metropolitan Museum's large sketch and the final composition, they can be sorted roughly into groups. Within the three largest groups, a chronological progression is assumed, not object by object but across the flow of them all, so that the last was definitely done later than the first.

Panels are nearly all 16 x 25 cm, varying only by fractions of a centimeter. Drawings are in black conté crayon and typically 31 x 24 cm. Only significant variations are noted. Works illustrated here, but not elsewhere in this book, are marked with an asterisk.

In his catalogue raisonné of Seurat's oeuvre, César de Hauke listed three canvases, thirty-one panels, and twenty-eight drawings as preparatory works for *La Grande Jatte*. Of the drawings, the authenticity of *Woman Standing, Left Profile* (H 623) should probably be doubted, and *Bust Study of a Seated Woman* (H 626), known only from a screened

photograph, is hard to evaluate. Another drawing listed by De Hauke, *Croquis confus* (H 621), is too vague to be securely identified as a study. Two genuine drawings (*Bustle*, H 615; and *Woman Fishing*, H 618) are too casual to be to be considered studies for the painting, although they are undoubtedly related to the work. One drawing listed here (H 615) was not included by De Hauke among the preparatory studies. Of the panels, two (*Women*, private collection, H 108; and *Women at the Water's Edge*, private collection, H 116) are not studies for the big picture, and one (*Study for La Grande Jatte*, H 131bis) is known only from a photograph too small to permit assessment. The small compositional study (H 141) disappeared during World War II, and the authenticity of *The Couple* (H 136) should probably be questioned. The panel *Fisherman and Fisherwoman* (H 114), while likely genuine, is so slight that it has not been included here.

Works probably executed before beginning *La Grande Jatte*

H 115 *Fisherman*, c. 1883. Panel. Private collection. CAT. 27.

H 617 *Fisherman*, c. 1883. Conté crayon. Von der Heydt Museum, Wuppertal. CH. 2, FIG. 5.

H 635 *Woman Fishing*, c. 1883. Conté crayon. The Metropolitan Museum of Art, New York. CAT. 28.

H 107 *Figures on the Shore*, 1883/84. Panel. Private collection. CH. 2, FIG. 1.

H 112 *Landscape with Figures*, 1884. Panel. The National Gallery, London. CAT. 35.

Earliest works

***H 118** *Woman Standing in Mid-Distance*, 1884. Panel. Location unknown.

H 140 *Seated Woman*, 1884. Panel. Private collection. CAT. 38.

H 117 *Seated and Standing Figures*, 1884. Panel. The Metropolitan Museum of Art, New York. CAT. 39.

The landscape defined

H 126 *Woman Sewing*, 1884. Panel. Private collection. CH. 2, FIG. 2.

H 123 *Seated Figures*, 1884. Panel. Fogg Art Museum, Harvard University Art Museums, Cambridge, Massachusetts. CAT. 40.

H 131bis *Study for La Grande Jatte*. Presumably panel. Location unknown. No illustration.

H 110 *Sailboat*, 1884. Panel. National Gallery of Art, Washington, D.C. CAT. 41.

H 111 *Landscape, Seated Man*, 1884. Panel. Collection André Bromberg. CAT. 42.

H 139 *Standing Man*, 1884. Panel. The National Gallery, London. CAT. 43.

H 119 *Seated Figures and Child in White*, 1884. Panel. The Barnes Foundation, Merion, Pennsylvania. CH. 2, FIG. 4.

H 125 *Seated and Standing Women*, 1884. Panel. Albright-Knox Art Gallery, Buffalo. CAT. 44.

H 619 *Trees*, 1884. Conté crayon; 62 x 47.5 cm. The Art Institute of Chicago. CAT. 45.

H 620 *Tree Trunks*, 1884. Conté crayon; 47.4 x 61.5 cm. The Art Institute of Chicago. CAT. 46.

H 122 *Three Men Seated*, 1884. Panel. Private collection. CAT. 47.

Compositional studies

H 128 *Sketch with Many Figures*, 1884. Panel. The Art Institute of Chicago. CAT. 48.

H 120 *Woman Fishing and Seated Figures*, 1884. Panel. Private collection. CAT. 49.

H 109 *Seated Man, Reclining Woman*, 1884. Panel. Musée d'Orsay, Paris. CAT. 50.

H 121 *Rose-Colored Skirt*, 1884. Panel. Private collection. CAT. 51.

***H 127** *Seated Man and Black Dog*, 1884. Panel. Foundation Emil G. Bührle Collection, Zurich.

***H 124** *White Dog and Seated Figures*, 1884. Panel. Rosengart Collection Museum, Lucerne.

H 129 *Seated Women with Baby Carriage*, 1884. Panel. Musée d'Orsay, Paris. CAT. 52.

H 130 *Soldier* ["*Cadet from Saint-Cyr*"], 1884. Panel. Private collection. CAT. 53.

***H 113** *Woman Fishing*, 1884. Panel. Tel Aviv Museum of Art, Moshe and Sara Mayer Collection.

H 636 *Monkey*, 1884. Conté crayon; 17.7 x 23.7 cm. The Metropolitan Museum of Art, New York. CAT. 54.

H 638 *Monkey*, 1884. Conté crayon; 13.2 x 23.2 cm. Private collection. CAT. 55.

H 640 *Monkeys*, 1884. Conté crayon. Private collection, Switzerland. CAT. 56.

H 639 *Seven Monkeys*, 1884. Conté crayon. Musée du Louvre, Paris, Département des Arts Graphiques, Fonds du Musée d'Orsay. CAT. 57.

H 637 *Seated Monkey*, 1884. Conté crayon; 17.2 x 21.3 cm. Solomon R. Guggenheim Museum, New York. CAT. 58.

H 135 *Woman with a Parasol*, 1884. Panel. Private collection. CH. 2, FIG. 3.

H 137 *Woman with a Monkey*, 1884. Panel. Smith College Museum of Art, Northampton, Massachusetts. CAT. 59.

***H 136** *The Couple*, 1884/85. Panel. Location unknown.

H 615 *Bustle*, 1884/86. Pen and ink; 16.5 x 10 cm. Location unknown. CH. 3, FIG. 8.

Final preparations

H 131 *Landscape, Island of La Grande Jatte*, 1884, 1885, painted border 1889/90. Canvas; 65.3 x 81.2 cm. Private collection. CAT. 60.

H 644 *The Couple*, 1884. Conté crayon. The British Museum, London. CAT. 61.

H 138 *The Couple*, 1884. Canvas; 81 x 65 cm. Fitzwilliam Museum, Cambridge, England. CAT. 62.

***H 642** *Black Dog*, 1884. Conté crayon. Location unknown.

***H 616** *Fisherman and Tree*, 1884. Conté crayon; 61 x 46 cm. Von der Heydt Museum, Wuppertal.

***H 618** *Woman Fishing*, 1884. Pen and ink; 13.2 x 10.2 cm. Private collection.

H 622 *Raised Arm*, 1884. Conté crayon; 29 x 20 cm. Location unknown. Zuccari and Langley, FIG. 37.

H 641 *Landscape, Island of La Grande Jatte*, 1884. Conté crayon; 42.2 x 62.8 cm. The British Museum, London. CAT. 63.

***H 141** Small compositional study for *La Grande Jatte*, 1884. Panel. Formerly Paul Signac; stolen in 1940 and never recovered.

H 142 Compositional study (large sketch) for *La Grande Jatte*, 1884, painted border 1888/89. Canvas; 70.5 x 104.1 cm. The Metropolitan Museum of Art, New York. CAT. 64.

H 624 *Skirt*, 1884/85. Conté crayon; 30 x 17 cm. Musée Picasso, Paris. CAT. 67.

***H 623** *Woman Standing, Left Profile*. 1884/85. Conté crayon; 30 x 18 cm. Location unknown.

H 625 *Woman Walking with a Parasol*, 1884/85. Conté crayon. The Art Institute of Chicago. CAT. 68.

H 632 *Seated Woman*, 1884/85. Conté crayon; 30.2 x 16.5 cm. The Philadelphia Museum of Art. CAT. 69.

H 634 *Head of Young Woman*, 1884/85. Conté crayon. Smith College Museum of Art, Northampton, Massachusetts. CAT. 70.

***H 626** *Bust Study of a Seated Woman*, 1884/85. Conté crayon; 18.5 x 13.5 cm. Private collection.

***H 628** *Seated Woman with a Parasol*, 1884/85. Conté crayon; 30 x 18 cm. Private collection.

H 629 *Seated Woman with a Parasol*, 1884/85. Conté crayon; 47.7 x 31.5 cm. The Art Institute of Chicago. CAT. 71.

H 627 *Young Woman*, 1884/85. Conté crayon; 31.3 x 16.2 cm. Kröller-Müller Museum, Otterlo, the Netherlands. CAT. 72.

H 631 *Child in White*, 1884/85. Conté crayon. Solomon R. Guggenheim Museum, New York. CAT. 73.

H 630 *Nurse*, 1884/85. Conté crayon. Albright-Knox Art Gallery, Buffalo. CAT. 74.

H 633 *Three Young Women*, 1884/85. Conté crayon. Smith College Museum of Art, Northampton, Massachusetts. CAT. 75.

H 115 **H 617** **H 635** **H 107** **H 112**

H 118 **H 140** **H 117**

The landscape defined

H 126 **H 123** **H 110** **H 111** **H 139** **H 119** **H 125**

H 619 **H 620** **H 122**

Compositional studies

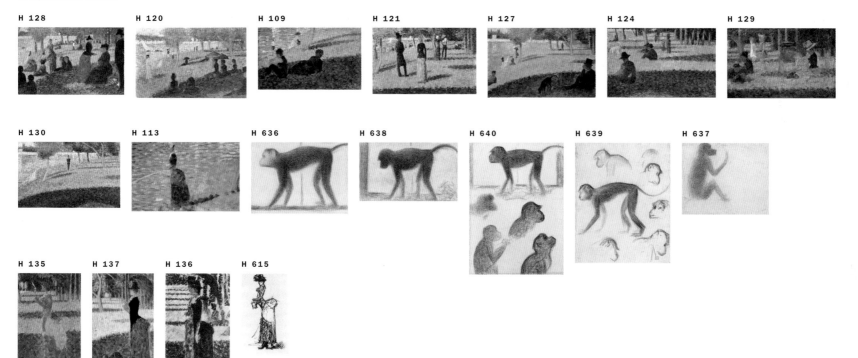

H 128 H 120 H 109 H 121 H 127 H 124 H 129

H 130 H 113 H 636 H 638 H 640 H 639 H 637

H 135 H 137 H 136 H 615

H 131

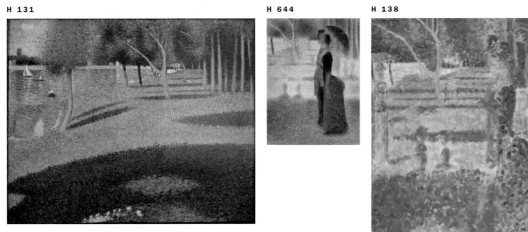

H 644

H 138

H 642

H 616

H 618

H 622

H 641

H 141

H 142

H 624 H 623 H 625 H 632 H 634 H 626 H 628 H 629 H 627 H 631

H 630 H 633

Appendices

Appendix A: Seurat's "Aesthetic"

In 1890, in response to an inquiry from the journalist Maurice Beaubourg, Seurat prepared several drafts of a letter outlining his theories, but he never sent it.[1] The final draft of the letter (private collection), dated August 28 [1890], consists of two parts: an autobiographical introduction and a formal statement of the artist's theories (the *esthétique*). There are four drafts of the *esthétique*, discussed and reproduced in Herbert et al. 1991 (Appendix E). Only the key portion of the final draft is printed here. Some punctuation and paragraphing have been added to ensure clarity. *Ton* and *teinte* have been translated by their nineteenth-century equivalents "tone" and "tint," although today many would say "value" and "hue" (the latter, however, is not the same as "tint," which incorporates the idea of a degree of saturation as distinct from pure hue).

Aesthetic:
Art is Harmony.
Harmony is the analogy of opposites, the analogy of similarities of tone, of tint, of line taking account of a dominant and under the influence of the lighting, in combinations that are

 gay calm or sad

———————————————

Opposites are:

for tone, a more luminous/lighter one for a darker one.

for tint, the complementaries, that is, a certain red opposed to its complementary, etc.

 Red – Green
 Orange – Blue
 Yellow – Violet

for line, those making a right angle.

———————————————

Gaiety of tone is the luminous dominant, *of tint*, the warm dominant, *of line*, lines above the horizontal.

Calmness of tone is the equality of dark and light; of tint, of warm and cool, and the horizontal for line.

Sadness of tone is the dark dominant; of tint, the cool dominant, and of line, downward directions.

———————————————

Technique

Given the phenomenon ~~that~~ of the duration of the luminous impression on the retina ~~are the same, The means of expression will be synthetic.~~

 Synthesis is logically the result.

The means of expression is the optical mixture of tones, of tints (of local color and the illuminating color: sun, oil lamp, gas, etc.), that is, of the lights and of their reactions (shadows) following the laws *of contrast*, of gradation, of irradiation.

The frame ~~is no longer as in the beginning~~ is in a harmony opposed to those of the tones, tints, and lines of the ~~motif~~ picture.

Appendix B: Seurat's letter to Fénéon, June 20, 1890

Reacting to an article on Signac by Fénéon that failed to mention his own name, Seurat prepared a letter to state his place as the initiator of Neoimpressionism (Bibliothèque Nationale, Département des Manuscrits, Paris, gift of César de Hauke). It is the most important surviving letter from his hand because it lists his readings among scientists, aestheticians, and artists,[2] as well as the key steps in his artistic development. For this letter and two shorter drafts, see Herbert et al. 1991, Appendix F. Minimum punctuation and paragraphing have been added to ensure clarity.

Paris June 20, 1890

My dear Fénéon

Allow me to point out an inaccuracy in your biography of Signac, or rather, in order to set aside all doubt, allow me to specify:

 – It seduced – it was about 1885, p. 2, par. 4.[3]

Begun ~~in~~ Pissarro's and Signac's evolution was slower. I object and I establish within about two weeks the following dates:

 The *purity of the spectral element being the keystone of* ~~the~~ *my technique* – ~~and being~~ that you were the first to devote yourself to,

 searching for an optical formula on this basis ever since I held a brush 1876–1884,

having read Charles Blanc in school and therefore knowing Chevreul's laws and Delacroix's precepts,

 having read the studies by the same Charles Blanc on the same painter (Gazette des Beaux-Arts, vol. XVI, if I remember correctly),

 knowing Corot's ideas on tone (copy of a private letter October 28, 1875) and Couture's precepts on the subtlety of tints (at the time of his exhibition),

 having been struck by the intuition of Monet and Pissarro,

 sharing certain of Sutter's ideas on the ancient art of the Greeks that I meditated while in Brest (the review L'Art) March and February 1880,

 Rood having been brought to my attention in an article by Philippe Gille, Figaro 1881,[4]

 I insist on establishing the following dates indicating my prior paternity. ~~and the discussions that I held~~

 1884 Grande Jatte study, exhibition of the Indépendants

 1884–1885 Grande Jatte composition

 1885 studies at the Grande Jatte and at Grandcamp; took up again the Grande Jatte composition October 1886 [i.e., 1885].[5]

———————————————

 October 85 I make Pissarro's acquaintance at Durand-Ruel's.

 1886 January or February, a small canvas by Pissarro, divided and pure color, at Clozet's the dealer on the rue de Châteaudun.

Signac, definitively won over and who had just modified The Milliners [CH. 4, FIG. 2], following my technique at the same time as I was finishing the Jatte, executes:

1. Le Passage du puits Bertin [location unknown]. Clichy. March–April 1886.
2. Gas Factories, Clichy [CAT. 117]. March–April 1886 (catalogue of the Indépendants). For these reasons

Coolness with Guillaumin who had introduced me to Pissarro and whom I saw thanks to his old friendship with Signac.

You'll agree that there's a nuance here and that if I was unknown in 85 I nonetheless existed, I and my vision that you have described in an impersonal fashion so superbly, aside from one or two insignificant details.

Already Mr. Lecomte had sacrificed me to Charles Henry whom we did not know before the Rue Laffitte (error explained).[6]

It was at Robert Caze's that we were put into contact with several writers of Lutèce and Le Carcan (Petit Bottin des arts et des lettres).[7] Pissarro came there with Guillaumin.

Then you brought me out of the shadows along with Signac who had benefited from my researches.

I count on your loyalty to communicate these notes to Messrs. Jules Christophe[8] and Lecomte.

I shake your hand cordially and faithfully.

Seurat

Notes

1 Beaubourg to César de Hauke, Oct. 6, 1937, De Hauke archives, Bibliothèque Nationale, Paris.

2 Seurat's readings, in the order he mentions them, are the following: Blanc 1867; Chevreul 1839; Blanc, "Eugène Delacroix," *Gazette des beaux-arts* (Jan. 1864), pp. 5–27, and (Feb. 1864), pp. 97–129; advice Corot gave to a neighbor, copied by Seurat (Herbert et al. 1991, Appendix M); Thomas Couture, *Méthode et entretiens d'atelier*, 1867 (Herbert et al. 1991, Appendix O); David Sutter, "Les Phénomènes de la vision," 1880 (Herbert et al. 1991, Appendix I); Rood 1879.

3 The reference is to "Signac," *Les Hommes d'aujourd'hui* 373 (1890), for which Seurat had made his portrait of Signac. Fénéon wrote that the new optical painting "seduced—it was about 1885—several young painters," but he named only Signac. Seurat was mentioned nowhere in the article.

4 In an earlier draft, Seurat wrote, "Rood was in my possession the day after the appearance of Philippe Gille's book review, published by Le Figaro 1881 (change of palette). I abandoned *earth colors* from 82 to 1884. On Pissarro's advice I stop using emerald green 1885." Gille's review appeared in *Le Figaro*, Jan. 25, 1881.

5 Seurat meant to write "1885." In an earlier draft, he wrote, "1884, Ascension Day: Grande Jatte, the studies and the painting. This canvas was ready in March 1885 for the abortive exhibition of the Indépendants, taken up again and finished after a trip to Grandcamp (1885) and exhibited May 15, 1886."

6 Seurat here referred to two articles published in March 1890 by Georges Lecomte. By "Rue Laffitte," Seurat meant the Impressionist exhibition, May–June 1886. Lecomte's "error" was to associate Henry's ideas with *La Grande Jatte.*

7 *Lutèce* and *Le Carcan* were short-lived vanguard reviews. The *Petit Bottin des lettres et des arts* (Paris, 1886), edited by Fénéon, Paul Adam, and others, was a compilation of short, saucy aphorisms about avant-garde figures. In an early draft of this letter to Fénéon, Seurat wrote, "Mr. Pissarro made the acquaintance of the group of writers around La Vogue, Lutèce, Le Carcan, by way of Signac and me, who were at Robert Caze's last Friday gatherings. He came to the same Robert Caze's once or twice, with Guillaumin."

8 Author of "Seurat," *Les Hommes d'aujourd'hui* 368 (1890), and other articles on the Neoimpressionists.

Checklist of the Exhibition

Works are listed by artist, starting with Seurat and then proceeding alphabetically. Within each artist grouping, works are organized chronologically.

Georges-Pierre Seurat
(French, 1859–1891)

CAT. 1

Harvester, 1881
Conté crayon on paper
31 x 24.2 cm (12 ¼ x 9 ½ in.)
Collection André Bromberg
H 456, illustrated p. 27

CAT. 2

Woman Leaning on a Parapet by the Seine, c. 1881
Conté crayon on paper
23.7 x 15.7 cm (9 ⅜ x 6 ⅛ in.)
Prat Collection, Paris
H 462, illustrated p. 28

CAT. 3

Railway Tracks, 1881/82
Conté crayon on paper
24.2 x 31.6 cm (9 ½ x 12 ½ in.)
Collection André Bromberg
H 471, illustrated p. 30

CAT. 4

Stone Breaker, 1881/82
Oil on canvas
33 x 41 cm (13 x 16 in.)
Private collection
H 36, illustrated p. 37

CAT. 5

Grassy Riverbank, 1881/82
Oil on canvas
32.5 x 40.7 cm (12 ¾ x 16 in.)
Dallas Museum of Art, The Wendy and Emery Reves Collection, 1985.R.68
H 27, illustrated p. 36

CAT. 6

Stone Breaker and Wheelbarrow, Le Raincy, c. 1882
Oil on panel
15.4 x 24.9 cm (6 x 9 ¾ in.)
The Phillips Collection, Washington, D.C., 1727
H 100, illustrated p. 35

CAT. 7

White Houses, Ville d'Avray, 1882/83
Oil on canvas
33 x 46 cm (13 x 18 ⅛ in.)
National Museums Liverpool, WAG 6112
H 20, illustrated p. 39

CAT. 8

Farm Women at Work, 1882/83
Oil on canvas
38.5 x 46.2 cm (15 ⅛ x 18 ¼ in.)
Solomon R. Guggenheim Museum, New York, gift, Solomon R. Guggenheim, 1941, 41.713
H 60, illustrated p. 40

CAT. 9

Nurse with Child, 1882/83
Conté crayon on paper
32 x 24.4 cm (12 ⅝ x 9 ⅝ in.)
Dian Woodner and Andrea Woodner, New York, WD-230
H 488, illustrated p. 31

CAT. 10

Stone Breakers, 1882/83
Oil on canvas
33 x 41.5 cm (13 x 16 ⅜ in.)
Nahmad Collection, Switzerland, G 53755
H 102, illustrated p. 38

CAT. 11

Woman with Bouquet, Seen from Behind, 1882/83
Conté crayon on paper
31.6 x 24.4 cm (12 ½ x 9 ⅝ in.)
Collection E.W.K., Bern, GS 1
H 496, illustrated p. 34

CAT. 12

Bridge; View of the Seine, 1883
Oil on panel
16.5 x 25.4 cm (6 ½ x 10 in.)
The Metropolitan Museum of Art, New York, bequest of Mabel Choate in memory of her father, Joseph Hodges Choate, 1958, 59.16.5
H 77, illustrated p. 43

CAT. 13

Seated Woman, 1883
Oil on canvas
38.1 x 46.2 cm (15 x 18 in.)
Solomon R. Guggenheim Museum, New York, gift, Solomon R. Guggenheim, 1937, 37.714
H 59, illustrated p. 40

CAT. 14

Man Painting a Boat, 1883
Oil on panel
15.9 x 25 cm (6 ¼ x 9 ⅞ in.)
Courtauld Institute Gallery, London, P.1948.SC.393
H 66, illustrated p. 43

CAT. 15

Horses in the Water (study for *Bathing Place, Asnières*), 1883
Oil on panel
15.2 x 24.8 cm (6 x 9 ¾ in.)
Private collection, on long-term loan to the Courtauld Institute Gallery, London, LP.1997.XX.17
H 86, illustrated p. 43

CAT. 16

Rainbow (study for *Bathing Place, Asnières*), 1883
Oil on panel
16 x 25 cm (6 ¼ x 9 ⅞ in.)
The National Gallery, London, NG 6555
H 89, illustrated p. 43

CAT. 17

Black Horse (study for *Bathing Place, Asnières*), 1883
Oil on panel
15.9 x 24.8 cm (6 ¼ x 9 ¾ in.)
National Gallery of Scotland, Edinburgh, NG 2222
H 88, illustrated p. 44

CAT. 18

Seated Man (study for *Bathing Place, Asnières*), 1883
Oil on panel
15.7 x 24.9 cm (6 ⅛ x 9 ¾ in.)
The Cleveland Museum of Art, bequest of Leonard C. Hanna, Jr., 1958.51
H 80, illustrated p. 44

CAT. 19

Two Seated Figures (study for *Bathing Place, Asnières*), 1883
Oil on panel
17.5 x 26.3 cm (6 ⅞ x 10 ⅜ in.)
The Nelson-Atkins Museum of Art, Kansas City, Missouri, purchase, Nelson Trust, 33-15/3
H 91, illustrated p. 44

CAT. 20

Compositional study for *Bathing Place, Asnières*, 1883
Oil on panel
15.8 x 25.1 cm (6 ¼ x 9 ⅞ in.)
The Art Institute of Chicago, gift of the Adele R. Levy Fund, Inc., 1962.578
H 93, illustrated p. 44

CAT. 21

Seated Boy, Nude (study for *Bathing Place, Asnières*), 1883
Conté crayon on paper
31.7 x 24.7 cm (12 ½ x 9 ¾ in.)
National Gallery of Scotland, Edinburgh, D 5110
H 598, illustrated p. 47

CAT. 22

Hat, Shoes, and Clothing (study for
Bathing Place, Asnières), 1883
Conté crayon on paper
23.6 x 30.9 cm (9 ¼ x 12 ⅛ in.)
Fogg Art Museum, Harvard University Art
Museums, Cambridge, Massachusetts,
gift of Lois Orswell, 1993.231
H 593, illustrated p. 47

CAT. 23

Reclining Man (study for *Bathing Place,
Asnières*), 1883
Conté crayon on paper
24.5 x 31.5 cm (9 ⅝ x 12 ⅜ in.)
Fondation Beyeler, Riehen/Basel, 50.1
H 589, illustrated p. 48

CAT. 24

Seated Boy with Straw Hat (study for
Bathing Place, Asnières), 1883
Conté crayon on paper
24.2 x 31.5 cm (9 ½ x 12 ⅜ in.)
Yale University Art Gallery, New Haven,
Everett V. Meeks, B.A. 1901, Fund, 1960.9.1
H 595, illustrated p. 49

CAT. 25

Echo (study for *Bathing Place,
Asnières*), 1883
Conté crayon on paper
31.2 x 24 cm (12 ¼ x 9 ½ in.)
Yale University Art Gallery, New Haven,
bequest of Edith Malvina K. Wetmore,
1966.80.11
H 597, illustrated p. 49

CAT. 26

Fishermen, 1883
Oil on panel
16 x 25 cm (6 ¼ x 9 ⅞ in.)
Musée d'Art Moderne de Troyes
H 78, illustrated p. 121

CAT. 27

Fisherman (study for *La Grande Jatte*),
c. 1883
Oil on panel
24 x 15 cm (9 ½ x 5 ⅞ in.)
Private collection, on long-term loan to
the Courtauld Institute Gallery, London,
LP 1997.XX.15
H 115, illustrated p. 68

CAT. 28

Woman Fishing (study for *La Grande
Jatte*), c. 1883
Conté crayon on paper
30.8 x 23.5 cm (12 ⅛ x 9 ¼ in.)
The Metropolitan Museum of Art, New York,
purchase, Joseph Pulitzer Bequest, 1951;
acquired from The Museum of Modern Art,
Lillie P. Bliss Collection, 55.21.4
H 635, illustrated p. 88

CAT. 29

Courbevoie, Landscape with Turret, 1883/84
Oil on panel
15.5 x 24.5 cm (6 ⅛ x 9 ⅝ in.)
Van Gogh Museum, Amsterdam, s489 S/1998
H 96, illustrated p. 50

CAT. 30

Girl in a Slouch Hat, 1883/84
Conté crayon on paper
31.8 x 24.1 cm (12 ½ x 9 ½ in.)
Private collection, New York
H 573, illustrated p. 34

CAT. 31

Acrobat by the Ticket Booth, 1883/84
Conté crayon on paper
31.5 x 24 cm (12 ⅜ x 9 ½ in.)
Private collection
H 671, illustrated p. 119

CAT. 32

Sidewalk Show, 1883/84
Conté crayon on paper
31.7 x 24.4 cm (12 ½ x 9 ⅜ in.)
The Phillips Collection, Washington, D.C.,
acquired 1939, 1728
H 668, illustrated p. 120

CAT. 33

*Banks of the Seine near
Courbevoie*, 1883/84
Oil on panel
16.5 x 24.8 cm (6 ½ x 9 ¾ in.)
The Hyde Collection, Glens Falls,
New York, 1971.45
H 67, illustrated p. 50

CAT. 34

Nurse with Carriage, 1883/84
Conté crayon on paper
31 x 25 cm (12 ⅛ x 9 ⅞ in.)
The Pierpont Morgan Library, New York,
gift of the Eugene Victor Thaw Art
Foundation, 1997.89
H 485, illustrated p. 32

CAT. 35

Landscape with Figures (study for
La Grande Jatte), 1884
Oil on panel
15.5 x 24.5 cm (6 ⅛ x 9 ⅝ in.)
The National Gallery, London, NG 6556
H 112, illustrated p. 69

CAT. 36

The Bineau Bridge, 1884
Oil on panel
14.5 x 24 cm (5 ¾ x 9 ½ in.)
Nationalmuseum, Stockholm, NM 6351
H 106, illustrated p. 51

CAT. 37

Riverman, 1884
Oil on panel
15.9 x 24.8 cm (6 ¼ x 9 ¾ in.)
Yale University Art Gallery, New Haven,
bequest of Edith Malvina K. Wetmore,
1966.80.11
H 65, illustrated p. 54

CAT. 38

Seated Woman (study for *La Grande
Jatte*), 1884
Oil on panel
15.6 x 25 cm (6 ⅛ x 9 ⅞ in.)
Private collection
H 140, illustrated p. 69

CAT. 39

Seated and Standing Figures (study for
La Grande Jatte), 1884
Oil on panel
15.6 x 24.1 cm (6 ⅛ x 9 ½ in.)
The Metropolitan Museum of Art, New York,
Robert Lehman Collection, 1975, 1975.1.207
H 117, illustrated p. 69

CAT. 40

Seated Figures (study for *La Grande
Jatte*), 1884
Oil on panel
16 x 24.5 cm (6 ¼ x 9 ⅝ in.)
Fogg Art Museum, Harvard University
Art Museums, Cambridge, Massachusetts,
bequest from the Collection of Maurice
Wertheim, Class of 1906, 1951.62
H 123, illustrated p. 70

CAT. 41

Sailboat (study for *La Grande Jatte*), 1884
Oil on panel
15.9 x 25 cm (6 ¼ x 9 ⅞ in.)
National Gallery of Art, Washington, D.C.,
Ailsa Mellon Bruce Collection, 1970.17.81
H 110, illustrated p. 73

CAT. 42

Landscape, Seated Man (study for
La Grande Jatte), 1884
Oil on panel
15.8 x 24.5 cm (6 ¼ x 9 ⅝ in.)
Collection André Bromberg
H 111, illustrated p. 73

CAT. 43

Standing Man (study for *La Grande
Jatte*), 1884
Oil on panel
15.2 x 24.8 cm (6 x 9 ¾ in.)
The National Gallery, London, NG 6560
H 139, illustrated p. 74

CAT. 44

Seated and Standing Women (study for
La Grande Jatte), 1884
Oil on panel
15.5 x 24.7 cm (6 ⅛ x 9 ¾ in.)
Albright-Knox Art Gallery, Buffalo, gift of
A. Conger Goodyear, 1948, 1948:7
H 125, illustrated p. 74

CAT. 45

Trees (study for *La Grande Jatte*), 1884
Conté crayon on paper, laid down on board
62 x 47.5 cm (24 ⅜ x 18 ¾ in.)
The Art Institute of Chicago, Helen
Regenstein Collection, 1966.184
H 619, illustrated p. 71

CAT. 46

Tree Trunks (study for *La Grande
Jatte*), 1884
Conté crayon on paper
47.4 x 61.5 cm (18 ⅝ x 24 ½ in.)
The Art Institute of Chicago, Helen
Regenstein Collection, 1987.184
H 620, illustrated p. 72

CAT. 47

Three Men Seated (study for *La Grande
Jatte*), 1884
Oil on panel
15.5 x 24.9 cm (6 ⅛ x 9 ⅞ in.)
Private collection
H 122, illustrated p. 74

CAT. 48

Sketch with Many Figures (study for
La Grande Jatte), 1884
Oil on panel
15.5 x 24.3 cm (6 ⅛ x 9 ⅝ in.)
The Art Institute of Chicago, gift of Mary
and Leigh Block, 1981.15
H 128, illustrated p. 74

CAT. 49

Woman Fishing and Seated Figures
(study for *La Grande Jatte*), 1884
Oil on panel
15.2 x 24 cm (6 x 9 ½ in.)
Private collection
H 120, illustrated p. 77

CAT. 50

Seated Man, Reclining Woman (study for
La Grande Jatte), 1884
Oil on panel
15.5 x 25 cm (6 ⅛ x 9 ⅞ in.)
Musée d'Orsay, Paris, gift of Mlle Thérèse
and M. Georges Henri Rivière in memory of
their parents, 1948, RF 1948-1
H 109, illustrated p. 86

CAT. 51

Rose-Colored Skirt (study for *La Grande
Jatte*), 1884
Oil on panel
15.2 x 24.1 cm (6 x 9 ½ in.)
Private collection
H 121, illustrated p. 76

CAT. 52

Seated Women with Baby Carriage (study
for *La Grande Jatte*), 1884
Oil on panel
16 x 25 cm (6 ¼ x 9 ⅞ in.)
Musée d'Orsay, Paris, anonymous gift, 1930,
RF 2828
H 129, illustrated p. 86

CAT. 53

Soldier ["*Cadet from Saint-Cyr*"] (study for
La Grande Jatte), 1884
Oil on panel
15.2 x 24.1 cm (6 x 9 ½ in.)
Private collection
H 130, illustrated p. 78

CAT. 54

Monkey (study for *La Grande Jatte*), 1884
Conté crayon on paper
17.7 x 23.7 cm (7 x 9 ¼ in.)
The Metropolitan Museum of Art, New York,
bequest of Miss Adelaide Milton de Groot
(1876–1967), 1967, 67.187.35
H 636, illustrated p. 87

CAT. 55

Monkey (study for *La Grande Jatte*), 1884
Conté crayon on paper
13.2 x 23.2 cm (5 ¼ x 9 ½ in.)
Private collection
H 638, illustrated p. 87

CAT. 56

Monkeys (study for *La Grande Jatte*), 1884
Conté crayon on paper
29.5 x 23 cm (11 ⅝ x 9 in.)
Private collection, Switzerland
H 640, illustrated p. 87

CAT. 57

Seven Monkeys (study for *La Grande
Jatte*), 1884
Conté crayon on paper
30 x 23.5 cm (11 ¾ x 9 ¼ in.)
Musée du Louvre, Paris, Département
des Arts Graphiques, Fonds du Musée
d'Orsay, RF 29 547
H 639, illustrated p. 87

CAT. 58

Seated Monkey (study for *La Grande
Jatte*), 1884
Conté crayon on paper
17.2 x 21.3 cm (6 ¾ x 8 ⅜ in.)
Solomon R. Guggenheim Museum,
New York, gift, Solomon R. Guggenheim,
June 28, 1937, 37.715
H 637, illustrated p. 87

CAT. 59

Woman with a Monkey (study for
La Grande Jatte), 1884
Oil on panel
24.8 x 15.9 cm (9 ¾ x 6 ¼ in.)
Smith College Museum of Art, Northampton,
Massachusetts, purchased, 1934:2-1
H 137, illustrated p. 79

CAT. 60

Landscape, Island of La Grande Jatte
(study for *La Grande Jatte*), 1884, 1885,
painted border 1889/90
Oil on canvas
65.3 x 81.2 cm (25 ¾ x 32 in.)
Private collection
H 131, illustrated p. 80

CAT. 61

The Couple (study for *La Grande Jatte*), 1884
Conté crayon on paper
31.2 x 23.6 cm (12 ¼ x 9 ¼ in.)
The British Museum, London, bequeathed by César Mange de Hauke, 1968-2-10-16
H 644, illustrated p. 85

CAT. 62

The Couple (study for *La Grande Jatte*), 1884
Oil on canvas
81 x 65 cm (31 ⅞ x 25 ⅝ in.)
Fitzwilliam Museum, Cambridge, England
H 138, illustrated p. 84

CAT. 63

Landscape, Island of La Grande Jatte (study for *La Grande Jatte*), 1884
Conté crayon on paper
42.2 x 62.8 cm (16 ¼ x 24 ¾ in.)
The British Museum, London, bequeathed by César Mange de Hauke, 1968-2-10-17
H 641, illustrated p. 79

CAT. 64

Compositional study (large sketch) for *La Grande Jatte*, 1884, painted border 1888/89
Oil on canvas
70.5 x 104.1 cm (27 ¾ x 41 in.)
The Metropolitan Museum of Art, New York, bequest of Sam A. Lewisohn, 1951, 51.112.6
H 142, illustrated p. 81

CAT. 65

Boat near the Riverbank, Asnières, c. 1884
Oil on panel
15 x 24 cm (5 ⅞ x 9 ½ in.)
Courtauld Institute Gallery, London, P.2000.XX.2
H 76, illustrated p. 51

CAT. 66

Man in a Top Hat, c. 1884
Conté crayon on paper
31 x 23 cm (12 ⅛ x 9 in.)
The John C. Whitehead Collection, courtesy of Achim Moeller Fine Art, New York
H 571, illustrated p. 90

CAT. 67

Skirt (study for *La Grande Jatte*), 1884/85
Conté crayon on paper
30 x 17 cm (11 ¾ x 6 ¾ in.)
Musée Picasso, Paris
H 624, illustrated p. 89

CAT. 68

Woman Walking with a Parasol (study for *La Grande Jatte*), 1884/85
Conté crayon on paper
31.7 x 24.1 cm (12 ½ x 9 ½ in.)
The Art Institute of Chicago, bequest of Abby Aldrich Rockefeller, 1999.8
H 625, illustrated p. 89

CAT. 69

Seated Woman (study for *La Grande Jatte*), 1884/85
Conté crayon on paper
30.2 x 16.5 cm (11 ⅞ x 6 ½ in.)
The Philadelphia Museum of Art, The Louis E. Stern Collection, 1963, 1963-181-180
H 632, illustrated p. 94

CAT. 70

Head of a Young Woman (study for *La Grande Jatte*), 1884/85
Conté crayon on paper
30 x 21.5 cm (11 ¾ x 8 ½ in.)
Smith College Museum of Art, Northampton, Massachusetts, purchased with the Tryon Fund, 1938:10-1
H 634, illustrated p. 93

CAT. 71

Seated Woman with a Parasol (study for *La Grande Jatte*), 1884/85
Conté crayon on paper
47.7 x 31.5 cm (18 ⅞ x 12 ⅜ in.)
The Art Institute of Chicago, bequest of Abby Aldrich Rockefeller, 1999.7
H 629, illustrated p. 94

CAT. 72

Young Woman (study for *La Grande Jatte*), 1884/85
Conté crayon on paper
31.3 x 16.2 cm (12 ⅜ x 6 ⅜ in.)
Kröller-Müller Museum, Otterlo, the Netherlands, KM 104.226
H 627, illustrated p. 94

CAT. 73

Child in White (study for *La Grande Jatte*), 1884/85
Conté crayon on paper
30.5 x 23.5 cm (12 x 9 ¼ in.)
Solomon R. Guggenheim Museum, New York, gift, Solomon R. Guggenheim, 1937, 37.717
H 631, illustrated p. 93

CAT. 74

Nurse (study for *La Grande Jatte*), 1884/85
Conté crayon on paper
23.5 x 31.1 cm (9 ¼ x 12 ¼ in.)
Albright-Knox Art Gallery, Buffalo, gift of A. Conger Goodyear, 1963, 1963:3
H 630, illustrated p. 92

CAT. 75

Three Young Women (study for *La Grande Jatte*), 1884/85
Conté crayon on paper
23.5 x 30.5 cm (9 ¼ x 12 in.)
Smith College Museum of Art, Northampton, Massachusetts, purchased with the Tryon Fund, 1938:10-2
H 633, illustrated p. 91

CAT. 76

Field of Alfalfa, Saint-Denis, 1884/85
Oil on canvas
64 x 81 cm (25 ¼ x 32 ⅞ in.)
National Gallery of Scotland, Edinburgh, NG 2324
H 145, illustrated p. 55

CAT. 77

Elegant Woman, 1884/85
Conté crayon on paper
31.8 x 23.8 cm (12 ½ x 9 ⁷⁄₁₆ in.)
J. Paul Getty Museum, Los Angeles
H 503bis, illustrated p. 89

CAT. 78

Woman with a Muff, 1884/86
Conté crayon on paper
30 x 23 cm (11 ⅞ x 9 in.)
The John C. Whitehead Collection, courtesy of Achim Moeller Fine Art, New York
H 611, illustrated p. 90

CAT. 79

Woman with a Muff, 1884/86
Conté crayon on paper, laid down on board
31.3 x 23.8 cm (12 ⅜ x 9 ⅜ in.)
The Art Institute of Chicago, gift of Robert Allerton, 1926.716
H 612, illustrated p. 90

CAT. 80

A Sunday on La Grande Jatte—1884, 1884–86, painted border 1888/89
Oil on canvas
207.5 x 308.1 cm (81 ¾ x 121 ¼ in.)
The Art Institute of Chicago, Helen Birch Bartlett Memorial Collection, 1926.224
H 162, illustrated pp. 82–83 and on rear gatefold

CAT. 81

Grandcamp, Evening, 1885,
painted border 1888/89
Oil on canvas
66.2 x 82.4 cm (26 x 32 ½ in.)
The Museum of Modern Art, New York,
estate of John Hay Whitney, 1983, 285.1983
H 161, illustrated p. 60

CAT. 82

Roadstead at Grandcamp, 1885
Oil on canvas
65 x 80 cm (25 ⅝ x 31 ⅞ in.)
Private collection, New York
H 160, illustrated p. 61

CAT. 83

Study for *Le Bec du Hoc*, 1885
Oil on panel
15.6 x 24.5 cm (6 ⅛ x 9 ⅝ in.)
National Gallery of Australia, Canberra,
purchased from proceeds of The Great
Impressionists exhibition, 1984, 84.1933
H 158, illustrated p. 62

CAT. 84

Le Bec du Hoc, 1885, reworked 1888/89
Oil on canvas
64.8 x 81.6 cm (25 ½ x 32 ⅛ in.)
Tate, London, purchased 1952, N 06067
H 159, illustrated p. 63

CAT. 85

Study for *The Seine at Courbevoie*, 1885
Oil on panel
24.9 x 15.7 cm (9 ¾ x 6 ⅛ in.)
The National Gallery, London, NG 6557
H 133, illustrated p. 65

CAT. 86

Approach to the Bridge at Courbevoie,
1885/86
Conté crayon on paper
23.2 x 30 cm (9 ⅛ x 11 ¾ in.)
Thaw Collection, The Pierpont Morgan
Library, New York
H 650, illustrated p. 132

CAT. 87

Condolences, 1885/86
Conté crayon on paper
24 x 31.7 cm (9 ½ x 12 ½ in.)
Collection Michael and Judy Steinhardt,
New York, M1997.02
H 655, illustrated p. 120

CAT. 88

*Lighthouse and Mariners' Home,
Honfleur*, 1886
Oil on canvas
66.7 x 81.9 cm (26 ¼ x 32 ¼ in.)
National Gallery of Art, Washington, D.C.,
Collection of Mr. and Mrs. Paul Mellon,
1983.1.33
H 173, illustrated p. 137

CAT. 89

The Bridge at Courbevoie, 1886
Conté crayon on paper
24.1 x 30.5 cm (9 ½ x 12 in.)
Private collection, courtesy Ivor Braka
LTD, London
H 653, illustrated p. 134

CAT. 90

Evening, Honfleur, 1886, painted
frame 1889/90
Oil on canvas
65.4 x 81.3 cm (25 ¾ x 32 in.)
The Museum of Modern Art, New York,
gift of Mrs. David M. Levy, 1957
H 167, illustrated p. 136

CAT. 91

Study for *The Shore at Bas-Butin,
Honfleur*, 1886
Oil on panel
17.2 x 26.1 cm (6 ¾ x 10 ¼ in.)
The Baltimore Museum of Art, bequest of
Saidie A. May, BMA 1951.357
H 168, illustrated p. 135

CAT. 92

Two Clowns, 1886/88
Conté crayon on paper
23.3 x 30.8 cm (9 ⅛ x 12 ⅛ in.)
Fine Arts Museums of San Francisco,
Museum Purchase, Archer M. Huntington
Ford, 1947.1
H 675, illustrated p. 119

Claude Monet (French, 1840–1926)

CAT. 93

Springtime on La Grande Jatte, 1878
Oil on canvas
50 x 61 cm (19 ⅝ x 24 ⅛ in.)
Nasjonalgalleriet, Oslo, NG.M.01290
W 459, illustrated p. 99

CAT. 94

*Springtime through the Branches, Island
of La Grande Jatte*, 1878
Oil on canvas
52 x 63 cm (20 ½ x 24 ¾ in.)
Musée Marmottan-Monet, Paris, 4018
W 455, illustrated p. 66

CAT. 95

The Meadow, 1879
Oil on canvas
79 x 98 cm (31 ⅛ x 38 ⅝ in.)
Joslyn Art Museum, Omaha, gift of Mr.
William Averell Harriman, JAM1944.79
W 535, illustrated p. 57

CAT. 96

Cliff Walk at Pourville, 1882
Oil on canvas
65.5 x 82.3 cm (25 ¾ x 32 ⅜ in.)
The Art Institute of Chicago, Mr. and Mrs.
Lewis Larned Coburn Memorial Collection,
1933.443
W 758, illustrated p. 59

CAT. 97

Custom House, 1882
Oil on canvas
60.3 x 81.4 cm (23 ¾ x 32 in.)
The Philadelphia Museum of Art, The William
L. Elkins Collection, 1924, E1924-3-61
W 743, illustrated p. 62

CAT. 98

Departure of the Boats, Étretat, 1885
Oil on canvas
73.5 x 93 cm (28 ⅞ x 36 ⅝ in.)
The Art Institute of Chicago, Potter Palmer
Collection, 1922.428
W 1025, illustrated p. 64

CAT. 99

*Poppy Field in a Hollow near
Giverny*, 1885
Oil on canvas
65.1 x 81.3 cm (25 ⅝ x 32 in.)
Museum of Fine Arts, Boston, Juliana
Cheney Edwards Collection, 25.106
W 1000, illustrated p. 56

Camille Pissarro (French, 1830–1903)

CAT. 100

Woodcutter, 1879
Oil on canvas
89 x 116.2 cm (35 x 45 ¾ in.)
Private collection
PV 499, illustrated p. 115

CAT. 101

Peasant Girl with a Straw Hat, 1881
Oil on canvas
73.4 x 59.6 cm (28 ⅞ x 23 ½ in.)
National Gallery of Art, Washington, D.C.,
Ailsa Mellon Bruce Collection, 1970.17.52
PV 548, illustrated p. 42

CAT. 102

*Repose, Young Female Peasant Lying in
the Grass*, 1882
Oil on canvas
63 x 78 cm (24 ¾ x 30 ¾ in.)
Kunsthalle Bremen, 960-1967/8
PV 565, illustrated p. 58

CAT. 103

Woman and Child at the Well, 1882
Oil on canvas
81.5 x 66.4 cm (32 ⅛ x 26 ⅛ in.)
The Art Institute of Chicago, Potter Palmer
Collection, 1922.436
PV 574, illustrated p. 103

CAT. 104

Gathering Apples, 1885–86
Oil on canvas
125 x 126.3 cm (49 ¼ x 49 ¾ in.)
Ohara Museum of Art, Kurashiki, Japan, 1008
PV 695, illustrated p. 122

CAT. 105

Landscape at Éragny, 1886
Oil on canvas
33 x 41 cm (13 x 15 ⅛ in.)
Private collection
Illustrated p. 137

Lucien Pissarro (French, 1863–1944)

CAT. 106

Church at Éragny, 1886
Oil on canvas
50 x 70 cm (20 x 27 ½ in.)
Ashmolean Museum, Oxford, presented by
the Pissarro Family 1952, WA 1952.6.7; A836
Illustrated p. 128

**Pierre-Auguste Renoir (French,
1841–1919)**

CAT. 107

*Lunch at the Restaurant Fournaise
(The Rowers' Lunch)*, c. 1875
Oil on canvas
55.1 x 65.9 cm (21 ¾ x 26 in.)
The Art Institute of Chicago, Potter Palmer
Collection, 1922.437
Illustrated p. 112

CAT. 108

Oarsmen at Chatou, 1879
Oil on canvas
81.2 x 100.2 cm (32 x 39 ½ in.)
National Gallery of Art, Washington, D.C.,
gift of Sam A. Lewisohn, 1951.5.2
Illustrated p. 45

CAT. 109

The Seine at Chatou, 1881
Oil on canvas
73.5 x 92.4 cm (28 ⅞ x 36 ⅜ in.)
Museum of Fine Arts, Boston, gift of Arthur
Brewster Emmons, 19.771
Illustrated p. 52

CAT. 110

Sunset on the English Channel, 1883
Oil on canvas
54 x 65 cm (21 ¼ x 26 ½ in.)
Sterling and Francine Clark Art Institute,
Williamstown, Massachusetts, 1955.607
Illustrated p. 41

CAT. 111

View at Guernsey, 1883
Oil on canvas
46 x 55.9 cm (18 ⅛ x 22 in.)
Sterling and Francine Clark Art Institute,
Williamstown, Massachusetts, 1955.601
Illustrated p. 64

CAT. 112

La Roche-Guyon, 1885
Oil on canvas
47 x 56 cm (18 ½ x 22 in.)
Aberdeen Art Gallery and Museums
Collections, ABDAG 3043
Illustrated p. 113

Paul Signac (French, 1863–1935)

CAT. 113

*Mariners' Cross at High Tide,
Saint-Briac*, 1885
Oil on canvas
33 x 46 cm (13 x 18 ⅛ in.)
The Dixon Gallery and Gardens,
Memphis, bequest of Mr. and Mrs. Hugo N.
Dixon, 1975.14
FC 104, illustrated p. 53

CAT. 114

Riverbank, Asnières, 1885
Oil on canvas
73 x 100 cm (28 ¾ x 39 ⅜ in.)
Private collection
FC 109, illustrated p. 125

CAT. 115

Les Andelys, Château Gaillard, 1886
Oil on canvas
45 x 65 cm (17 ¾ x 25 ⅝ in.)
The Nelson-Atkins Museum of Art,
Kansas City, Missouri, purchase, acquired
through the generosity of an anonymous
donor, F78-13
FC 120, illustrated p. 138

CAT. 116

The Branch Line at Bois-Colombes, 1886
Oil on canvas
33 x 47 cm (13 x 18 ⅛ in.)
Leeds City Art Gallery, 34/48
FC 116, illustrated p. 124

CAT. 117

Gas Tanks at Clichy, 1886
Oil on canvas
65 x 81 cm (25 ⅝ x 31 ⅞ in.)
National Gallery of Victoria, Melbourne,
Felton Bequest, 1948, 1817–4
FC 117, illustrated p. 127

CAT. 118

*Hillside from Downstream,
Les Andelys*, 1886
Oil on canvas
60 x 92 cm (23 ⅝ x 36 ¼ in.)
The Art Institute of Chicago, through prior
gift of William Wood Prince, 1993.208
FC 125, illustrated p. 140

CAT. 119

Riverbank, Les Andelys, 1886
Oil on canvas
65 x 81 cm (25 ⅝ x 31 ⅞ in.)
Musée d'Orsay, Paris, acquired through gift,
RF 1996-6
FC 128, illustrated p. 139

CAT. 120

Snow, Boulevard Clichy, 1886
Oil on canvas
46 x 65 cm (18 ⅛ x 25 ⅝ in.)
Minneapolis Institute of Arts, bequest of
Putnam Dana McMillan, 61.36.16
FC 115, illustrated p. 125

Selected Bibliography

This bibliography includes the most essential works and those referred to more than once in the notes. More complete bibliographies are found in Herbert et al. 1991, Smith 1997, and Clement and Houzé 1999. Articles of 1886 reprinted in Berson 1996 are so indicated.

Adam, Paul. 1886. "Peintres impressionnistes." *Revue contemporaine* 5 (May), pp. 541–51. Reprinted in Berson 1996, pp. 427–30.

———. 1888. "Les Impressionnistes à l'exposition des Indépendants." *La Vie moderne* 10, 15 (April 15), pp. 228–29.

Barr, Alfred H., Jr. 1936. *Cubism and Abstract Art.* Exh. cat. New York: Museum of Modern Art.

Berson, Ruth, ed. 1996. *The New Painting: Impressionism, 1874–1886; Documentation.* Vol. 1, reviews. San Francisco: Fine Arts Museums of San Francisco.

Blanc, Charles. 1880. *Grammaire des arts du dessin.* Paris. First published 1867.

Boime, Albert. 1964. "Le Musée des copies." *Gazette des beaux-arts* 64, 1149 (October), pp. 237–47.

———. 1985. "The Teaching of Fine Arts and the Avant-Garde in France during the Second Half of the Nineteenth Century." *Arts Magazine* 60, 4 (December), pp. 46–57.

Booth, Wayne C. 1974. *A Rhetoric of Irony.* Chicago: University of Chicago Press.

Brettell, Richard R. 1986. "The Bartletts and the *Grande Jatte*: Collecting Modern Painting in the 1920s." *Art Institute of Chicago Museum Studies* 12, 2, pp. 103–13.

Broude, Norma, ed. 1978. *Seurat in Perspective.* Englewood Cliffs, N.J.: Prentice-Hall.

Cachin, Françoise. 2000. *Signac: Catalogue raisonné de l'oeuvre peint.* In collaboration with Marina Ferretti-Bocquillon. Paris: Gallimard, 2000.

Chevreul, M.-E. 1839. *De la loi du contraste simultané des couleurs.* Paris, 1839.

Christophe, Jules. 1886. "Chronique: Rue Laffitte, no. 1." *Journal des artistes* (June 13), pp. 193–94. Reprinted in Berson 1996, pp. 436–37.

———. 1890. "Georges Seurat." *Les Hommes d'aujourd'hui* 8, 368 (April), n. pag.

Clark, T. J. 1984. *The Painting of Modern Life: Paris in the Art of Manet and His Followers.* New York: Knopf.

Clayson, S. Hollis. 1989. "The Family and the Father: The *Grande Jatte* and Its Absences." *Art Institute of Chicago Museum Studies* 14, 2, pp. 155–64.

Clement, Russell T., and Annick Houzé. 1999. *Neo-Impressionist Painters: A Sourcebook on Georges Seurat, Camille Pissarro, Paul Signac, Théo van Rysselberghe, Henri-Edmond Cross, Charles Angrand, Maximilien Luce, and Albert Dubois-Pillet.* Westport, Conn.: Greenwood Press.

Coquiot, Gustave. 1924. *Seurat.* Paris: A. Michel.

CP. See Pissarro 1980–89.

Dorra, Henri, and John Rewald. 1959. *Seurat: L'Oeuvre peint, biographie et catalogue critique.* Paris: Les Beaux-Arts.

FC. See Cachin 2000.

Fénéon, Félix. 1886a. "Les Impressionnistes." *La Vogue* 1, 8 (June 13), pp. 261–75. Reprinted in Berson 1996, pp. 441–45.

———. 1886b. "L'Impressionnisme aux Tuileries." *L'Art moderne* 6, 38 (September 19), pp. 300–02.

———. 1889. "Exposition des artistes indépendantes à Paris." *L'Art moderne* 9, 43 (October 27), pp. 339–41.

———. 1970. *Oeuvres plus que complètes.* Edited by Joan U. Halperin. Two vols. Geneva: Droz. Writings by Fénéon in the present volume have been separately listed in the bibliography and in footnotes, but all are found in this anthology, which eclipses all prior collections of Fénéon's writings.

Ferretti-Bocquillon, Marina, Anne Distel, John Leighton, and Susan Alyson Stein. 2001. *Signac, 1863–1935.* With contributions by Kathryn Calley Galitz and Sjraar van Heugten. Exh. cat. New York: Metropolitan Museum of Art.

Fèvre, Henry. 1886. "L'Exposition des impressionnistes." *Revue de demain* (May–June), pp. 148–56. Reprinted in Berson 1996, pp. 445–47.

Fiedler, Inge. 1984. "Materials Used in Seurat's *La Grande Jatte*, Including Color Changes and Notes on the Evolution of the Artist's Palette." *Preprints of Papers Presented at the Twelfth Annual Meeting, Los Angeles, California, 15–20 May 1984,* pp. 43–51. Washington, D.C.: The American Institute for Conservation of Historic and Artistic Works.

———. 1989. "A Technical Evaluation of the *Grande Jatte*." *Art Institute of Chicago Museum Studies* 14, 2, pp. 173–79.

Franz, Erich, and Bernd Growe. 1984. *Georges Seurat, Drawings.* Translated by John William Gabriel. Boston: Little, Brown.

Gage, John. 1987. "The Technique of Seurat: A Reappraisal." *Art Bulletin* 69, 3 (September), pp. 448–54.

———. 1993. *Colour and Culture: Practice and Meaning from Antiquity to Abstraction.* London: Thames and Hudson.

———. 1999. *Colour and Meaning: Art, Science, and Symbolism.* London: Thames and Hudson.

Goldwater, Robert J. 1941. "Some Aspects of the Development of Seurat's Style." *Art Bulletin* 23, 2 (June), pp. 117–30.

"The *Grande Jatte* at 100." 1989. Special issue, *Art Institute of Chicago Museum Studies* 14, 2.

H. See Hauke 1961.

Halperin, Joan U. 1988. *Félix Fénéon, Aesthete and Anarchist in Fin-de-Siècle Paris.* New Haven: Yale University Press.

———. 2002. "The Ironic Eye/I in Jules Laforgue and Georges Seurat." Unpublished typescript. Included in a collection of essays being assembled by Paul Smith for eventual publication.

Hauke, César M. de. 1961. *Seurat et son oeuvre.* Two vols. Paris: Gründ.

Herbert, Eugenia W. 1961. *The Artist and Social Reform: France and Belgium, 1885–1898.* New Haven: Yale University Press.

Herbert, Robert L. 1962. *Seurat's Drawings.* New York: Shorewood.

———. 1970. "Seurat's Theories." In Sutter and Herbert 1970, pp. 23–42. Reprinted in Herbert 2001.

———. 1980. "'Parade de cirque' de Seurat et l'esthétique scientifique de Charles Henry." *Revue de l'art* 50, pp. 9–23. Translated in Herbert 2001.

———. 2001. *Seurat: Drawings and Paintings.* New Haven: Yale University Press, 2001.

Herbert, Robert L., Françoise Cachin, Anne Distel, Susan Alyson Stein, and Gary Tinterow. 1991. *Georges Seurat, 1859–1891.* Exh. cat. New York : Metropolitan Museum of Art.

Hermel, Maurice. 1886. "L'Exposition de peinture de la rue Laffitte." *La France libre* (28 May), pp. 1–2. Reprinted in Berson 1996, pp. 456–57.

Herz-Fischler, Roger. 1983. "An Examination of Claims Concerning Seurat and 'The Golden Number.'" *Gazette des beaux-arts* 101, 1370 (March), pp. 109–12.

———. 1997. "Le Nombre d'or en France de 1896 à 1927." *Revue de l'art* 118, 4, pp. 9–16.

Homer, William I. 1964. *Seurat and the Science of Painting.* Cambridge, Mass.: MIT Press.

House, John. 1980. "Meaning in Seurat's Figure Paintings." *Art History* 3, 3 (September), pp. 345–56.

———. 1989. "Reading the *Grande Jatte.*" *Art Institute of Chicago Museum Studies* 14, 2, pp. 115–31.

Humbert de Superville, David-Pierre-Giottino. 1827–32. *Essai sur les signes inconditionnels dans l'art.* Leiden: C. C. van der Hoek.

Hutton, John G. 1994. *Neo-Impressionism and the Search for Solid Ground: Art, Science, and Anarchism in Fin-de-Siècle France.* Baton Rouge: Louisiana State University Press.

Kahn, Gustave. 1891. "Seurat." *L'Art moderne* 11, 14 (April 5), pp. 107–10.

———. 1928. *Les Dessins de Georges Seurat (1859–1891).* Two vols. Paris: Bernheim-Jeune.

Katz, Leslie. 1958. "Seurat: Allegory and Image." *Arts* 32, 7 (April), pp. 40–47.

Kemp, Martin. 1990. *The Science of Art: Optical Themes in Western Art from Brunelleschi to Seurat.* New Haven: Yale University Press.

Kinney, Leila W. 1994. "Fashion and Figuration in Modern Life Painting." In *Architecture: In Fashion,* edited by Deborah Fausch et al., pp. 270–313. New York: Princeton Architectural Press.

Kirby, Jo, Kate Stonor, Ashok Roy, Aviva Burnstock, Rachel Grout, and Raymond White. 2003. "Seurat's Painting Practice: Theory, Development and Technology." *National Gallery Technical Bulletin* 24, pp. 5–37.

Kochi, Museum of Art. 2002. *Georges Seurat et le Néo-Impressionnisme, 1885–1905.* Exh. cat. Tokyo: APT International.

Leighton, John, and Richard Thomson. 1997. *Seurat and the Bathers.* With David Bomford, Jo Kirby, and Ashok Roy. Exh. cat. London: National Gallery.

Lhote, André. 1922. *Seurat.* Rome: Editions de Valori Plastici.

Moffett, Charles S. 1986. *The New Painting: Impressionism, 1874–1886.* With the assistance of Ruth Berson, Barbara Lee Williams, and Fronia E. Wissman. Exh. cat. San Francisco: Fine Arts Museums of San Francisco; Washington, D.C.: National Gallery of Art.

[Moore, George]. 1886. "Half-a-Dozen Enthusiasts." *The Bat* [London] (May 25), pp. 185–86. Reprinted in Berson 1996, pp. 435–36.

Muecke, D. C. 1969. *The Compass of Irony.* London: Methuen.

Neveux, Marguerite. 1990. "Construction et proportion: Apports germaniques dans une théorie de la peinture française de 1850 à 1950." Ph.D. diss. Université de Paris.

Nochlin, Linda. 1989. "Seurat's *Grande Jatte*: An Anti-Utopian Allegory." *Art Institute of Chicago Museum Studies* 14, 2, pp. 133–53.

Orton, Fred, and Griselda Pollock. 1980. "Les Données bretonnantes: La Prairie de représentation." *Art History* 3, 3 (September), pp. 314–44.

Pissarro, Camille. 1980–89. *Correspondance de Camille Pissarro.* Five vols. Edited by Janine Bailly-Herzberg. Paris: Presses universitaires de France.

Pissaro, Ludovic Rodolphe, and Lionello Venturi. 1939. *Camille Pissarro: Son Art, son oeuvre.* Two vols. Paris: P. Rosenberg.

PV. See Pissarro and Venturi 1939.

Rewald, John. 1943. *Georges Seurat.* New York: Wittenborn.

———. 1956. *Post-Impressionism: From van Gogh to Gauguin.* New York: Museum of Modern Art.

Rich, Daniel Catton. 1935. *Seurat and the Evolution of "La Grande Jatte."* Chicago: University of Chicago Press.

Rood, Ogden. 1879. *Modern Chromatics: Students' Text-Book of Color with Applications to Art and Industry.* New York: Appleton. Translated as *Théorie scientifique des couleurs et leurs applications à l'art et à l'industrie.* Paris, 1881.

Roque, Georges. 1997. *Art et science de la couleur: Chevreul et les peintres de Delacroix à l'abstraction.* Nîmes: J. Chambon.

Russell, John. *Seurat.* 1965. New York: Oxford University Press.

Salmon, André. 1920. "Georges Seurat." *Burlington Magazine* 37, 210 (September), pp. 115–22.

Schapiro, Meyer. 1935. "Seurat and 'La Grande Jatte.'" *Columbia Review* 17, pp. 9–16.

———. 1937. "The Nature of Abstract Art." *Marxist Quarterly* 1 (January–March), pp. 77–99. Reprinted in Schapiro 1978, pp. 185–211.

———. 1958. "New Light on Seurat." *Art News* 57, 2 (April), pp. 22–24ff. Reprinted in Schapiro 1978, pp. 101–09.

———. 1978. *Modern Art, 19th and 20th Centuries: Selected Papers.* New York: G. Braziller.

Seligman, Germain. 1947. *The Drawings of Georges Seurat.* New York: C. Valentin.

Seurat's Argus. Press clippings and hand-written reviews, preserved in a largely dismembered set of pages and in press-service sheets, in the archives of César M. de Hauke, incorporating Félix Fénéon's archives concerning Seurat. Bibliothèque Nationale, Paris, fonds Jacques Doucet.

Shiff, Richard. 2002. "Puppet and Test Pattern: Mechanicity and Materiality in Modern Pictorial Representation." In *From Energy to Information: Representation in Science and Technology, Art, and Literature,* edited by Bruce Clarke and Linda Dalrymple Henderson, pp. 327–50. Stanford: Stanford University Press.

Signac's Album. Press clippings preserved in albums, with some loose-leaf pages. Private collection, Paris.

Signac, Paul. 1899. *D'Eugène Delacroix au néo-impressionnisme.* Paris: Éditions de la Revue Blanche, 1899.

Silver, Kenneth E. 1989. *Esprit de Corps: The Art of the Parisian Avant-Garde and the First World War, 1914–1925.* Princeton, N.J.: Princeton University Press.

Smith, Paul. 1997. *Seurat and the Avant-Garde.* New Haven: Yale University Press.

Sutter, Jean. 1964. "Recherches sur la vie de Georges Seurat." Unpublished typescript.

Sutter, Jean, and Robert L. Herbert. 1970. *The Neo-Impressionists.* London: Thames and Hudson.

Thomson, Richard. 1985. *Seurat.* Oxford: Phaidon.

———. 1989. "The *Grande Jatte:* Notes on Drawing and Meaning." *Art Institute of Chicago Museum Studies* 14, 2, pp. 181–97.

Venturi, Lionello. 1950. *Impressionists and Symbolists.* New York: Scribner.

Verhaeren, Émile. 1891. "Georges Seurat." *La Société nouvelle* 7, 1, pp. 429–38. Reprinted with minor variations in his *Sensations.* Paris, 1927.

W. See Wildenstein 1974–91.

Ward, Martha. 1986. "The Rhetoric of Independence and Innovation." In Moffett 1986, pp. 421–42.

———. 1996. *Pissarro, Neo-Impressionism, and the Spaces of the Avant-Garde.* Chicago: University of Chicago Press.

Webster, J. Carson. 1944. "The Technique of Impressionism: A Reappraisal." *College Art Journal* 4, 1 (November), pp. 3–22.

Wildenstein, Daniel. 1974–91. *Claude Monet: Biographie et catalogue raisonné.* Five vols. Lausanne: La Bibliothèque des Arts.

Zimmermann, Michael F. 1989. "Seurat, Charles Blanc, and Naturalist Art Criticism." *Art Institute of Chicago Museum Studies* 14, 2, pp. 199–209.

———. 1991. *Seurat and the Art Theory of His Time.* Antwerp: Fonds Mercator.

———. 1995. "Die 'Erfindung' Pieros und seine Wahlverwandtschaft mit Seurat." In *Piero della Francesca and His Legacy,* edited by Marilyn Aronberg Lavin, pp. 269–301. Washington, D.C.: National Gallery of Art.

Lenders to the Exhibition

Catalogue numbers follow lenders' names.

Public Institutions

Aberdeen Art Gallery and Museums
Collections, 112

Albright-Knox Art Gallery, Buffalo, 44, 74

The Art Institute of Chicago, 20, 45, 46, 48,
68, 71, 79, 80, 96, 98, 103, 107, 118

Ashmolean Museum, Oxford, 106

The Baltimore Museum of Art, 91

The British Museum, London, 61, 63

The Cleveland Museum of Art, 18

Courtauld Institute Gallery, London, 14, 65

Dallas Museum of Art, 5

The Dixon Gallery and Gardens, Memphis, 113

Fine Arts Museums of San Francisco, 92

Fitzwilliam Museum, Cambridge, England, 62

Fogg Art Museum, Harvard University Art
Museums, Cambridge, Massachusetts,
22, 40

Fondation Beyeler, Riehen/Basel, 23

The Hyde Collection, Glens Falls, New
York, 33

J. Paul Getty Museum, Los Angeles, 77

Joslyn Art Museum, Omaha, 95

Kröller-Müller Museum, Otterlo,
the Netherlands, 72

Kunsthalle Bremen, 102

Leeds City Art Gallery, 116

The Metropolitan Museum of Art, New York,
12, 28, 39, 54, 64

Minneapolis Institute of Arts, 120

Musée d'Art Moderne de Troyes, 26

Musée d'Orsay, Paris, 50, 52, 119

Musée du Louvre, Paris, Département
des Arts Graphiques, Fonds du Musée
d'Orsay, 57

Musée Marmottan-Monet, Paris, 94

Musée Picasso, Paris, 67

Museum of Fine Arts, Boston, 99, 109

The Museum of Modern Art, New York, 81, 90

Nasjonalgalleriet, Oslo, 93

The National Gallery, London, 16, 35, 43, 85

National Gallery of Art, Washington, D.C., 41,
88, 101, 108

National Gallery of Australia, Canberra, 83

National Gallery of Scotland, Edinburgh, 17,
21, 76

National Gallery of Victoria, Melbourne, 117

Nationalmuseum, Stockholm, 36

National Museums Liverpool, 7

The Nelson-Atkins Museum of Art, Kansas
City, Missouri, 19, 115

Ohara Museum of Art, Kurashiki, Japan, 104

The Philadelphia Museum of Art, 69, 97

The Phillips Collection, Washington, D.C.,
6, 32

The Pierpont Morgan Library, New York,
34, 86

Smith College Museum of Art, Northampton,
Massachusetts, 59, 70, 75

Solomon R. Guggenheim Museum, New York,
8, 13, 58, 73

Sterling and Francine Clark Art Institute,
Williamstown, Massachusetts, 110, 111

Tate, London, 84

Van Gogh Museum, Amsterdam, 29

Yale University Art Gallery, New Haven, 24,
25, 37

Private Collectors

Collection André Bromberg, 1, 3, 42

Collection E.W.K., Bern, 11

Collection Michael and Judy Steinhardt,
New York, 87

Dian Woodner and Andrea Woodner,
New York, 9

The John C. Whitehead Collection,
courtesy of Achim Moeller Fine Art,
New York, 66, 78

Nahmad Collection, Switzerland, 10

Prat Collection, Paris, 2

Anonymous, 4, 15, 27, 30, 31, 38, 47, 49, 51,
53, 55, 56, 60, 82, 89, 100, 105, 114

Index

Page numbers in italics refer to illustrations.

Photography Credits

Unless otherwise stated, all photographs of works of art appear courtesy of the lenders. The following credits apply to all images for which separate acknowledgement is due. Many of the images in this catalogue are protected by copyright and may not be available for further reproduction without the permission of the artist or copyright holder. Credits have been arranged according to the order in which they appear in the catalogue.

Druick and Groom FIG. 1: Photo courtesy of the late John Greg Allerton. The Art Institute of Chicago (hereafter AIC), Department of Imaging, E9138. FIGS. 2, 5: Courtesy of the Ryerson and Burnham Archives, AIC, G20957, C11989. FIG. 3: The Grillo Group, Inc. FIG. 4: AIC, Department of Imaging, E8986.

Introduction FIG. 1: Courtesy of Robert L. Herbert, gift from Dr. Jean Sutter, c. 1966.

Chapter 1 FIGS. 1, 6, 7: Réunion des Musées Nationaux/Art Resource, N.Y. (hereafter R.M.N./A.R.). Photography by Michéle Bellot. FIG. 2: R.M.N./A.R. FIG. 4: The Moore Danowski Trust. CAT. 9: Photography by Jim Strong. CAT. 34: Photography by Joseph Zehavi, 2003. FIG. 10: Loys Delteil, *Le Peintre-graveur illustré (XIXe et XXe siècles)*, vol. 26, Honoré Daumier (VII) (Paris, 1926). FIG. 11: Kunstmuseum Basel, Switzerland/ Lauros-Giraudon-Bridgeman Art Library. CAT. 7: National Museums Liverpool (The Walker). CATS. 110, 111: © Sterling and Francine Clark Art Institute, Williamstown, Massachusetts. CATS. 101, 108: Image © 2003 Board of Trustees, National Gallery of Art, Washington, D.C. CAT. 12: Photograph © 1990 The Metropolitan Museum of Art. CATS. 14, 65: Courtauld Institute of Art Gallery. CAT. 15: Private collection, on extended loan to the Courtauld Institute of Art Gallery. CAT. 19: Photography by Mel McLean. FIG. 12: Erich Lessing/Art Resource, N.Y. CAT. 22: Photography by Allen Macintyre © 2003 President and Fellows of Harvard College. CAT. 33: Photography by Joseph Levy. CAT. 99: Photograph © 2003 Museum of Fine Arts, Boston. CAT. 81: Digital Image © 2003 The Museum of Modern Art, New York. CAT. 82: Photo by Malcolm Varon, N.Y.C. © 2004. CAT. 94: Giraudon/Art Resource, N.Y.

Chapter 2 FIG. 1: *Wegbereiter der modernen Malerei: Cézanne, Gauguin, Van Gogh, Seurat: 4. Mai bis 14. Juli 1963* (Hamburg: Kunstverein in Hamburg, 1963), p. 119. CAT. 38: Richard Green, London. CATS. 39, 54, 28: Photograph © 1989 The Metropolitan Museum of Art. CAT. 40: Photography

by Photographic Services © 2003 President and Fellows of Harvard College. CAT. 42: Photograph courtesy Sotheby's. CAT. 41: Image © 2003 Board of Trustees, National Gallery of Art, Washington, D.C. CAT. 49: Photograph © The Metropolitan Museum of Art. FIG. 4: Photograph © reproduced with permission of The Barnes Foundation. All Rights Reserved. BF 2506. CAT. 64: Photograph © 1990 The Metropolitan Museum of Art. CAT. 62: Provost and Fellows of King's College, via Fitzwilliam Museum, Cambridge. CATS. 52, 50: R.M.N./A.R. Photography by Hervé Lewandowski. CAT. 55: Museum of Art, Rhode Island School of Design. Photography by Erik Gould. CAT. 57: R.M.N./A.R. Photography by Michéle Bellot. CAT. 56: Photo – 2003 Peter Tillessen. CAT. 67: R.M.N./A.R. Photography by J. G. Berizzi. CATS. 75, 70: Photography by Stephen Petegorsky.

Chapter 3 CAT. 27: Private collection, on extended loan to the Courtauld Institute of Art Gallery. FIG. 1: Mapping Specialists, Madison, Wisconsin. FIGS. 2, 10: R.M.N./A.R. Photography by Hervé Lewandowski. FIG. 3: Sotheby's, New York, *19th Century European Paintings, Drawings and Sculpture*, sale cat. (New York: Sotheby's, Feb. 16, 1994), lot 179. FIG. 4: Courtesy of the Ryerson and Burnham Archives, AIC, G20292. CAT. 93: Photography by J. Lathion © National Gallery, Norway 1998. FIGS. 7, 18, 19, 20: Photography by Robert L. Herbert. FIG. 8: César M. de Hauke, *Seurat et son oeuvre*, vol. 2 (Paris: Gründ, 1961), p. 195. FIG. 9: Reproduced by kind permission of the Trustees of the Wallace Collection, London. FIG. 13: © Studio Basset G. Dufrene. FIG. 14: © Scala/Art Resource, N.Y. FIG. 15: R.M.N./A.R. Photography by R. G. Ojeda. FIG. 16: Published by Martin Delahaye, Lille. FIG. 17: Courtesy of Robert L. Herbert. CAT. 107: Photograph by Robert Hashimoto.

Chapter 4 CAT. 26: R.M.N./A.R. Photography by Gérard Blot. CAT. 116: Leeds Museums and Galleries (City Art Gallery) U.K./Bridgeman Art Library © Artists Rights Society (ARS), New York/ADAGP, Paris.

Chapter 5 CAT. 86: Photography by Joseph Zehavi. FIG. 1: Photograph © 1994 The Metropolitan Museum of Art. FIG. 2: Photograph: Speltdoorn. FIGS. 3, 6: Courtauld Institute of Art Gallery. FIG. 4: Musée des Beaux-Arts, Tournai, Belgium/Bridgeman Art Library. CAT. 90: Digital Image © 2003 The Museum of Modern Art, New York. CAT. 88: Image © 2003 Board of Trustees, National Gallery of Art, Washington, D.C. CAT. 115: Photography by Mel

McLean. CAT. 119: R.M.N./A.R. Photography by Hervé Lewandowski. FIG. 5: Photograph © 1989 The Metropolitan Museum of Art. FIG. 9: Photograph © reproduced with permission of The Barnes Foundation. All Rights Reserved. BF 811. FIG. 13: CNAC/MNAM/Dist. R.M.N./A.R. FIG. 14: Photography by Robert L. Herbert.

Chapter 6 FIG. 1: R.M.N./A.R. Photography by Jean Schormans. © Artists Rights Society (ARS), New York/ADAGP, Paris. FIG. 3: Rheinisches Bildarchiv Köln. FIG. 5: Photography by CNAC/MNAM/Dist. R.M.N./A.R. © Artists Rights Society (ARS), New York/ADAGP, Paris. FIG. 6: Digital Image © 2003 The Museum of Modern Art, New York. FIG. 7: Photography by Lee Stalsworth. FIG. 8: Digital Image © 2003 The Museum of Modern Art, New York © Artists Rights Society (ARS), New York/ADAGP, Paris.

Chapter 7 FIGS. 1, 2: *Art Institute of Chicago Museum Studies* 14, 2 (1989), p. 126. FIG. 3: George Augustus Sala, *Paris Herself Again in 1878–79*, 6th ed. (London, 1882), p. 514. FIG. 4: Art Renewal Center. FIG. 5: Photography by Katherine Wetzel © Virginia Museum of Fine Arts.

Chapter 8 FIG. 1: R.M.N./A.R.

Zuccari and Langley All contour drawings, silhouetting, and grid-line overlays: Frank Zuccari and Allison Langley. FIGS. 3, 8, 12, 17, 19, 31: Photograph © 1990 The Metropolitan Museum of Art. FIG. 4: Photography by Inge Fiedler. FIG. 5: Provost and Fellows of King's College, via Fitzwilliam Museum, Cambridge. FIGS. 10, 16, 21, 24, 27, 29, 35: X-radiography by Tim Lennon. FIGS. 13, 18, 32: X-radiography by Charlotte Hale. FIG. 37: César M. de Hauke, *Seurat et son oeuvre*, vol. 2 (Paris: Gründ, 1961), p. 203.

Fiedler All photomicrographs and cross-sections: Photography by Inge Fiedler. FIG. 1: AIC, Department of Conservation. FIG. 7: Provost and Fellows of King's College, via Fitzwilliam Museum, Cambridge. FIG. 13: Allison Langley. TABLE: Inge Fiedler.

Berns FIGS. 1, 6: AIC, Department of Imaging, and Roy S. Berns. FIGS. 2, 5, 7, 8, 9, 10, 13, 14: Roy S. Berns. FIGS. 3, 11, 12: Lawrence A. Taplin. FIG. 4: Roy S. Berns, after Ewald Hering.

Harris FIG. 1: Photograph by Martin J. Schmidt. Courtesy of the Ryerson and Burnham Archives, AIC, G20882. FIGS. 2, 6, 12: Courtesy of the Ryerson and Burnham Archives, AIC, C24178, C11894, G20311. FIG. 3: Chicago Historical Society

ICHi-00889. Photograph by J. W. Taylor. FIG. 5: AIC, Ryerson and Burnham Libraries, G20883. FIGS. 7, 8, 10: AIC, Department of Imaging, C11757, E34082, C11522. FIG. 11: Photograph by Greg Williams. AIC, Department of Imaging, G20884. FIG. 13: © 1958 AP/Wide World Photos. FIG. 14: Ezra Stoller © Esto 71CC.7, 1967. FIG. 15: Gerry Goodstein © 1983 All Rights Reserved. FIG. 16: Courtesy of Playbill, the National Theatre Magazine. FIG. 17: Courtesy of Lands' End Direct Merchants. FIG. 18: Photograph by Randall Lee Schieber. Courtesy of the Topiary Garden. FIG. 19: *Ferris Bueller's Day Off* © Paramount Pictures. All Rights Reserved. FIG. 20: The New Yorker Collection. 1990 J. B. Handelsman. From cartoonbank.com. All Rights Reserved. FIG. 21: Klaus Staeck and Gerhard Steidl, Beuys in Amerika (Heidelberg: Editions Staeck, 1987), n. pag. FIG. 22: Photography by Joel P. DeGrand.

Catalogue of All Known Work For works illustrated elsewhere in the book, see credits for primary images. H 118, H 136, H 141: César M. de Hauke, *Seurat et son oeuvre*, vol. 1 (Paris: Gründ, 1961), pp. 73, 89, 93. H 642, H 618: César M. de Hauke, *Seurat et son oeuvre*, vol. 2 (Paris: Gründ, 1961), pp. 221, 199. H 623: Michael F. Zimmermann, *Seurat and the Art Theory of His Time* (Antwerp: Fonds Mercator, 1991), p. 184. H 626: Germain Seligman, *The Drawings of Georges Seurat*, 2nd ed. (New York: C. Valentin, 1947), pl. 8.

Bibliography Initial letter for article by Paul Adam, "Les Impressionnistes à l'exposition des indépendants," *La Vie moderne* 10 (April 15, 1888), p. 228. Photography by Robert L. Herbert.